MARINETTI

Selected Writings

*Edited, and
with an introduction, by*
R. W. Flint

Translated by
R. W. Flint *and*
Arthur A. Coppotelli

MARINETTI

Selected Writings

FARRAR, STRAUS AND GIROUX

New York

Grateful acknowledgment is made to Arnoldo Mondadori Editore,
publisher of the Italian texts from which selections for
this edition have been made: F. T. Marinetti, *Teoria e invenzione futurista,*
© Arnoldo Mondadori Editore 1968; *La Grande Milano
tradizionale e futurista/Una sensibilità italiana nata in
Egitto,* © Il Libro S.A. Bellinzona 1969, © Arnoldo
Mondadori Editore 1969

Contents

MARINETTI

Selected Writings

Introduction

No dossier on revolution in the arts, or even on revolution in general, would be complete without a selection from the works of Filippo Tommaso Marinetti, 1876–1944, the founder, promoter, Maecenas, and all-round demiurge of the Italian Futurist movement. Of all the theorists and instigators of aesthetic modernism's heroic age, Marinetti has been dealt with most harshly by time, and this neglect, though firmly grounded in his character and action, foreseen and even somewhat courted by the man himself, can now be taken as an inevitable result of his radical program for renewal. The experience of ends makes possible the understanding of beginnings; the cycle of modernism has come around to a point where its origins can finally be detached from the politics that submerged them so soon after their birth. Futurism can now be enjoyed in its comedy, its haphazard profundity, its welter of crazily naïve, exuberant paradox and divination.

For the best of reasons we cling to the hallowed dream of a gay, casual, intensely charming bohemia when we think of the decade that Roger Shattuck chose to call *The Banquet Years* in the title of his excellent book. At first and within its own small Italian world, as I hope to show, Futurism was all of that. But Futurism in Italy and Futurism as a greatly but mysteriously influential gospel of action in the arts were two distinct things.

Between 1909 and 1914, when D'Annunzio was self-exiled in France, Marinetti was master of the revels in Italy. Very rich, personable, loyal

and courtly toward friends, immensely energetic, a maniac for action
and overtness at any cost, he aroused and divided the cultural scene.
Having broadcast his credo in the First Manifesto of 1909 and seized
the initiative from D'Annunzio, who had been in many but not all
respects his master, he scourged and ridiculed the quasi-academic rou-
tine of Italian cultural life. He was everywhere at once, thanks to the
railroads, organizing, orating, propagandizing, staging exhibitions and
theatrical "evenings" of music, recitation, and riot; clowning, providing
a screen of systematically irrational uproar behind which his friends for
the most part enjoyed themselves immensely.

This purely Italian aspect of Futurism as it affected literature, paint-
ing, sculpture, music, drama, dance, and the cinema (in its later tame
Fascist phase, also cooking, mathematics, radio, and the self-invented
art of "Tactilism") is fairly easy to disinter from the First World War
and its political sequel. Readers should look up *Futurism,* the illus-
trated catalog of an exhibition assembled in 1961 by the Museum of
Modern Art in New York, with an excellent text by Joshua C. Taylor.
The history of Futurist theater, music, and cinema is now available in
Futurist Performance, a clear, concise, and well-illustrated survey by
Michael Kirby (E. P. Dutton, 1971). I am chiefly indebted to Luciano
De Maria for his two-volume set *Opere di F. T. Marinetti* (Arnoldo
Mondadori, 1968), the first reliable, though incomplete, collection in
Italian. More translation of Futurist writing, of the poetry of Govoni,
Buzzi, and Palazzeschi, may eventually appear. But the "composed
noises" of Luigi Russolo, brilliantly prophetic and vastly amusing as
they must have been, seem to have been lost along with his eccentric
battery of noisemakers (*intonarumori*); and the early *musique concrète*
for conventional orchestra of Balilla Pratella is gone from the repertory.
Such as they were, the innovations of "Futurist dance" have long been
absorbed, and the few surviving reels of Futurist film are decaying in
the archives. But except for fine arts and music, Marinetti signed the
manifestos of all these arts, writing them with a bristling charm and
bravura that may often be a more than adequate substitute for the
works that followed. As a writer of manifestos he had few rivals in his
time; the death of Lenin and the decay of Futurism marked the begin-
ning of the end of the looseleaf or pamphlet manifesto as a serious
weapon in either politics or art. But even the manifestos that Marinetti
did not sign, including Apollinaire's bizarre *L'Antitradition futuriste,*

tend to ape his manner and tone. The Dada manifestos of Tristan Tzara were a flagrant imitation.

Enjoyment of all this will depend on one's curiosity about a colorful but, until recently, largely forgotten Italian episode—the excited, pugnacious, dreamlike, improvising, utopian stage in the formation of the proto-Fascist and Fascist mentalities. This aspect of the book must appeal to the reader's common-sense conviction that no nation, least of all Italy, is composed of pure angels and devils. As any good anthropologist will tell you, aesthetics and politics are so closely interwoven that it is often impossible to determine where one begins and the other ends. Aesthetic Futurism in its earliest years was far more vital and influential, interesting and exhilarating, than the Mussolinian aesthetics that caused only laughter and dismay in much of the rest of the world. A lack of certain essential qualities, of *humanitas* in the broadest sense, does indeed make the two aesthetics akin. On the other hand the laughter-producing features that both of them shared were actively courted by the Futurists, not by Mussolini. And the whole matter of the use to which the Nazis, Fascists, and Bolsheviks put the most advanced art of their day is just beginning to be noticed. The equation Art = Action is as much in question today as it was in 1909.

The wider influence of Futurism, and especially of Marinetti's tours of Europe and Russia, was considerably more decisive than most histories of the era have bothered to admit, swayed as they were by the matchless talent of the French for keeping attention on themselves. Only in the light of the latest evolutions in the arts—of McLuhan and Cage, of Tinguely's self-destroying machines, of the marriage of art and technology consummated in E.A.T. (Experiment in Art and Technology), of all that Harold Rosenberg discusses in *The Anxious Object*— does the seemingly incoherent mass of Futurist divination begin to compose itself into the remarkable act of foresight it has proven to be. At the height of its influence, coming on the scene at the critical moment in the consolidation of modernist practice and changing the work of such very different men as D. H. Lawrence, Mayakovsky, Apollinaire, and Hart Crane, Futurism added a vital strain of bluff Latin rationality to the growing cult of the irrational in art. Someone had to be the first to carry things to ridiculous lengths and to do so on principle. Someone had to explore the hopeless paradox of unanimity in the arts, to dramatize in the loudest, plainest, most blatant manner possible

the joys and absurdities of organized movements in art, to furnish a protocol for Dada, Surrealism, each later attempt at solidarity. As Renato Poggioli put it in his *Theory of Avantgarde Art,* "The futurist moment belongs to all the avantgardes, not only to the movement that took that name." Activism, antagonism, nihilism, and agonism—all four of Poggioli's indices of a true avantgarde found strong and equal expression in the First Manifesto. All the movement's griefs and failures followed from its attempt to make a collective faith out of Rimbaud's anarchic motto: *Il faut être absolument moderne.*

In his role as "the caffeine of Europe," Marinetti was a dramatic break in the smooth evolution of Italian elegiac pessimism from Leopardi to Pascoli, Carducci, Gozzano, and D'Annunzio. A monster sprung, apparently, from D'Annunzio's loins who nevertheless kept his distance from the Divine Gabriele, a man who during his best years seemed to have no inner life at all, certainly not by the reigning standards of polite letters, the first wholesale Italian enthusiast for American promotional techniques, the first important Italian disciple of Whitman and yawper of the barbaric yawp, Marinetti became one of the great intuitive sleepwalking impresarios of Europe. His scale of operation was so original that it seems out of place to call his later submergence as an Accademico d'Italia under Mussolini tragic; pathetic is the better word. It was the revenge of history on a man who tried to destroy history in the name of art.

To define what sets him apart from a dozen contemporary rivals in anarchy and artistic utopianism is not easy. As soon as you dip below the surface of his dream of himself as the caffeine of Europe begetting "an anarchy of perfectionisms," an "association of desperate ideas"; as the liberator of the machine and prophet of "the metalization of man"; as the scourge of "psychology," scorner of lechery and D'Annunzian *amore* (but he was in and out of exotic beds no less than his repudiated master); as a self-proclaimed "primitive of a new sensibility," discoverer of "the proletariat of gifted men," the "madness of becoming," and "the extrinsicated will"; as soon as you apply the normal procedures of the history of ideas, you find the ghost of Futurist originality —even though events prove that it was there—dissolving backward and sideward into the bubbling acids of that prewar world. Nietzsche clearly hovers in the background, but Marinetti, in response to the German's own directives, intended to convert everything private, fugitive,

and driven in Nietzscheanism into the hearty noonday bustle of optimistic Milanese enterprise; failing that, into genial farce. He saw himself rising like a dragon from the mountainous lairs of cisalpine Gaul to avenge his people on *everything* German, or so he sometimes thought, although in gentler moods he was delighted to exhibit and lecture in Germany.

Aside from the letters and memoirs of such men as Lawrence, Gramsci, Apollinaire, and scattered stories in biographies, the documentation of the movement is surprisingly sparse—one more reason to publish the original texts, especially Marinetti's memoirs of 1944 in Arthur Coppotelli's translation. There is one entirely affectionate account, *Le serate futuriste* (*The Futurist Evenings*) by Francesco Cangiullo, Marinetti's own Leporello and partner in the Futurist comic theater (see "Dynamic and Synoptic Declamation" and the theater manifestos), an ebullient, providential little man who cheered everyone up when they needed it most, who helped smooth the movement's descent from the heights of prophecy to the lowlands of vulgar commercial success on the stage. But Cangiullo's entertaining book is by a master of vaudeville, not of cultural history.

In 1968 when De Maria's two-volume *Opere* was published, Italian reactions to the attempted resurrection were confused and gingerly, closely following political lines. For most Italians Marinetti was a new author. The more conservative saw De Maria's books as an effort to bolster the prestige of the current "Neo-Avantgarde" and reacted accordingly; but the leading *neo-avanguardista,* Edoardo Sanguineti, replied with a severe condemnation of Futurism's social and political impulses, citing a powerful indictment of Marinetti by Walter Benjamin, the current critic *de cri* among many young Italians—of which more later.

As a middle-aged American, conscripted and politically half-awake during the Axis war, I dislike Marinetti's strident bellicosity as much as Sr. Sanguineti does. Certainly the Futurist cult of "synthetic" verbal violence, of "war, the world's only hygiene," the appalling innocence about war, as it seems now, of the whole European prewar world, is the greatest obstacle to the understanding of Futurism. Yet its forthrightness in the matter, like Tennyson's in the opening sections of "Maud," is appealing and radical. And this belligerence was fundamental, an energizing theme that reaches back to the oldest springs of Italian ac-

tion, that fuses the farcical immoralism of D'Annunzio or Casanova with a wildly accelerated Viconian philosophy of action and creativity at any price.

Moreover, this ferocious antihumanitarian bristling was naïve enough in the Futurists to be enjoyable in its accidents, if rarely in its essence. My epigraph by Santayana uncovers its roots.

Marinetti's nature, in other words, contained many of the sturdier ingredients of Renaissance *virtù:* a true valor behind the clownish urbanity, a good soldier's kind of loyalty, the Hemingway type of courage (which sent him out to a dangerous sector of the Russian front in 1944) and strength to openly oppose his "friend" Mussolini, in 1920 when he left the Fascist party, and in 1938 when, after years of uneasy support of the regime, he published an open letter condemning anti-Semitism in the arts.

In the final accounting, Marinetti *was* Futurism. Like de Chirico and Modigliani, the painters would have made their way without him, as would have the musicians, the actors, and the architect Sant' Elia. The Russian Futurists would have found another name, other masters to follow and deny.

Nationalism, even Nietzschean nationalism with libertarian-anarchist trimmings, proved in both Russia and Italy to have been too narrow a base. Waking too late from its dream of a utopian *proletariato dei geniali* (proletariat of gifted men) and its slogan of Power to the Artists, Futurism was defeated by its internal contradictions and the evil genius it seemed to have summoned from the depths—the real Mussolini, always careless of friends who had served his purpose, but also the Nietzschean-aesthetic Mussolini of Marinetti's "Portrait" (see page 158), whose aura steadily dimmed but never entirely disappeared until the final catastrophe.

As Apollinaire wrote in his parody manifesto *L'Antitradition futuriste* (1913), Futurism was the first collective effort to suppress history in the name of art. Sooner or later the nineteenth-century historicism of such giants as Hugo and Manzoni was bound to generate its opposite, not only private literary philosophies like Rimbaud's, but popular creeds. In this respect the Futurists were the pre-Socratics of modernism, coining a *tesoro* of maxims and striking images whose common theme was the repudiation of all middle terms, all agencies and intermediaries engaged in making history out of the arts. They were well aware

of how quixotic this enterprise was; they positively welcomed the Nietzschean *amor fati* that foresaw their own obsolescence.

> They will come against us, our successors, will come from far away, from every quarter, dancing to the winged cadence of their first songs, flexing the hooked claws of predators, sniffing doglike at the academy doors the strong odor of our decaying minds, which already will have been promised to the literary catacombs.
> But we won't be there. . . . At last they'll find us—one winter's night —in open country, beneath a sad roof drummed by a monotonous rain. They'll see us crouched beside our trembling airplanes in the act of warming our hands at the poor little blaze that our books of today will give out when they take fire from the flight of our images.
>
> [First Manifesto]

Under the spell of a "synthetic" madman, striving to extrinsicate their wills, across Europe from riot to riot, exhibition to exhibition, theater to theater, they sketched one of the tightest equations ever drawn between Art and Life, in a grand parody of Vico's idea that one can only really know what one has made oneself. Vico applied the idea to history in general; Futurism thought that art was the only history worth knowing.

Marinetti and D'Annunzio in pre-Futurist Italy. Like Napoleon, the future "caffeine of Europe" was born and raised outside the country whose cause he took up with a typically Latin mixture of shrewdness and histrionics. His capable Piedmontese lawyer father, known in youth as "Felfel" (pepper), had married the daughter of a Milanese professor of literature, a handsome, gentle woman who read poetry to her sons Leone and "Tom." In Egypt, where the father made a large fortune speculating and advising the khedive of Alexandria, where Tom was taught in French by Jesuits, the older Leone was considered the poet of the family, the most promising child.

A biographer speaks of Tom's "temperament of a gentle, volcanic, nostalgic, amazed, and sentimental *bambinone* [big baby]," and this is probably a good enough description of a boy whose essay on an Egyptian sunset his Jesuit teacher found surpassed "anything Chateaubriand wrote," but who later claimed to have been expelled for bringing some novels of Zola into class. In 1893 he went to Paris for his baccalaureate, two years later to Pavia and then Genoa for a degree in law.

Meanwhile, the more robust Leone developed rheumatic fever and died in Milan. There the family had moved to a large, appallingly Egyptianized apartment, the scene of the opening pages of the First Manifesto, where the saddened (and perhaps bored) mother retired into herself and died in 1902. The millionaire father amused himself by hiring young women to read him comparative religion, alternated with erotica, and by visits to the local *case chiuse*. He died in 1907 on the eve of Futurism, resigned to Tom's already well-advanced literary career— his son was now universally known as "the poet Marinetti," having won a prize for a French poem, *Les Vieux Marins*, recited from the stage by Sarah Bernhardt at the *Samedis Populaires*, and having had his play *Le Roi Bombance*, a boisterous plagiarism of Jarry's *Ubu Roi*, produced in Paris by the producer of *Ubu*, Lugné-Poë; it was greeted with a small but satisfactory riot. Soothed by these credentials, Marinetti *père* left his son the apartment and all his money.

This was the familiar, almost classic, formula of his childhood: successful entrepreneur father, solitary, extravagant, and fond of loose women; sensitive Milanese mother who wanted to redeem her sons through art; a petted older brother who died young; a black Sudanese nurse who focused his early erotic feelings and established his sense of himself as an outcast adventurer.

The great Giuseppe Verdi, last of the Risorgimento giants, died in 1901 and was given an impressive state funeral in Milan, the Italian counterpart to Victor Hugo's funeral: the formal obsequies, so to speak, of heroic popular romance. Marinetti attended and was deeply moved. In 1907 he also attended the funeral of the poet Carducci, a former senator and Republican of considerable moral authority, noting with disdain that D'Annunzio had neglected to come and had merely sent an olive branch to be laid on the bier.

This left D'Annunzio himself, the Divine Imaginifico (maker of images), as the chief guide and magnet for the aspiring young, a role that, among the many this versatile man took up in the course of a seemingly endless life, he was the least fitted to play. When he fled to France in 1908, pursued by debt and scandal, the path was open to Marinetti and his essentially puritan revolution.

When the dramatic First Manifesto appeared on February 20, 1909, on the first page of *Le Figaro* in Paris, Italy was nearing the end of a placid period of "Humbertine" middle-class democracy, a time that fed

on government scandal, the excitements of minor wars, and harsh labor trouble. In Italy as elsewhere, these were years of rapid growth for socialism, but a socialism deeply tinged by a Sorelian cult of applied violence.

Whatever its origin (some think it came from Marinetti's secretary, Decio Cinti, so faithful a shadow that he could imitate his master's handwriting exactly, sign checks, and write letters that passed for originals), the mere word *Futurism* had an astonishing success. At first printed alone in huge block letters on vermilion posters plastered on the walls of whatever city Marinetti was alerting to a forthcoming demonstration, the word Futurism did for the populace at large what the First Manifesto had done for the intelligentsia of Europe and Russia: it guaranteed attention. Antonio Gramsci, Italy's leading Communist thinker, later wrote to Trotsky: "Before the war, Futurism was very popular among the workers. At the time of the many Futurist demonstrations in the theaters of Italy's largest cities, the workers defended the Futurists against the young people—semiaristocrats and bourgeois—who attacked them. The review *Lacerba,* whose circulation reached 20,000, found four-fifths of its readers among the workers."

Together with the word, a style of action was born. Marinetti had begun his career in 1900 as a "declaimer" of French poetry on French and Italian stages, in the broad forensic style of popular elocution. In 1910 he was sounding a silver trumpet from the *loggia* of the Clock Tower in Venice, showering the Sunday afternoon crowd with thousands of leaflets, reading his anti-Venetian manifesto in a stentorian voice through a megaphone—a style unknown in Italy except in legends of foreigners like P. T. Barnum.

But this style of action was a natural sequel to certain grandiose strains already sounded by the Imaginifico. Until 1908 the latter had managed to keep everyone interested, amused, and scandalized, as he poured out poems, novels, and plays that for two decades had created a popular taste of their own—for exquisite Theocritan and Virgilian pathos, for neo-imperial bombast, for the pious and sonorous antiquarianism of his "classical" plays, for the great colored energy of his writing about the peasantry among whom he was born, for his skill in popularizing and plagiarizing the advanced "decadent" sexual psychology of the age. Like Rossini, Verdi, and Puccini, for better or worse, he was a true orphic unifier of taste. Very short, bald, subject to embarrassing

accidents like falls from horses or out of the windows of houses, a phi-
landerer of genius, the visible epitome of the little, rosy, refined profes-
sional of dubious origin, D'Annunzio was the Napoleon of Humber-
tine mediocritism who sometimes rose to heights of vision and elegiac
beauty in his verse, a crowned prince of stagnation, both the Fatal Man
of romantic legend (hence acolyte of the Fatal Woman) and the most
amiable satire on Romance that nature could devise. If Marinetti's aims
had been less "global"—his word—if he had sought merely to fill the
gap in Italy between the Imaginifico's first retreat and his reappearance
as an eloquent spokesman in the Interventionist cause, then Futurism
would have been stillborn. But Marinetti was shrewd enough to see
D'Annunzio as a European phenomenon, only to be countered by an
appeal to all of Europe.

It was also the *buffone*, the clown, who carried with him a large part
of D'Annunzio's natural audience, those workers and lower-middle-
class lieutenants and captains of the eastern front for whom Marinetti
wrote some of his most sensational (and worst) prose extravaganzas
just before and during the war, in what a young Italian has accurately
described as the *style canaille del arditismo nostrano*—the doggy style
of veterans' literature. Indeed, it was Marinetti, a genuinely brave
man and better soldier than Mussolini, who together with D'An-
nunzio created the Italian vogue for sentimental veterans' camaraderie
that gave Fascism a powerful opening wedge, that in the course of time
made both the Futurist and the hero of Fiume virtual state prisoners of
a Duce to whose lips the title of "poet" would eventually bring only a
laugh.

D'Annunzio the famous entertainer, master plagiarist of Decadence,
high priest of *passatismo* (the cult of the past), sportsman, pilot, syn-
thetic English country gentleman—and his erstwhile disciple Marinetti,
who was transformed, during a strange short spell of sleepwalking in-
tensity and purity of aim, into the first philosopher of collective action
in the arts. Both debt and difference are clear in *Les Dieux s'en vont,
D'Annunzio reste* (*The Gods Depart, D'Annunzio Stays*), a pamph-
let Marinetti published in 1908. After obligatory jabs at "those glittering
chiseled poems polished like gems, that false decorative verdure, those
ideas sick and plaintive beneath a weight of futile opulence, that rou-
lette of banalities, those *rastas* and *cocottes* who render the work of the
Divine Gabriele the Monte Carlo of all literatures," Marinetti comes to
the point:

In truth, his presence alone is enough to disarm the satire and sarcasm of his enemies and systematic detractors. Thank God that I am not among them, for a violent personal sympathy always forces me to admire him as the distinguished seducer he is, the ineffable descendant of Cagliostro and Casanova and of many other Italian adventurers, whose finesse, triumphant courage, and tireless diplomatic resourcefulness will always be legendary.

Marinetti in France. Futurism, as should be apparent, was really Franco-Italian and owed a great deal to the ferment of the Bateau Lavoir, to the Polish-Italian Gallomane poet Apollinaire, and to the extraordinary Alfred Jarry. (Marinetti always gave more credit to minor influences like Verhaeren, Whitman, or the *vers-libriste* Gustave Kahn than he did to rivals who touched him more deeply.) The few remaining mysteries lie in an inaccessible region of memory and rumor surrounding talks between the Futurists and these revolutionary "French." Who first coined the magic word *simultaneity*? No one knows. To the gifted young Russian painters Malevich, Burliuk, Larionov, and Goncharova, who became avowed Futurists for a short time in 1911, Cubism and Futurism were enough alike to merit the term Cubo-Futurism. But this may only have expressed their hope of combining the Cubist analysis of space with the Futurist sense of motion. Critics seem to agree that Futurism in art was a distinct moment in the transition from earliest Analytic Cubism to later Synthetic Cubism, Orphism, and their descendants. In *The Language of Vision* (1944), Gyorgy Kepes analyzes the threefold progression of Futurist technique:

> Their first step was to represent on the same picture-plane a sequence of positions of a moving body. This was basically nothing but a cataloguing of stationary spatial locations. The idea corresponded to the concept of classical physics, which describes objects existing in three-dimensional space and changing locations in sequence of absolute time. The concept of the object was kept. The sequence of events frozen on the picture-plane only amplified the contradictions between the dynamic reality and the fixity of the three-dimensional object-concept.
>
> Their second step was to fuse the different positions of the object by filling out the pathway of their movement. . . . Potential and kinetic energies were included as optical characteristics. The object was considered either to be in active motion, indicating its direction by "lines of force," or in potential motion, pregnant with lines of force, which pointed the direction in which the object would go if freed. . . .

The third step was guided by a desire to integrate the increasingly complicated maze of movement-directions. The chaotic jumble of centrifugal forces needed to be unified. . . . The Cubist space analysis was synchronized with the lines of force. The body of the moving object, the path of its movement and its background were portrayed in the same picture by fusing all these elements in a kinetic pattern.

This is a good account of what they were thinking, but in fact the steps were neither as distinct nor as sequential as Mr. Kepes makes out. A normal Italian taste for the solid and monumental always held them back. One of Boccioni's finest paintings is *Materia,* a portrait of his mother: one remembers the powerful, sculpted hands that dominate the canvas. Conversely, when the gentle, reflective, Epicurean Severini determined in 1915 to follow Marinetti's prescriptions to the letter and painted *The Armored Train,* he, of all people, became Futurism's finest painter-poet of war. Such paradoxes always ruled the work of a group of artists as separate and self-willed as Boccioni, Severini, Carrà, Balla, and Russolo.

Furthermore, to cite the art critic Werner Haftmann: "The artistic techniques used by the Dadaists at the Cabaret Voltaire were primarily inspired by Tzara. Most of them came from the Futurist arsenal, and Dada meetings must have been very like those of the Futurists. . . ." Gide bears his usual emphatic witness to this:

> I attended a Dada meeting. It took place at the Salon des Indépendants. I hoped to have more fun and that the Dadaists would take more abundant advantage of the public's artless amazement. A group of prim, formal, stiff young men climbed onto the stage and, in chorus, uttered insincere audacities. . . . From the back of the hall someone shouted, "What about gestures?" and everyone laughed, for it was clear that, for fear of compromising themselves, none of them dared move a muscle.

Nothing of the sort could have been said of the hyperkinetic Italians under their galvanic maestro, or of the Russians who adapted Marinetti's methods to the rather more liberal Russian prewar atmosphere. In postwar Dada, the Futurist enthusiasm had been pacified, ironized and introverted. To claim, as Frank Kermode recently has, that the Dadaists were the original crazies is an odd inversion of the truth.

The three main fomenters of twentieth-century modernism seem to have been Apollinaire, Picasso, and Marinetti, with Diaghilev playing a

similar if less intellectual role, and none of them were French. As un-
rooted in youth as Marinetti, more polyglot, and, needless to say, a
much better poet, Apollinaire was more than Marinetti's match in
happy, improvised chauvinism. Tender toward a fellow Italian but in-
clined to poke fun, he dropped punctuation from his verses, like a good
Futurist, and copied them in his charming *idéogrammes*. He even tried
unsuccessfully to persuade the painter Delaunay that *he* had become a
Futurist. But his manifesto *L'Antitradition futuriste,* first printed in
Italian at Milan, reads like a midnight joke with just enough conviction
behind it to be a touching left-handed tribute.

MERDA is distributed to a long list of Critics, Pedagogues, Profes-
sors, Trecentisti, Quattrocentisti, Cinquecentisti, Ruins, Patinas, Histo-
rians, Venice, Versailles, Pompeii, Bruges, Oxford, etc. Dante,
Shakespeare, Goethe, Tolstoy . . . (with the odd inclusion of Whit-
man, Poe, and Baudelaire). *ROSE* are awarded in the following order
to Marinetti, Picasso, Boccioni, Apollinaire, Paul Fort, Mercereau, Max
Jacob, Carrà, Delaunay, Matisse. . . . This document, which Apolli-
naire never formally repudiated, may have been an apology to Marinetti
for not having pushed Futurism very hard. "The new art being devel-
oped in France," he wrote in a newspaper column, "seems so far to have
remained at the stage of melody. The Futurists have now taught us by
their titles, not by their works, that it could be truly symphonic." A
queasy compliment! but from a man whose judgments of painting
have not stood up very well, whose critical intelligence Picasso always
derided.

Among the French, however, it was the poet Alfred Jarry—here I
make my own daring plunge—who had the strongest influence on
Marinetti. So far I have not tried to account for his cult of the machine,
of "multiplied" and "metalized" man, of what Wyndham Lewis called
his Automobilism. Faith in Progress is understandable in a Milanese,
from a city where this faith still thrives. The cult of cars may have come
from D'Annunzio. Belligerence and a belief in Struggle as the bass note
of existence was temperamental, fortified by popular social Darwinism,
by an early reading of Zola. But when these elements coalesced into a
doctrine of impersonation, of imitative travesty in the world at large, in
a grand attempt to *swallow* the machine, to *become* it, then the model
was obviously Jarry, author of the mechanico-erotic fantasy *Le surmâle,*
as well as of *Ubu Roi*—parodist extraordinary of the higher Nie-
tzschean egotism of the European intelligentsia. Being mostly secret

Nietzscheans themselves, few of Jarry's spectators were aware of what he was doing. But they all rejoiced in it. Here is Gide:

> He was an incredible figure whom I also met at Marcel Schwob's, and always with tremendous enjoyment. . . . This plaster-faced Kobold, got up like a circus clown and acting a fantastic, strenuously contrived role which showed no human characteristic, exercised a remarkable fascination at the *Mercure*. Almost everyone there attempted, some more successfully than others, to imitate him, to adopt his humor; and above all his bizarre implacable accent—no inflection or nuance and equal stress on every syllable, even the silent ones. A nutcracker, if it could talk, would do no differently. He asserted himself without the least reticence and in perfect disdain of good manners.

Jarry, whom Apollinaire called "the last sublime debauchee of the Renaissance," embodied the age's attraction to unreason more vividly and *reasonably* than any other—and what else could have been the germ of Futurism? His philosophy of 'Pataphysics, the science of exceptions and imaginary solutions, brings Nietzsche down to the marketplace in an amiable, all-forgiving spirit, shorn of the great German's haughtiness and refined apocalyptic racism. If Nietzsche had been death on the "weak," then surely the "science of exceptions" would find a place even for them. This acted role showed that Supermanism, turned from the contemplation of Cesare Borgia and stuffed inside the skin of a little round-faced Frenchman, could be overwhelmingly funny without losing its air of tragic seriousness, of pathetic, alcoholic suicide. Jarry was a robot Père Ubu, compounded, according to Catulle Mendès, "of Punch and Judy . . . Monsieur Thiers, the Catholic Torquemada and the Jew Deutz, of a Sûreté policeman and the anarchist Vaillant, an enormous parody of Macbeth and Napoleon, a flunky become king. . . ." In other words, a parody of most of the varieties of "supermen" acknowledged in France since Rabelais—over whom Jarry fitted the ultimate mask of "metal man."

This charade's steadying effect on Marinetti can hardly be overestimated. The two men often met in salons; Jarry published in Marinetti's magazine, *Poesia*. And the Italian became the vehicle by which the French poet's painfully ambiguous embrace of the present and of the future, so far as the future could be travestied in advance, was incorporated into the larger body of European art and thought. In comparison Jules Verne had been a placid Victorian bourgeois romantic. It was the note of menace and terror in Jarry's charade that Marinetti so firmly

picked up, as earlier he had picked up Rimbaud's demand, *changer la vie.*

In honesty I cannot end this section without showing how, even among the French who welcomed him for his evident courtesy, his facility in the language, and his charm, Marinetti offended the sensibilities of those for whom his doctrine had small appeal. Gide once more:

> He paws the ground and sends up clouds of dust; he curses and swears and massacres; he organizes oppositions, contradictions and intrigues just for the pleasure of triumphing over them.
>
> Otherwise he is the most charming man in the world with the exception of D'Annunzio, animated in the Italian fashion, which often takes verbosity for eloquence, ostentation for wealth, agitation for movement, feverishness for divine rapture.
>
> He came to call on me some ten years ago and displayed such incredibly polite attentions that they forced me to leave for the country at once; if I had seen him again I would have been done for: I might have decided that he had genius.

Marinetti and the English. A curious thing about the culture of northern Italy—Piedmont, Milan, and the Po Valley—is the intermittent light it sheds on the rest of Europe. Alpine and individualist, protected by the amnesis of border regions, it tends to have marked pulses. After Rousseau's sojourn at Turin and Stendhal's Milanese raptures, the region virtually disappears from French writing. In a sense, Anglo-Italian relations have not yet recovered from the moral exertion of both sides during the Risorgimento, a struggle that more or less began with the first Piedmontese rising of 1821 and ended only with Mazzini's death in 1872, eleven years after Elizabeth Barrett Browning's and six after Jane Carlyle's. This was a very long time for the upkeep of cordial, let alone heroic, relations between English and Italian liberals, considering all that divided them otherwise. The stilted attitudinizing of the Italian parts of Meredith's novel *Vittoria* (1866), about the rising of 1848, in contrast to the vivacity of *Sandra Belloni,* the first volume of the duo, set in England, underlines the sense of strain one finds in Mrs. Browning's agonies on Italy's behalf, or Jane Carlyle's frustrations in the care and feeding of Mazzini. It was really the unintellectual figure of Garibaldi that suited popular English taste.

Futurism arrived at a moment of deep quiescence between the two cultures. Italy's Triple Alliance with Germany and Austria had not

been inspiring. D'Annunzio's admiration for England, expressed in his costume and fondness for horses and dogs, was only tepidly reciprocated.

Mazzini was one of Marinetti's heroes, and Futurism tried to be as violently anti-Austrian as Mazzini's Giovane Italia. But in the hands of men like Rossetti, Symonds, and Arthur Symons, English Italianism had retired once again into the high aesthetic ether. Why the First Manifesto should have impressed so many Continental and Russian writers and artists but have produced only one English Futurist, the painter C. R. W. Nevinson, why it should have sparked so much snobbish hostility from Wyndham Lewis—and Pound, who leaned toward it in 1913 but then, when Marinetti pressed too hard and gave too many flamboyant London lectures in 1914, leaned as far in the opposite direction—all this is understandable when one looks more closely at the First Manifesto. A striking feature is its note of alarm; it was the first unambiguous portent of the coming European war addressed to the European elite. It announced an ingathering of the tribes under the leadership of natural fighters, artificial Red Indians; it announced the revival of the waning forces of Latin *machismo* ("scorn for women," and so on) to face up to the imminent cataclysm. It sanctioned aesthetic nationalism under the tragic law of obsolescence.

In England, however, even Lewis resisted the notion that the coming war implied a symbolic crisis for art, or that it revealed the *true* bases of art and life. When Marinetti came to London and recited his *Battle of Adrianople* with machine-gun noises, cannon noises, whinnies, and yells, at the top of one of the most powerful sets of lungs in Europe, accompanied by Nevinson on the bass drum, Lewis and his friends Hulme, Epstein, and Gaudier-Brzeska were there to jeer. Lewis reported later that even at the front, when bullets whistled around him, he had never encountered such a terrifying volume of noise as Marinetti produced. The fact that the whole show was meant to enlist sympathy for the anti-German cause seemed not to affect him. It was *vulgar*.

During a taxi ride (as Lewis remembered it in *Blasting and Bombardiering* in 1937) between the Doré Gallery and the Café Royal, Lewis told Marinetti that, after all, the English had *invented* the machine society and could hardly be expected to get excited about it at that late date. Progress was a dead god for the newer English spirits. Then, in a last crushing blow, he added, *"Je hais le mouvement qui déplace les*

lignes," to which Marinetti could only splutter, *"Zut alors!* you English, they say you never weep! What must it be like?"

When Pound reversed his field in the late twenties and began to hail Marinetti as the inventor of modernism, perhaps to please his Fascist friends, Lewis attacked in *Time and Western Man:*

> My opposition to Marinetti, and the criticism of his "futurist" doctrines that I launched, Pound took a hand in, though really why I do not know; for my performances and those of my friends were just as opposed to Pound's antiquarian and romantic tendencies, his velvet jacket and his blustering *trouvère* airs, as was the futurism of Marinetti. . . .
>
> I should be tempted to think that it had taken a decade for Pound to catch up to Marinetti, if I were not sure that, from the start, the histrionics of the Milanese prefascist were secretly much to his sensation-loving taste.

D. H. Lawrence and the poet Mayakovsky were the two major writers whose work was most obviously influenced by Marinetti. In June of 1914, Lawrence wrote his friend A. W. McLeod:

> I have been interested in the futurists. I got a book of their poetry—a very fat book too—and a book of pictures—and I read Marinetti's and Paolo Buzzi's manifestations and essays and Soffici's essays on cubism and futurism. It interests me very much. I like it because it is the applying to emotions of the purging of the old forms and sentimentalities. I like it for its saying—enough of this sickly cant, let us be honest and stick by what is in us. . . . They are very young, college-student and medical-student at his most blatant. But I like them. Only I don't believe in them. I agree with them about the weary sickness of pedantry and tradition and inertness, but I don't agree with them as to the cure and escape. They will progress down the purely male or intellectual or scientific line. They will even use their intuition for intellectual or scientific purposes.

He continues in this vein for another paragraph, predicting that "Italy has to go through the most mechanical and dead stage of all" before it can reach the Lawrencian utopia where all art is "the joint work of man and woman." Ignoring the entire theme of the coming war in Marinetti, Lawrence dignifies him in this first letter with a greater devotion to science than he actually had.

But in a second and often quoted letter to Edward Garnett, written

three days later, he had found something new, nothing less than the impetus for his change of direction between *The Rainbow* and *Women in Love*.

> But when I read Marinetti—the profound intuitions of life added one to the other, word by word, according to their illogical conception, will give us the general lines of an intuitive physiology of matter—I see something of what I am after. I translate him clumsily, and his Italian is obfuscated—and I don't care about physiology of matter—but some-how—that which is physic—non-human, in humanity, is more interest-ing to me than the old-fashioned human element—which causes one to conceive a character in a certain moral scheme and make him consistent. The certain moral scheme is what I object to.

One might conclude from this that Lawrence had merely rediscovered nineteenth-century Continental naturalism in a new form, the social Darwinism of Blind Forces in Zola and the Goncourts. The novelty of the Futurist version of this usually rather grim gospel, however, was exactly the "medical-student" gaiety and optimism that he had laughed at in the first letter, which he then put into the sympathetic characters, Birkin and Ursula, of *Women in Love,* while the actual Futurist doc-trines were put in the mouths of sinister characters like Gerald and Loerke. Lawrence's division of mind at this point can be taken as one more indication of the universal wisdom with which F. R. Leavis en-dows him. I would not want to deny it, not very strenuously. But Law-rence was also slightly insane on the topic of what he liked to call science.

The Futurists in Action. Considering the movement's whole bent to-ward extroversion, I think the flavor of its best days can be found in memoirs of public events. But before these demonstrations could ripen into full-blown scandal, Marinetti took care to coerce and neutralize his only serious rivals in cultural subversion, the editors and authors of the avantgarde Florentine journal *La Voce*. These were Giovanni Papini, the famous *stroncatore* (decapitator) and Tuscan H. L. Mencken, a Nietzschean and promoter of William James, enemy of all systematic and Germanic philosophies; and Ardengo Soffici, a gentle, witty coun-tryman, excellent art critic and good painter, who had befriended Mo-digliani and frequented the liveliest Parisian circles since 1900. Dra-gooned into Futurism in the celebrated Punch-Up of Florence, in the autumn of 1912, these men founded a new magazine, *Lacerba,* and

opened it to Marinetti, who took such abundant advantage, pressing so much dubious work of his young disciples on the subtle Florentines that by the end of 1913 the proud Papini rebelled, bolted Futurism, and took Soffici with him.

The end of this strange collaboration, the movement's intellectual apogee—as Gramsci noted, *Lacerba*'s circulation had reached 20,000—was implicit in its beginning. Papini, for instance, had cut a poor figure reading his Denunciation of Rome at the Costanzi Theater.

> As for Papini [Marinetti wrote], he has neither the physique nor the voice for the part. Very myopic, with a thin monotonous voice, he reads his speech against passéist Rome badly, which I then hurl from the footlights in fistfuls of manifestos that contain a substantial text of the speech that further excites the audience. "I violently throw in your faces the speech of my great friend, the antiphilosophical Futurist, Giovanni Papini!" Indescribably fierce uproar.

Sad to say, both these formerly staunch reformers of Italian taste melted even more completely into the Fascist background than their vulgar Milanese friend. Converted to Catholicism in 1920, Papini became known as "the great penitent," an Accademico d'Italia like Soffici and Marinetti, winner of the Mussolini Prize in 1933 for a Fascist interpretation of Dante, author of a best-selling *Life of Christ*. Soffici was aroused by the art magazine *Jugend* in 1902 (Jugendstil had been shown at the first Venice Biennale in 1895, then in 1902 at a large show of decorative arts at Turin), and finding Jugendstil sentimental, he progressed through an Impressionist phase to a Picassoesque attack on Impressionism for its "idolization of color, the fetishism of the palette." He liked "the soberness, consistency, gravity, and balance" of early Cubism, but even as a Futurist he was recommending the Latin *concetto della mente* (intellectualism) of Leonardo against almost every foreign painter except Cézanne and Degas. The Italians, he thought, were "a great race of constructive minds." After this first step toward neoclassicism—his models were Giotto and Masaccio—he grew steadily more conservative until in an article, "The Periplus of Art," he fiercely attacked all modern schools of northern Europe, insisting on the values of blood and soil and national tradition.

In Soffici's defense it must be added that later "waves" of Futurist painters, though a tribute to Marinetti's stalwart single-mindedness in his role of impresario, were essentially as backward-looking as Soffici

himself in those years: except that the later Futurists—Balla, Prampo-
lini, Depero, Farfa, and the others—while keeping up an aura of radi-
calism, returned to the complacent spirit of eighteenth- and nineteenth-
century decoration, to "geometric landscape," "cosmic idealism," and
other grandiosities suggestive, like much of Marinetti's late *aeropoesia,*
of a Tiepolo ceiling viewed in a badly cracked mirror.

After twenty-four Futurist numbers, *Lacerba* disappeared in 1914
with a bitter blast by Papini, first at what he considered to be Mari-
netti's bullying, but chiefly at Italy herself. "Gifted Italians, like the
damned in Dante, always look backward." Another revolution had
failed, another in an abortive series imported from the north: the reli-
gious revolution (he thought) had been German and English, the par-
liamentary English, the constitutional French, the Romantic German,
English, and French, the astronomical Polish, the artistic French, the
philosophical German, and the labor English. As for the Futurists:

> I found I had joined a church or academy or sect more attractive and
> picturesque than many others, but one in which faith was valued over
> freedom, noise over creation, reputation over discovery, submission to
> gospel over richness of experiment. I thought I was among a republic
> of poets and artists and found myself committed to a political theocracy
> whose supreme pontiff, like the despots of old, treasured the latest com-
> moner in order to suppress the nobles.
>
> Inside this sect, appearance counted more than substance, ingenious-
> ness more than genius, makeshift more than painful labor, the number
> of allies more than their value, quantity more than quality. . . . The
> bold and aristocratic group of earlier days had become a sort of low,
> bigoted democracy. . . . The church was now mature, every "mys-
> tique" abandoned in order to become a political party with electoral
> ambitions.

Powerful as this indictment may sound, much private disappointment
and rancor went into it. It was a classic sundering of Bolshevik and
Menshevik forces on the eve of real revolution. Papini, like everyone
else, had not taken Marinetti's war doctrine seriously enough.

Nor had his or Soffici's subtlety and aristocracy of mind been able to
save them from the great Punch-Up of 1912. The painter Carrà arrived
at Futurist headquarters with a copy of *La Voce* containing an attack
by Soffici on a recent Futurist exhibition. The Florentine Futurist Pa-
lazzeschi was sent ahead to Florence to scout the enemy. All were
found at the literary café Giubbe Rosse on a quiet Sunday afternoon.

Boccioni approached Soffici. "You are Mr. Soffici?" "Yes." "I'm Boccioni." A tremendous slap floored Soffici, who stood up and laid about Boccioni with a cane. The distinguished older sculptor Medardo Rosso lost a tooth to a Futurist. Police arrived and broke it up. Later in the day the Florentines waited for the Futurists at the railway station. Here is Marinetti's account:

> While we are buying tickets, Palazzeschi arrives and tells us that the enemy is in ambush at the station. I lead. Boccioni follows two meters behind. Two meters after him, Carrà. Behind a pillar we see Soffici with a bandaged head and a raised cane. Prezzolini behind a second pillar. Other pillars hide Slapater and other *vociani*. Prezzolini hurls himself on me. I receive him with open arms, flail his head with blows, bite him, and find a tuft of hair in my mouth. When he lets up I see blood on his face. Soffici has thrown himself on Boccioni who, being an experienced fighter, has the upper hand. Carrà defends himself hotly with a too-fragile cane lent him by Palazzeschi. As all this was going on, a train pulls up, vomiting English, Americans, women, children, porters, and luggage, amid a frantic punch-up aggravated by heavy carabinieri with three-cornered hats, red and blue tassels flying. All hustled to the police station, to dumbfounded exclamations of the police:
>
> "What punches! What slaps! Those canes! Never have seen such a fight! What is this Futurism?"
>
> Sitting on a dirty red velvet sofa, Boccioni, appeased, jokes and attacks, beginning to like Soffici. Prezzolini, though bleeding, keeps trying to shred my manifesto "Let's Murder the Moonshine" with his irony. I threaten him, we separate, and finally we take the train back to Milan with three new friends on board.

The "Futurist evenings" in hired theaters had already started before this occasion. Marinetti encouraged his friends to do whatever they could on stage. When they were absent or shy, he read their works himself. He encouraged the painter-composer Luigi Russolo to perform on his battery of noisemakers, or *intonarumori,* which was made up of *ululatori, rombatori, crepitatori, sibilatori, stropicciatori, ronzatori, scoppiatori, gorgogliatori,* and *frusciatori* (howlers, roarers, cracklers, whistlers, rubbers, buzzers, exploders, gurglers, and rustlers). The other composer, Balilla Pratella, was supplied with a conventional orchestra which, following a sort of Gregorian notation and minutely subdividing the octave "enharmonically," produced some of the earliest *musique concrète,* mimicking the sounds of a busy industrial city. The best ac-

count of more than a dozen such evenings is probably Cangiullo's, of the show at his native Naples. The performance has just started.

In another box Eduardo Scarpetta appears. This stirs a frantic, joyful ovation: *"Viva* Don Eduardo! Speak, Sciosciamocca! *Viva* Don Felice!"

At first the comedian enjoys this personal success; but then, squeezed into his box, he makes an evil face. In truth he doesn't know how to interpret the applause: master of audience psychology, Don Eduardo finds himself in rough seas, from which he doesn't know what fish to pull.

He smiles awkwardly, silly and insecure; he winks an eye, stretches his mouth, shows his tongue, lifts an eyebrow, wrinkles his forehead, drops his jaw, places one hand on his chest like Jacques Murat, but says nothing. Is he lost for words? Seized by panic? One of his bad evenings, certainly.

But "Don Felice Sciosciamocca" seems to be making a debut; he begins with a tremble, his stage voice shakier and fuller of tears than usual:

"Honored audience . . ." Good Lord! The honored audience suspects the rest, and *uhuhuhu! uiuiuiui! brr! pprrr!* Whistles and catcalls. God, what a fiasco!

The greatest comic actor of Italy, with a madly merry grin, would like to put a witty face on a losing game and disappears into the safe cover of his box, to the great astonishment of his admirers.

Suddenly a storm broke in the orchestra seats, the room was beginning to divide in two: friends and enemies. The latter inveighing against the Futurists in gusts of insult and profanity, fists shaking, faces twisted into masks. The others clapped insanely. *"Viva* Marinetti! . . . Abbasso! . . . Viva! . . . Abbasso!* . . . Idiots! . . . Cretins! Sons of whores!" The whole was crowned by a rain of vegetables: potatoes, tomatoes, chestnuts . . . an homage to Ceres. Finally, in a moment of calm (very relatively speaking), the chief of Futurism began. . . .

No amount of goodwill can reconstruct his exordium that night. You could make out words only once in a while; you heard bursts of his powerful voice and saw his cutting, flailing gestures. He seemed a very stubborn, strange lion-tamer to want to master such a seraglio.

Among whom a mediocre writer of dialect comedies, seized by one of his sadder inspirations, yelled at Marinetti:

"Dentist!"

He should never have said it, this poor man, blind in one eye, drooling at the mouth, worm-eaten. He heard the lightning answer:

"And you are the rotten tooth that I will pull out."

This fast, pithy reply was such a good portrait of the unlucky man that the audience .clapped enthusiastically and changed its opinion of Futurism, when a moment before it had been entirely on the side of its favorite comedian. The fickle public! which then, for good measure, shouted: "Throw him out! Pull out the rotten tooth!"

And he had to leave, the poor devil, I don't know how.

Now the theater had completely come round . . .

Then Boccioni, attractively nervous, reads the manifesto of Futurist painting; but that blue smock and fluttering cravat make him look wild and dissolute. The painters were always the most severe with the public, and when the dear, unforgettable Boccioni scornfully cries: "Let's make an end of photographers, landscapers, lake-painters, mountainists . . ." the whole crowd of *plein air* Parthenopian painters roars its protest. Russolo is beside himself. Palazzeschi smiles his smile of a young-old Beguine, very peculiar.

The theater is in full revolt. Marinetti begins declaiming Buzzi's "Hymn to the New Poetry." But after the noise unchained by Boccioni, a recital of verses made up of lights and shades is impossible, unthinkable. Outside the theater it's Piedigrotta: tumult, sea-quake.

The Futurists come out, shoved, trampled, heaved around. Cries, howls from every side: "There they are! Look at them! The Futurists!"

Summer. Sweat. Sultry night on the Piazza Castello.

"There's Marinetti! It's him! He's a millionaire!" (In those days when you said millionaire, you tipped your hat, especially in Naples.)

Suddenly, at the sight of this golden man, little more than thirty, electrifying, exceptional, of faith and fascination, exalter of Italianism and youth, the enormous crowd warms up in a typically southern, magnetic way. The sea of faces sways in waves of rejoicing; how we moved is a mystery. Men's straw hats and women's faces floated on the surface of the waves. . . . Carabinieri and civil police try to dam the flood, but are swamped, in the midst of which appears an illiterate *camorrista,* nicknamed *Vastiano o cchiummo* (*o cchiummo* because a criminal and quick on the trigger), which in Italian would be Sebastiano del Piombo. Mark how ignorance sometimes vindicates itself! Vastiano makes circles in the air with his stick, looking like Masaniello, and shouts: *"Viva sempri il Fotorismi!"*

So much, then, for a typical evening, remembered with uncommon brio. Marinetti describes the climactic moment in Rome:

Nevertheless we had a crowd of young defenders, which grew, fifty became a hundred, then about five hundred, against a bigger crowd than Patti, Tamagno, or Caruso ever attracted. In two boxes at my right, the Roman princes, led by a clerical idiot, the Prince Altieri; all very elegant in frock coats, holding little bags of coal. They bombarded the orchestra, which still went on playing Pratella's symphony. He impassively took care of every nuance under the bombardment, which retired all the players one by one. Smashed flute, split violin, puffed-out cheeks doubly swollen by a missile. Pratella still impassive. I ran forward and shook my fist at the princely box, flung at Altieri a hundred accurate insults, among which "Rotten syphilitic! Son of a priest!" were the most gracious.

To read these and the much milder stories about the tours of the Futurist theatrical companies in the early twenties is, I think, to admit that there is little danger of the same methods being adopted again in defense of the arts. These were remarkably representative, mixed audiences, though the expensive seats were often very expensive. Marinetti would stay up the rest of the night writing graphic telegrams to the leading Italian newspapers. Futurism supplied an ideal object lesson to men like Gide, Montale, or Ungaretti who liked to dramatize the essential solitude of art. But to revive all the charges of vulgarity and *lèse-coûtume* made against it is to fall into a well-baited trap; Marinetti never once bothered to deny them. Whatever may later have been true in politics, Futurism did far less harm than had been done to the arts by many earlier puritan revolutions. Writing a coda to the Roman episode described above, the gentle Soffici touches the quick:

Strolling the streets, drunk on the day's emotions, on our youth. Laughter in front of the mechanical "Altar of the Fatherland," a glimmering witness under the great Roman sky to the barbarizing of a people whom we had to regenerate.

Marinetti, dressed entirely in black, his bourgeois bowler raked back on his glowing pate, his eyes staring like a bull's, his bow tie, his kaiser's mustache, beats out a rhythm with his patent leathers, one of them recovered shortly before from between the buttocks of a young patrician [the Prince Altieri], in the fervent "ideal" brawl at the theater door. . . . And brotherly libations; confidences of new friends; shapeless songs beside the eternal monuments; cheerful banter. Holy lightheartedness of poets, swollen with new harmonies, beneath the golden swarm of the incomprehensible stars.

Futurism in Russia. Vladimir Mayakovsky, a self-proclaimed Futurist until his suicide in 1930, was too good and original a poet, his attitude toward the Soviet state too volatile, for him to have been entirely suppressed by official reaction. Art and literature were as closely interwoven in Russian as in Italian Futurism, but until recently the earliest Russian "abstractionist" painters, the best of whom were Futurists or Cubo-Futurists in 1912 and 1913—Larionov, his wife Goncharova, Malevich, and David Burliuk—have been lost to the Russians and only rarely seen in small European showings.

The decisive influence of Marinetti's manifestos, translated by the poet Shershenevich almost as soon as they appeared, and of Futurist exhibitions seen by the painters in Paris and Monaco, has been solidly established by Vladimir Markov in his *Russian Futurism* (1968), Werner Haftmann in his *Painting in the Twentieth Century* (1967), and the art critic Maurizio Calvesi in a special issue of *Arte Moderna* vol. V, no. 44, 1967). These critics show no special political or national bias; they merely trace the constant presence in slightly modified language of Marinettisms in the manifestos, prose, and verse of the writers, or of Italian Futurist themes and techniques among the painters—all of this involving enough lapse of time between Italian example and Russian exemplum to warrant talk of influence.

Well aware of the importance to both schools of nationalism and Nietzschean individualism, these critics can discount the swift repudiation of influence by men like the fiery Larionov that, beyond all else, confirm the polemical fraternity of Futurists. One should not be fooled by Larionov's "Rayonism," Malevich's "Suprematism," or Tatlin's and Pevsner's "Constructivism"—any more than by Wyndham Lewis's "Vorticism" or the American "Synchronism"—into forgetting their common source in the Cubo-Futurist imbroglio of 1910–1913. All self-made "madmen" seem to be sticklers for originality.

More than anyone in the industrialized European countries that separated them, the Russians, especially Mayakovsky and Goncharova, were open to the Italian enthusiasm for the beauty of machines and modern city life. (Even today the Russians turn to the Italians for help in making automobiles.) In 1913 poets and artists coalesced into a performing circus on the Marinettian model, anticipating Dada by about a decade. In 1912 the "Hylean" poets, as they called themselves at first, were persuaded by the poet, painter, and publisher David Burliuk to issue on gray and brown wrapping-paper, bound in coarse sackcloth, the mani-

festo *A Slap in the Face of Public Taste*. Though somewhat less cosmic
in tone than Marinetti, it announced that "the Academy and Pushkin
are more incomprehensible than hieroglyphics." The beauty of cities,
the scorn of women, and the pleasure of being booed are endorsed; the
"New-Coming Beauty of the Self-Sufficient [self-centered] Word" is
predicted.

The aristocratic poet Severyanin, a quaintly mixed caricature of
Marinetti and Oscar Wilde (if that is conceivable), was the first to
attract attention, the most popular Russian poet during his lifetime. His
verse was loose, flamboyant, cheerfully and vulgarly decadent. He re-
cited his poems "by singing them to one or two melodies from Am-
broise Thomas operas, while holding a white lily in his hands"
(Markov). His book *Goblet Seething with Thunders* went through
seven editions.

As might be surmised, the cultivated Russian art public was much
more hospitable to the new and strange than the Italian. An avid vogue
for avantgarde collecting had grown up, the collectors often vying with
the artists in bohemian bravado. This was Diaghilev's original world.
In October 1913, the Cubo-Futurist writers and painters took to the
stage for the first time. Toilet-paper posters announced the event. Ma-
yakovsky took five strolls through Moscow in a yellow shirt made by
his mother, a wooden spoon in his buttonhole. To their chagrin the
Futurists were rather blandly received, though in the course of later
meetings they several times poured hot tea on the first rows and pleaded
their thirst for catcalls. A vein of Slavophile conservatism made them
less aggressively missionary than the Italians. Yet one of them per-
formed with a urinating dog painted on his cheek "to show his sense of
smell." Another had an airplane painted on his forehead "to symbolize
universal dynamism." Sometimes they read each other's work in con-
cert, sometimes they suspended a piano upside down over the stage.

But the bellicose impetus of *Ur*-Futurism was already weakening in
the Russians. The poet Khlebnikov, said by Markov to be as fascinating
as he is untranslatable in his rampant neologism, wrote some powerful
short antiwar poems before being drafted. The war thinned Futurist
ranks and took away most of their audience. But Larionov and Gon-
charova painted stage sets for the Russian ballet in 1914. Tatlin's Con-
structivism was—until 1921—"the style of the proletarian revolution"
with its "exaltation of technology, its dynamism, and the declamatory
eloquence with which it adorned the festive rites of the masses" (Haft-

mann). Lenin had lived next door to the Cabaret Voltaire in Zurich where Dada was spawned and described Russian modernist movements as "a left-wing infantile disorder." Mayakovsky, always addicted to brave attitudes, first welcomed war as "the world's only hygiene," then vacillated as usual. This lack of dogmatism was one of the traits that made Mayakovsky more *simpatico* than any of the Italians except perhaps Boccioni. In his character and art he was in many respects the best that literary Futurism had to show in either country.

As among the poets, so among the painters, folkish themes alternated from the start with more or less strict abstraction, foreshadowing Chagall and Bakst as well as Tatlin and Pevsner. Chiefly for this reason, the movement was a striking case of the inability of the most well-meaning bureaucrats and political thinkers to keep abreast of change in the arts. Lunacharsky, the Commissar for Education, actually praised Marinetti as "a revolutionary intellectual" during the Second Congress of the Communist International in 1920, to which Gramsci rather bizarrely replied, "The Futurists have performed this service within the field of bourgeois culture: they have destroyed, destroyed, destroyed, unconcerned about whether or not the new work resulting from their efforts would be better than the work destroyed. They had this strictly revolutionary, absolutely Marxist conception."

No Russian or Italian, as a matter of fact, was destined to render as dramatic a summary judgment on the whole Futurist episode as the brilliant Marxist critic Walter Benjamin, at the end of his essay "The Work of Art in the Age of Mechanical Reproduction" (from *Illuminations,* translated by Harry Zohn, 1969):

> Fascism attempts to organize the newly created proletarian masses without affecting the property structure which the masses strive to eliminate. Fascism sees its salvation in giving these masses not their right, but instead a chance to express themselves. The masses have a right to change property relations; Fascism seeks to give them an expression while preserving property. The logical result of Fascism is the introduction of aesthetics into public life.
>
> All efforts to make politics aesthetic culminate in one thing: war. War and only war can set a goal for mass movements on the largest scale while respecting the traditional property system.
>
> *Fiat ars—pereat mundus,* says Fascism, and, as Marinetti admits, expects war to supply the artistic gratification of a sense of perception that has been changed by technology. This is evidently the consummation of

"l'art pour l'art." Mankind, which in Homer's time was an object of contemplation for the Olympian gods, now is one for itself. Its self-alienation has reached such a point that it can experience its own destruction as an aesthetic pleasure of the first order. This is the situation of politics which Fascism is rendering aesthetic. Communism responds by politicizing art.

These are indeed counsels of despair; I doubt if Benjamin realized how well they play into the hands of philistines of all political persuasions for whom art is one of the first things expendable in any difficulty. After three more decades of political metamorphosis, no view of the matter can be so certain. Once again the arts have begun to embrace technology in an attempt to keep both free of *any* absolutist politics, Fascist, Communist, or sentimental nativist. Again the appeal is to an unquenchable love for improvisation, action and inconclusiveness, process and change. But, ironically enough, the word Futurism itself now belongs only to the museums, historians, and pedagogues—or to a very dubious branch of popular statistical science.

Futurism in the United States. Futurism cast many yearning glances across the Atlantic, although Marinetti never came here and he usually prefixed his mention of Americans with the adjective "eccentric." In 1955, when Soffici looked back in *Fine di un Mondo* (*End of a World*), he described Futurism as "a strange mixture of D'Annunzianism, Victor-Hugoism, and Americanism." Our newspapers, of course, ran accounts of Futurist goings-on. Randolph Bourne, the radical young Socialist critic, went to Florence and reported back excitedly, although he was to react so violently against the First World War and to be so roundly condemned for it that he died something of a martyr's death, out of sympathy with everything that Marinetti stood for.

Nevertheless, the critic Gorham Munson promoted straight Futurism. The painters John Marin and Joseph Stella (whose well-known painting *Brooklyn Bridge* inspired Hart Crane and wore all the right insignia) admitted to Futurist leanings. Marcel Duchamp's kinetic *Nude Descending a Staircase* (shown at the Armory in 1913), his "found objects," his mounted urinal and defaced Gioconda worked largely in the Futurist spirit, which he never acknowledged.

Whatever the means of contagion after the Armory Show had planted the virus, it scarcely needs to be said that bringing Futurism to the United States was like bringing coals to Newcastle. There were

energies, perceptions, and enthusiasms ready to take fire from the whole gamut of modernist practice. A historian soon bogs down when he tries to trace the exact lines of force. All we lacked was, first, the pristine naïveté that Marinetti was at least able to simulate in his discovery of the machine, and second, the political pretext that Marinetti had found in his Interventionism of 1913.

Because of Hart Crane's temporary conversion through the work of Gorham Munson, because Crane was devoted to Whitman and offered an interesting parallel to Mayakovsky, we are able to see how far an American poet of the first quality could go toward embracing the Futurist apocalypse. One of his early magazines, *The Soil,* had celebrated indigenous machinery, business, films, window displays, ships, bridges, rivers, vaudeville, skyscrapers, and prizefighters. It was in the "Cape Hatteras" section of *The Bridge,* however, a congested extravaganza in praise of dynamos, airplanes, dirigibles, and other Marinettian icons, that he set out to rival Mayakovsky and the early films of Eisenstein (*Strike!* and *October,* for example) in the grandeur of his Futurist vision. Unfortunately his mind seems to have been too subtle in the wrong way, too little vulgar in the genial manner of Mayakovsky, to bring it off successfully. The section contains memorable lines:

> Stars prick the eyes with sharp ammoniac proverbs
> . . . but fast in whirling armatures,
> As bright as frogs' eyes, giggling in the girth
> Of steely gizzards—axle-bound, confined
> In coiled precision, bunched in mutual glee
> The bearings glint,—O murmurless and shined
> In oilrinsed circles of blind ecstasy.
>
> . . . satellited wide
> By convoy planes, moonferrets that rejoin thee
> On fleeing balconies as thou dost glide

Despite moments like these, "Cape Hatteras" is the most "period" section of the long, magnificent poem, the most strained and forced—and it boasts a few of Crane's most painfully awful lines. "Slit the cloud's pancreas of foaming anthracite"! Lines of this unique nonsensicality were like tombstones over the hope that American poetry would ever rival the movies in celebrating machinery during machinery's Homeric age. The solution to the problem, of course, as the founders of Experi-

ment in Art and Technology have lately rediscovered, is to use machinery the best one can to celebrate itself.

Futurist Politics. When one reads Wyndham Lewis's breezy remarks in *Blasting and Bombardiering*—"Marinetti, for instance. You may have heard of him! It was he who put Mussolini up to Fascism. Mussolini admits it. They ran neck and neck for a bit, but Mussolini was the better politician"—one wonders what it is in modern Italian politics that generates such blithe nonsense in the minds of foreigners. Perhaps he was unaware that Arturo Toscanini, a man not exactly susceptible to the sneers of Wyndham Lewis, appeared with Mussolini and Marinetti on the first list of Fascist candidates in 1919, along with sixteen others, all of them defeated by the Socialists. Toscanini's time in the party was very brief and his hostility from exile was uncompromising. But in that stormy year of 1919 when every kind of political possibility seemed to waver in the balance, the word *Fascism* meant virtually nothing to the Italians, nothing more than a group of oddly assorted veterans, aesthetes, and careerists, a few of whom had won reputations for foresightedness and courage, patriotism, and private generosity. (Marinetti, for example, opened his Milan apartment to wounded veterans.)

When they were "maximalist" Socialist friends, Mussolini and Pietro Nenni enthusiastically approved the doctrines of Georges Sorel, whose *Reflections on Violence* had confirmed their dislike of parliamentary compromise and reform. Marinetti also read Sorel and other like-minded theorists, but he needed no coaxing to join a coalition of veterans, Nietzscheans, and political opportunists. He was not a political opportunist himself; he was a sincere naïf. He had loved every moment of the war, most of all the poetic anarchy (see his "Manifesto of the Futurist Dance") of fighting in the eastern mountains, on the Grappa, Piave, and Carso, small engagements that encouraged bravado. If Fascism became a movement of the frightened lower middle class, veterans, and workers disillusioned with parliamentary socialism, Marinetti had not foreseen or wanted the inclusion of the very rich. In his speech in Florence in 1919, he said:

> No, Italians! Political Futurism will vigorously oppose any leveling impulse. Let everything, everything be granted the working proletariat except the sacrifice of spirit, of genius, of the great guiding light. To the oppressed classes, to the impoverished workers, let the entire para-

sitical plutocracy of the world be sacrificed. But let the intellectual workers spring to the head of the manual workers, the intuitive creators who alone can invent, discover, renew, who alone can increase the sum of earthly happinesses.

This was intellectual snobbery of a peculiarly utopian cast. He believed that the war had been joined and won through the efforts of a small intellectual minority, against the inertia of the parliamentary professors and Germanophiles. A respectable argument can be made that Italy should have remained neutral. But this would have required a patient rationality astonishing at any time. Northern pride was easily kindled against the Austrians. The long struggle of the Risorgimento had never allowed Italy the luxury of thinking of herself as a naturally peaceable nation. Machiavelli had written that "wars cannot be avoided, and a postponement is to the advantage of others. . . . Like a woman [Fortune] is always a friend of the young, because they are less cautious, fiercer, and master her with greater audacity."

American and English readers might assume from the elegiac tone of Hemingway's *Farewell to Arms* that the defeat of Caporetto had been the whole story. But not only did Marinetti and his friends think the later battle of Vittorio Veneto a great victory, some of them thought that it had saved the Allies by drawing the cream of the Austrian army away from the Western front.

The need for struggle and the beauty supposed to accompany it were the main themes of Marinetti's politics. But there is no reason to doubt his good faith when he filled a large part of his manifestos of 1919 and 1920, "Futurist Democracy" and "Beyond Communism" (see page 148), with a cluster of anarcho-libertarian ideas that are often contradictory but are clearly aimed at destroying hereditary power. In the first of the two one finds Henry George's Single Tax, anarchism, collectivized property, suffragettism, and the gospel of mass production articulated at Dearborn (Henry Ford's first principle having been "an absence of fear of the future or veneration of the past") all impartially recommended.

Mussolini, raised in a small town by a hard-bitten Socialist father and a gifted journalist who had increased the circulation of his newspaper *Avanti!* in 1912 from twenty thousand to a hundred thousand in his first three months as editor, was the last person to be taken in by Marinetti's vision of a brilliant corps of young artist-inventor-technicians

ready to leap to the public service. Until late in 1914 his newspapers had laughed at Futurist pranks like burning Austrian flags in streets and theaters, or the invention by the painter Balla of "anti-neutralist clothes," worn by Marinetti and Cangiullo in a noisy raid on "neutralist" classrooms at the University of Rome. These clothes, according to Balla, should "include no neutral colors and possess the Futurist characteristics of flexibility and lack of symmetry, as well as phosphorescence and perishability." A historian of the era reports that "Marinetti himself always carried a few grenades in his pocket and gave them away to his friends like cigars. Mussolini used to keep these unwelcome gifts in his stove (and a pistol on his desk) and was nearly blown through the roof one morning when a new porter tried to light the stove without clearing it."

Mussolini's vaunted intellectuality was mostly window dressing. But Marinetti's politics resulted in no more than a few episodes of street theater in the style of his beloved Scala opera or the seventeenth-century Milan of Manzoni's *I promessi sposi* rather than the pompous, brassy style favored by the Duce. Here is Marinetti's version of the "Battle of Via Mercanti" in Milan:

> April 15, 1919, will always be famous in Italian history. A mighty Bolshevist offensive had been announced, to disperse our meager forces and take control of Milan.
>
> The night of the fourteenth we and Mussolini had decided in the editorial offices of *Popolo d'Italia* [Mussolini's newspaper of the time] not to make a counter-demonstration. Nevertheless Arditi [veterans], Futurists, and Fascists appeared on the Cathedral Square and in the Gallery around two in the afternoon, in small groups, alert and armed with revolvers.
>
> [Meanwhile some thirty thousand "subversives" had assembled in a large theater, ready to attack. Marinetti started his march from the Bakery Shop in the Gallery.]
>
> I was very calm, cold, but convinced that the battle had to be joined at any cost. The groups merged and formed a small procession. It grew. Ferrucio Vecchi and I directed it toward the Politecnico, where we knew that Lt. Chiesa had organized three hundred student officers and was holding them ready. We had just reached the door of the Institute when these men burst out, were harangued, formed into a column, and marched toward the Naviglio, Corso Venezia, Via Agnello, and the Piazza della Scala, avoiding the infantry columns. The number and threatening power of the column increased. The infantry that closed off

the Gallery were scattered. I marched at the head. . . . Now I was sure of the inevitable, decisive clash; I wanted to swell the column's power, so I brutally asked the bystanders to join us. They applauded and I shouted at them so impetuously that some, frightened by my ferocious eyes, ran like rabbits. The column surrounded the Vittorio Emanuele Monument, covered it, fleshed it with writhing bodies and waving arms. . . .

From the back of a lion on the monument, I surveyed the scene. The ardito Meraviglia returned out of breath from his reconnoitering. We heard the strains of *The Red Banner* coming nearer. The head of the Bolshevist column approached. As a great pyramid of fruit topples on a table, the monument was bared of people and everyone ran full speed toward the police cordon behind which the enemy column was advancing in marching rhythm, preceded by the Anarchists, red flowers in their buttonholes, three women in red blouses, two boys holding high a portrait of Lenin. A cane flew over the heads of the police and landed at my feet. The signal. A revolver shot, two, three, twenty, thirty . . .

The Left was routed and Marinetti's forces ran to burn the offices of *Avanti!,* Mussolini's former paper. The national battle seesawed throughout 1920 and 1921, and only after the Fascist terrorist *squadre* had been organized and Mussolini had endorsed the monarchy was a coup d'état possible. Meanwhile Marinetti, who had never wanted the support of industrialists or bankers, must have discovered the Duce's soft center. But his time of revolt was short. Having left the party in 1920, by 1924 he had backed down and announced that Fascism had fulfilled his "minimal program," that the Futurists were only "mystics of action" who "intervene in political contests only in hours of great danger for the Nation."

After 1924 he was much on his dignity, out of active politics, soon to become an official *accademico* but still eagerly recruiting new Futurist artists and arranging their exhibitions at the Venice Biennale. He lived in Rome with his tall, gentle, religious wife, the "aeropoet" Benedetta, and his three daughters, Vittoria, Ala, and Luce. The more flamboyant D'Annunzio was once again the official *Poeta,* writing Mussolini almost daily notes about his ever-infringed rights and dignities, exalted in 1924 to the rank of Prince of the Snowy Mountain, granted a state visit by the dictator in 1925, finally dying in 1938. One can imagine the amusement and grudging respect with which Marinetti watched his old rival assemble and preside over his private museum, *il Vittoriale,* of the grandly vulgar, long-deceased Humbertine Decadenza.

Having swallowed the monarchy (more or less), Marinetti could pass without too much embarrassment to discreet imperial drum-beating, even to a shy insertion of religious sentiment into his still-copious but not very interesting writing.

> Up up there where you feel on your cheeks the sweet silken cheeks of God every hunter angel bristling with swift firebrands feeling itself suddenly attacked from behind spying in its diabolical mirror

In his "Aeropoem of the Gulf of Spezia," even the angels are spitfires! His "Non-Human Poem of Technicisms" is weaker than its title suggests; a swatch of art-prose, at once steamy and staccato, in which he makes the best case he can for Fascist public works. Finally there were more novels, most of them doggedly humorous, the heavy-handed *gai savoir* of the Fascist noontime—*Novelle colle labbra tinte* (*Stories with Painted Lips*) to divert the populace.

A desperately comforting illusion was ready for him at the end. In the so-called Republic of Salò, set up by the Germans in 1944 with Mussolini theoretically in charge, he saw through exhausted eyes the end of the hated monarchy and a moribund rebirth of Futurism's collective ideal. Returned sick after twenty-three months on the Russian front, he lay bedridden at Lake Como in the heart of Manzoni's *paesaggio*.

Shortly before he died, he had written a last poem in his daughter Vittoria's notebook. It ends:

> The voluptuous first line of battle vibrates like long stretched cords strummed by projectiles. A thundering cathedral prostrate to call on Jesus with the ache of lacerated breasts
>
> We will be we are the kneeling machine guns whose barrels throb with prayer
>
> I kiss I kiss again the weapons nailed down by a thousand thousand thousand hearts all pierced by vehement everlasting forgetfulness

R. W. Flint

PART I

Futurist Theory and Invention
Manifestos and Polemical Writings

Translated by R. W. Flint

The Founding and Manifesto of Futurism

Published in LE FIGARO *of Paris*
February 20, 1909

We had stayed up all night, my friends and I, under hanging mosque lamps with domes of filigreed brass, domes starred like our spirits, shining like them with the prisoned radiance of electric hearts. For hours we had trampled our atavistic ennui into rich oriental rugs, arguing up to the last confines of logic and blackening many reams of paper with our frenzied scribbling.

An immense pride was buoying us up, because we felt ourselves alone at that hour, alone, awake, and on our feet, like proud beacons or forward sentries against an army of hostile stars glaring down at us from their celestial encampments. Alone with stokers feeding the hellish fires of great ships, alone with the black specters who grope in the red-hot bellies of locomotives launched down their crazy courses, alone with drunkards reeling like wounded birds along the city walls.

Suddenly we jumped, hearing the mighty noise of the huge double-decker trams that rumbled by outside, ablaze with colored lights, like villages on holiday suddenly struck and uprooted by the flooding Po and dragged over falls and through gorges to the sea.

Then the silence deepened. But, as we listened to the old canal muttering its feeble prayers and the creaking bones of sickly palaces above their damp green beards, under the windows we suddenly heard the famished roar of automobiles.

"Let's go!" I said. "Friends, away! Let's go! Mythology and the Mystic Ideal are defeated at last. We're about to see the Centaur's birth and,

soon after, the first flight of Angels! . . . We must shake the gates of
life, test the bolts and hinges. Let's go! Look there, on the earth, the
very first dawn! There's nothing to match the splendor of the sun's red
sword, slashing for the first time through our millennial gloom!"

We went up to the three snorting beasts, to lay amorous hands on
their torrid breasts. I stretched out on my car like a corpse on its bier,
but revived at once under the steering wheel, a guillotine blade that
threatened my stomach.

The raging broom of madness swept us out of ourselves and drove us
through streets as rough and deep as the beds of torrents. Here and
there, sick lamplight through window glass taught us to distrust the
deceitful mathematics of our perishing eyes.

I cried, "The scent, the scent alone is enough for our beasts."

And like young lions we ran after Death, its dark pelt blotched with
pale crosses as it escaped down the vast violet living and throbbing
sky.

But we had no ideal Mistress raising her divine form to the clouds,
nor any cruel Queen to whom to offer our bodies, twisted like Byzan-
tine rings! There was nothing to make us wish for death, unless the
wish to be free at last from the weight of our courage!

And on we raced, hurling watchdogs against doorsteps, curling them
under our burning tires like collars under a flatiron. Death, domesti-
cated, met me at every turn, gracefully holding out a paw, or once in a
while hunkering down, making velvety caressing eyes at me from every
puddle.

"Let's break out of the horrible shell of wisdom and throw ourselves
like pride-ripened fruit into the wide, contorted mouth of the wind!
Let's give ourselves utterly to the Unknown, not in desperation but only
to replenish the deep wells of the Absurd!!"

The words were scarcely out of my mouth when I spun my car
around with the frenzy of a dog trying to bite its tail, and there, sud-
denly, were two cyclists coming toward me, shaking their fists, wob-
bling like two equally convincing but nevertheless contradictory argu-
ments. Their stupid dilemma was blocking my way—damn! Ouch!
. . . I stopped short and to my disgust rolled over into a ditch with my
wheels in the air. . . .

Oh! Maternal ditch, almost full of muddy water! Fair factory drain!
I gulped down your nourishing sludge; and I remembered the blessed
black breast of my Sudanese nurse. . . . When I came up—torn, filthy,

and stinking—from under the capsized car, I felt the white-hot iron of joy deliciously pass through my heart!

A crowd of fishermen with handlines and gouty naturalists were already swarming around the prodigy. With patient, loving care those people rigged a tall derrick and iron grapnels to fish out my car, like a big beached shark. Up it came from the ditch, slowly, leaving in the bottom like scales its heavy framework of good sense and its soft upholstery of comfort.

They thought it was dead, my beautiful shark, but a caress from me was enough to revive it; and there it was, alive again, running on its powerful fins!

And so, faces smeared with good factory muck—plastered with metallic waste, with senseless sweat, with celestial soot—we, bruised, our arms in slings, but unafraid, declared our high intentions to all the *living* of the earth:

MANIFESTO OF FUTURISM

1. We intend to sing the love of danger, the habit of energy and fearlessness.

2. Courage, audacity, and revolt will be essential elements of our poetry.

3. Up to now literature has exalted a pensive immobility, ecstasy, and sleep. We intend to exalt aggressive action, a feverish insomnia, the racer's stride, the mortal leap, the punch and the slap.

4. We say that the world's magnificence has been enriched by a new beauty; the beauty of speed. A racing car whose hood is adorned with great pipes, like serpents of explosive breath—a roaring car that seems to ride on grapeshot—is more beautiful than the *Victory of Samothrace*.

5. We want to hymn the man at the wheel, who hurls the lance of his spirit across the Earth, along the circle of its orbit.

6. The poet must spend himself with ardor, splendor, and generosity, to swell the enthusiastic fervor of the primordial elements.

7. Except in struggle, there is no more beauty. No work without an aggressive character can be a masterpiece. Poetry must be conceived as a violent attack on unknown forces, to reduce and prostrate them before man.

8. We stand on the last promontory of the centuries! . . . Why should we look back, when what we want is to break down the mysterious doors of the Impossible? Time and Space died yesterday. We already live in the absolute, because we have created eternal, omnipresent speed.

9. We will glorify war—the world's only hygiene—militarism, patriotism, the destructive gesture of freedom-bringers, beautiful ideas worth dying for, and scorn for woman.

10. We will destroy the museums, libraries, academies of every kind, will fight moralism, feminism, every opportunistic or utilitarian cowardice.

11. We will sing of great crowds excited by work, by pleasure, and by riot; we will sing of the multicolored, polyphonic tides of revolution in the modern capitals; we will sing of the vibrant nightly fervor of arsenals and shipyards blazing with violent electric moons; greedy railway stations that devour smoke-plumed serpents; factories hung on clouds by the crooked lines of their smoke; bridges that stride the rivers like giant gymnasts, flashing in the sun with a glitter of knives; adventurous steamers that sniff the horizon; deep-chested locomotives whose wheels paw the tracks like the hooves of enormous steel horses bridled by tubing; and the sleek flight of planes whose propellers chatter in the wind like banners and seem to cheer like an enthusiastic crowd.

It is from Italy that we launch through the world this violently upsetting, incendiary manifesto of ours. With it, today, we establish *Futurism* because we want to free this land from its smelly gangrene of professors, archaeologists, ciceroni, and antiquarians. For too long has Italy been a dealer in secondhand clothes. We mean to free her from the numberless museums that cover her like so many graveyards.

Museums: cemeteries! . . . Identical, surely, in the sinister promiscuity of so many bodies unknown to one another. Museums: public dormitories where one lies forever beside hated or unknown beings. Museums; absurd abattoirs of painters and sculptors ferociously macerating each other with color-blows and line-blows, the length of the fought-over walls!

That one should make an annual pilgrimage, just as one goes to the graveyard on All Souls' Day—that I grant. That once a year one should leave a floral tribute beneath the *Gioconda,* I grant you that. . . . But I don't admit that our sorrows, our fragile courage, our morbid restlessness should be given a daily conducted tour through the museums. Why poison ourselves? Why rot?

And what is there to see in an old picture except the laborious contortions of an artist throwing himself against the barriers that thwart his desire to express his dream completely? . . . Admiring an old picture is the same as pouring our sensibility into a funerary urn instead of hurling it far off, in violent spasms of action and creation.

Do you, then, wish to waste all your best powers in this eternal and futile worship of the past, from which you emerge fatally exhausted, shrunken, beaten down?

In truth I tell you that daily visits to museums, libraries, and academies (cemeteries of empty exertion, calvaries of crucified dreams, registries of aborted beginnings!) is, for artists, as damaging as the prolonged supervision by parents of certain young people drunk with their talent and their ambitious wills. When the future is barred to them, the admirable past may be a solace for the ills of the moribund, the sickly, the prisoner. . . . But we want no part of it, the past, we the young and strong *Futurists*!

So let them come, the gay incendiaries with charred fingers! Here they are! Here they are! . . . Come on! set fire to the library shelves! Turn aside the canals to flood the museums! . . . Oh, the joy of seeing the glorious old canvases bobbing adrift on those waters, discolored and shredded! . . . Take up your pickaxes, your axes and hammers, and wreck, wreck the venerable cities, pitilessly!

The oldest of us is thirty: so we have at least a decade for finishing our work. When we are forty, other younger and stronger men will probably throw us in the wastebasket like useless manuscripts—we want it to happen!

They will come against us, our successors, will come from far away, from every quarter, dancing to the winged cadence of their first songs, flexing the hooked claws of predators, sniffing doglike at the academy doors the strong odor of our decaying minds, which already will have been promised to the literary catacombs.

But we won't be there. . . . At last they'll find us—one winter's night —in open country, beneath a sad roof drummed by a monotonous rain. They'll see us crouched beside our trembling airplanes in the act of warming our hands at the poor little blaze that our books of today will give out when they take fire from the flight of our images.

They'll storm around us, panting with scorn and anguish, and all of them, exasperated by our proud daring, will hurtle to kill us, driven by hatred: the more implacable it is, the more their hearts will be drunk with love and admiration for us.

Injustice, strong and sane, will break out radiantly in their eyes.

Art, in fact, can be nothing but violence, cruelty, and injustice.

The oldest of us is thirty: even so we have already scattered treasures,

a thousand treasures of force, love, courage, astuteness, and raw will power; have thrown them impatiently away, with fury, carelessly, unhesitatingly, breathless and unresting. . . . Look at us! We are still untired! Our hearts know no weariness because they are fed with fire, hatred, and speed! . . . Does that amaze you? It should, because you can never remember having lived! Erect on the summit of the world, once again we hurl our defiance at the stars!

You have objections?—Enough! Enough! We know them . . . we've understood! . . . Our fine deceitful intelligence tells us that we are the revival and extension of our ancestors—perhaps! . . . If only it were so!—But who cares? We don't want to understand! . . . Woe to anyone who says those infamous words to us again!

Lift up your heads!

Erect on the summit of the world, once again we hurl defiance to the stars!

Let's Murder the Moonshine

April, 1909

I

Hail! great incendiary poets, my Futurist friends! Hail! Paolo Buzzi, Palazzeschi, Cavacchioli, Govoni, Altomare, Folgore, Boccioni, Carrà, Russolo, Balla, Severini, Pratella, D'Alba, Mazza! Let's flee Paralysis, let's devastate Gout and lay the great military Railroad to the flanks of Gorisankar, summit of the world!

With a quick firm stride, almost dancing in our universal search for obstacles to conquer, we left the city. Around us and in our hearts, the immense intoxication of the old European sun swaying between wine-colored clouds. . . . That sun struck our faces with its great torch of incandescent purple, then flared out, vomiting itself to infinity.

Whirlwinds of aggressive dust; a blinding mixture of sulfur, potash, and silicates through the windows of the Ideal! . . . Fusion of a new solar orb that soon we shall see shine forth!

"Cowards!" I cried, turning to the inhabitants of Paralysis heaped below us, an enormous mass of angry howitzers ready now for our waiting cannon.

"Cowards! Cowards! Why these cries of yours, like cats skinned alive? . . . Afraid perhaps that we'll set fire to your hovels?—Not yet! . . . But next winter we may need to warm ourselves! . . . For the moment we are content with blowing up all the traditions, like rotten bridges!—War? . . . Very well, yes: It's our only hope, our reason for living, our only desire! . . . Yes, war! Against you, for dying too slowly, and against all the dead for cluttering our roads!

"Yes, our nerves demand war and despise women, because we fear supplicating arms that might encircle our knees on the morning of departure! . . . What can they want, women, the sedentary, invalids, the sick, and all the prudent counselors? To their vacillating lives, broken by dismal agonies, by fearful dreams and heavy nightmares, we prefer violent death and glorify it as the only thing worthy of man, that beast of prey.

"We want our sons to follow their whims joyfully, to oppose the old brutally and to mock everything consecrated by time!

"This offends you? You hiss me? . . . Louder!—I missed the insult! Louder! What's that? Ambitious? . . . By all means! We're ambitious men, we are, because we don't wish to rub against your smelly fleece, O reeking, mud-colored flock, driven down the ancient streets of the Earth. But 'ambitious' is not the exact word! We're more like young artillerymen on a toot!—and you, however you may hate it, must get used to the thunder of our cannon! What say? . . . We're mad? . . . All hail! There it is, at last the word I was looking for!—Ah! Ah! Happiest inspiration! Pick up this massively golden word with care, carry it quickly in procession, and hide it deep in your safest cellar! With this word between your fingers and on your lips you could live another twenty centuries. . . . For my part I tell you that the world is rotten with wisdom!

"That is why we teach today a daily methodical heroism, a joy in desperation when the heart yields up all its profit, the habit of enthusiasm, an abandonment to vertigo.

"We teach the plunge into shadowy death under the white, staring eye of the Ideal. . . . And we ourselves will give the example, abandoning ourselves to the raging Tailoress of battles who, when she has sewn us into handsome scarlet uniforms, gorgeous in the sun, will anoint our hair with flame and brush it smooth with projectiles. Just so does the heat of a summer's night spread the fields with an undulant shimmer of fireflies.

"Each day men must electrify their nerves to a fearless pride! . . . Men must stake their lives on a single cast, not on the lookout for cheating croupiers or trying to control the wheels, but standing bowed above the vast green carpets of war, brooded over by the sun's luck-bearing lamp. It is necessary—do you understand?—necessary for the soul to launch the body in flames, like a fireship, against the enemy, the eternal enemy that we would have to invent if it didn't exist.

"Look down there, those ears of grain lined up for battle by the million . . . those ears, agile soldiers with sharp bayonets, glorify the power of bread that changes into blood and shoots straight up to the Zenith. Blood, as you know, has no value or splendor until it is freed from the prison of the arteries with iron and fire! And we'll teach all the *armed* soldiers of the world how blood should be shed. . . . But first we must clean out the great Barracks where you pullulate, insects that you are!—It won't be difficult. . . . Meanwhile, monkeys, you can still go home tonight to the dirty traditional pallets on which we'll never sleep again!"

As I turned away, I could sense from the pain in my back that for too long I'd been dragging that moribund populace in the immense dark net of my speech, those people with the foolish friskiness of fish, heaped under the last flood of light thrown by the evening against the cliffs of my forehead.

2

The city of Paralysis with its henhouse cackle, its impotent prides of truncated columns, its bloated domes that give birth to mean little statues, the whim of its cigarette smoke curling from childish bastions that invite you to poke them in the nose . . . it fades behind us, dancing to the beat of our swift strides.

Ahead of us, still several kilometers away, the Madhouse suddenly rears up, high on the ridge of an elegant hill that seems to be frisking like a colt.

"Brothers," I said, "let's rest for the last time, before we go on to construct the great Futurist Railroad!"

We lay down to sleep, each of us wrapped in the limitless madness of the Milky Way, in the shadow of the Palace of the living, and immediately the uproar of the great square hammers of space and time fell silent. . . . But Paolo Buzzi couldn't sleep; his exhausted body continually started up, pricked by the poisonous stars that assailed us from every quarter.

"Brother!" I murmured. "Scatter far from me these bees, who buzz on the purple rose of my will!"

Then we went back to sleep, in the visionary shade of the Palace crowned with fantasy from which there wafted the soothing, ample melopoeia of eternal joy.

Enrico Cavacchioli was dozing and dreaming out loud: "I feel my

twenty-year-old body growing young again! . . . With an ever-younger step, I return to my cradle. . . . Soon I'll reenter my mother's womb! . . . For me, then, everything is lawful! . . . I want expensive playthings to smash . . . cities to crumble, human anthills to kick aside! . . . I want to domesticate the winds and hold them on a leash. . . . I want a pack of winds, supple greyhounds to chase the flaccid, bearded cirrus."

The breathing of my sleeping brothers feigned the sleep of a potent sea along the beach. But the inexhaustible enthusiasm of the dawn was already pouring down from the mountains, as richly as the night had poured out perfumes and heroic essences. Paolo Buzzi, suddenly waked from that delirious flood, tossed as if in the anguish of a nightmare.

"Do you hear it, the Earth's sighing? . . . The Earth is tormented by the horror of light! . . . Too many suns lean over its livid pillow! Let it sleep! . . . Longer! Forever! . . . Give me clouds, masses of clouds, to cover its eyes and its weeping mouth!"

At these words the sun presented to us its red and trembling wheel of fire, from the farthest horizon.

"Get up, Paolo!" I cried. "Seize that wheel! . . . I proclaim you driver of the world! . . . But, alas, we won't be equal to the work of the great Futurist Railroad! Our hearts are still full of filthy rubbish: peacocks' tails, pompous weathercocks, fancy scented handkerchiefs! And we still haven't emptied our heads of the lugubrious ants of wisdom. . . . We need madmen!—Away and free them!"

We approached walls flooded with solar joy, coasted a sinister valley where thirty metal cranes rose up with a cry, railway cars full of smoking laundry, the useless linen of those Pure Ones already cleansed of every stain of logic.

Two alienists appeared, categorically, on the Palace threshold. I had nothing in my hand but a blinding automobile headlight; with its polished brass handle I dealt them out death.

Madmen and madwomen poured out by the thousands from the open doors, in torrents, shirtless, half-naked, to rejuvenate and recolor the Earth's wrinkled face.

Immediately some of them wanted to brandish the shining bell towers like ivory batons; others began to sit in a circle and toss the domes around like balls. . . . The women were combing their distant cloud-tresses with the sharp points of a constellation.

"O madmen, O beloved brothers of ours, follow me!—We'll build the Railroad over all the mountain peaks, as far as the sea! How many are you? . . . Three thousand? . . . Not enough! You don't want boredom and monotony to cut short your fine beginnings. . . . Let's run for advice to the beasts of the menageries clustered around the Capital gates. Of all beings they are the most alive, the most rootless, the least vegetal! Forward!—To Gout! To Gout!"

So we went, a mighty discharge from an enormous sluice gate.

From plain to plain the army of madness advanced, poured down the valleys, swiftly climbed the peaks, with the easy fatal rush of a liquid between huge connecting vessels. Finally, with outcries, foreheads, and fists, it raked the walls of Gout until they rang like a bell.

When it had killed or trampled the guardians or made them drunk, the gesticulating tide swamped the slimy corridors of the seraglio whose cages, full of dancing tresses, swayed in the vapor of savage urines, swung more lightly than canary cages in the embrace of the mad.

The reign of the lions rejuvenated the Capital. The rebellion of their manes and the swelling arches of their backs carved out the façades. Their torrential force dug up the pavement and transformed the streets into so many tunnels with open vaults. All the phthisic vegetation of the inhabitants of Gout was baked to a crisp in their houses, which, full of howling limbs, trembled under the boisterous hail of dismay that riddled their roofs.

With sudden leaps and the mien of clowns the madmen mounted the beautiful, diffident lions who were hardly aware of them, and those weird knights exulted in the tranquil swishing of the tails that continually brushed them off. . . . Then the animals pulled up short, the madmen fell silent before the walls that no longer moved. . . .

"The old ones are dead! . . . The young have run away! . . . All the better!—Quick! Strip off the statues and lightning rods! Rob the strongboxes heaped with gold! Ingots and coins! . . . Melt every precious metal down, for the great military Railroad!"

We all rushed out, the madmen gesticulating and the madwomen disheveled, the lions, tigers, and panthers ridden by naked horsemen rigid and contorted in the fever of their wild excitement.

Gout was no more than an immense tub of red wine in foaming gorges, pouring vehemently out of gates whose drowned drawbridges shuddered and sounded.

We crossed the ruins of Europe and entered Asia, scattering the terri-fied hordes of Gout and Paralysis, as sowers cast their seed in wide sweeping gestures.

3

At midnight we were almost in the sky, on the high Persian plateau, sublime altar of the world, whose boundless steppes bear populous cities. Reaching to infinity along the Railroad, we panted over crucibles of barite, aluminum, and manganese that every so often terrified the clouds with their blinding explosions; and looking down on us from above was the majestic circular patrol of lions who switched their tails, cast their manes to the wind, bored holes in the deep black sky with their burly white roarings.

But, little by little, the clear, warm smile of the moon broke from the torn clouds. And when she finally appeared, dripping with the intoxi-cating milk of acacias, the madmen felt their hearts burst from their breasts as they climbed to the surface of the liquid night.

Suddenly a piercing cry split the air: the sound spread out, everyone ran up. . . . It was a very young madman with a virgin's eyes, struck by lightning on the Railroad.

Immediately the body was raised. In his hands he held an ardent white flower whose pistil flickered like a woman's tongue. Some wished to touch it, but no: as swift as dawn spreading over the sea, a sighing verdure rose by magic from an earth crisped by surprising undulations.

From the blue fluctuations of the meadows there emerged the filmy crowns of numberless swimming women, who sighed as they opened the petals of their mouths and their humid eyes. Then, in the inebriat-ing drench of perfumes, we saw a fabulous forest growing and spread-ing around us; its drooping leaves seemed tired by a lazy breeze. A bitter tenderness wavered there. . . . Nightingales were drinking the shadows with long gurgles of pleasure. From time to time in their hid-ing places they broke into laughter like lively, wicked children at hide-and-seek. Gradually the sweet drowsiness began to conquer the army of the mad, who began to howl with terror.

Impetuously the wild beasts ran to help them. Three times the tigers bore down, rolled tight as balls, their claws sharp with explosive rage, on the invisible phantoms in whom the depths of that forest of delights constantly rose to the surface. . . . Finally a breach was forced: huge convulsions of stricken foliage whose drawn-out moans wakened the

distant loquacious echoes crouching in the mountains. But while we, all of us, were raging to free our arms and legs from the last clinging lianas, suddenly we felt the carnal Moon, the Moon of lovely warm thighs, abandoning herself languidly against our broken backs.

A cry went up in the airy solitude of the high plains: "Let's murder the moonshine!"

Some ran to nearby cascades; gigantic wheels were raised, and turbines transformed the rushing waters into magnetic pulses that rushed up wires, up high poles, up to shining, humming globes.

So it was that three hundred electric moons canceled with their rays of blinding mineral whiteness the ancient green queen of loves.

And the military Railroad was built. An extravagant Railroad, following the chain of the highest mountains on which our vehement locomotives soon set out, plumed with loud cries, down one peak and up another, casting themselves into every gulf and climbing everywhere in search of hungry abysses, ridiculous turns, and impossible zigzags. . . . From far away and from every side boundless hatred marked our horizon that bristled with fugitives. . . . They were the hordes of Gout and Paralysis, and we threw them head-over-heels into Hindustan.

4

Hot pursuit—now the Ganges is overleapt! Finally our impetuous breathing put to flight the shuffling clouds and their clinging hostility, and on the horizon we caught sight of the dark-green throb of the Indian Ocean, over which the sun was fitting a fantastic golden muzzle. . . . Languishing in the gulfs of Bengal and Oman, it was treacherously preparing an invasion of the land.

At the far end of the promontory of Cormorin, edged with a rubble of gray-white bones, behold the colossal fleshless Ass, whose grayish parchment rump has been hollowed by the delicious weight of the Moon. . . . Behold the learned Ass, its wordy member patched up with writings, as from time immemorial it rattles its asthmatic rancor against the mists of the horizon where three great motionless vessels advance, their spars looking like human spines in an X ray.

Suddenly, the immense troop of wild beasts ridden by madmen had spread numberless snouts over the waves, under a whirling flare of manes that called on the Ocean for help. And the Ocean answered their appeal, arching a mighty back and shaking the promontories before it sprang. For a long time it tested its strength, moving its haunches and

flexing its sonorous belly between its vast, elastic foundations. Then, with a great heave of the loins, the Ocean succeeded in lifting its whole mass and flooded the crooked line of its shores. . . . Thus did the fearful invasion begin.

We were marching in the wide waves' pawing embrace, great globes of white spume that rolled and toppled, soaking the lions' backs. . . . And they, drawn up in a semicircle around us, added their fangs to the fangs of the sea, the hissing spray and the howling. Sometimes from hilltops we watched the Ocean slowly stretch its monstrous profile, like an immense whale that drives ahead on a million fins. And it was we who led it up to the Himalayan chain as we spread open the fleeing hordes like a fan, whom we meant to shatter on the sides of Gorisankar.

"Hurry, my brothers!—Do you want the beasts to overtake us? We must stay ahead, despite our slow steps that pump the earth's juices. . . . To the devil with these sticky hands and root-dragging feet! . . . Oh! We're nothing but poor vagabond trees! We need wings!—Then let's make airplanes."

"Make them blue!" the madmen shouted, "blue, the better to hide us from the watchful enemy and confound us with the blue of the sky, the sky that chatters against the wind-blown peaks like an immense banner."

And, to the Buddha's glory, the madmen seized sky-blue mantles from ancient pagodas, to build their flying machines.

We cut our Futurist planes from the ocher-colored cloth of sailing ships. Some had balancing wings and, carrying their motors, rose like the bloody vultures that lift thrashing heifers into the sky.

Here it is: my own multicellular biplane steered by the tail; 100 HP, 8 cylinders, 80 kilograms. . . . Between my feet I have a tiny machine gun that I can fire by pushing a steel button. . . .

And we take off, in the intoxication of a keen maneuver, a lively, snapping flight, rhythmic and graceful like a song of invitation to drink and dance.

"Hurrah! Finally we're worthy to command the great army of the mad and the unchained beasts! Hurrah! We master our rearguard, the Ocean with its tangle of foaming cavalry! . . . Forward, madmen, madwomen, lions, tigers, and panthers! Forward, you squadrons of waves! . . . For you our biplanes will be as war banners and passionate lovers. Delicious lovers who swim with open arms on the undulating leaves, or who gently idle in the breeze's seesaw!—But look down there,

to the right, those azure shuttles . . . they're the madmen cradling
their monoplanes in the south wind's hammock! . . . I, meanwhile, sit
like a weaver before his loom, weaving the sky's evening blue!—Oh!
All the fresh valleys, all the wild mountains beneath us! How many
flocks of rosy sheep scattered on the slopes of the green hills that offer
themselves to the sunset! . . . My soul, you have loved them! . . . No!
No! Enough! No more, never again will such insipidities please you!
. . . The reeds that once we shaped to shepherds' pipes make the
armor of this plane! . . . Nostalgia! Triumphal intoxication! . . .
Soon we'll overtake the inhabitants of Gout and Paralysis because the
headwinds give us speed. . . . What says the anemometer? . . . The
wind from ahead has a speed of one hundred kilometers an hour!—
Who cares? I climb to two thousand meters to surmount the high pla-
teau. . . . Look! There are the hordes! There, there, ahead of us, al-
ready beneath our feet! . . . Look down, straight down, among the
masses of greenery, the riotous tumult of that human flood in flight!—
This uproar?—It's the crash of trees! Ah! Ah! The enemy hordes are
already thrown against the high walls of Gorisankar! . . . And the
battle is joined! . . . Do you hear, do you hear how our motors ap-
plaud? . . . What ho, great Indian Ocean, to the rescue!"

Solemnly the Ocean followed us, leveling the walls of venerated cities
and casting illustrious towers from their seats. Old horsemen with
sounding armor toppled from the marble arches of temples.

Finally! Finally! So there you are ahead of us, great swarming popu-
lace of Paralysis and Gout, disgusting leprosy devouring the mountain-
sides. . . . Swiftly we fly against you, flanked by the galloping lions our
brothers, and behind us the menacing friendship of the Ocean that fol-
lows closely to foul the foot-draggers! . . . That's a mere precaution,
because we don't fear you! . . . But you are numberless! . . . And we
might use up our ammunition and grow old in the slaughter! . . . Let
me direct the fire! . . . Up 800 meters! Ready! . . . Fire! . . . Oh!
the joy of playing billiards with Death! . . . This is something you
cannot take from us! . . . Still hanging back? We'll soon be over this
plateau! . . . My airplane runs on its wheels, skates along, and then up
again in flight! . . . I'm flying against the wind! . . . *Bravissimi,* mad-
men! . . . Continue the massacre! . . . Watch me! I seize the stick
and glide smoothly down, magnificently stable, and touch ground
where the fight rages hottest!

See the furious coitus of war, gigantic vulva stirred by the friction of

courage, shapeless vulva that spreads to offer itself to the terrific spasm
of final victory! It's ours, the victory . . . of that I'm sure, because the
madmen are already hurling their hearts toward heaven, like bombs!
. . . I raise my sights to a hundred meters! . . . Ready! . . . Fire!
. . . Our blood?—Yes! All our blood, in waves, to recolor the sick
dawns of the Earth! . . . Yes, we will warm you again between our
smoking arms, O pitiful, decrepit, and shivering sun, trembling on the
summit of Gorisankar!

Against Past-loving Venice

April, 27, 1910

We renounce the old Venice, enfeebled and undone by worldly luxury, although we once loved and possessed it in a great nostalgic dream.

We renounce the Venice of foreigners, market for counterfeiting antiquarians, magnet for snobbery and universal imbecility, bed unsprung by caravans of lovers, jeweled bathtub for cosmopolitan courtesans, *cloaca maxima* of passéism.

We want to cure and heal this putrefying city, magnificent sore from the past. We want to cheer and ennoble the Venetian people, fallen from their ancient grandeur, drugged by a contemptible mean cowardice in the practice of their little one-eyed businesses.

We want to prepare the birth of an industrial and military Venice that can dominate the Adriatic Sea, that great Italian lake.

Let us hasten to fill in its little reeking canals with the shards of its leprous, crumbling palaces.

Let us burn the gondolas, rocking chairs for cretins, and raise to the heavens the imposing geometry of metal bridges and howitzers plumed with smoke, to abolish the falling curves of the old architecture.

Let the reign of holy Electric Light finally come, to liberate Venice from its venal moonshine of furnished rooms.

[*On July 8, 1910, 800,000 leaflets containing this manifesto were launched by the Futurist poets and painters from the top of the Clock Tower onto a crowd returning from the Lido. Therewith began the campaign that Futurists kept up for three years against past-loving Venice.*]

The following "Speech to the Venetians" was improvised by Marinetti and provoked a terrible battle. The Futurists were hissed, the passéists were knocked around.

The Futurist painters Boccioni, Russolo, and Carrà punctuated this speech with resounding slaps. The fists of Armando Mazza, a Futurist poet who was also an athlete, left an unforgettable impression.—Ed.]

MARINETTI'S FUTURIST SPEECH TO THE VENETIANS

Venetians!

When we cried out, "Let's murder the moonshine!" we were thinking of you, old Venice soiled with romanticism!

But now our voice grows louder, and we roar, "Let's free the world from the tyranny of *amore!* We're sick of erotic adventures, of lechery, sentimentality, and nostalgia!"

Why then so stubborn, Venice, in offering us veiled women at every twilit turn of your canals?

Enough! Enough! Stop whispering obscene invitations to every mortal passerby, O Venice, old procuress, who, under your heavy mosaic mantilla, still eagerly prepare exhausting romantic nights, querulous serenades, and frightful ambushes!

Nevertheless, O Venice, I used to love the sumptuous shade of your Grand Canal steeped in exotic lewdnesses, the hectic pallor of your women who slip from their balconies down ladders woven of lightning, slanting rain, and moonrays, to the tinkle of crossed swords.

But enough! All this absurd, abominable, and irritating nonsense nauseates us! And now we want electric lamps brutally to cut and strip away with their thousand points of light your mysterious, sickening, alluring shadows!

Your Grand Canal, widened and dredged, must become a great commercial port. Trains and trams, launched on wide roads built over canals that have finally been filled in, will bring you mountains of goods and a shrewd, wealthy, busy crowd of industrialists and businessmen!

Don't howl against the so-called ugliness of locomotives, trams, automobiles, and bicycles, in which we see the first outlines of the great Futurist aesthetic. They can always serve to upset some horrible grotesque Nordic professor in his Tyrolean hat.

But you want to prostrate yourself before all foreigners. Your servility is repulsive!

Venetians! Venetians! Why do you always want to be faithful slaves of the past? The seedy custodians of the greatest bordello in history, nurses in the saddest hospital in the world, where mortally corrupted souls languish in the pestilence of sentimentality?

Oh! I lack no images to describe your vain and silly inertia, like that of a great man's son or the husband of a famous singer! Your gondoliers, can't you perhaps compare them with gravediggers trying in cadence to dig ditches in a flooded cemetery?

But nothing can offend you, your humility is boundless!

One knows, moreover, that you are sagely absorbed in enriching the Society of Grand Hotels, and this is exactly why you stubbornly sit there and rot!

And yet, once you were invincible warriors and gifted artists, audacious navigators, ingenious industrialists, and tireless merchants. . . . And you have become waiters in hotels, ciceroni, pimps, antiquarians, imposters, fakers of old pictures, plagiarists and copyists. Have you forgotten that first of all you are Italians, and that in the language of history this word means: *builders of the future?*

Oh! Don't defend yourselves by bringing up the debilitating effects of the sirocco! What else was it but that torrid warlike wind that filled the sails of the heroes of Lepanto? This very African wind will one day, on some hellish noon, speed the blind work of the corroding waters that mine your venerable city.

Oh! How we'll dance on that day! Oh! How we'll applaud the lagoons, will egg them on to destruction! And what a splendid round dance we'll have in the illustrious ruins! All of us will be insanely gay, we, the last student rebels of this too wise world!

So it was, O Venetians, that we sang, danced, and laughed before the agony of the Island of Philae that perished like a worn-out mouse behind the Aswan Dam, immense trap with electric folding doors in which the Futurist genius of England imprisons the fleeing sacred waters of the Nile!

All right, shrug your shoulders and shout at me that I'm a barbarian, unable to enjoy the divine poetry that hovers over your enchanting isles!

Come! You have no reason to be so proud of it! . . .

Free Torcello, Burano, and the Isle of the Dead from all the diseased literature and all the endless romantic embroidery draped over them by poets poisoned with the Venetian fever; then, laughing with me, think of these islands as heaps of manure dropped at random by mammoths as they forded your prehistoric lagoons!

But you contemplate them stupidly, happy to decay in your dirty waters, happy to go on enriching the Society of Grand Hotels as it anxiously prepares its elegant nights for all the magnificos of the earth!

Certainly, it's no small thing to stimulate their love. Say that your guest is an emperor: for hours he navigates in the filth of this immense sewer full of cracked historical crockery; his gondoliers dig their way with oars through several kilometers of liquefied excrement, passing close, in a sacred stink of latrines, to barges heaped with lovely garbage, escorted by dubious floating paper bags, before he reaches his goal in true imperial style, pleased with himself and his lordly state!

This, this has been your glory up to now, O Venetians!

Shame on you! Shame on you! And you throw yourselves one on top of another like bags of sand to make an earthworks on the border, while we prepare a great strong industrial, commercial, and military Venice on the Adriatic Sea, that great Italian lake!

Futurist Speech to the English

Given at the Lyceum Club of London
1910

To give you a clear idea of what we are, I will tell you first what we think of you.

I will express myself with complete frankness and abstain entirely from paying you court in the style of cosmopolitan lecturers who crush their audiences with praise before cramming them full of banalities.

One of our young humorists has said that every good Futurist should be discourteous twenty times a day. So I will be discourteous with you, bravely confessing to you all the ill we think of the English, after having spoken much good of them.

Because, as you well know, we love the indomitable bellicose patriotism that sets you apart; we love the national pride that guides your great muscularly courageous race; we love the potent individualism that doesn't prevent you from opening your arms to individualists of every land, whether libertarians or anarchists.

But your broad love of liberty is not all we admire. What most sets you apart is that, amid so much pacifist nonsense and evangelical cowardice, you nourish an unbridled passion for every kind of struggle, from boxing—simple, brutal, and rapid—to the monstrous roaring necks of the cannon on the decks of your dreadnoughts, crouched in their swiveling caves of steel, turning to scent the distant, delectable enemy squadrons.

You know perfectly well that there is nothing worse for a man's blood than the forgiveness of offenses; you know that prolonged peace,

fatal to the Latin races, equally poisons the Anglo-Saxon races. . . .
But I promised you discourtesies, and here they are:

To a degree you are the victims of your traditionalism and its medieval trappings. In spite of everything, a whiff of archives and a rattling of chains survive and hinder your precise, free and easy forward march.

You will admit the oddness of this in a people of explorers and colonizers whose enormous ocean liners have obviously shrunk the world.

Most of all I will chide you for your morbid cult of the aristocracy. No one admits to being a *bourgeois* in England: everyone despises his neighbor and calls *him* a bourgeois.

Your obsessive mania is to be always *chic*. For love of the *chic* you always renounce passionate action, violence of heart, exclamations, shouts, and even tears.

Everywhere and at any cost, the English want to be cold: by the bedside of an adored person, in the face of death or happiness. For the love of *chic* you never discuss what you are doing, because your rule is always to be light and airy in conversation.

When the women leave after dinner, you talk a little politics, but not too much: it wouldn't be *chic*. . . .

You lack both a sharp, adventurous love of ideas and an impulse toward the unknowns of the imagination; you lack a passion for the future and a thirst for revolution. You are so custom-bound, in fact, as to believe firmly in this old wives' tale: that the Puritans saved England, and that chastity is a nation's most important virtue. But remember the dismal, ridiculous condemnation of Oscar Wilde. Intellectual Europe will never forgive you for it. Didn't all your newspapers cry out then that it was time to throw open every window, because the plague was over?

Naturally, in such an atmosphere of habitual and hypocritical formality, your young women are skilled in the use of their naïve elegance to carry on the most audaciously lascivious games, to prepare themselves well for marriage, the intangible domain of the conjugal police.

As for your twenty-year-old young men, almost all of them are homosexual for a time. This highly respectable taste of theirs evolves through a kind of intensification of *camaraderie* and friendship, in athletic sports, before the age of thirty, the time for work and good order, when they show their heels to Sodom in order to marry a shamelessly licentious young lady, making haste to condemn the born invert severely, the counterfeit man, the half woman who fails to conform.

Isn't it excessively formalistic of you to declare, as you do, that in order to know someone you must break bread with him, that is, have studied the way he eats?

But how could you judge us, the Italians, from our way of eating when we always eat sloppily, our epigastric regions strangled by love or ambition?

This is how an obsessive desire unfolds in you, to save appearances at any price, a base, finicking mania for etiquette, masks, and screens of every sort, invented by *pruderie* and a hypocritical morality.

Yet I won't insist, but hurry to denounce what we consider your greatest defect: a defect that you yourselves have bequeathed to Europe and that, in my opinion, is an obstacle to your marvelous practical instinct and your science of the rapid life.

I allude to your snobbery, whether it consists of a mad, exclusive cult of racial purity, in your aristocracy, or whether it creates a kind of religion out of fashion and transforms your illustrious tailors into so many high priests of lost religions. I also refer to your dogmatic and imperious norms for good living and the sacred tables of *comme il faut*, in the light of which you despise and abolish, with an astonishing light-heartedness, the fundamental worth of the individual, just as soon as he falls short of the sacred *laws* of snobbery.

All of this renders your existence singularly artificial, and makes you the most contradictory people on earth; hence, all your intellectual maturity cannot save you from sometimes seeming a people in the process of formation.

You invented the love of hygiene, the adoration of muscles, a harsh passion for effort, all of which triumph in your fine life of sport. But, to your disgrace, you push your exaggerated cult of the body to the point of scorning ideas, and you care seriously only for the physical pleasures. Platonic love is virtually absent from among you, and that is good; but you too much love succulent meals, and it's in the brutalizing religion of the table that you appease all your anxieties and all your worries!

From your sensuality you extract a formidable serenity in the face of moral suffering. Cease, therefore, to give so much importance to physical suffering!

You think yourselves very religious, but this is only an illusion.

You pay no attention to your inner lives, and your race lacks true mystical feeling. I congratulate you on this! But you seem equally impelled to take refuge in protestantism, *bonne-à-tout-faire* of your intelli-

FUTURIST SYNTH

We glorify war, which for us is the only hygiene of the world.
(First Futurist Manifesto), whereas for the Germans it serves as
a fat feast for crows and hyenas. The old cathedrals do not in-
terest; but we deny medieval, plagiarist, clumsy Germany, un-

ELASTICITY
INTUITIVE SYNTHESIS
INVENTION
MULTIPLICATION
OF FORCES
INVISIBLE ORDER **AGAIN**
CREATIVE GENIUS

SERBIA { INDEPENDENCE
AMBITION
TEMERITY

ENGLAND { PRACTICAL SPIRIT
SENSE OF DUTY
COMMERCIAL HONESTY
RESPECT FOR
INDIVIDUALITY

BELGIUM { ENERGY
WILL
INITIATIVE
INDUSTRIAL
PERFECTION

MONTENEGRO { INDEPENDENCE
AMBITION
TEMERITY

FRANCE { INTELLIGENCE
COURAGE
SPEED
ELEGANCE
SPONTANEITY
EXPLOSIVENESS
EASE

JAPAN { AGILITY
PROGRESS
RESOLUTENESS

ITALY { ALL THE STRENGTHS
ALL THE WEAKNESSES
OF GENIUS

AGAINS

RUSSIA { POWER
SOLIDITY
IMPREGNABILITY
QUANTITY

MARINETTI
BOCCIONI
CARRÀ
RUSSOLO
PIATTI

ESIS OF THE WAR

endowed with creative genius, the Futuristic right to destroy works of art. This right belongs solely to the Italian creative Genius, capable of creating a new and greater beauty on the ruins of the old.

RIGIDITY
ANALYSIS
METHODICAL IMITATION
ADDITION
 OF IDIOCIES
NUMISMATIC ORDER
GERMAN CULTURE

GERMANY
{
SHEEPISHNESS
— AWKWARDNESS
— PHILOSOPHICAL FUMES
— HEAVINESS
— CRUDENESS
— BRUTALITY
— ESPIONAGE
— PROFESSIONAL PEDANTRY
— ARCHAEOLOGY
— CONSTIPATION OF
 INDUSTRIAL CAMELOTS
— BOTCHERS AND GAFFEURS
}

UTURISM AGAINST ▷ PASSÉISM

8 PEOPLE-POETS AGAINST THEIR PEDANTIC CRITICS

AUSTRIA
{
IDIOCY
— FILTHINESS — FEROCITY
— POLICE DIMWITTEDNESS
— CLOTTED BLOOD
— GALLOWS — ESPIONAGE
— BIGOTRY
— PAPALISM
— INQUISITION
— REQUISITION
— BEDBUGS — PRIESTS
}

TURKEY } = 0

From the Milanese Cell, *September 20, 1914*
Directory of the Futurist Movement: Corso Venezia, 61—MILAN

gence, which saves you the trouble of thinking freely, without fear and without hope, like a black banner among the shadows.

It's through intellectual laziness that you fall so often to your knees, and it's also for love of good conventional and puerile Formalism.

No one loves the fleshly pleasures more than you, and yet you are the Europeans who most pride themselves on their chastity!

You love and generously welcome every revolutionary, but that doesn't hinder you from solemnly defending the principles of order! . . . You adore the fine swift machines that deflower the earth, sea, and clouds, yet you carefully preserve every least remnant of the past!

After all, is this a defect? You shouldn't treat all my remarks as reproofs. To contradict oneself is to live and you know how to contradict yourselves bravely.

But, besides, I know that you nurse a deep hatred for German clumsiness, and this is enough to absolve you completely.

. .

I have told you summarily what we think of England and the English.

Must I now hear the courteous reply that I already suspect is on your lips?

You surely want to stop my discourtesies by telling me all the good you think of Italy and the Italians. . . . Well: no, I don't want to listen.

The compliments you are about to pay could only sadden me, because what you love in our dear peninsula is exactly the object of all our hatreds. Indeed, you crisscross Italy only to meticulously sniff out the traces of our oppressive past, and you are happy, insanely happy, if you have the good fortune to carry home some miserable stone on which our ancestors have trodden.

When, when will you disembarrass yourselves of the lymphatic ideology of that deplorable Ruskin, which I would like to cover with so much ridicule that you would never forget it?

With his morbid dream of primitive rustic life, with his nostalgia for Homeric cheeses and legendary wool-winders, with his hatred for the machine, steam, and electricity, that maniac of antique simplicity is like a man who, after having reached full physical maturity, still wants to sleep in his cradle and feed himself at the breast of his decrepit old nurse in order to recover his thoughtless infancy.

Ruskin would certainly have applauded those passéist Venetians who

wanted to rebuild the absurd Bell Tower of San Marco, like offering a baby girl who has lost her nurse a little cloth and cardboard doll as a substitute.

We Abjure Our Symbolist Masters, the Last Lovers of the Moon

From War, the World's Only Hygiene

1911–1915

We have sacrificed everything to the triumph of this Futurist conception of life. To such a degree that today we hate our glorious intellectual fathers, after having greatly loved them: the grand Symbolist geniuses, Edgar Poe, Baudelaire, Mallarmé, and Verlaine. We despise them now for having swum the river of time with their heads always turned back toward the far blue spring of the past, toward the *"ciel antérieur où fleurit la beauté."*

No poetry without nostalgia, without the evocation of dead time, without the fog of history and legend, existed for those geniuses.

We hate them, the Symbolist masters, we who have dared to emerge naked from the river of time and create in spite of ourselves, our bodies skinned by the stones of the craggy ascent, new singing sources of heroism, new torrents that drape the mountain in scarlet.

We are red and love red: eyes and cheeks reddened by reflections from the fireboxes of locomotives. We love and we sing the ever-growing triumph of the machine, which they stupidly curse.

Our Symbolist fathers had a passion that we consider ridiculous: A passion for eternal things, a desire for immortal, imperishable masterworks.

We on the other hand think that nothing is lower or meaner than to think of immortality while creating a work of art, lower or meaner than the calculated, usurious idea of the Christian heaven, which is supposed to reward our earthly virtues at a million percent profit.

One must simply create, because creation is useful, unrewarded, ignored, despised; in a word, heroic.

To the poetry of nostalgic memory we oppose the poetry of feverish expectation. To tears of beauty brooding tenderly over tombs, we oppose the keen, cutting profile of the pilot, the chauffeur, the aviator.

To the conception of the imperishable, the immortal, we oppose, in art, that of becoming, the perishable, the transitory, and the ephemeral.

Thus we will transform the *nevermore* of Edgar Poe into a sharp joy and will teach people to love the beauty of an emotion or a sensation *to the degree that it is unique and destined to vanish* irreparably.

History, in our eyes, is fatally a forger, or at least a miserable collector of stamps, medals, and counterfeit coins.

The past is necessarily inferior to the future. That is how we wish it to be. How could we acknowledge any merit in our most dangerous enemy: the past, gloomy prevaricator, execrable tutor?

This is how we deny the obsessing splendor of the dead centuries and how we cooperate with the victorious Mechanics that holds the world firm in its web of speed.

We cooperate with Mechanics in destroying the old poetry of distance and wild solitudes, the exquisite nostalgia of parting, for which we substitute the tragic lyricism of ubiquity and omnipresent speed.

Our Futurist sensibility, in fact, is no longer moved by the dark mystery of an unexplored valley, of a mountain cleft that we, in spite of ourselves, picture as crossed by the elegant ribbon of a white road, where an automobile gleaming with progress and full of civilized voices brusquely pulls up, coughing; a boulevard corner camped in the middle of solitude.

Every pine woods madly in love with the moon has a Futurist road that crosses it from end to end.

The simple, doleful reign of endlessly soliloquizing vegetation is over. With us begins the reign of the man whose roots are cut, of the multiplied man who mixes himself with iron, who is fed by electricity and no longer understands anything except the lust for danger and daily heroism.

That should be enough to tell you how we despise the defenders of *l'esthétique paysagiste,* a witless anachronism.

Multicolored billboards on the green of the fields, iron bridges that chain the hills together, surgical trains that pierce the blue belly of the

mountains, enormous turbine pipes, new muscles of the earth, may you be praised by the Futurist poets, since you destroy the old sickly cooing sensitivity of the earth!

When we have such passions, such innovating rage, how can you expect us to accept the artistic philosophy of our contemporary Italy?

Too long has Italy submitted to the enfeebling influence of Gabriele D'Annunzio, lesser brother of the great French Symbolists, nostalgic like them and like them hovering above the naked female body.

One must at all costs combat Gabriele D'Annunzio, because with all his great skill he has distilled the four intellectual poisons that we want to abolish forever: 1) the sickly, nostalgic poetry of distance and memory; 2) romantic sentimentality drenched with moonshine that looks up adoringly to the ideal of Woman-Beauty; 3) obsession with lechery, with the adulterous triangle, the pepper of incest, and the spice of Christian sin; 4) the professorial passion for the past and the mania for antiquity and collecting.

We likewise reject the stammering botanical sentimentality of Pascoli, which, in spite of his unquestionable genius, is nevertheless guilty of having had a degrading, deleterious influence.

We accept only the illuminating work of the four or five great precursors of Futurism. I allude to Émile Zola, Walt Whitman, Rosny aîné, author of *Bilatéral* and the *Vague Rouge,* to Paul Adam, author of *Trust,* to Gustave Kahn, creator of free verse, to Verhaeren, glorifier of machines and tentacular cities.

The Futurist lyricism, essentially mobile and changeable, like, for that matter, the pictorial dynamism of the Futurist painters, Boccioni, Carrà, Russolo, Balla, and Severini, expresses our *I* with a steady velocity, and it in turn creates itself with a ceaseless inspiration.

The Futurist lyricism, a perpetual dynamism of thought, an uninterrupted current of images and sounds, is alone able to express the ephemeral, unstable, and symphonic universe that is forging itself in us and with us.

Down with the Tango and Parsifal

Futurist letter circulated among cosmopolitan women friends who give tango-teas and Parsifalize themselves January 11, 1914

A year ago I was replying to a questionnaire sent out by *Gil Blas* that denounced the effeminizing poisons of the tango. This epidermic oscillation is spreading little by little through the whole world and threatens to rot every race of men, turning them to gelatine. Once again, therefore, we see that we must hurl ourselves against the imbecility of fashion and deflect the sheeplike current of snobbery.

Monotony of romantic haunches, amid the flashing eyes and Spanish daggers of de Musset, Hugo, and Gautier. Industrialization of Baudelaire, *Fleurs du mal* weaving around the taverns of Jean Lorraine for impotent voyeurs *à la* Huysmans and inverts like Oscar Wilde. Last crazy fling of a sentimental, decadent, paralytic romanticism toward the Fatal Woman of cardboard.

Clumsiness of English and German tangos, mechanical lusts and spasms of bones and *fracs* unable to externalize their sensibilities. Mimicry of Parisian and Italian tangos, mollusk-couples, savage felinity of the Argentine race, stupidly domesticated, morphinized, powdered over.

To possess a woman is not to rub against her but to penetrate her.

"Barbarian!"

"A knee between the thighs? Come! they want two!"

"Barbarian!"

Well then, yes, we are barbarians! Down with the tango and its rhythmic swoons. Is it so amusing for you to look each other in the mouth and ecstatically examine each other's teeth, like two hallucinated dentists? To yank? . . . To lunge? . . . Is it so much fun to arch des-

perately over each other, trying to pop each other like two corked bot-
tles, and never succeeding? . . . Or to stare at the points of your shoes,
like hypnotized cobblers? Soul of mine, do you really wear a size 7?
. . . What lovely stockings, dreeeamboat! . . . You toooo! . . .

Tristan and Isolde who withhold their climax to excite King Mark.
Medicine-dropper of love. Miniature of sexual anguish. Spun sugar of
lust. Lechery out in the open. Delirium tremens. Cockeyed hands and
feet. Pantomime coitus for the camera. Masturbated waltz. Pouah!
Down with the diplomatics of the skin! Up with the brutality of a
violent possession and the fine fury of an exciting, strengthening, mus-
cular dance.

Tango, roll and pitch of sailboats who have cast their anchors in the
depths of cretinism. Tango, roll and pitch of sailboats drenched with
tenderness and lunar stupidity. Tango, tango, a pitching to make one
vomit. Tango, slow and patient funeral of dead sex! Oh! it's not a
question of religion or morality or modesty! These words mean noth-
ing to us! We shout *Down with the tango!* in the name of Health,
Force, Will, and Virility.

If the tango is bad, *Parsifal* is worse, because it inoculates the danc-
ers swaying in languorous boredom with an incurable musical neuras-
thenia.

How shall we avoid *Parsifal* and its cloudbursts, puddles, and bogs of
mystical tears? *Parsifal* is the systematic devaluation of life! Coopera-
tive factory of sadness and desperation. Unmelodious protrusion of
weak stomachs. Bad digestion and heavy breath of forty-year-old vir-
gins. Lamentations of fat old constipated priests. Wholesale and retail
sale of remorses and elegant cowardices for snobs. Insufficiency of
blood, weakness of the loins, hysteria, anemia, and green sickness.
Genuflection, brutalizing and crushing of Man. Silly scraping of
wounded, defeated notes. Snoring of drunken organs stretched in the
vomit of bitter leitmotivs. Tears and false pearls of Mary Magdalen in
décolletage at Maxim's. Polyphonic suppuration of Amfortas's wound.
Lachrymose sleepiness of the Knights of the Grail! Ridiculous satanism
of Kundry. . . . Passéism! Passéism—enough!

King and Queen of snobbery, do you know that you owe an absolute
obedience to us, the Futurists, living innovators! Then leave the corpse
of Wagner to the bestial lusts of the public, Wagner the innovator of
fifty years ago, whose work, now surpassed by Debussy, by Strauss, and
by our great Futurist Pratella, has lost all meaning! You helped us to

defend him when he needed it. We will teach you to love and defend something alive, you dear slaves and sheep of snobbery.

Furthermore, you forget *this final argument, the only persuasive one for you:* to love Wagner and *Parsifal* today, performed everywhere and especially in the provinces . . . to give tango-teas like all good bourgeois all over the world, come come, *it's no longer* CHIC!

Against *Amore* and Parliamentarianism

From War, the World's Only Hygiene
1911–1915

This hatred, precisely, for the tyranny of *Amore* we expressed in a laconic phrase: "scorn for women."

We scorn woman conceived as the sole ideal, the divine reservoir of *Amore,* the woman-poison, woman the tragic trinket, the fragile woman, obsessing and fatal, whose voice, heavy with destiny, and whose dreaming tresses reach out and mingle with the foliage of forests drenched in moonshine.

We despise horrible, dragging *Amore* that hinders the march of man, preventing him from transcending his own humanity, from redoubling himself, from going beyond himself and becoming what we call *the multiplied man.*

We scorn horrible, dragging *Amore,* immense leash with which the sun in its orbit chains the courageous earth that would surely rather leap at random, run every starry risk.

We are convinced that *Amore*—sentimentality and lechery—is the least natural thing in the world. There is nothing natural and important except coitus, whose purpose is the futurism of the species.

Amore—romantic, voluptuary obsession—is nothing but an invention of the poets, who gave it to humanity. . . . And it will be the poets who will take it away from humanity, as one recovers a manuscript from the hands of a publisher who has shown himself incapable of printing it decently.

In this campaign of ours for liberation, our best allies are the suffragettes, because the more rights and powers they win for woman, the more will she be deprived of *Amore,* and by so much will she cease to be a magnet for sentimental passion or lust.

The carnal life will be reduced to the conservation of the species, and that will be so much gain for the growing stature of man.

As for the supposed inferiority of woman, we think that if her body and spirit had, for many generations past, been subjected to the same physical and spiritual education as man, it would perhaps be legitimate to speak of the equality of the sexes.

It is obvious, in any case, that in her actual state of intellectual and erotic slavery, woman finds herself wholly inferior in respect to character and intelligence and can therefore be only a mediocre legislative instrument.

For just this reason we most enthusiastically defend the rights of the suffragettes, at the same time that we regret their childish eagerness for the miserable, ridiculous right to vote.

Indeed, we are convinced that they will win it hands down, and thus involuntarily help us to destroy that grand foolishness, made up of corruption and banality, to which parliamentarianism is now reduced.

This style of government is exhausted almost everywhere. It accomplished a few good things: it created the illusory participation of the majority in government. I say "illusory" because it is clear that the people cannot be and never will be represented by spokesmen whom they do not know how to choose.

Consequently, the people are always estranged from the government. On the other hand, it is precisely to parliamentarianism that the people owe their real existence.

The pride of the mob was inflated by the elective system. The stature of the individual was heightened by the idea of representation. But this idea has completely undermined the value of intelligence by immeasurably exaggerating the worth of eloquence. This state of affairs worsens day by day.

Therefore I welcome with pleasure the aggressive entrance of women into the parliaments. Where could we find a dynamite more impatient or more effective?

Nearly all the European parliaments are mere noisy chicken coops, cow stalls, or sewers.

Their first principles are: 1) financial corruption, shrewdness in brib-

ery, to win a seat in parliament; 2) gossipy eloquence, grandiose falsification of ideas, triumph of high-sounding phrases, tom-tom of Negroes and windmill gestures.

These gross elements of parliamentarianism give an absolute power to the horde of lawyers.

As you well know, lawyers are alike in every country. They are beings closely tied to everything mean and futile, spirits who see only the small daily fact, who are wholly unable to handle the great general ideas, to imagine the collisions and fusions of races or the blazing flight of the ideal over individuals and peoples. They are argument-merchants, brains for sale, shops for subtle ideas and chiseled syllogisms.

Because of parliamentarianism a whole nation is at the mercy of these fabricators of justice who, by means of the ductile iron of the law, assiduously build traps for fools.

Then let us hasten to give women the vote. And this, furthermore, is the final and absolutely logical conclusion of the ideal of democracy and universal suffrage as it was conceived by Jean Jacques Rousseau and the other preparers of the French Revolution.

Let women hurry to make, with the speed of lightning, this great test of the total animalization of politics.

We who deeply despise the careerists of politics are happy to abandon parliamentarianism to the envious claws of women; inasmuch as to women, exactly, is reserved the noble task of killing it for good and forever.

Oh! how careful I am to avoid irony; I speak as seriously as I know how.

Woman, as she has been shaped by our contemporary society, can only increase in splendor the principle of corruption inseparable from the principle of the vote.

Those who oppose the legitimate rights of the suffragettes do so for entirely personal reasons: they eagerly defend the monopoly of useless or harmful eloquence, which the women will not hesitate to snatch away from them. Fundamentally, this bores us. We have very different mines to put under the ruins.

They tell us that a government composed of women or sustained by women would fatally drag us through the paths of pacificism and Tolstoyan cowardice into a definitive triumph of clericalism and moralistic hypocrisy.

Perhaps! Probably! And I'm sorry!

We will, however, have the war of the sexes, undoubtedly prepared by the great agglomerations of the capital cities, by night life and the stabilizing of workers' salaries. Maybe some misogynistic humorists are already dreaming of a Saint Bartholomew's Night for the women.

But you imagine that I am amusing myself by offering you paradoxes more or less bizarre. . . . Consider, at any rate, that nothing is as paradoxical or as bizarre as reality, and there is very little reason for believing in the logical probabilities of history.

The history of peoples runs at hazard, in any and every direction, like a rather giddy girl who cannot remember what her parents taught her except on New Year's Day, or only when abandoned by a lover. But she is still too disgracefully wise and not disorderly enough, this young history of the world. So the sooner women mix into it, the better, because the men are filthy with millenarian wisdom. These are no paradoxes, I assure you, but gropings into the night of the future.

You will admit, for example, that the victory of feminism and especially the influence of women on politics will end by destroying the principle of the family. One could easily demonstrate that: but you surely would rebel, terrified, and oppose me with ingenious arguments because you do not want the family touched at all. Every right, every liberty should be given to women, but let the family stay intact!

Allow me to smile just a bit skeptically and say to you that if the family, suffocater of vital energies, disappears, we will endeavor to do without it.

It is plain that if modern woman dreams of winning her political rights, it is because without knowing it she is intimately sure of being, as a mother, as a wife, and as a lover, a closed circle, purely animal and wholly without usefulness.

You will certainly have watched the takeoff of a Blériot plane, panting and still held back by its mechanics, amid mighty buffets of air from the propeller's first spins.

Well then: I confess that before so intoxicating a spectacle we strong Futurists have felt ourselves suddenly detached from women, who have suddenly become too earthly, or, to express it better, have become a symbol of the earth that we ought to abandon.

We have even dreamed of one day being able to create a mechanical son, the fruit of pure will, a synthesis of all the laws that science is on the brink of discovering.

Marriage and the Family

From Futurist Democracy
1919

Family feeling is an inferior sentiment, almost animal, created by fear of the great free beasts, by fear of nights bursting with adventure and ambush. It comes to birth with the first signs of old age that crack the metal of youth. First signs of quietism, of wise moderating prudence, the need to rest, to furl one's sails in a calm and comfortable harbor.

The family lamp is a luminous broody hen who hatches her rotten eggs of cowardice. Father, mother, granny, aunts, and children always end up, after a few dumb scrimmages among themselves, plotting together against holy danger and hopeless heroism. And the steaming soup bowl is the censer burning in this temple of monotony.

<p style="text-align:center">* * *</p>

As it is now constituted, the family of marriage-without-divorce is absurd, harmful, and prehistoric. Almost always a prison. Often a Bedouin tent covering a lurid mixture of old invalids, women, babies, pigs, asses, camels, hens, and filth.

The family dining room is the twice-daily sewer drain of bile, irritation, prejudice, and gossip.

In this grotesque squeeze of souls and nerves, boredom lives and empty irritation systematically wears and corrodes every private impulse, every young initiative, every practical businesslike decision.

The most marked, energetic characters eat out their hearts in this ceaseless friction of elbows.

An infection arrives, sometimes a real epidemic of swollen idiocy, of

catastrophic manias, nervous tics, that changes into a German goose step or a ragtag of emigrants down in the hold.

Female whims flourish anew, litters of babies over the apoplectic stubbornness of their avaricious fathers.

Springlike faces lose their color around an agony that lasts ten years. One victim, two victims, three martyrs, one slaughter, one total madness, a tyrant who is losing his power.

All suffer, all are deprived, exhausted, cretinized in the name of a fearful divinity that must be overthrown: family feeling.

Hallways of idiot wranglings, litanies of reproaches, impossibility of thought or creation on one's own. One mucks around in the daily swamp of dirty domestic economy and dull vulgarities.

The family functions badly, being a hell of plots, arguments, betrayals, contempts, basenesses, and a relative desire on everyone's part for escape and revolt. Jealousy at knife point between the mother and her elegant, beautiful daughters; a contest in greed and wastefulness between conservative father and his playboy son. Everywhere in Italy there is the sad spectacle of the rich egotistical father who wants to force the usual *serious profession* on his poetic or artistic son.

When the family functions well, you have the glue of sentiment, tombstone of maternal tenderness. Daily school of fear. Physical and moral cowardice in the face of a cold, of any new action or idea.

The family that almost always, for the woman, becomes a hypocritical masquerade or else the wise façade behind which one carries on a legal prostitution powdered over with moralism.

All this in the name of a fearful divinity that must be overthrown: Sentiment.

We proclaim that Sentiment is the typical virtue of vegetables, for digging down and growing roots. It becomes a vice in animals, a crime among men, because it fatally restrains their dynamism and swift evolution.

To say *my woman* can be nothing but a childish idiocy or an expression of Negroes. Today, just now, for an hour, a month, two years, according to the flight of my fancy and the power of my animal magnetism or intellectual ascendancy, the woman is as much *mine* as I am hers.

With the words *my wife, my husband,* the family clearly establishes the law of adultery at any cost, or masked prostitution at any cost. Hence is born a school of hypocrisy, treason, and equivocation.

We want to destroy not only the ownership of land, but also the ownership of woman. Whoever cannot work his land should be dispossessed. Whoever cannot give his woman strength and joy should never force his embrace or his company upon her.

Woman does not belong to a man, but rather to the future and the race's development.

We want a woman to love a man and give herself to him for as long as she likes; then, not chained by a contract or by moralistic tribunals, she should bear a child whom society will educate physically and intellectually to a high conception of Italian freedom.

A single woman suffices to support and defend the first growth of a hundred babies, without constriction; their first overmastering perception will be the need to build their own courage, the urgency of personally solving as fast as possible their little physical problems of equilibrium and nourishment; that atmosphere of weeping and hands grasping skirts and sickly smooching that currently comprises earliest childhood will be completely abolished.

We will finally do away with the mixture of males and females that —during the earliest years—produces a damnable effeminizing of the males.

The male babies should—according to us—develop far away from the little girls so that their first games can be entirely masculine, that is, free of every emotional morbidity, every womanly delicacy, so that they can be lively, pugnacious, muscular, and violently dynamic. When little boys and girls live together, the formation of the male character is always retarded. They are always attracted by the charm and willful seductiveness of the little woman, like little *cicisbei* or stupid little slaves.

The abject hunt for a *good match* will be done away with, and the witless calvary of suffocating mothers who bring marriageable daughters to dances and watering places, like heavy crosses to plant on the idiot Golgotha of a good marriage.

"We have to find them a good place"—in a tubercular bed, under an old man's tongue, under the fists of a neurasthenic, like a dry leaf between the pages of a dictionary, in a tomb, a safe, or a sewer—but "find them a good place."

Grim strangulation of the heart and senses of a virgin who fatally thinks of the legal prostitution of marriage as an indispensable condi-

tion for gaining the half freedom of adultery and the recovery of her ego through treason.

The wide participation of women in the national work produced by the war has created a typical matrimonial grotesque: the husband had money or was earning it, now he has lost it or can't win it back.

His wife works and finds the way to earn a handsome income at a time when life is exceptionally expensive.

For her kind of work the wife has little need of a domestic life, while the nonworking husband concentrates his activity on an absurd preoccupation with domestic order.

Complete subversion of a family in which the husband has become a useless woman with masculine vanities, and his wife has doubled her human and social value.

Inevitable clash between the two spouses; struggle and defeat of the man.

The Birth of a Futurist Aesthetic

From War, the World's Only Hygiene
1911–1915

Yes, by all means, many objections to our destructive, antitraditionalist principle have already occurred to you.

Let me take one of them: "What," you say to me, "are the works in stone, marble, or bronze that you can set against the inimitable works left to us by past centuries?"

I have this simple answer:

1. The masterpieces of the past are all that remain of a vast number of works of art that disappeared because of their ugliness or fragility.

So you really cannot ask us to oppose the masterworks of a mere fifty years to the sifted residue of at least a millennium.

2. Furthermore, I say that such modern phenomena as cosmopolitan nomadism, the democratic spirit, and the decline of religions have reduced to uselessness the great, decorative, imperishable buildings that once expressed kingly authority, theocracy, and mysticism.

The right to strike, equality before the law, the authority of numbers, the usurping power of mobs, the speed of international communications, the habits of hygiene and domestic comfort; these wholly new phenomena require large, popular, well-ventilated apartment blocks, absolutely comfortable trains, tunnels, iron bridges, huge and fast ocean liners, hillside villas shrewdly sited toward the cool sweep of horizons, immense meeting halls, and perfected *chambres de toilette* for the rapid daily care of the body.

A modern aesthetic most responsive to utility has no need of royal palaces with domineering lines and granite foundations that loom mas-

sively out of the past over their little medieval towns, confused welters of wretched dog kennels.

To what end, today, would we launch into the sky the pinnacles of those majestic cathedrals that used to mount to the clouds, joining the hands of their ogives in prayer in defense of the little hamlets that cowered in their shadow?

To them we oppose the wholly mastered, definitive Futurist aesthetic of great locomotives, twisting tunnels, armored cars, torpedo boats, monoplanes, and racing cars.

We create the new aesthetic of speed. We have almost abolished the concept of space and notably diminished the concept of time. We are thus preparing the ubiquity of multiplied man. We will thus arrive at the abolition of the year, the day, and the hour.

Meteorological phenomena anticipate us, because the seasons have already been fused together.

The tragic return of the traditional annual holidays is already losing its hold on our minds.

The noctambulism of work and pleasure in France, Italy, and Spain, has it not already melted together day and night? Naturally, the works in which we have expressed this whirlwind of intense life spinning toward an ideal future cannot be understood and appreciated by a public thunderstruck by our savage eruption and offended by our cruel violence.

Later the public will love these works. Meanwhile it is already beginning to feel disgust with what we struggle against.

Already we have provoked a growing nausea for the antique, for the worm-eaten and moss-grown. And this is an important, decisive gain.

In our First Manifesto you read this affirmation, which raised a hurricane of disapproval: "A racing car is more beautiful than the *Victory of Samothrace.*"

I will leave you an explosive gift, this image that best completes our thought: "Nothing is more beautiful than the steel frame of a house in construction."

To a finished house we prefer the framework of a house in construction whose girders are the color of danger—landing platforms for airplanes—with its numberless arms that claw and comb out stars and comets, its aerial quarterdecks from which the eye embraces a vaster horizon. The steel skeleton with its rhythms of blocks and pulleys, of hammers and hearts, and from time to time—yes, let it happen—the

harrowing cry and heavy thud of a fallen construction worker, great drop of blood on the pavement!

The frame of a house in construction symbolizes our burning passion for the coming-into-being of things.

Things already built and finished, bivouacs of cowardice and sleep, disgust us!

We love only the immense, mobile, and impassioned framework that we can consolidate, always differently, at every moment, according to the ever-changing moods of the winds, with the red concrete of our bodies set firm by our wills.

You ought to fear everything from the moss-grown past. All your hope should be in the Future.

Put your trust in Progress, which is always right even when it is wrong, because it is movement, life, struggle, hope.

And see that you do not go to law with Progress. Let it be an imposter, faithless, an assassin, a thief, an incendiary, Progress is always right.

But the plainest, the most violent of Futurist symbols comes to us from the Far East.

In Japan they carry on the strangest of trades: the sale of coal made from human bones. All their powderworks are engaged in producing a new explosive substance, more lethal than any yet known. This terrible new mixture has as its principal element coal made from human bones with the property of violently absorbing gases and liquids. For this reason countless Japanese merchants are thoroughly exploring the corpse-stuffed Manchurian battlefields. In great excitement they make huge excavations, and enormous piles of skeletons multiply in every direction on those broad bellicose horizons. One hundred *tsin* (7 kilograms) of human bones bring in 92 *kopeks*.

The Japanese merchants who direct this absolutely Futurist commerce buy no skulls. It seems that they lack the necessary qualities. Instead the merchants buy great mounds of other bones to send to Japan, and the Benikou station from a distance looks to travelers on the Trans-Siberian Railway like a gigantic grayish white pyramid: skeletons of heroes who do not hesitate to be crushed in mortars by *their own sons, their relatives, or their fellow citizens,* to be brutally vomited out by Japanese artillery against hostile armies.

Glory to the indomitable ashes of man, that come to life in cannons! My friends, let us applaud this noble example of synthetic violence. Let

us applaud this lovely slap in the face of all the stupid cultivators of sepulchral little kitchen gardens.

Quickly! To free the roads let all our loved and venerated corpses stuff themselves into the throats of cannon! Or, better still, let them await the enemy, gently cradled in graceful speeding torpedoes, offering mouthfuls of deadly kisses.

There will always be more corpses. All the better! Then explosive materials will also increase, and this will be just what our so flaccid world needs!

Unfurl the Futurist banner! Ever higher, to exalt the aggressive, forgetful will of man, and to affirm once again the ridiculous nullity of nostalgic memory, of myopic history and the dead past.

Do we seem too brutal? That is because we speak under dictation from a new sun, which is certainly not the sun that caressed the placid backs of our grandfathers—those slow steps sagely measured to the lazy hours of provincial cities with their grassy cobblestones of silence.

We breathe an atmosphere that to them would have seemed unbreathable. We have no more time to lose in praying over tombs! And, besides, how could we make their sluggish souls comprehend, souls more like Homer's than our own?

In the inevitable conflicts of peoples soon to come, the conqueror will be the one with the deepest awareness of this difference.

The most gifted people will win, the most elastic, quick, forgetful, Futurist, and hence the richest.

On the eve of this fearful conflict, we Italian Futurists have no desire to see Italy left in an inferior state. That is why we cast into the sea the heavy burden of the past that weighs down our swift and warlike vessel.

Technical Manifesto of Futurist Literature

May 11, 1912

Sitting on the gas tank of an airplane, my stomach warmed by the pilot's head, I sensed the ridiculous inanity of the old syntax inherited from Homer. A pressing need to liberate words, to drag them out of their prison in the Latin period! Like all imbeciles, this period naturally has a canny head, a stomach, two legs, and two flat feet, but it will never have two wings. Just enough to walk, to take a short run and then stop short, panting!

This is what the whirling propeller told me, when I flew two hundred meters above the mighty chimney pots of Milan. And the propeller added:

1. One must destroy syntax and scatter one's nouns at random, just as they are born.

2. One should use infinitives, because they adapt themselves elastically to nouns and don't subordinate them to the writer's *I* that observes or imagines. Alone, the infinitive can provide a sense of the continuity of life and the elasticity of the intuition that perceives it.

3. One must abolish the adjective, to allow the naked noun to preserve its essential color. The adjective, tending of itself toward the shadows, is incompatible with our dynamic vision, because it supposes a pause, a meditation.

4. One must abolish the adverb, old belt buckle that holds two words together. The adverb preserves a tedious unity of tone within a phrase.

5. Every noun should have its double; that is, the noun should be followed, with no conjunction, by the noun to which it is related by

analogy. Example: man-torpedo-boat, woman-gulf, crowd-surf, piazza-funnel, door-faucet.

Just as aerial speed has multiplied our knowledge of the world, the perception of analogy becomes ever more natural for man. One must suppress the *like,* the *as,* the *so,* the *similar to.* Still better, one should deliberately confound the object with the image that it evokes, fore-shortening the image to a single essential word.

6. Abolish even the punctuation. After adjectives, adverbs, and conjunctions have been suppressed, punctuation is naturally annulled, in the varying continuity of a *living* style that creates itself without the foolish pauses made by commas and periods. To accentuate certain movements and indicate their directions, mathematical symbols will be used: $+ - \times : =$ and the musical symbols.

7. Up to now writers have been restricted to immediate analogies. For instance, they have compared an animal to a man or to another animal, which is almost the same as a kind of photography. (They have compared, for example, a fox terrier to a very small thoroughbred. Others, more advanced, might compare that same trembling fox terrier to a little Morse Code machine. I, on the other hand, compare it to gurgling water. In this there is *an ever-vaster gradation of analogies,* there are ever-deeper and more solid affinities, however remote.)

Analogy is nothing more than the deep love that assembles distant, seemingly diverse and hostile things. An orchestral style, at once polychromatic, polyphonic, and polymorphous, can embrace the life of matter only by means of the most extensive analogies.

When, in my *Battle of Tripoli,* I compared a trench bristling with bayonets to an orchestra, a machine gun to a fatal woman, I intuitively introduced a large part of the universe into a short episode of African battle.

Images are not flowers to be chosen and picked with parsimony, as Voltaire said. They are the very lifeblood of poetry. Poetry should be an uninterrupted sequence of new images, or it is mere anemia and green-sickness.

The broader their affinities, the longer will images keep their power to amaze. One must—people say—spare the reader's capacity for wonder. Nonsense! Let us rather worry about the fatal corrosion of time that not only destroys the expressive value of a masterpiece but also its power to amaze. Too often stimulated, have our old ears per-

haps not already destroyed Beethoven and Wagner? We must therefore eliminate from our language everything it contains in the way of stereotyped images, faded metaphors; and that means almost everything.

8. There are no categories of images, noble or gross or vulgar, eccentric or natural. The intuition that grasps them has no preferences or *partis pris*. Therefore the analogical style is absolute master of all matter and its intense life.

9. To render the successive motions of an object, one must render the *chain of analogies* that it evokes, each condensed and concentrated into one essential word.

Here is an expressive example of a chain of analogies still masked and weighed down by traditional syntax:

> Ah yes! you, little machine gun, are a fascinating woman, and sinister, and divine, at the driving wheel of an invisible hundred horsepower, roaring and exploding with impatience. Oh! soon you will leap into the circuit of death, to a shattering somersault or to victory! . . . Do you want me to make you some madrigals full of grace and color? As you wish, *signora*. . . . To me you resemble a lawyer before the bar, whose tireless eloquent tongue strikes his circle of listeners to the heart, moving them profoundly. . . . At this moment you are an omnipotent trepan that cuts rings around the too hard skull of this stubborn night. . . . And you are also a rolling mill, an electric lathe, and what else? A great blowtorch that sears, chisels, and slowly melts the metal points of the last stars! . . . [*Battle of Tripoli*]

In some cases one must join the images two by two, like those chained iron balls that level a whole grove of trees in their flight.

To catch and gather whatever is most fugitive and ungraspable in matter, one must shape *strict nets of images or analogies,* to be cast into the mysterious sea of phenomena. Except for the traditional festoons of its form, the following passage from my *Mafarka the Futurist* is an example of such a strict net of images:

> All the bitter sweetness of past youth mounted in his throat, as the cheerful cries of boys rose from the schoolyard toward their teachers leaning on the parapets of the terraces from which ships could be seen taking flight. . . .

And here are two more nets of images:

> Around the well of Bumeliana, beneath the thick olive trees, three camels squatting comfortably on the sand were gargling with content-

ment, like old stone gutters, mixing the *chak-chak* of their spitting with the steady beat of the steam pump that supplies water to the city. Cries and Futurist dissonances, in the deep orchestra of the trenches with their winding depths and noisy cellars, as the bayonets pass and repass, violin bows that the sunset's ruddy baton inflames with enthusiasm. . . .

It is the sunset-conductor whose wide sweep gathers the scattered flutes of tree-bound birds, the grieving harps of insects, the creak of branches, and the crunch of stones. It is he who suddenly stops the mess-tin kettledrums and the rifles' clash, to let the muted instruments sing out above the orchestra, all the golden stars, upright, open-armed, across the footlights of the sky. And here is the *grande dame* of the play. . . . Prodigiously bare, it is indeed the desert who displays her immense bosom in its liquefied curves, all glowing in rosy lacquer beneath the mighty night's cascading jewels. [*Battle of Tripoli*]

11. Destroy the *I* in literature: that is, all psychology. The man sidetracked by the library and the museum, subjected to a logic and wisdom of fear, is of absolutely no interest. We must therefore drive him from literature and finally put matter in his place, matter whose essence must be grasped by strokes of intuition, the kind of thing that the physicists and chemists can never do.

To capture the breath, the sensibility, and the instincts of metals, stones, wood, and so on, through the medium of free objects and whimsical motors. To substitute for human psychology, now exhausted, the lyric obsession with matter.

Be careful not to force human feelings onto matter. Instead, divine its different governing impulses, its forces of compression, dilation, cohesion, and disaggregation, its crowds of massed molecules and whirling electrons. We are not interested in offering dramas of humanized matter. The solidity of a strip of steel interests us for itself; that is, the incomprehensible and nonhuman alliance of its molecules or its electrons that oppose, for instance, the penetration of a howitzer. The warmth of a piece of iron or wood is in our opinion more impassioned than the smile or tears of a woman.

We want to make literature out of the life of a motor, a new instinctive animal whose general instincts we will know when we have learned the instincts of the different forces that make it up.

For a Futurist poet, nothing is more interesting than the action of a mechanical piano's keyboard. The cinema offers us the dance of an

object that divides and recomposes without human intervention. It also offers us the backward sweep of a diver whose feet leave the ocean and bounce violently back on the diving board. Finally, it shows us a man driving at two hundred miles an hour. These are likewise movements of matter, outside the laws of intelligence and therefore of a more significant essence.

Three elements hitherto overlooked in literature must be introduced:
1. Sound (manifestation of the dynamism of objects).
2. Weight (objects' faculty of flight).
3. Smell (objects' faculty of dispersing themselves).
To force oneself, for example, to render the landscape of smells that a dog perceives. To listen to motors and to reproduce their conversations.

Material has always been contemplated by a cold, distracted *I*, too preoccupied with itself, full of preconceived wisdom and human obsessions.

Man tends to foul matter with his youthful joy or elderly sorrows; matter has an admirable continuity of impulse toward greater warmth, greater movement, a greater subdivision of itself. Matter is neither sad nor gay. Its essence is courage, will power, and absolute force. It belongs entirely to the intuitive poet who can free himself from traditional, heavy, limited syntax that is stuck in the ground, armless and wingless, being merely intelligent. Only the unsyntactical poet who unlinks his words can penetrate the essence of matter and destroy the dumb hostility that separates it from us.

The Latin period that has served us up to now was a pretentious gesture with which the myopic and overweening imagination forced itself to master the multiform and mysterious life of matter. The Latin period, consequently, was born dead.

Deep intuitions of life joined to one another, word for word according to their illogical birth, will give us the general lines of an *intuitive psychology of matter*. This was revealed to me when I was flying in an airplane. As I looked at objects from a new point of view, no longer head on or from behind, but straight down, foreshortened, that is, I was able to break apart the old shackles of logic and the plumb lines of the ancient way of thinking.

All you Futurist poets who have loved and followed me up to now have, like me, been frenzied makers of images and courageous explorers of analogies. But your strict nets of metaphor are too disgracefully weighed down by the plumb line of logic. I advise you to lighten them,

in order that your immensified gesture may speed them farther, cast them over a vaster ocean.

Together we will invent what I call *the imagination without strings* [*l'immaginazione senza fili*]. Someday we will achieve a yet more essential art, when we dare to suppress all the first terms of our analogies and render no more than an uninterrupted sequence of second terms. To achieve this we must renounce being understood. It is not necessary to be understood. Moreover we did without it when we were expressing fragments of the Futurist sensibility by means of traditional and intellective syntax.

Syntax was a kind of abstract cipher that poets used to inform the crowd about the color, musicality, plasticity, and architecture of the universe. Syntax was a kind of interpreter or monotonous cicerone. This intermediary must be suppressed, in order that literature may enter directly into the universe and become one body with it.

They shout at us, "Your literature won't be beautiful! Where is your verbal symphony, your harmonious swaying back and forth, your tranquilizing cadences?" Their loss we take for granted! And how lucky! We make use, instead, of every ugly sound, every expressive cry from the violent life that surrounds us. We bravely create the "ugly" in literature, and everywhere we murder solemnity. Come! Don't put on these grand priestly airs when you listen to me! Each day we must spit on the *Altar of Art*. We are entering the unbounded domain of free intuition. After free verse, here finally are *words-in-freedom*.

In this there is nothing absolute or systematic. Genius has impetuous gusts and muddy torrents. Sometimes it imposes analytic and explanatory longueurs. No one can suddenly renovate his own sensibility. Dead cells are mixed with the living. Art is a need to destroy and scatter oneself, a great watering can of heroism that drowns the world. Microbes—don't forget—are essential to the health of the intestines and stomach. There is also a microbe essential to the vitality of *art, this extension of the forest of our veins,* that pours out, beyond the body, into the infinity of space and time.

Futurist poets! I have taught you to hate libraries and museums, to prepare you *to hate the intelligence,* reawakening in you divine intuition, the characteristic gift of the Latin races. Through intuition we will conquer the seemingly unconquerable hostility that separates out human flesh from the metal of motors.

Multiplied Man and the Reign of the Machine

From War, the World's Only Hygiene
1911–1915

All this will have prepared you to understand one of our principal Fu-
turist efforts, namely the abolition in literature of the seemingly unchal-
lengeable fusion of the two ideas Woman and Beauty, which has reduced
all of romanticism to a kind of heroic assault leveled by a bellicose
and lyric male against a tower that bristles with enemies who cluster
around the divine Beauty-Woman.

Novels like *The Workers of the Sea* by Victor Hugo or *Salammbô* by
Flaubert can explain my point. It is a matter of a dominant leitmotiv,
tiresome and outworn, of which we want to disembarrass literature and
art in general. Consequently we are developing and proclaiming a great
new idea that runs through modern life: the idea of mechanical beauty.
We therefore exalt love for the machine, that love we notice flaming on
the cheeks of mechanics scorched and smeared with coal. Have you
never seen a mechanic lovingly at work on the great powerful body of
his locomotive? His is the minute, knowing tenderness of a lover ca-
ressing his adored woman.

One can say of the great French railway strike that the organizers
were unable to persuade a single mechanic to sabotage his locomotive.

To me this seems entirely natural. How could one of those men have
been able to wound or kill his great faithful devoted mistress with her
quick and ardent heart? his beautiful steel machine that had so often
glowed with pleasure beneath his ardent caress?

This is no fantasy, but almost a reality that in a few years we will
easily be able to control.

You surely must have heard the remarks that owners of automobiles and factory directors commonly make: motors, they say, are truly mysterious. . . . They seem to have personalities, souls, or wills. They have whims, freakish impulses. You must caress them, treat them respectfully, never mishandle or overtire them. If you behave like this, your machine of fused iron and steel, this motor built to exact specifications, will give you back not only what you put into it, but double or triple, much more and much better than the calculations of its builder—its father!—made provision for.

Very well: I attribute a great revelatory importance to these phrases that tell me of the coming discovery of the laws of a true sensibility of machines!

Hence we must prepare for the imminent, inevitable identification of man with motor, facilitating and perfecting a constant interchange of intuition, rhythm, instinct, and metallic discipline of which the majority are wholly ignorant, which is guessed at by the most lucid spirits.

It is certain that if we grant the truth of Lamarck's transformational hypothesis we must admit that we look for the creation of a nonhuman type in whom moral suffering, goodness of heart, affection, and love, those sole corrosive poisons of inexhaustible vital energy, sole interrupters of our powerful bodily electricity, will be abolished.

We believe in the possibility of an incalculable number of human transformations, and without a smile we declare that wings are asleep in the flesh of man.

On the day when man will be able to externalize his will and make it into a huge invisible arm, Dream and Desire, which are empty words today, will master and reign over space and time.

This nonhuman and mechanical being, constructed for an omnipresent velocity, will be naturally cruel, omniscient, and combative.

He will be endowed with surprising organs: organs adapted to the needs of a world of ceaseless shocks.

From now on we can foresee a bodily development in the form of a prow from the outward swell of the breastbone, which will be the more marked the better an aviator the man of the future becomes.

One sees a similar development precisely among the birds who are the better fliers.

You can easily understand these seemingly paradoxical hypotheses by studying the phenomena of externalized will that continually reveal themselves at spiritualist séances.

Furthermore it is certain, and you can easily verify it, that today you increasingly find ordinary people with no culture or education but nonetheless gifted with what I call the great mechanical divination or the metallic scent.

This is because such workers are already being educated by the machine and are coming into some relationship with motors.

Future man will reduce his heart to its true distributive function. The heart must in some way become a kind of stomach for the brain, which will methodically empty and fill so that the spirit can go into action.

You meet men today who go through life almost without love, in a fine steel-colored atmosphere. Let us act in such a way that the number of these exemplary men may increase. These energetic beings have no sweet mistress to visit in the evening, but each morning they love to check meticulously the perfect working of their factories.

We are also convinced that art and literature exercise a determining influence on all the social classes, even the most ignorant, who drink them in through mysterious infiltrations.

We can therefore speed or retard the movement of humanity toward this form of life freed from sentimentality and lust. In defiance of our skeptical determinism, which we must daily destroy, we believe in the usefulness of an artistic propaganda against the proselytizing conception of the Don Giovanni and his comic sidekick, the cuckold.

When we free ourselves from these two themes we will have been freed from the great morbid phenomenon of jealousy, which is nothing but a product of Don Giovannian vanity.

The immense *Amore* of the romantics is thus reduced solely to the conservation of the species, and friction of the epidermis is finally freed from all provocative mystery, from all appetizing spice, from all Don Giovannian vanity: a simple bodily function, like eating and drinking.

The *multiplied man* we dream of will never know the tragedy of old age!

To this end the young modern male, finally nauseated by erotic books and the double alcohol of lust and sentiment, finally inoculated against the disease of *Amore,* will methodically learn to destroy in himself all the sorrows of the heart, daily lacerating his affections and infinitely distracting his sex with swift, casual contacts with women.

Our frank optimism thus neatly challenges the pessimism of Schopenhauer, the bitter philosopher who so often threatens with the

seductive revolver of his philosophy to destroy our profound nausea for *Amore* with a capital *A*.

It is precisely with this revolver that we gaily shoot down the grand romantic Moonshine.

The New Religion-Morality of Speed

Futurist Manifesto Published in the
First Number of L'Italia Futurista
May 11, 1916

In my First Manifesto (February 20, 1909) I declared: the magnificence of the world has been enriched by a new beauty, *the beauty of speed.* Following dynamic art, the new religion-morality of speed is born this Futurist year from our great liberating war. Christian morality served to develop man's inner life. Today it has lost its reason for existing, because it has been emptied of all divinity.

Christian morality defended the physiological structure of man from the excesses of sensuality. It moderated his instincts and balanced them. The *Futurist morality* will defend man from the decay caused by slowness, by memory, by analysis, by repose and habit. Human energy centupled by speed will master Time and Space.

Man began by despising the isochronal, cadenced rhythm, identical with the rhythm of his own stride, of the great rivers. Man envied the rhythm of torrents, like that of a horse's gallop. Man mastered horse, elephant, and camel to display his divine authority through an increase in speed. He made friends with the most docile animals, captured the rebellious animals, and fed himself with the eatable animals. From space man stole electricity and then the liquid fuels, to make new allies for himself in the motors. Man shaped the metals he had conquered and made flexible with fire, to ally himself with his fuels and electricity. He thereby assembled an army of slaves, dangerous and hostile but sufficiently domesticated to carry him swiftly over the curves of the earth.

Tortuous paths, roads that follow the indolence of streams and wind

along the spines and uneven bellies of mountains, these are the laws of the earth. Never straight lines; always arabesques and zigzags. Speed finally gives to human life one of the characteristics of divinity: *the straight line.*

The opaque Danube under its muddy tunic, its attention turned on its inner life full of fat libidinous fecund fish, runs murmuring between the high implacable banks of its mountains as if within the immense central corridor of the earth, a convent split open by the swift wheels of the constellations. How long will this shuffling stream allow an automobile, barking like a crazy fox terrier, to pass it at top speed? I hope to see the day when the Danube will run in a straight line at 300 kilometers an hour.

One must persecute, lash, torture all those who sin against speed.

Grave guilt of the passéist cities where the sun settles in, slows down, and never moves again. Who can believe that the sun will go away tonight? Nonsense! Impossible! It has been domiciled here. Squares, lakes of stagnant fire. Streets, rivers of lazy fire. No one can pass, for the moment. You can't escape! An inundation of sun. You would need a refrigerated boat or a diving suit of ice to cross that fire. Dig in. A despotism, a police raid of light, about to arrest the rebels in their blazons of coolness and speed. A solar state of siege. Woe to the body that leaves home. A sledgehammer blow on the head. Finished. Solar guillotine over every door. Woe to the thought that leaves its skull. Two, three, four leaden notes will fall on it from the ruined bell tower. In the house, sultrily, a madness of nostalgic flies. A stir of thighs and sweaty memories.

Criminal slowness of Sunday crowds and the Venetian lagoons.

Speed, having as its essence the intuitive synthesis of every force in movement, is naturally *pure.* Slowness, having as its essence the rational analysis of every exhaustion in repose, is naturally *unclean.* After the destruction of the antique good and the antique evil, we create a new good, speed, and a new evil, slowness.

Speed = synthesis of every courage in action. Aggressive and warlike.

Slowness = analysis of every stagnant prudence. Passive and pacifistic.

Speed = scorn of obstacles, desire for the new and unexplored. Modernity, hygiene.

Slowness = arrest, ecstasy, immobile adoration of obstacles, nostalgia for the already seen, idealization of exhaustion and rest, pessimism

about the unexplored. Rancid romanticism of the wild, wandering poet and long-haired, bespectacled dirty philosopher.

If prayer means communication with the divinity, running at high speed is a prayer. Holiness of wheels and rails. One must kneel on the tracks to pray to the divine velocity. One must kneel before the whirling speed of a gyroscope compass: 20,000 revolutions per minute, the highest mechanical speed reached by man. One must snatch from the stars the secret of their stupefying, incomprehensible speed. Then let us join the great celestial battles, vie with the star 1830 Groombridge that flies at 241 km. a second, with Arthur that flies at 413 km. a second. Invisible mathematical artillery. Wars in which the stars, being both missiles and artillery, match their speeds to escape from a greater star or to strike a smaller one. Our male saints are the numberless corpuscles that penetrate our atmosphere at an average velocity of 42,000 meters a second. Our female saints are the light and electromagnetic waves at 3×10^{10} meters a second.

The intoxication of great speeds in cars is nothing but the joy of feeling oneself fused with the only *divinity*. Sportsmen are the first catechumens of this religion. Forthcoming destruction of houses and cities, to make way for great meeting places for cars and planes.

Geometric and Mechanical Splendor and the Numerical Sensibility

March 18, 1914

We are hastening the grotesque funeral of passéist Beauty (romantic, symbolist, and decadent) whose essential elements were memory, nostalgia, the fog of legend produced by remoteness in time, the exotic fascination produced by remoteness in space, the picturesque, the imprecise, rusticity, wild solitude, multicolored disorder, twilight shadows, corrosion, weariness, the soiled traces of the years, the crumbling of ruins, mold, the taste of decay, pessimism, phthisis, suicide, the blandishments of pain, the aesthetics of failure, the adoration of death.

A new beauty is born today from the chaos of the new contradictory sensibilities that we Futurists will substitute for the former beauty, and that I call Geometric and Mechanical Splendor.

Its essential elements are: hygienic forgetfulness, hope, desire, controlled force, speed, light, will power, order, discipline, method; a feeling for the great city; the aggressive optimism that results from the cult of muscles and sport; the imagination without strings, ubiquity, laconism, and the simultaneity that derives from tourism, business, and journalism; the passion for success, the keenest instinct for setting records, the enthusiastic imitation of electricity and the machine; essential concision and synthesis; the happy precision of gears and well-oiled thoughts; the concurrence of energies as they converge into a single victorious trajectory.

My Futurist senses perceived this splendor for the first time on the bridge of a dreadnought. The ship's speed, its trajectories of fire from the height of the quarterdeck in the cool ventilation of warlike proba-

bilities, the strange vitality of orders sent down from the admiral and suddenly become autonomous, human no longer, in the whims, impatiences, and illnesses of steel and copper. All of this radiated geometric and mechanical splendor. I listened to the lyric initiative of electricity flowing through the sheaths of the quadruple turret guns, descending through sheathed pipes to the magazine, drawing the turret guns out to their breeches, out to their final flights. Up sights, aim, lift, fire, automatic recoil, the projectile's very personal path, hit, smash, smell of rotten eggs, mephitic gases, rust, ammonia, and so on. This new drama full of Futurist surprise and geometric splendor is a thousand times more interesting to us than human psychology with its very limited combinations.

Sometimes the great human collectivities, tides of faces and howling arms, can make us feel a slight emotion. To them we prefer the great solidarity of preoccupied motors, arrayed and eager. Nothing is more beautiful than a great humming central electric station that holds the hydraulic pressure of a mountain chain and the electric power of a vast horizon, synthesized in marble distribution panels bristling with dials, keyboards, and shining commutators. These panels are our only models for the writing of poetry. For precursors we have gymnasts and high-wire artists who, in their evolutions, their rests, and the cadences of their musculature, realize the sparkling perfection of precise gears, and the geometric splendor that we want to achieve in poetry with words-in-freedom.

1. We systematically destroy the literary *I* in order to scatter it into the universal vibration and reach the point of expressing the infinitely small and the vibrations of molecules. E.g.: lightning movement of molecules in the hole made by a howitzer (last part of "Fort Cheittam-Tepe" in my *Zang tumb tumb*). Thus the poetry of cosmic forces supplants the poetry of the human.

The traditional narrative proportions (romantic, sentimental, and Christian) are abolished, according to which a battle wound would have a greatly exaggerated importance in respect to the instruments of destruction, the strategic positions, and atmospheric conditions. In my poem *Zang tumb tumb* I describe the shooting of a Bulgarian traitor with a few words-in-freedom, but I prolong a discussion between two Turkish generals about the line of fire and the enemy cannon. In fact I observed in the battery of Suni, at Sidi-Messri, in October, 1911, how the shining, aggressive flight of a cannonball, red hot in the sun and

speeded by fire, makes the sight of flayed and dying human flesh almost negligible.

2. Many times I have demonstrated how the noun, enfeebled by multiple contacts or the weight of Parnassian and decadent adjectives, regains its absolute value and its expressive force when it is denuded and set apart. Among naked nouns I distinguish *the elementary noun* and *the motion-synthesis noun* (or node of nouns). This distinction is not absolute and it comes from almost ungraspable intuitions. According to an elastic and comprehensive analogy, I see every noun as a vehicle or belt set in motion by the verb in the infinitive.

3. Except for needed contrast or a change of rhythm, the different moods and tenses of the verb should be abolished, because they make the verb into a stagecoach's loose wheel adapting itself to rough country roads, but unable to turn swiftly on a smooth road. *The infinitive verb,* on the other hand, *is the very movement of the new lyricism,* having the fluency of a train's wheel or an airplane's propeller.

The different moods and tenses of the verb express a prudent and reassuring pessimism, a clenched, episodic, accidental egotism, a high and low of force and tiredness, of desire and delusion, of pauses, in other words, in the trajectory of hope and will. The infinitive verb expresses optimism itself, the absolute generosity of the folly of Becoming. When I say *to run,* what is that verb's subject? Everyone and everything: that is, the universal irradiation of life that runs and of which we are a conscious particle. E.g.: the finale of *Salone d'albergo* by the free-wordist Folgore. The infinitive is the passion of the *I* that abandons itself to the becoming of *all,* the heroic disinterested continuity of the joy and effort of acting. Infinitive verb = the divinity of action.

4. By means of one or more adjectives isolated between parentheses or set next to words-in-freedom behind a perpendicular line (in clefs) one can give the different atmospheres of the story and the tones that govern it. *These adjective-atmospheres or adjective-tones cannot be substituted for by nouns.* They are intuitive convictions difficult to explain. I nevertheless believe that by isolating, for example, the noun *ferocity* (or putting it in brackets, describing a slaughter), one will create a mental state of ferocity, firmly enclosed within a clean profile. Whereas, if I put between parentheses or brackets the adjective *ferocious,* I make it into an adjective-atmosphere or adjective-tone that will envelop the whole description of the slaughter without arresting the current of the words-in-freedom.

5. Despite the most skillful deformations, the syntactic sentence always contains a scientific and photographic perspective absolutely contrary to the rights of emotion. *With words-in-freedom this photographic perspective is destroyed* and one arrives naturally at the multiform emotional perspective. (E.g.: *Man + mountain + valley* of the free-wordist Boccioni.)

6. Sometimes we make *synoptic tables of lyric values* with our words-in-freedom, which allow us as we read to follow many currents of intertwined or parallel sensations at the same time. These synoptic tables should not be a goal but a means of increasing the expressive force of the lyricism. One must therefore avoid any pictorial preoccupation, taking no satisfaction in a play of lines nor in curious typographic disproportions.

Everything in words-in-freedom that does not contribute toward the expression of the fugitive, mysterious Futurist sensibility with the newest geometric-mechanical splendor must be resolutely banned. The free-wordist Cangiullo, in *Fumatori* [*Smokers*] *II^a*, had the happy thought of rendering the long and monotonous reveries and self-expansion of the boredom-smoke of a long train trip with this *designed analogy:*

TO sMOKE

The words-in-freedom, in this continuous effort to express with the greatest force and profundity, naturally transform themselves into *self-illustrations,* by means of free, expressive orthography and typography, the synoptic tables of lyric values and designed analogies. (E.g.: The military balloon I designed typographically in my *Zang tumb tumb.*) As soon as this greater expression is reached, the words-in-freedom return to their normal flow. The synoptic tables of values are in addition the basis of criticism in words-in-freedom. (E.g.: *Balance 1910–1914* by the free-wordist Carrà.)

7. *Free expressive orthography and typography also serve to express the facial mimicry and the gesticulation of the narrator.*

Thus the words-in-freedom manage to make use of (rendering it completely) that part of communicative exuberance and epidermic geniality that is one of the characteristics of the southern races. This energy of accent, voice, and mimicry that has shown up hitherto only in

moving tenors and brilliant talkers finds its natural expression in the disproportions of typographic characters that reproduce the facial grimaces and the chiseling, sculptural force of gestures. In this way words-in-freedom become the lyric and transfigured prolongation of our animal magnetism.

8. Our growing love for matter, the will to penetrate it and know its vibrations, the physical sympathy that links us to motors, push us to the *use of onomatopoeia.*

Since noise is the result of rubbing or striking rapidly moving solids, liquids, or gases, onomatopoeia, which reproduces noise, is necessarily one of the most dynamic elements of poetry. As such, onomatopoeia can replace the infinitive verb, especially if it is set against one or more other onomatopoeias. (E.g.: the onomatopoeia *tatatata* of the machine guns, set against the *Hoooraaaah* of the Turks at the end of the chapter "Ponte" in my *Zang tumb tumb.*)

The brevity of the onomatopoeias in this case permits the most skillful combination of different rhythms. These would lose a part of their velocity if expressed more abstractly, with greater development, that is, without the help of the onomatopoeias. There are different kinds of onomatopoeias:

a. *Direct, imitative, elementary, realistic onomatopoeia,* which serves to enrich lyricism with brute reality, which keeps it from becoming too abstract or *artistic.* (E.g.: *ratta-tat-tat,* gunfire.) In my "Contraband of War" in *Zang tumb tumb,* the strident onomatopoeia *ssiiiiii* gives the whistle of a towboat on the river Meuse and is followed by the veiled onomatopoeia *ffiiiii ffiiiiii,* echo from the opposite bank. The two onomatopoeias saved me from needing to describe the width of the river, which is defined by the contrast between the two consonants *s* and *f.*

b. *Indirect, complex, and analogical onomatopoeia.* E.g.: in my poem *Dunes* the onomatopoeia *dum-dum-dum-dum* expresses the circling sound of the African sun and the orange weight of the sun, creating a rapport between sensations of weight, heat, color, smell, and noise. Another example: the onomatopoeia *stridionla stridionla stridonlaire* that repeats itself in the first canto of my epic poem *The Conquest of the Stars* forms an analogy between the clashing of great swords and the furious action of the waves, just before a great battle of stormy waters.

c. *Abstract onomatopoeia,* noisy, unconscious expression of the most

complex and mysterious motions of our sensibility. (E.g.: in my poem *Dunes,* the abstract onomatopoeia *rnn rnn rnn* corresponds to no natural or mechanical sound, but expresses a state of mind.)

d. *Psychic onomatopoetic harmony,* that is, the fusion of two or three abstract onomatopoeias.

9. My love of precision and essential brevity has naturally given me a taste for numbers, which live and breathe on the paper like living beings in our new *numerical sensibility.* E.g.: instead of saying, like the ordinary traditional writer, "A vast and deep boom of bells" (an imprecise, hence inefficient, denotation), or else, like an intelligent peasant, "This bell can be heard from such and such a village" (a more precise and efficient denotation), I grasp the force of the reverberation with intuitive precision and determine its extent, saying: "Bell boom breadth 20 square kilometers." In this way I give the whole vibrating horizon and a number of distant beings stretching their ears to the same bell sound. I escape imprecision and dullness, and I take hold of reality with an act of will that subjects and deforms the very vibration of the metal in an original manner.

The mathematical signs $+ - \times$ serve to achieve marvelous syntheses and share, with their abstract simplicity of anonymous gears, in expressing the geometric and mechanical splendor. For example, it would have needed at least an entire page of description to render this vast and complex battle horizon, had I not found this definitive lyric equation: "horizon $=$ sharp bore of the sun $+$ 5 triangular shadows (1 kilometer wide) $+$ 3 lozenges of rosy light $+$ 5 fragments of hills $+$ 30 columns of smoke $+$ 23 flames."

I make use of x to indicate interrogative pauses in my thought. I thereby eliminate the question mark, which too arbitrarily localizes its atmosphere of doubt on a single point of awareness. With the mathematical x, the doubting suspension suddenly spreads itself over the entire agglomeration of words-in-freedom.

Always intuitively, I introduce numbers that have no direct significance or value between the words-in-freedom, but that (addressing themselves phonically and optically to the numerical sensibility) express the various transcendental intensities of matter and the indestructible correspondences of sensibility.

I create true theorems or lyric equations, introducing numbers chosen intuitively and placed in the very middle of a word, with a certain quantity of $+ - \times =$; I give the thicknesses, the relief, the volume of the

thing the words should express. The placement $+ - + - + + \times$ serves to render, for example, the changes and acceleration of an automobile's speed. The placement $+ + + + +$ serves to render the clustering of equal sensations. (E.g.: *fecal odor of dysentery + the honeyed stench of plague sweats + smell of ammonia,* etc., in "Train full of sick soldiers" in my *Zang tumb tumb*).

Thus for the *"ciel antérieur où fleurit la beauté"* of Mallarmé we substitute geometric and mechanical splendor and the numerical sensibility of words-in-freedom.

Electrical War
(A Futurist Vision-Hypothesis)

From War, the World's Only Hygiene
1911–1915

Oh! how I envy the men who will be born into the next century on my beautiful peninsula when it is wholly vivified, shaken, and bridled by the new electric forces!

A haunting vision of the future carries my soul away in delicious gusts. . . .

Look, how down the whole littoral the immense gray-green sea, no longer idle, no longer lazy like a loved, prodigal, and faithless courtesan, finally shows itself mastered, finally functional and productive.

The immense gray-green sea, stupidly adored by the poets, now labors in truth, with all its diligent, raging storms to set in ceaseless motion numberless iron pontoons that energize two million dynamos scattered along the beaches and in a thousand working gulfs.

Through a network of metal cables the double force of the Tyrrennian and Adriatic seas climbs to the crest of the Apennines to concentrate itself in great cages of iron and crystal, mighty accumulators, enormous nervous centers planted here and there along Italy's mountainous spine.

The energy of distant winds, the rebellions of the sea, transformed by man's genius into many millions of Kilowatts, will penetrate every muscle, artery, and nerve of the peninsula, needing no wires, controlled from keyboards with a fertilizing abundance that throbs beneath the fingers of the engineers.

These men live in high-tension rooms where a hundred thousand Volts palpitate between the plate-glass windows. They sit before switch-

boards, with dials to right and left, keyboards, regulators, and commutators, and everywhere the splendid flash of polished levers.

These men have finally won the joy of living between iron walls. They have steel furniture, twenty times lighter and less expensive than ours. They are finally free of wood and its lesson of weakness and debilitating softness, and from fabrics with their rustic ornaments. These men can write in books of nickel no thicker than three centimeters, costing no more than eight francs, and still containing one hundred thousand pages.

Because heat and coolness and ventilation are controlled by swift mechanisms, they finally know the fullness and resistant solidity of their will power. Their flesh, forgetful of the germinating roughness of trees, forces itself to resemble the surrounding steel.

These men launch out in their monoplanes, agile projectiles, to survey the entire irradiating circulation of electricity across the limitless checkerboard of the plains. They visit the centers of secondary activity, polyhedral garages from which motorized plows incessantly leap out to the fields, to till, plow, and irrigate lands and crops, electrically.

Using wireless telephones, from high in their monoplanes they regulate the lightning speed of the seed-scattering trains that two or three times a year cross the lowlands for basic sowing. Every car carries a gigantic steel arm on its roof that sweeps horizontally, throwing the fecundating seed in all directions.

And it is electricity that hastens its sprouting. All the atmospheric electricity hanging over us, all the incalculable electricity of the earth, is finally harnessed. Those numberless lightning rods and those accumulating poles scattered to infinity through rice fields and gardens tickle the turgid bellies of storm clouds and make them drop their stimulating powers, down to the roots of the plants.

The miracle, the great miracle dreamed by the passéist poets, is coming to life around us.

Everywhere the plants grow in abnormal fashion, from the effects of artificial electricity at high tension. Electric irrigation and drainage.

By means of electrolysis and the multiple reactions it sets off, electricity stimulates assimilation everywhere, in vegetal cells, in the nutritive properties of the soil, and directly excites vegetative energy. . . . That is why it shoots up from the earth prodigiously and grows, stretching out branches with lightning speed, trees in clusters, small woods, in vast oases. . . . Great forests, immense woodlands spring up, matting the

mountainsides, higher and higher, obeying our Futurist wills and scourging the cadaverous old face, pitted with tears, of the ancient queen of loves.

In our monoplanes we follow the fantastic growth of the forests toward the moon.

Hurrah! Hurrah for those trains that run so fast down there! Freight trains, because only freight still creeps on the earth. Man, having become airborne, sets his foot there only once in a while!

Finally the earth gives its full yield. Held close in the vast electrical hand of man, it presses out all its rich juices, lovely orange so long promised to our thirst and finally won!

Hunger and poverty disappear. The bitter social question, annihilated. The financial question reduced to a simple matter of accounting. Freedom for all to make money and to coin gleaming coins.

Ended now the need for wearisome and debasing labors. Intelligence finally reigns everywhere. Muscular work ceases to be servile, now having only three goals: hygiene, pleasure, and struggle—no longer needing to strive for his daily bread, man finally conceives the pure idea of the ascensional *record*. His will power and ambition grow immense.

All surpluses are at play in every human spirit. Rivalry strives for the impossible, purifying itself in an atmosphere of danger and speed. Every intelligence grows lucid, every instinct is brought to its greatest splendor, they clash with each other for a surplus of pleasure. Because they easily find enough to eat, men can perfect their lives in numberless antagonistic exertions. An anarchy of perfections.

No vibration of life is lost, no mental energy is wasted.

Electrical energy inexhaustibly obtained from heat or chemical energy.

With the discovery of the wireless telegraph far in the past, the use of dielectrics increases every day. All the laws of electricity in rarefied gases are cataloged. Scientists govern the docile masses of electrons with surprising ease. We already knew the earth to be composed of tiny electrified particles; now it is regulated like an enormous Rumkorff generator. Eyes and other human organs are no longer simple sensory receptors, but true accumulators of electric energy.

The free human intelligence reigns everywhere. Czarism has long ceased to exist. Some anarchists disguised as coffin-bearers solemnly carry into the imperial palace a coffin full of bombs, and the czar is

blown up with all his obstinate medievalism, like the cork in a last bottle of overaged champagne.

Twenty five great powers govern the world, fighting over the markets of a superabundant industrial production. And this is why we finally arrive at the first electric war.

No more of those old explosives! Then we will know what to do with the rebellion of imprisoned gases that throb angrily beneath the atmosphere's heavy knees.

Steel elephants, bristling with shiny trunks pointed at the enemy, advance from two directions on the border between two peoples—enormous pneumatic machines rolling down their tracks.

These monstrous drinkers of air are easily driven by mechanics perched high up, like mahouts, in their glassed-in cabins. Their tiny figures are rounded off by a kind of diving suit that lets them make all the oxygen they need for breathing.

The refined and subtle electrical potential of those men is able to make use of the friendship and force of thunderstorms, to conquer weariness and sleep.

Suddenly the most adroit of the two armies has thinned out its enemy's atmosphere through the violent breathing of its thousand pneumatic machines.

These slip away soon afterward, to right and left along their tracks, making way for locomotives armed with electric batteries. See them, pointed at the border like cannon. Certain men, or rather masters of primordial forces, control the fire of those batteries that shoot great clusters of angry bolts through the gaps of a new sky, unbreathable and empty of all matter.

Can you see them rioting in the blue, those convulsive nodes of thundering serpents? They strangle the numberless chimney pots that the worker cities flourish; they shatter the seaports' open jaws; they cuff the white mountain peaks and sweep clean the bile-colored sea, the howling sea, that falls back and then rises madly to lay waste the maritime cities. Twenty electric explosions in the sky, now a measureless glass chamber pneumatically emptied, have echoed the brave torments of two rival peoples with the fullness and splendor of their frightful interplanetary electric volleys.

Between one battle and another, diseases have been attacked from every side, confined to two or three final hospitals that have become

useless. The sick and weak, crushed, crumbled, pulverized by the vehement wheels of intense civilization. The green beards of provincial back alleys will be shaved clean by the cruel razors of speed. Radiotherapists, their faces protected by india-rubber masks, their bodies encased in coveralls woven of lead, india rubber, and bismuth, will train their spectacles down through leaded windows on the piercing, healing danger of radium.

Ah, when will we finally invent masks and coveralls to protect ourselves from the deadly infection of imbecility, the imbecility that you betray, you who naturally dislike the cruel sincerity of my attacks on Italian *passéism?* You say that everyone should wash his own dirty laundry in private. . . . Nonsense! We are no subtle and delicate-handed washerwomen. Today we make a joyful bonfire of our infected, pestilential laundry on the loftiest peak of human thought.

We spare no one. After having insulted every stranger who adores our Italian past and despises us as singers of serenades, as ciceroni or beggars, we have asked them to admire us as the most gifted race on earth.

Thanks to us, Italy will cease to be the love-room of the cosmopolitan world.

To this end we have undertaken to propagandize courage against the epidemic of cowardice, to create an artificial optimism against chronic pessimism. Our hatred of Austria; our feverish anticipation of war; our desire to strangle Pan-Germanism. This is the corollary of our Futurist theorem! . . . Then silence, imbeciles! We hurl ourselves against you, holding our hearts in our fingers like revolvers, our hearts burdened with hate and courage.

The violent strike of the young gravediggers begins with us. *Basta,* with the tombs! We let the corpses bury themselves, and enter into the great Futurist City that points its mighty battery of smoking factory chimneys against the degrading army of the Dead, marching along the Milky Way.

Tactilism

1924

In January of 1921 I presented to the Parisian intellectual public gathered in the auditorium of the *Théâtre de L'Oeuvre* my tactile tables, the first account of a tactile art that I had thought out, based on the harmonious combination of tactile values. My investigations have intensified between that famous lecture and today.

Before expounding them to my readers, I think it proper to tell them about the origins of this invention of mine.

A tactile sensibility has existed for a long time in literature and plastic art. My great friend Boccioni, the Futurist painter and sculptor, already in 1911 was feeling tactilistically when he created his plastic ensemble *Fusion of a Head and Window,* with materials entirely contrary to each other in weight and tactile value: iron, porcelain, clay, and woman's hair. This plastic complex, he told me, was made to be not only seen, but also touched. One night during the winter of 1917 I was crawling on hands and knees down to my pallet in the darkness of an artillery battery's dugout. Hard as I tried not to, I keep hitting bayonets, mess tins, and the heads of sleeping soldiers. I lay down, but didn't sleep, obsessed with the tactile sensations I'd felt and classified. For the first time that night I thought of a tactile art.

During the summer of 1911, at Antignano, where the Amerigo Vespucci Road curves around as it follows the seacoast, I created the first tactile table.

Red banners were snapping over factories manned by workers.

I was naked in the silky water that was being torn by rocks, by foaming scissors, knives, and razors, among beds of iodine-soaked algae. I was naked in a sea of flexible steel that breathed with a virile, fecund breath. I was drinking from a sea-chalice brimming with genius as far as the rim. With its long searing flames, the sun was vulcanizing my body and welding the keel of my forehead rich in sails.

A peasant girl, who smelt of salt and warm stone, smiled as she looked at my first tactile table. "You're having fun making little boats!" I answered her, "Yes, I'm making a launch that will carry the human spirit to unknown shores."

Still, the difficulties were enormous. I had to begin to educate my tactile sense. By sheer will power I localized the confused phenomena of thought and imagination on the different parts of my body. I observed that healthy bodies can use this education to give precise and surprising results.

On the other hand, diseased sensibilities, which derive their excitability and their apparent perfection from their bodies' very weakness, achieve the great tactile faculty less easily, more haphazardly and unreliably.

Among the different experiences, I found the following three preferable:

1. to wear gloves for several days, during which time the brain will force the condensation into your hands of a desire for different tactile sensations;

2. to swim underwater in the sea, trying to distinguish interwoven currents and different temperatures tactilistically;

3. every night, in complete darkness, to recognize and enumerate every object in your bedroom.

In this way I created the first educational scale of touch, which at the same time is a scale of tactile values for Tactilism, or the Art of Touch.

First scale, flat, with four categories of different touches—First category: certain, abstract, cold touch. Sandpaper. Emery paper.

Second category: colorless, persuasive, reasoning touch. Smooth silk. Shot silk.

Third category: exciting, lukewarm, nostalgic. Velvet. Wool from the Pyrenees. Plain wool. Silk-wool crepe.

Fourth category: almost irritating, warm, willful. Grainy silk. Plaited silk. Spongy material.

Second scale of values—Fifth category: soft, warm, human. Chamois leather. Skin of horse or dog. Human hair and skin. Marabou.

Sixth category: warm, sensual, witty, affectionate. This category has two branches: Rough iron. Light brush bristles. Sponge. Wire bristles. Animal or peach down. Bird down.

After long concentration of my attention on the sensations felt by my hands in stroking these scales of tactile values, I put them brutally aside. Rapidly, in bursts of intuition, I created the first abstract suggestive tactile table, the name of which is *Sudan-Paris*. In its *Sudan* part this table has spongy material, sandpaper, wool, pig's bristle, and wire bristle. (*Crude, greasy, rough, sharp, burning tactile values, that evoke African visions in the mind of the toucher.*)

In the *sea* part, the table has different grades of emery paper. (*Slippery, metallic, cool, elastic, marine tactile values.*)

In the *Paris* part, the table has silk, watered silk, velvet, and large and small feathers. (*Soft, very delicate, warm and cool at once, artificial, civilized.*)

This still-embryonic tactile art is cleanly distinct from the plastic arts. It has nothing in common with painting or sculpture.

As much as possible one must avoid variety of colors in the tactile tables, which would lend itself to plastic impressions. Painters and sculptors, who naturally tend to subordinate tactile values to visual values, would have trouble creating significant tactile tables. Tactilism seems to me especially reserved to young poets, pianists, stenographers, and to every erotic, refined, and powerful temperament.

Tactilism, on the other hand, must avoid not only collaboration with the plastic arts, but also morbid erotomania. Its purpose must be, simply, to achieve tactile harmonies and to contribute indirectly toward the perfection of spiritual communication between human beings, through the epidermis.

The distinction between the five senses is arbitrary. Today one can uncover and catalog many other senses.

Tactilism promotes this discovery.

TOWARD THE DISCOVERY OF NEW SENSES

Imagine the Sun leaving its orbit and forgetting the Earth! Darkness. Men stumbling around. Terror. Then, the birth of a vague sense of

security and adjustment. Precautions of the skin. Life on hands and knees. After having tried to make new artificial lights, men adapt themselves to the shadows. They admire the night-seeing animals. Dilatation of human pupils, which perceive the thin gleams of light mixed in the shadows. Attention accumulates in the optic nerve.

A visual sense is born in the fingertips.

X-ray vision develops, and some people can already see inside their bodies. Others dimly explore the inside of their neighbors' bodies. They all realize that sight, smell, hearing, touch, and taste are modifications of a single keen sense: touch, divided in different ways and localized in different points.

Other localizations take place. For instance: the epigastrium sees. The knees see. The elbows see. All admire the variations in velocity that differentiate light from sound.

I am convinced that Tactilism will render great practical services, by preparing good surgeons with seeing hands and by offering new ways to educate the handicapped.

The Futurist Balla declares that Tactilism will enable everyone to recover the sensations of his past life with freshness and complete surprise, more than he ever could through either music or painting.

Exactly. But I go beyond that.

We are aware of the hypothesis of material essence. This provisional hypothesis considers matter to be a harmony of electronic systems, and through it we have come to deny the distinction between matter and spirit.

When we feel a piece of iron, we say: This is iron; we satisfy ourselves with a word and nothing more. Between iron and hand a conflict of preconscious force-thought-sentiment takes place. Perhaps there is more thought in the fingertips and the iron than in the brain that prides itself on observing the phenomenon.

With Tactilism we propose to penetrate deeper and outside normal scientific method into the true essence of matter.

The Pleasure of Being Booed

From War, the World's Only Hygiene
1911–1915

Among all literary forms, the one that can serve Futurism most effectively is certainly the theater. Therefore we do not want the dramatic art to continue to be what it is today: a mean industrial product subject to the market for cheap popular amusements. We must sweep away all the dirty prejudices that crush authors, actors, and the public.

1. We Futurists, above all, teach authors to *despise the audience* and especially to despise first-night audiences, whose psychology we can synthesize as follows: rivalry of coiffures and toilettes—vanity of the expensive seat, which transmutes itself into intellectual pride—boxes and orchestra seats occupied by rich, mature men with naturally contemptuous brains and very poor digestions, which make any effort of mind impossible.

The audience, varying from month to month, from city to city and from quarter to quarter, subject to political and social events, to the whims of fashion, to deluges of rain, excesses of heat or cold, to the last article read in the afternoon, having to its disgrace no other desire but a peaceful digestion at the theater, can judge, approve, or disapprove nothing in a work of art. The author can force himself to bluff it out, despite his mediocrity, as a shipwrecked man drags himself to the shore. But woe to anyone who lets himself be grasped by those frightened hands, because he will go to the bottom along with the drowning man, to the sound of applause.

2. We especially teach *a horror of the immediate success* that normally crowns dull and mediocre works. The theater pieces that imme-

diately take hold of each member of the audience, with no intermediaries or explanations, are more or less well-made works that lack any novelty or creative intelligence.

3. Authors should have no preoccupation except *an absolute innovative originality*. All the dramatic works built on a cliché or that borrow their conception, plot, or a part of their development from other works of art are wholly contemptible.

4. The *leitmotivs* of *amore* and the adulterous triangle, by now overworked, should be entirely banned from the theater.

Amore and the adulterous triangle on the stage should be reduced to a minor role, accessory and episodic, to the same importance they now have in life itself, thanks to the great achievement of the Futurists.

5. Since the dramatic art, like every art, can have no other purpose than to force the soul of the audience away from base everyday reality and to lift it into a blinding atmosphere of intellectual intoxication, we despise all those works that merely want to make people weep or to move them, by means of the always pitiful spectacle of a mother whose child has died, or of a girl who cannot marry her lover, or other such insipidities. . . .

6. We *despise* in art, and especially in the theater, *every kind of historical reconstruction,* no matter whether it takes its interest from a famous hero or famous heroine (Nero, Julius Caesar, Napoleon, or Francesca da Rimini), or whether it is founded on the appeal of pointlessly sumptuous costumes and scenery.

The modern drama should reflect some part of the great Futurist dream that rises from our daily lives, stimulated by terrestrial, marine, and aerial velocities, dominated by steam and electricity. One must introduce into the theater the sensation of the Machine's dominion, the great shudders that move the crowd, new currents of ideas, and the great discoveries of science that have completely transformed our sensibility and our mentality as men of the twentieth century.

7. The dramatic art ought not to concern itself with psychological photography, but rather to move toward *a synthesis of life in its most typical and most significant lines.*

8. Dramatic art without poetry cannot exist, that is, without intoxication and without synthesis.

Regular prosodic forms should be excluded. The Futurist writer in the theater will therefore employ *free verse:* a mobile orchestration of images and sounds that, passing from the simplest tone, when for ex-

ample a servant must enter or a door must be closed, can slowly rise to the rhythm of the passions, in strophes by turn cadenced or chaotic, to the moment when the victory of a people or the glorious death of an aviator must be announced.

9. One must destroy the obsession for money among writers, because greed for gain has pushed into the theater writers gifted with the mere qualities of a critic or worldly journalist.

10. We want to subordinate the actors completely to the authority of writers, to free them from domination by the audience, a force that fatally moves them to search for easy effects and estranges them from any effort toward interpretation in depth. For this reason we must abolish the grotesque habit of clapping and whistling, a good enough barometer of parliamentary eloquence but certainly not of artistic worth.

11. While waiting for this abolition, we teach authors and actors *the pleasure of being booed.*

Not everything booed is beautiful or new. But everything applauded immediately is certainly no better than the average intelligence and is therefore *something mediocre, dull, regurgitated, or too well digested.*

As I affirm these Futurist convictions for you, I have the joy of knowing that my talent, many times booed by the audiences of France and Italy, will never be buried beneath too heavy applause . . . like some Rostand or other!

The Variety Theater

September 29, 1913

We are deeply disgusted with the contemporary theater (verse, prose, and musical) because it vacillates stupidly between historical reconstruction (pastiche or plagiarism) and photographic reproduction of our daily life; a finicking, slow, analytic, and diluted theater worthy, all in all, of the age of the oil lamp.

Futurism exalts the Variety Theater because:

1. The Variety Theater, born as we are from electricity, is lucky in having no tradition, no masters, no dogma, and it is fed by swift actuality.

2. The Variety Theater is absolutely practical, because it proposes to distract and amuse the public with comic effects, erotic stimulation, or imaginative astonishment.

3. The authors, actors, and technicians of the Variety Theater have only one reason for existing and triumphing: incessantly to invent new elements of astonishment. Hence the absolute impossibility of arresting or repeating oneself, hence an excited competition of brains and muscles to conquer the various records of agility, speed, force, complication, and elegance.

4. The Variety Theater is unique today in its use of the cinema, which enriches it with an incalculable number of visions and otherwise unrealizable spectacles (battles, riots, horse races, automobile and airplane meets, trips, voyages, depths of the city, the countryside, oceans, and skies).

5. The Variety Theater, being a profitable show window for count-less inventive forces, naturally generates what I call "the Futurist mar-velous," produced by modern mechanics. Here are some of the elements of this "marvelous": (a) powerful caricatures; (b) abysses of the ridicu-lous; (c) delicious, impalpable ironies; (d) all-embracing, definitive symbols; (e) cascades of uncontrollable hilarity; (f) profound analo-gies between humanity, the animal, vegetable, and mechanical worlds; (g) flashes of revealing cynicism; (h) plots full of the wit, repartee, and conundrums that aerate the intelligence; (i) the whole gamut of laugh-ter and smiles, to flex the nerves; (j) the whole gamut of stupidity, imbecility, doltishness, and absurdity, insensibly pushing the intelli-gence to the very border of madness; (k) all the new significations of light, sound, noise, and language, with their mysterious and inexpli-cable extensions into the least-explored part of our sensibility; (l) a cumulus of events unfolded at great speed, of stage characters pushed from right to left in two minutes ("and now let's have a look at the Balkans": King Nicholas, Enver-Bey, Daneff, Venizelos, belly-blows and fistfights between Serbs and Bulgars, a *couplet,* and everything van-ishes); (m) instructive, satirical pantomimes; (n) caricatures of suffer-ing and nostalgia, strongly impressed on the sensibility through ges-tures exasperating in their spasmodic, hesitant, weary slowness; grave words made ridiculous by funny gestures, bizarre disguises, mutilated words, ugly faces, pratfalls.

6. Today the Variety Theater is the crucible in which the elements of an emergent new sensibility are seething. Here you find an ironic de-composition of all the worn-out prototypes of the Beautiful, the Grand, the Solemn, the Religious, the Ferocious, the Seductive, and the Terri-fying, and also the abstract elaboration of the new prototypes that will succeed these.

The Variety Theater is thus the synthesis of everything that human-ity has up to now refined in its nerves to divert itself by laughing at material and moral grief; it is also the bubbling fusion of all the laugh-ter, all the smiles, all the mocking grins, all the contortions and grim-aces of future humanity. Here you sample the joy that will shake men for another century, their poetry, painting, philosophy, and the leaps of their architecture.

7. The Variety Theater offers the healthiest of all spectacles in its dynamism of form and color (simultaneous movement of jugglers, bal-lerinas, gymnasts, colorful riding masters, spiral cyclones of dancers

spinning on the points of their feet). In its swift, overpowering dance rhythms the Variety Theater forcibly drags the slowest souls out of their torpor and forces them to run and jump.

8. The Variety Theater is alone in seeking the audience's collaboration. It doesn't remain static like a stupid voyeur, but joins noisily in the action, in the singing, accompanying the orchestra, communicating with the actors in surprising actions and bizarre dialogues. And the actors bicker clownishly with the musicians.

The Variety Theater uses the smoke of cigars and cigarettes to join the atmosphere of the theater to that of the stage. And because the audience cooperates in this way with the actors' fantasy, the action develops simultaneously on the stage, in the boxes, and in the orchestra. It continues to the end of the performance, among the battalions of fans, the honeyed dandies who crowd the stage door to fight over the *star;* double final victory: chic dinner and bed.

9. The Variety Theater is a school of sincerity for man because it exalts his rapacious instincts and snatches every veil from woman, all the phrases, all the sighs, all the romantic sobs that mask and deform her. On the other hand it brings to light all woman's marvelous animal qualities, her grasp, her powers of seduction, her faithlessness, and her resistance.

10. The Variety Theater is a school of heroism in the difficulty of setting records and conquering resistances, and it creates on the stage the strong, sane atmosphere of danger. (E.g., death-diving, "looping the loop" on bicycles, in cars, and on horseback.)

11. The Variety Theater is a school of subtlety, complication, and mental synthesis, in its clowns, magicians, mind readers, brilliant calculators, writers of skits, imitators and parodists, its musical jugglers and eccentric Americans, its fantastic pregnancies that give birth to objects and weird mechanisms.

12. The Variety Theater is the only school that one can recommend to adolescents and to talented young men, because it explains, quickly and incisively, the most abstruse problems and most complicated political events. Example: a year ago at the Folies-Bergère, two dancers were acting out the meandering discussions between Cambon and Kinderlen-Watcher on the question of Morocco and the Congo in a revealing symbolic dance that was equivalent to at least three years' study of foreign affairs. Facing the audience, their arms entwined, glued together, they kept making mutual territorial concessions, jumping back and

forth, to left and right, never separating, neither of them ever losing sight of his goal, which was to become more and more entangled. They gave an impression of extreme courtesy, of skillful, flawlessly diplomatic vacillation, ferocity, diffidence, stubbornness, meticulousness.

Furthermore the Variety Theater luminously explains the governing laws of life:

a) the necessity of complication and varying rhythms;

b) the fatality of the lie and the contradiction (e.g., two-faced English *danseuses:* little shepherd girl and fearful soldier);

c) the omnipotence of a methodical will that modifies human powers;

d) a synthesis of speed + transformations.

13. The Variety Theater systematically disparages ideal love and its romantic obsession that repeats the nostalgic languors of passion to satiety, with the robotlike monotony of a daily profession. It whimsically mechanizes sentiment, disparages and healthily tramples down the compulsion toward carnal possession, lowers lust to the natural function of coitus, deprives it of every mystery, every crippling anxiety, every unhealthy idealism.

Instead, the Variety Theater gives a feeling and a taste for easy, light, and ironic loves. Café-concert performances in the open air on the terraces of casinos offer a most amusing battle between spasmodic moonlight, tormented by infinite desperations, and the electric light that bounces off the fake jewelry, painted flesh, multicolored petticoats, velvets, tinsel, the counterfeit color of lips. Naturally the energetic electric light triumphs and the soft decadent moonlight is defeated.

14. The Variety Theater is naturally antiacademic, primitive, and naïve, hence the more significant for the unexpectedness of its discoveries and the simplicity of its means. (E.g., the systematic tour of the stage that the *chanteuses* make, like caged animals, at the end of every *couplet.*)

15. The Variety Theater destroys the Solemn, the Sacred, the Serious, and the Sublime in Art with a capital *A*. It cooperates in the Futurist destruction of immortal masterworks, plagiarizing them, parodying them, making them look commonplace by stripping them of their solemn apparatus as if they were mere *attractions.* So we unconditionally endorse the performance of *Parsifal* in forty minutes, now in rehearsal in a great London music hall.

16. The Variety Theater destroys all our conceptions of perspective,

proportion, time, and space. (E.g., a little doorway and gate, thirty centimeters high, alone in the middle of the stage, which certain eccentric Americans open and close as they pass and repass, very seriously as if they couldn't do otherwise.)

17. The Variety Theater offers us all the records so far attained: the greatest speed and the finest gymnastics and acrobatics of the Japanese, the greatest muscular frenzy of the Negroes, the greatest development of animal intelligence (horses, elephants, seals, dogs, trained birds), the finest melodic inspiration of the Gulf of Naples and the Russian steppes, the best Parisian wit, the greatest competitive force of different races (boxing and wrestling), the greatest anatomical monstrosity, the greatest female beauty.

18. The conventional theater exalts the inner life, professorial meditation, libraries, museums, monotonous crises of conscience, stupid analyses of feelings, in other words (dirty thing and dirty word), *psychology*, whereas, on the other hand, the Variety Theater exalts action, heroism, life in the open air, dexterity, the authority of instinct and intuition. To psychology it opposes what I call "body-madness" [*fisicofollia*].

19. Finally, the Variety Theater offers to every country (like Italy) that has no great single capital city a brilliant résumé of Paris considered as the one magnetic center of luxury and ultrarefined pleasure.

FUTURISM WANTS TO TRANSFORM THE VARIETY THEATER INTO A THEATER OF AMAZEMENT, RECORD-SETTING, AND BODY-MADNESS.

1. One must completely destroy all logic in Variety Theater performances, exaggerate their luxuriousness in strange ways, multiply contrasts, and make the absurd and the unlifelike complete masters of the stage. (Example: Oblige the *chanteuses* to dye their décolletage, their arms, and especially their hair, in all the colors hitherto neglected as means of seduction. Green hair, violet arms, blue décolletage, orange chignon, etc. Interrupt a song and continue with a revolutionary speech. Spew out a *romanza* of insults and profanity, etc.)

2. Prevent a set of traditions from establishing itself in the Variety Theater. Therefore oppose and abolish the stupid Parisian "Revues," as tedious as Greek tragedy with their *Compère* and *Commère* playing the part of the ancient chorus, their parade of political personalities and events set off by wisecracks in a most irritating logical sequence. The

Variety Theater, in fact, must not be what it unfortunately still is today, nearly always a more or less amusing newspaper.

3. Introduce surprise and the need to move among the spectators of the orchestra, boxes, and balcony. Some random suggestions: spread a powerful glue on some of the seats, so that the male or female spectator will stay glued down and make everyone laugh (the damaged frock coat or toilette will naturally be paid for at the door)—sell the same ticket to ten people: traffic jam, bickering, and wrangling—offer free tickets to gentlemen or ladies who are notoriously unbalanced, irritable, or eccentric and likely to provoke uproars with obscene gestures, pinching women, or other freakishness. Sprinkle the seats with dust to make people itch and sneeze, etc.

4. Systematically prostitute all of classic art on the stage, performing for example all the Greek, French, and Italian tragedies, condensed and comically mixed up, in a single evening—put life into the works of Beethoven, Wagner, Bach, Bellini, Chopin by inserting Neapolitan songs.—put Duse, Sarah Bernhardt, Zacconi, Mayol, and Fregoli side by side on the stage—play a Beethoven symphony backward, beginning with the last note—boil all of Shakespeare down to a single act—do the same with all the most venerated actors—have actors recite *Hernani* tied in sacks up to their necks—soap the floorboards to cause amusing tumbles at the most tragic moments.

5. In every way encourage the *type* of the eccentric American, the impression he gives of exciting grotesquerie, of frightening dynamism; his crude jokes, his enormous brutalities, his trick weskits and pants as deep as a ship's hold out of which, with a thousand other things, will come the great Futurist hilarity that should make the world's face young again.

Because, and don't forget it, we Futurists are YOUNG ARTIL-LERYMEN ON A TOOT, as we proclaimed in our manifesto "Let's Murder the Moonshine," fire + fire + light against moonshine and against old firmaments war every night great cities to blaze with electric signs Immense black face (30 meters high + 150 meters height of the building = 180 meters) open close open close a golden eye 3 meters high SMOKE SMOKE MANOLI SMOKE MANOLI CIGA-RETTES woman in a blouse (50 meters + 120 meters of building = 170 meters) stretch relax a violet rosy lilac blue bust froth of electric light in a champagne glass (30 meters) sizzle evaporate in a mouthful

of darkness electric signs dim die under a dark stiff hand come to life
again continue stretch out in the night the human day's activity courage
+ folly never to die or cease or sleep electric signs = formation and
disaggregation of mineral and vegetable center of the earth circulation
of blood in the ferrous faces of Futurist houses increases, empurples (joy
anger more more still stronger) as soon as the negative pessimist senti-
mental nostalgic shadows besiege the city brilliant revival of streets
that channel a smoky swarm of workers by day two horses (30 meters
tall) rolling golden balls with their hoofs GIOCONDA PURGATIVE
WATERS crisscross of *trrrr trrrrr* Elevated *trrrr trrrrr* overhead
trrrombone whissstle ambulance sirens and firetrucks transformation
of the streets into splendid corridors to guide push logic necessity the
crowd toward trepidation + laughter + music-hall uproar FOLIES-
BERGÈRE EMPIRE CRÈME-ÉCLIPSE tubes of mercury red red red
blue violet huge letter-eels of gold purple diamond fire Futurist de-
fiance to the weepy night the stars' defeat warmth enthusiasm faith
conviction will power penetration of an electric sign into the house
across the street *yellow slaps* for that gouty, dozy bibliophile in slippers
3 mirrors watch him the sign plunges to 3 redgold abysses open close
open close 3-thousand meters deep horror quick go out out hat stick
steps taximeter push shove *zuu zuoeu* here we are dazzle of the prom-
enade solemnity of the panther-cocottes in their comic-opera tropics
fat warm smell of music-hall gaiety = tireless ventilation of the world's
Futurist brain.

The Futurist Synthetic Theater

Filippo Tommaso Marinetti, Emilo Settimelli,
Bruno Corra
Milan
January 11, 1915; February 18, 1915

As we await our much-prayed-for great war, we Futurists carry our violent antineutralist action from city square to university and back again, using our art to prepare the Italian sensibility for the great hour of maximum danger. Italy must be fearless, eager, as swift and elastic as a fencer, as indifferent to blows as a boxer, as impassive at the news of a victory that may have cost fifty thousand dead as at the news of a defeat.

For Italy to learn to make up its mind with lightning speed, to hurl itself into battle, to sustain every undertaking and every possible calamity, books and reviews are unnecessary. They interest and concern only a minority, are more or less tedious, obstructive, and relaxing. They cannot help chilling enthusiasm, aborting impulses, and poisoning with doubt a people at war. War—Futurism intensified—obliges us to march and not to rot [*marciare, non marcire*] in libraries and reading rooms. THEREFORE WE THINK THAT THE ONLY WAY TO INSPIRE ITALY WITH THE WARLIKE SPIRIT TODAY IS THROUGH THE THEATER. In fact 90 percent of Italians go to the theater, whereas only 10 percent read books and reviews. But what is needed is a FUTURIST THEATER, completely opposed to the passéist theater that drags its monotonous, depressing processions around the sleepy Italian stages.

Not to dwell on the historical theater, a sickening genre already abandoned by the passéist public, we condemn the whole contemporary theater because it is too prolix, analytic, pedantically psychological, ex-

planatory, diluted, finicking, static, as full of prohibitions as a police
station, as cut up into cells as a monastery, as moss-grown as an old
abandoned house. In other words it is a pacifistic, neutralist theater, the
antithesis of the fierce, overwhelming, synthesizing velocity of the war.
 Our Futurist theater will be

Synthetic. That is, very brief. To compress into a few minutes, into a
few words and gestures, innumerable situations, sensibilities, ideas, sen-
sations, facts, and symbols.
 The writers who wanted to renew the theater (Ibsen, Maeterlinck,
Andreyev, Claudel, Shaw) never thought of arriving at a true synthesis,
of freeing themselves from a technique that involves prolixity, meticu-
lous analysis, drawn-out preparation. Before the works of these authors,
the audience is in the indignant attitude of a circle of bystanders who
swallow their anguish and pity as they watch the slow agony of a horse
that has collapsed on the pavement. The sigh of applause that finally
breaks out frees the audience's stomach from all the indigestible time it
has swallowed. Each act is as painful as having to wait patiently in an
antichamber for the minister (*coup de théâtre:* kiss, pistol shot, verbal
revelation, etc.) to receive you. All this passéist or semi-Futurist theater,
instead of synthesizing fact and idea in the smallest number of words
and gestures, savagely destroys the variety of place (source of dyna-
mism and amazement), stuffs many city squares, landscapes, streets,
into the sausage of a single room. For this reason this theater is entirely
static.
 We are convinced that mechanically, by force of brevity, we can
achieve an entirely new theater perfectly in tune with our swift and
laconic Futurist sensibility. Our acts can also be moments [*atti—attimi*]
only a few seconds long. With this essential and synthetic brevity the
theater can bear and even overcome competition from the *cinema.*

Atechnical. The passéist theater is the literary form that most distorts
and diminishes an author's talent. This form, much more than lyric
poetry or the novel, is subject to *the demands of technique:* (1) to omit
every notion that doesn't conform to public taste; (2) once a theatrical
idea has been found (expressible in a few pages), to stretch it out over
two, three, or four acts; (3) to surround an interesting character with
many pointless types: coat-holders, door-openers, all sorts of bizarre

comic turns; (4) to make the length of each act vary between half and three-quarters of an hour; (5) to construct each act taking care to (a) begin with seven or eight absolutely useless pages, (b) introduce a tenth of your idea in the first act, five-tenths in the second, four-tenths in the third, (c) shape your acts for rising excitement, each act being no more than a preparation for the finale, (d) always make the first act *a little boring* so that the second can be *amusing* and the third *devouring;* (6) to set off every *essential* line with a hundred or more insignificant *preparatory* lines; (7) never to devote less than a page to explaining an entrance or an exit minutely; (8) to apply systematically to the whole play *the rule of a superficial variety,* to the acts, scenes, and lines. For instance, to make one act a day, another an evening, another deep night; to make one act pathetic, another anguished, another sublime; when you have to prolong a dialogue between two actors, make something happen to interrupt it, a falling vase, a passing mandolin player. . . . Or else have the actors constantly move around from sitting to standing, from right to left, and meanwhile vary the dialogue to make it seem as if a bomb might explode outside at any moment (e.g., the betrayed husband might catch his wife red-handed) when actually nothing is going to explode until the end of the act; (9) to be enormously careful about the *verisimilitude of the plot;* (10) to write your play in such a manner that *the audience understands in the finest detail the how and why of everything that takes place on the stage, above all that it knows by the last act how the protagonists will end up.*

With our synthetist movement in the theater, we want to destroy the Technique that from the Greeks until now, instead of simplifying itself, has become more and more dogmatic, stupid, logical, meticulous, pedantic, strangling. THEREFORE:

1. *It's stupid to write one hundred pages where one would do,* only because the audience through habit and infantile instinct wants to see character in a play result from a series of events, wants to fool itself into thinking that the character really exists in order to admire the beauties of Art, meanwhile refusing to acknowledge any art if the author limits himself to sketching out a few of the character's traits.

2. *It's stupid* not to rebel against the prejudice of theatricality when life itself (which consists *of actions vastly more awkward, uniform, and predictable* than those that unfold in the world of art) is for the most part *antitheatrical* and even in this offers *innumerable possibilities for the stage.* EVERYTHING OF ANY VALUE IS THEATRICAL.

3. *It's stupid* to pander to the primitivism of the crowd, which, in the last analysis, wants to see the bad guy lose and the good guy win.

4. *It's stupid* to worry about verisimilitude (absurd because talent and worth have little to do with it).

5. *It's stupid* to want to explain with logical minuteness everything taking place on the stage, when even in life one never grasps an event entirely in all its causes and consequences, because reality throbs around us, bombards us *with squalls of fragments of interconnected events, mortised and tenoned together, confused, mixed up, chaotic.* E.g., it's stupid to act out a contest between two persons *always* in an orderly, clear, and logical way, since in daily life we nearly always encounter mere *flashes of argument* made *momentary* by our modern experience, in a tram, a café, a railway station, which remain cinematic in our minds like fragmentary dynamic symphonies of gestures, words, lights, and sounds.

6. *It's stupid* to submit to obligatory *crescendi, prepared effects, and postponed climaxes.*

7. *It's stupid* to allow one's talent to be burdened with the weight of a technique that *anyone* (even imbeciles) *can acquire by study, practice, and patience.*

8. It's stupid to renounce the dynamic leap in the void of total creation, beyond the range of territory previously explored.

Dynamic, simultaneous. That is, born of improvisation, lightninglike intuition, from suggestive and revealing actuality. We believe that a thing is valuable to the extent that it is improvised (hours, minutes, seconds), not extensively prepared (months, years, centuries).

We feel an unconquerable repugnance for desk work, a priori, that fails to respect the ambience of the theater itself. The greater number of our works have been written in the theater. The theatrical ambience is our inexhaustible reservoir of inspirations: the magnetic circular sensation invading our tired brains during morning rehearsal in an empty gilded theater; an actor's intonation that suggests the possibility of constructing a cluster of paradoxical thoughts on top of it; a movement of scenery that hints at a symphony of lights; an actress's fleshiness that fills our minds with genially full-bodied notions.

We overran Italy at the head of a heroic battalion of comedians who imposed on audiences *Electricità* and other Futurist syntheses (alive

yesterday, today surpassed and condemned by us) that were revolutions imprisoned in auditoriums—from the Politeama Garibaldi of Palermo to the Dal Verme of Milan. The Italian theaters smoothed the wrinkles in the raging massage of the crowd and rocked with bursts of volcanic laughter. We fraternized with the actors. Then, on sleepless nights in trains, we argued, goading each other to heights of genius to the rhythm of tunnels and stations. Our Futurist theater jeers at Shakespeare but pays attention to the gossip of actors, is put to sleep by a line from Ibsen but is inspired by red or green reflections from the stalls. WE ACHIEVE AN ABSOLUTE DYNAMISM THROUGH THE INTERPENETRATION OF DIFFERENT ATMOSPHERES AND TIMES. E.g., whereas in a drama like *Più che l'amore* [D'Annunzio], the important events (for instance, the murder of the gambling house keeper) don't take place on the stage but are narrated with a complete lack of dynamism; in the first act of *La Figlia di Jorio* [D'Annunzio] the events take place against a simple background with no jumps in space or time; and in the Futurist synthesis, *Simultaneità*, there are two ambiences that interpenetrate and many different times put into action simultaneously.

Autonomous, alogical, unreal. The Futurist theatrical synthesis will not be subject to logic, will pay no attention to photography; it will be *autonomous*, will resemble nothing but itself, although it will take elements from reality and combine them as its whim dictates. Above all, just as the painter and composer discover, scattered through the outside world, a narrower but more intense life, made up of colors, forms, sounds, and noises, the same is true *for the man gifted with theatrical sensibility, for whom a specialized reality exists that violently assaults his nerves:* it consists of what is called THE THEATRICAL WORLD.

THE FUTURIST THEATER IS BORN OF THE TWO MOST VITAL CURRENTS in the Futurist sensibility, defined in the two manifestos "The Variety Theater" and "Weights, Measures, and Prices of Artistic Genius," which are: (1) our frenzied passion for real, swift, elegant, complicated, cynical, muscular, fugitive, Futurist life; (2) our very modern cerebral definition of art according to which no logic, no tradition, no aesthetic, no technique, no opportunity can be imposed on the artist's natural talent; he must be preoccupied only with creating synthetic expressions of cerebral energy that have THE ABSOLUTE VALUE OF NOVELTY.

The *Futurist theater* will be able to excite its audience, that is, make it

forget the monotony of daily life, by sweeping it through *a labyrinth of sensations imprinted on the most exacerbated originality and combined in unpredictable ways.*

Every night the *Futurist theater* will be a gymnasium to train our race's spirit to the swift, dangerous enthusiasms made necessary by this Futurist year.

CONCLUSIONS

1. TOTALLY ABOLISH THE TECHNIQUE THAT IS KILLING THE PASSÉIST THEATER.

2. DRAMATIZE ALL THE DISCOVERIES (no matter how unlikely, weird, and antitheatrical) THAT OUR TALENT IS DISCOVERING IN THE SUBCONSCIOUS, IN ILL-DEFINED FORCES, IN PURE ABSTRACTION, IN THE PURELY CEREBRAL, THE PURELY FANTASTIC, IN RECORD-SETTING AND BODY-MADNESS. (E.g., *Vengono,* F. T. Marinetti's first drama of objects, a new vein of theatrical sensibility discovered by Futurism.)

3. SYMPHONIZE THE AUDIENCE'S SENSIBILITY BY EXPLORING IT, STIRRING UP ITS LAZIEST LAYERS WITH EVERY MEANS POSSIBLE; ELIMINATE THE PRECONCEPTION OF THE FOOTLIGHTS BY THROWING NETS OF SENSATION BETWEEN STAGE AND AUDIENCE; THE STAGE ACTION WILL INVADE THE ORCHESTRA SEATS, THE AUDIENCE.

4. FRATERNIZE WARMLY WITH THE ACTORS WHO ARE AMONG THE FEW THINKERS WHO FLEE FROM EVERY DEFORMING CULTURAL ENTERPRISE.

5. ABOLISH THE FARCE, THE VAUDEVILLE, THE SKETCH, THE COMEDY, THE SERIOUS DRAMA, AND THE TRAGEDY, AND CREATE IN THEIR PLACE THE MANY FORMS OF FUTURIST THEATER, SUCH AS: LINES WRITTEN IN FREE WORDS, SIMULTANEITY, COMPENETRATION, THE SHORT, ACTED-OUT POEM, THE DRAMATIZED SENSATION, COMIC DIALOGUE, THE NEGATIVE ACT, THE REECHOING LINE, "EXTRALOGICAL" DISCUSSION, SYNTHETIC DEFORMATION, THE SCIENTIFIC OUTBURST THAT CLEARS THE AIR.

6. THROUGH UNBROKEN CONTACT, CREATE BETWEEN US AND THE CROWD A CURRENT OF CONFIDENCE RATHER THAN RESPECTFULNESS, IN ORDER TO INSTILL IN OUR AUDIENCES THE DYNAMIC VIVACITY OF A NEW FUTURIST THEATRICALITY.

These are the *first* words on the theater. Our first eleven theatrical syntheses (by Marinetti, Settimelli, Bruno Corra, R. Chiti, Balilla Pratella) were victoriously imposed on crowded theaters in Ancona, Bo-

logna, Padua, Naples, Venice, Verona, Florence, and Rome, by Ettore Berti, Zoncada, and Petrolini. In Milan we shall soon have the great metal building, enlivened by all the electromechanical inventions that alone will permit us to realize our most free conceptions on the stage.

The Futurist Cinema

Filippo Tommaso Marinetti, Bruno Corra,
Emilio Settimelli, Arnaldo Ginna,
Giacomo Balla, Remo Chiti
September 11, 1916

The book, a wholly passéist means of preserving and communicating thought, has for a long time been fated to disappear like cathedrals, towers, crenelated walls, museums, and the pacifist ideal. The book, static companion of the sedentary, the nostalgic, the neutralist, cannot entertain or exalt the new Futurist generations intoxicated with revolutionary and bellicose dynamism.

The conflagration is steadily enlivening the European sensibility. Our great hygienic war, which should satisfy *all* our national aspirations, centuples the renewing power of the Italian race. The Futurist cinema, which we are preparing, a joyful deformation of the universe, an alogical, fleeting synthesis of life in the world, will become the best school for boys: a school of joy, of speed, of force, of courage, and heroism. The Futurist cinema will sharpen, develop the sensibility, will quicken the creative imagination, will give the intelligence a prodigious sense of simultaneity and omnipresence. The Futurist cinema will thus cooperate in the general renewal, taking the place of the literary review (always pedantic) and the drama (always predictable), and killing the book (always tedious and oppressive). The necessities of propaganda will force us to publish a book once in a while. But we prefer to express ourselves through the cinema, through great tables of words-in-freedom and mobile illuminated signs.

With our manifesto "The Futurist Synthetic Theater," with the victorious tours of the theater companies of Gualtiero Tumiati, Ettore Berti, Annibale Ninchi, and Luigi Zoncada, with the two volumes of

Futurist Synthetic Theater containing eighty theatrical syntheses, we have begun the revolution in the Italian prose theater. An earlier Futurist manifesto had rehabilitated, glorified, and perfected the Variety Theater. It is logical therefore for us to carry our vivifying energies into a new theatrical zone: the *cinema*.

At first look the cinema, born only a few years ago, may seem to be Futurist already, lacking a past and free from traditions. Actually, by appearing in the guise of *theater without words,* it has inherited all the most traditional sweepings of the literary theater. Consequently, everything we have said and done about the stage applies to the cinema. Our action is legitimate and necessary insofar as the cinema up to now *has been and tends to remain profoundly passéist,* whereas we see in it the possibility of an eminently Futurist art and *the expressive medium most adapted to the complex sensibility of a Futurist artist.*

Except for interesting films of travel, hunting, wars, etc., the filmmakers have done no more than inflict on us the most backward-looking dramas, great and small. The same scenario whose brevity and variety may make it seem advanced is, in most cases, nothing but the most trite and pious *analysis.* Therefore all the immense *artistic* possibilities of the cinema still rest entirely in the future.

The cinema is an autonomous art. The cinema must therefore never copy the stage. The cinema, being essentially visual, must above all fulfill the evolution of painting, detach itself from reality, from photography, from the graceful and solemn. It must become antigraceful, deforming, impressionistic, synthetic, dynamic, free-wording.

ONE MUST FREE THE CINEMA AS AN EXPRESSIVE MEDIUM in order to make it the ideal instrument *of a new art,* immensely vaster and lighter than all the existing arts. We are convinced that only in this way can one reach that *polyexpressiveness* toward which all the most modern artistic researches are moving. Today the *Futurist cinema* creates precisely the POLYEXPRESSIVE SYMPHONY that just a year ago we announced in our manifesto "Weights, Measures, and Prices of Artistic Genius." The most varied elements will enter into the Futurist film as expressive means: from the slice of life to the streak of color, from the conventional line to words-in-freedom, from chromatic and plastic music to the music of objects. In other words it will be painting, architecture, sculpture, words-in-freedom, music of colors, lines, and forms, a jumble of objects and reality thrown together at random. We shall offer new

inspirations for the researches of painters, which will tend to break out of the limits of the frame. We shall set in motion the words-in-freedom that smash the boundaries of literature as they march toward painting, music, noise-art, and throw a marvelous bridge between the word and the real object.

Our films will be:

1. CINEMATIC ANALOGIES that use reality directly as one of the two elements of the analogy. Example: If we should want to express the anguished state of one of our protagonists, instead of describing it in its various phases of suffering, we would give an equivalent impression with the sight of a jagged and cavernous mountain.

The mountains, seas, woods, cities, crowds, armies, squadrons, airplanes, will often be our formidable expressive words: THE UNIVERSE WILL BE OUR VOCABULARY. Example: We want to give a sensation of strange cheerfulness: we show a chair cover flying comically around an enormous coat stand until they decide to join. We want to give the sensation of anger: we fracture the angry man into a whirlwind of little yellow balls. We want to give the anguish of a hero who has lost his faith and lapsed into a dead neutral skepticism: we show the hero in the act of making an inspired speech to a great crowd; suddenly we bring on Giovanni Giolitti who treasonably stuffs a thick forkful of macaroni into the hero's mouth, drowning his winged words in tomato sauce.

We shall add color to the dialogue by swiftly, simultaneously showing every image that passes through the actors' brains. Example: Representing a man who will say to his woman, "You're as lovely as a gazelle," we shall show the gazelle. Example: If a character says, "I contemplate your fresh and luminous smile as a traveler after a long rough trip contemplates the sea from high on a mountain," we shall show traveler, sea, mountain.

This is how we shall make our characters as understandable *as if they talked*.

2. CINEMATIC POEMS, SPEECHES, AND POETRY. We shall make all of their component images pass across the screen. Example: "Canto dell'Amore" ["Song of Love"] by Giosuè Carducci:

> In their German strongholds perched
> Like falcons meditating the hunt

We shall show the strongholds, the falcons in ambush.

> From the.churches that raise long marble
> arms to heaven, in prayer to God
>
> From the convents between villages and towns
> crouching darkly to the sound of bells
> like cuckoos among far-spaced trees
> singing boredoms and unexpected joys . . .

We shall show churches that little by little are changed into imploring women, God beaming down from on high, the convents, the cuckoos, etc. Example: "Sogno d'Estate" ["Summer's Dream"] by Giosuè Carducci:

> Among your ever-sounding strains of battle, Homer, I am conquered by the warm hour: I bow my head in sleep on Scamander's bank, but my heart flees to the Tyrrhenian Sea.

We shall show Carducci wandering amid the tumult of the Achaians, deftly avoiding the galloping horses, paying his respects to Homer, going for a drink with Ajax to the inn, The Red Scamander, and at the third glass of wine his heart, whose palpitations we ought to see, pops out of his jacket like a huge red balloon and flies over the Gulf of Rapallo. This is how we make films out of the most secret movements of genius.

Thus we shall ridicule the works of the passéist poets, transforming to the great benefit of the public the most nostalgically monotonous, weepy poetry into violent, exciting, and highly exhilarating spectacles.

3. CINEMATIC SIMULTANEITY AND INTERPENETRATION of different times and places. We shall project two or three different visual episodes at the same time, one next to the other.

4. CINEMATIC MUSICAL RESEARCHES (dissonances, harmonies, symphonies of gestures, events, colors, lines, etc.).

5. DRAMATIZED STATES OF MIND ON FILM.

6. DAILY EXERCISES IN FREEING OURSELVES FROM MERE PHOTOGRAPHED LOGIC.

7. FILMED DRAMAS OF OBJECTS. (Objects animated, humanized, baffled, dressed up, impassioned, civilized, dancing—objects removed from their normal surroundings and put into an abnormal state that, by contrast, throws into relief their amazing construction and nonhuman life.)

8. SHOW WINDOWS OF FILMED IDEAS, EVENTS, TYPES, OBJECTS, ETC.

9. CONGRESSES, FLIRTS, FIGHTS AND MARRIAGES OF FUNNY FACES, MIMICRY,

ETC. Example: a big nose that silences a thousand congressional fingers by ringing an ear, while two policemen's mustaches arrest a tooth.

10. FILMED UNREAL RECONSTRUCTIONS OF THE HUMAN BODY.

11. FILMED DRAMAS OF DISPROPORTION (a thirsty man who pulls out a tiny drinking straw that lengthens umbilically as far as a lake and dries it up *instantly*).

12. POTENTIAL DRAMAS AND STRATEGIC PLANS OF FILMED FEELINGS.

13. LINEAR, PLASTIC, CHROMATIC EQUIVALENCES, ETC., of men, women, events, thoughts, music, feelings, weights, smells, noises (with white lines on black we shall show the inner, physical rhythm of a husband who discovers his wife in adultery and chases the lover—rhythm of soul and rhythm of legs).

14. FILMED WORDS-IN-FREEDOM IN MOVEMENT (synoptic tables of lyric values—dramas of humanized or animated letters—orthographic dramas —typographical dramas—geometric dramas—numeric sensibility, etc.).

Painting + sculpture + plastic dynamism + words-in-freedom + composed noises + architecture + synthetic theater = Futurist cinema.

THIS IS HOW WE DECOMPOSE AND RECOMPOSE THE UNIVERSE ACCORDING TO OUR MARVELOUS WHIMS, to centuple the powers of the Italian creative genius and its absolute preeminence in the world.

Some Episodes from the Film *Futurist Life*

I

Projection of the principal innovative affirmations of the manifesto on Futurist cinematography, written and distributed in many thousands of copies by Marinetti, Settimelli, Bruno Corra, A. Ginna, G. Balla.

2

Presentation of the Futurists: Marinetti, Settimelli, B. Corra, Remo Chiti, G. Balla, Arnaldo Ginna.

3

Futurist life:

How a Futurist sleeps—interpreted by Marinetti, Settimelli, Corra, Giulio Spina.

4

Morning gymnastics—fencing, boxing—swordplay between Marinetti and Remo Chiti—discussion in fencing gloves between Marinetti and Ungari.

Futurist breakfast—interpreted by Settimelli, Corra, Marinetti, Venna, Spada, Josia, Remo Chiti. Intervention of symbolic old men.

5

Searches for inspiration—drama of objects. Marinetti and Settimelli approach strangely assorted objects very carefully in order to see them

in new lights. Exploration of herrings, carrots, eggplants. *Finally* to understand these animals and vegetables by placing them completely outside their usual surroundings. For the first time and from every point of view, an entire rubber ball is seen as it falls on the head of a statue and remains there, not in the hands of a playful boy. Interpreted by Settimelli, Chiti, Bruno Corra.

Futurist declamation.

Settimelli declaims. Ungari expresses his sensations by gesture, Chiti his by drawing.

Discussion between a foot, a hammer, and an umbrella—extraction of human expressions from objects to project oneself into new realms of artistic expression.

6

Futurist stroll. Study of new ways of walking—caricature of the *neutralist walk,* interpreted by Marinetti and Balla.

Interventionist walk sketched out by Marinetti—creditor's walk, sketched by Balla—debtor's walk, sketched by Settimelli.

Futurist march interpreted by Marinetti, Settimelli, Balla, Chiti, etc.

7

Futurist tea party—invasion of a passéist tea party—conquest of the women—Marinetti declaims amid their enthusiasm.

8

*Futurist work—paintings ideally and outwardly deformed—*Balla falls in love with and marries a settee, and a footstool is born—interpreted by Marinetti, Balla, and Settimelli.

Manifesto of the Futurist Dance

July 8, 1917

Once the glorious Italian ballet was dead and buried, there began in Europe stylizations of savage dances, elegant versions of exotic dances, modernizations of ancient dances. Parisian red pepper + panache + shield + lance + ecstasy in front of idols that have lost all meaning + undulations of Montmartre thighs = an erotic passéist anachronism for foreigners. . . .

With Nijinsky the pure geometry of the dance, free of mimicry and without sexual stimulation, appears for the first time.

Isadora Duncan creates the free dance, with no preparatory mime, that ignores musculature and eurythmy in order to devote everything to emotional expression, to the aerial ardor of its steps. But fundamentally she merely proposes to intensify, enrich, and modulate in a hundred different ways the rhythm of a woman's body that languidly rejects, languidly invokes, languidly accepts, and languidly regrets the masculine giver of erotic happiness.

Isadora Duncan, whom I often had the pleasure of admiring in her free improvisations among the veils of mother-of-pearl smoke of her atelier, used to dance freely, thoughtlessly, as if talking, desiring, loving, weeping, to any sort of little tune no matter how vulgar, like "Mariette, ma petite Mariette" strummed on a piano. But she never managed to project anything but the most complex feelings of desperate nostalgia, of spasmodic sensuality and cheerfulness, childishly feminine.

There are many points of contact between Isadora's art and pictorial

Impressionism, as there are between Nijinsky's art and Cézanne's constructions of volumes and forms.

So, naturally, under the influence of the Cubist researches and of Picasso especially, a dance of geometrized volumes was created, almost independent of the music. Dance became an autonomous art, the music's equal. Dance no longer submitted to the music, it replaced it.

Valentine de Saint-Pont conceived an abstract, metaphysical dance that was supposed to embody pure thought without sentimentality or sexual excitement. Her *métachorie* consists of mimed and danced poetry. Unfortunately it is passéist poetry that navigates within the old Greek and medieval sensibility: abstractions danced but static, arid, cold, emotionless. Why deprive oneself of the vivifying element of mime? Why put on a Merovingian helmet and veil one's eyes?

In a much more modern spirit Dalcroze has created a very interesting *rhythmic gymnastics,* which nevertheless limits its effects to muscular hygiene and the description of the work of the fields.

We Futurists prefer Louie Fuller and the "cakewalk" of the Negroes (utilization of electric light and mechanisms).

One must go beyond muscular possibilities and aim in the dance for that ideal *multiplied body* of the motor that we have so long dreamed of. One must imitate the movements of machines with gestures; pay assiduous court to steering wheels, ordinary wheels, pistons, thereby preparing the fusion of man with the machine, to achieve the metallicity of the Futurist dance.

Music is fundamentally and incurably passéist, hence hard to employ in the Futurist dance. Noise, being the result of the rubbing together or the collision of solids, liquids, or gases in fast motion, has become by means of onomatopoeia one of the most dynamic elements of Futurist poetry. Noise is the language of the new human-mechanical life. The Futurist dance will therefore be accompanied by *organized noises* and by the orchestra of special effects [*intonarumori*] invented by Luigi Russolo.

In this Futurist epoch of ours, when more than twenty million men form with their battle lines a fantastic Milky Way of exploding shrapnel stars that bind the earth together; when the Machine and the Great Explosives, cooperating with the war, have centupled the force of the races, obliging them to give all they have of boldness, instinct, and muscular resistance, the Futurist dance can have no other purpose than to

immensify heroism, master of metals, and to fuse with the divine machines of speed and war.

I therefore extract the first three Futurist dances from the three mechanisms of war: shrapnel, the machine gun, and the airplane.

DANCE OF THE SHRAPNEL

Part One I want to give the fusion of the mountain with the parabola of the shrapnel. The fusion of the carnal human song with the mechanical noise of shrapnel. To give the ideal synthesis of the war: a mountain soldier who carelessly sings beneath an uninterrupted vault of shrapnel.

Movement 1: With the feet mark the *boom-boom* of the projectile coming from the cannon's mouth.

Movement 2: With arms spread apart describe at moderate speed the long whistling parabola of the shrapnel as it passes over the soldier's head and explodes too high or behind him. The danseuse will hold up a sign printed in blue: *Short to the right.*

Movement 3: With the hands (wearing very long silver thimbles) raised and open, as high as possible, give the proud, blessed, silvery explosion of the shrapnel in its *paaaak.* The danseuse will hold up a sign printed in blue: *Long to the left.* Then she will hold up another printed in silver: *Don't slip on the ice. Synovitis.*

Movement 4: With the whole body vibrating, the hips weaving, and the arms making swimming motions, give the waves and flux and reflux and concentric or eccentric motions of echoes in ravines, in open fields and up the slopes of mountains. The danseuse will hold up a sign printed in black: *Water duty;* another in black: *Mess duty;* still another in black: *The mules, the mail.*

Movement 5: With little leaping handclaps and a pose of ecstatic suspension, express the indifferent and always idyllic calm of nature and the *cheep-cheep-cheep* of the birds. The danseuse will hold up a sign printed in disordered letters: *300 meters to camp.* Then another in red: *15 degrees below zero. 800 meters red ferocious suave.*

Part Two

Movement 6: The slow, casual, thoughtless gait of the mountain soldiers who march under successive furious parabolas of shrapnel. The

danseuse will light a cigarette while hidden voices sing one of the many war songs:

> *il comandante del sesto alpini*
> *incomincia a* sbombardar. . . .
> [the commander of the Sixth Alpines
> begins the *bombardment*. . . .]

Movement 7: The undulation with which the danseuse continues to express the war song will be interrupted by Movement 2 (whistling parabola of shrapnel).

Movement 8: The undulation with which the danseuse continues to express the war song will be interrupted by Movement 3 (explosion of the shrapnel high up).

Movement 9: The undulation will be interrupted by Movement 4 (waves of echoes).

Movement 10: The undulation will be interrupted by Movement 5 (*cheep-cheep-cheep* of the birds in the placidity of nature).

DANCE OF THE MACHINE GUN

I want to give the Italian carnality of the shout *Savoia!* that rips itself apart and dies heroically in shreds against the mechanical geometrical inexorable rolling-mill of the machine-gun fire.

Movement 1: With the feet (arms stretched forward), give the mechanical hammering of the machine gun *tap-tap-tap-tap-tap*. The danseuse will show in a rapid gesture a sign printed in red: *Enemy at 700 meters.*

Movement 2: With the hands rounded like cups (one full of white roses, the other full of red roses), imitate fire as it pours steadily and violently out of the machine-gun barrels. The danseuse will have a large white orchid between her lips and will have a sign printed in red: *Enemy at 500 meters.*

Movement 3: With arms wide open describe the circling, sprinkling fan of projectiles.

Movement 4: Slow turn of the body, while the feet hammer on the wooden floor.

Movement 5: Accompany with violent forward thrusts of the body the cry *Savoiaaaaa!*

Movement 6: The danseuse, on hands and knees, will imitate the

form of a machine gun, silver-black under its ribbon-belt of cartridges. Stretching her arms forward, she will feverishly shake the white and red orchid like a gun barrel in the act of firing.

DANCE OF THE AVIATRIX

The danseuse will dance on top of a large, violently colored geographical map (four meters square) on which will be drawn in large, highly visible characters the mountains, woods, rivers, geometries of the countryside, the great traffic centers of the cities, the sea.

The danseuse must form a continual palpitation of blue veils. On her chest, like a flower, a large celluloid propeller that because of its very nature will vibrate with every bodily movement. Her face dead white under a white hat shaped like a monoplane.

Movement 1: Lying on her stomach on the carpet-map, the danseuse will simulate with jerks and weavings of her body the successive efforts of a plane trying to take off. Then she will come forward on hands and knees and suddenly jump to her feet, her arms wide, her body straight but shivering all over.

Movement 2: The danseuse, still straight, will shake a sign printed in red: *300 meters—3 spins—climb*. Then, right away, a second sign: *600 meters—avoid mountain*.

Movement 3: The danseuse will heap up a lot of green cloth to simulate a green mountain, then will leap over it. She will reappear immediately, arms open, all vibrant.

Movement 4: The danseuse, all vibrant, will wave in front of herself a great gilded cardboard sun and will run a very fast circle, pretending to follow it (frenzied, mechanical).

Movement 5: With *organized noises* imitate the rain and the sighing of the wind and, with continual interruptions of the electric light, imitate the lightning flashes. Meanwhile the danseuse will raise up a frame covered with red vellum paper in the form of a sunset cloud and will break through it in a graceful leap (grand and slow melancholy waves of sound).

Movement 6: The danseuse will wave in front of herself another frame covered with dark-blue vellum paper, in the form and color of a starry night. She will step across it, breaking through. Then she will scatter golden stars on the ground around her (gay ironic thoughtless).

Dynamic and Synoptic Declamation

March 11, 1916

‎While we await the honor-pleasure of our return to the front, we Futurists are renewing, accelerating, and virilizing the genius of our race.

Our activity steadily expands. A great Futurist show of Balla at Rome. Boccioni's lecture on Futurist painting at the Istituto di Belle Arti of Naples. Boccioni's manifesto on the southern painters. A lecture by Boccioni on Futurist painting at Mantua. A lecture-declamation on words-in-freedom by Marinetti, Cangiullo, Janelli, and Bruno Corra at the Istituto di Belle Arti of Naples. The Futurist pages on the Art of Noises and the *Intonarumori* of Luigi Russolo and Ugo Piatti in Casa Marinetti.

I offered the politicians the only solution to their financial problem: a gradual, canny sale of our artistic patrimony in order to multiply a hundredfold Italy's military, industrial, commercial, and agricultural power, and to smash Austria forever, our eternally hated enemy.

Yesterday Settimelli, Bruno Corra, Remo Chiti, Francesco Cangiullo, Boccioni, and I excited the Florentine public to war, by means of our violently patriotic, antineutral and anti-German synthetic theater. Today I want to liberate intellectual circles from the old, static, pacifist, and nostalgic declamation and to create a new, dynamic, synoptic, and warlike declamation.

My indisputable world primacy as a declaimer of free verse and words-in-freedom has equipped me to notice the deficiencies of declamation as it has been understood up to now. This passéist declamation,

even when supported by the most marvelous vocal organs and the strongest temperaments, always comes down to an inevitable monotony of highs and lows, to a ragbag of gestures that repeatedly swamp the stony imbecility of lecture audiences in boredom.

For too long now I have amused myself with seducing and moving them better and more reliably than all the other declaimers of Europe, insinuating into their obtuse brains the most astonishing images, caressing them with the most refined vocal sensations, with velvety softnesses and brutalities until, mastered by my look or entranced by my smile, they feel a feminine need to applaud something they neither understand nor love.

I have had enough experience of the femininity of crowds and the weakness of their collective virginity in the course of forcing Futurist free verse upon them. The most accomplished tricks of facial mimicry combined with gestures served admirably for the early forms of Futurist lyricism; in its employment of every symbolist and decadent tendency, this was, in its way, a very complete, convulsive humanization of the universe.

What characterizes the passéist declaimer is the immobility of his legs, while the excessive agitation of the upper part of his body makes him look like a puppet in a Punch and Judy show, worked from under the stage by the puppeteer.

In the new Futurist lyricism, an expression of geometrical splendor, our literary *I* consumes and obliterates itself in the grand cosmic vibration, so that the declaimer himself must also somehow disappear in the dynamic and synoptic manifestation of words-in-freedom.

The Futurist declaimer must declaim as much with his legs as with his arms. This lyric sport will oblige poets to be less lachrymose, more active, more optimistic.

The declaimer's hands should wield his different noise-making instruments. No longer will we see them flapping spasmodically around in the audience's turbid brain. No longer will we have those orchestra-conductor gesticulations shaping phrases, or the gesticulations of the courthouse, more or less decorative, or those of a languid prostitute over her lover's weary body. Caressing or lace-making hands, supplicating hands, nostalgic and sentimental hands: all these will disappear in the declaimer's dynamic totality.

Therefore the Futurist declaimer must:

1. Dress anonymously (a smoking jacket in the evening if possible), and avoid every form of dress that suggests some special ambience. No flower in the buttonhole, no gloves.

2. Completely dehumanize his voice, systematically doing away with every modulation or nuance.

3. Completely dehumanize his face, avoiding every facial expression and trick of the eyes.

4. Metallize, liquefy, vegetalize, petrify, and electrify his voice, grounding it in the vibrations of matter itself as expressed by words-in-freedom.

5. Gesticulate geometrically, thereby giving his arms the sharp rigidity of semaphore signals and lighthouse rays, to indicate the direction of forces, or of pistons and wheels, to express the dynamism of words-in-freedom.

6. Gesticulate in a draughtsmanlike, topographical manner, synthetically creating in midair cubes, cones, spirals, ellipses, etc.

7. Make use of a certain number of elementary instruments such as hammers, little wooden tables, automobile horns, drums, tambourines, saws, and electric bells, to produce precisely and effortlessly the different simple or abstract onomatopoeias and different onomatopoetic harmonies.

These different instruments, in certain orchestral groupings of words-in-freedom, could function orchestrally, each handled by its own executor.

8. Make use of other declaimers, equal or subordinate, mixing or alternating their voices with his.

9. Move to different parts of the room, running with greater or lesser speed or walking slowly, thus making his own body's movement collaborate in the scattering of words-in-freedom. Each part of the poem will thus have a special light [luce] of its own, and the audience, though magnetized as it follows the figure of the declaimer, will nevertheless not statically submit itself to the lyric force but will, as it turns toward different parts of the room, compete with the dynamism of the Futurist poetry.

10. Complete his declamation with two, three, or four blackboards placed in different parts of the room, on which he should rapidly draw theorems, equations, and synoptic tables of lyric values.

11. Must in his declamation be a tireless creator and inventor:

a. Deciding instinctively, at every moment, the point at which the

adjective-tone and the adjective-atmosphere should be accentuated and repeated. Since words-in-freedom contain no precise indications, he must follow his own nose in this respect, taking care to achieve the highest geometrical splendor and the greatest numerical sensibility. In this way he will collaborate with the author, precipitating new laws and creating unexpected new horizons in the words-in-freedom that he interprets.

b. Clarifying and explaining, as coldly as an engineer or mechanic, the synoptic tables and equations of lyric values, which form zones of luminous, almost geographic clarity (between the most obscure and most complex parts of the words-in-freedom) as momentary concessions to the reader's understanding.

c. In all ways imitating motors and their rhythms (without worrying about understanding) while declaiming these more obscure and complex parts, and especially all the onomatopoetic harmonies.

The *First Dynamic and Synoptic Declamation* took place on March 29, 1914, in the hall of the permanent Futurist Exposition in Rome, Via del Tritone 125.

PIEDIGROTTA

WORDS-IN-FREEDOM by the free-wording Futurist
FRANCESCO CANGIULLO

declaimed by { MARINETTI
CANGIULLO

with the assistance of

the very famous dwarf artists {
Miss TOFA (Sprovieri)
Mr. PUTIPÙ (Balla)
Mr. TRICCABBALLACCHE (Radiante)
Mr. SCETAVAIASSE (Depero)
Mr. FISCHIATORE (Sironi)

who will appear in their patented
onomatopoetic creations

FINAL CHORUS OF 6 VOICES

Before the performance MARINETTI will explain the artistic value of the onomatopoetic artists

Messieurs TOFA—PUTIPÙ
 TRICCABBALLACCHE
 SCETAVAIASSE

I began by explaining to the audience the artistic and symbolic value
of the different onomatopoetic instruments. In the *Tofa,* a large seashell
on which Neapolitan street boys blow and make a dark-blue, tragi-
comic melopoeia, I discovered a ferocious satire on mythology and all
the sirens, tritons, and seashells that populate the passéist Gulf of
Naples.

The *putipù* (orange-colored noise), also known as the *caccavella* or
pernacchiatore, a little bundle of tin or terracotta covered with leather
into which a reed is fitted that vibrates comically when stroked by a wet
hand; it is a violent irony with which a young and sane race corrects
and combats all the nostalgic poisons of Moonshine.

The *scetavaiasse* (red and green noise), whose bow is a wooden saw,
covered with little bells and pieces of tin, is the genial parody of the
violin in its expression of the inner life and sentimental anguish. It
makes lively fun of musical virtuosity, Paganini, Kubelik, the angelic
viola players of Benozzo Gozzoli, classical music, the halls of the Con-
servatory, full of boredom and enervating gloom.

The *triccabballacche* (red noise) is a sort of lyre whose strings are
very thin strips of wood ending in square wooden hammers. You play
it like the cymbals, opening and closing your raised hands, which grasp
the frame. It is a satire on the Greco-Roman sacred processions and
cithara-players who fill the friezes of passéist architecture.

Then, dynamically, I declaimed *Piedigrotta,* marvelous, overwhelm-
ing words-in-freedom sprung from the most original, exhilarating gen-
ius of Francesco Cangiullo, great free-wording Futurist, the first writer
of Naples and first humorist of Italy. Every so often the author leapt to
the piano, in alternation with my declaiming of his words-in-freedom.
The room was lit by red lamps that doubled the dynamism of the Piedi-
grottesque backdrop painted by Balla. The audience greeted the appear-
ance of the procession of dwarfs with frenzied applause, this troupe who
bristled with fantastic hairdos of vellum paper and who circled around
me as I declaimed.

The varicolored vessel that the painter Balla wore on his head was
much admired. Conspicuous in a corner was the bile-green still life of
three Crocean philosophers, a tasty funereal dissonance in the ultradry

atmosphere of Futurism. Those who believe in a joyful, optimistic, divinely careless art captivate the indecisive ones. The audience accompanied with voice and gesture the marvelous uproar that burst out every so often during my declamation, a great and most effective success in its fusion with the onomatopoetic instruments.

The second dynamic and synoptic declamation was performed by me in London on April 28, 1914, in the Doré Gallery.

Dynamically and synoptically I declaimed several passages from my *Zang tumb tumb* (the *Siege of Adrianople*). On the table in front of me I had a telephone, some boards, and matching hammers that permitted me to imitate the Turkish general's orders and the sounds of artillery and machine-gun fire.

Blackboards had been set up in three parts of the hall, to which in succession I either ran or walked, to sketch rapidly an analogy with chalk. My listeners, as they turned to follow me in all my evolutions, participated, their entire bodies inflamed with emotion, in the violent effects of the battle described by my words-in-freedom.

There were two big drums in a distant room, from which the painter Nevinson, my colleague, produced the boom of cannon, when I told him to do so over the telephone.

The swelling interest of the English audience became frantic enthusiasm when I achieved the greatest dynamism by alternating the Bulgarian song "Sciumi Maritza" with the dazzle of my images and the clamor of the onomatopoetic artillery.

Beyond Communism

1920

We Italian Futurists have amputated all the ideologies and everywhere imposed our new conception of life, our formulas for spiritual health, our aesthetic and social dynamism, the sincere expression of our creative and revolutionary Italian temperaments.

After having struggled for ten years to rejuvenate Italy, after having dismantled the ultrapasséist Austro-Hungarian Empire at Vittorio Veneto, we were put in jail, accused of criminal assault on the security of the state, in reality of the guilt of being Italian Futurists.

We are more inflamed than ever, tireless and rich in ideas. We have been prodigal of ideas and will continue to be so. We are therefore in no mood to take directions from anyone, nor, as creative Italians, to copy the Russian Lenin, disciple of the German Marx.

Humanity is marching toward anarchic individualism, the dream and vocation of every powerful nature. Communism, on the other hand, is an old mediocritist formula, currently being refurbished by war-weariness and fear and transmuted into an intellectual fashion.

Communism is the exasperation of the bureaucratic cancer that has always wasted humanity. A German cancer, a product of the characteristic German preparationism. Every pedantic preparation is antihuman and wearies fortune. History, life, and the earth belong to the improvisers. We hate military barracks as much as we hate Communist barracks. The anarchist genius derides and bursts the Communist prison.

For us, the fatherland represents the greatest expansion of individual generosity, overflowing in every direction on all similar human beings who sympathize or are sympathetic. It represents the broadest concrete solidarity of spiritual, agricultural, fluvial, commercial, and industrial interests tied together by a single geographical configuration, by the same mixture of climates and the same coloration of horizons.

In its circular expansion, the heart of man bursts the little suffocating family circle and finally reaches the extreme limits of the fatherland, where it feels the heartbeats of its fellow nationals as if they were the outermost nerves of its body. The idea of the fatherland cancels the idea of the family. The idea of the fatherland is generous, heroic, dynamic, Futurist, while the idea of the family is stingy, fearful, static, conservative, passéist. For the first time a strong idea of *patria* springs today from our Futurist conception. Up to now it has been a confused mishmash of small-townishness, Greco-Roman rhetoric, commemorative rhetoric, unconscious heroic instinct, praise for dead heroes, distrust of the living, and fear of war.

But Futurist patriotism is an eager passion, for the becoming-progress-revolution of the race.

As the greatest affective force of the individual, Futurist patriotism, while remaining disinterested, becomes the most favorable atmosphere for the continuity and development of the race.

The affective circle of our Italian heart expands and embraces the fatherland, that is, the greatest maneuverable mass of ideals, interests, and private and common needs fraternally linked together.

The fatherland is the greatest extension of the individual, or better: the largest individual capable of living at length, of directing, mastering, and defending every part of its body.

The fatherland is the psychic and geographical awareness of the power for individual betterment.

You cannot abolish the idea of the fatherland unless you take refuge in an absentist egotism. For example, to say: I'm not Italian, I'm a citizen of the world, is equal to saying: Damn Italy, Europe, Humanity, I'll think of myself.

The concept of the fatherland is as indestructible as the concept of party.

The fatherland is nothing but a vast party.

To deny the fatherland is the same as to isolate, castrate, shrink, denigrate, or kill yourself.

The workers who today are marching and waving red banners demonstrate after four years of victorious war an obscure need of their own to wage a little heroic and glorious war.

It's absurd to sabotage our victory with the cry "Long live Lenin, down with war," because Lenin, after having pushed the Russians into renouncing one war, forced another war on them against Kolchak, Denikin, and the Poles.

Russian Bolshevism thereby involuntarily creates Russian patriotism, which is born of the need for a defensive war.

You cannot escape these two idea-feelings: *patriotism*, or the active development of the individual and race, and *heroism*, or the synthetic need to transcend human powers, the ascensional force of the race.

All those who are tired of the stormy-dynamic variety of life dream of the fixed, restful uniformity promised by Communism. They want a life without surprises, the earth as smooth as a billiard ball.

But the pressures of space have not yet leveled the mountains of the earth, and the life that is Art is made up (like every work of art) of points and contrasts.

Human progress, whose essence is increasing velocities, like every velocity admits obstacles to overthrow, that is, revolutionary wars.

The life of insects demonstrates that everything comes down to reproduction at any cost and to purposeless destruction.

Humanity vainly dreams of escaping these two laws that alternately excite and exhaust it. Humanity dreams of stabilizing peace by means of a single type of world man, who should then be immediately castrated lest his aggressive virility declare new wars.

A single human type should live on a perfectly smooth earth. Every mountain defies every Napoleon and Lenin. Every leaf curses the wind's warlike will. . . .

Communism may be realized in cemeteries. But, considering that many people are buried alive, that a man's total death cannot be guaranteed, that sensibilities survive to die later, cemeteries doubtless contain furious gatherings, rebels in jail, and ambitions that want to arise. There will be many attempts at Communism, counterrevolutions that wage war and revolutions that defend themselves with war.

Relative peace can be nothing but the exhaustion of the final war or the final revolution. Perhaps absolute peace will reign when the human race disappears. If I were a Communist, I would concern myself with

the next war between pederasts and Lesbians, who will then unite against normal men.

I would begin propagandizing against the coming interplanetary war.

The more leveling revolutionaries in Russia defend their power against the attacks of less leveling revolutionaries who would like a fresh inequality.

Above all, Bolshevism was a violent, vindictive antidote to czarism.

Now it is belligerently defended by those social doctors who are changing themselves into masters of a sick people. . . .

In every country, particularly in Italy, the distinction between proletariat and bourgeoisie is false. An entirely soiled and moribund bourgeoisie does not exist, nor an entirely sane and vigorous proletariat. Rich and poor exist; poor from bad luck, illness, incapacity, honesty; rich from fraud, cleverness, avarice, ability; exploiters and exploited; stupid and intelligent; false and sincere; so-called rich bourgeois who work much more than the workers; workers who work as little as possible; slow and fast; conquerors and conquered.

"Soiled and moribund bourgeoisie" is an absurd description of that great mass of young, intelligent, and hard-working lower middle class; notaries, lawyers, etc., all sons of the people, all absorbed in working furiously to do better than their fathers.

All of them fought the war as lieutenants and captains, and, tired as they are today, they are ready to take up their lives again with heroism.

They are not intellectuals, but workers endowed with intelligence, foresight, the spirit of will and sacrifice. They constitute the better part of our race. The war was fought by these energetic young men always in command of worker and peasant infantry.

The peasants and workers who fought the war, not having acquired any national awareness, could never have won without the example and intelligence of those *piccoli borghesi,* the heroic lieutenants. It is moreover unquestionable that attempts at Communism are and will always be led by the young, willful, and ambitious lower middle class.

On the other hand it is absurd to characterize all workers with the word *proletariat,* promising equal glory and dictatorship to the peasant infantry who are now resuming their work on the land without tiredness, and to the factory workers who claim to be exhausted.

We must destroy passéism, cowardice, quietism, conservative tradi-
tionalism, materialist egotism, misogyny, the fear of responsibility, and
plagiarist provincialism.

It is provincial plagiarism to cry: *Long Live Lenin; Down with
Italy; Long Live the Russian Revolution!* Cry instead: *Long Live the
Italy of Tomorrow! Long Live the Italian Revolution! Long Live Ital-
ian Futurism!*

The Russian Revolution has its *raison d'être* in Russia and can only
be judged by the Russians. It cannot be imported into Italy.

Innumerable differences separate the Russian from the Italian people,
beyond the typical one separating a conquered from a conquering
people.

Their needs are different and opposite.

A conquered people feels its patriotism dying within it, turns itself
inside out with a revolution, or copies the revolution of a neighboring
people. A conquering people like ours wants to make its own revolu-
tion, just as the pilot of an airplane throws ballast overboard in order to
climb higher.

Let's not forget that the Italian people, notably bristling with sharp
individualisms, is the most anti-Communist and dreams of individualist
anarchy.

Anti-Semitism does not exist in Italy. Therefore we have no Jews to
redeem, validate, or follow.

The Italian people can be compared to an excellent wrestler who
wants to wrestle with no special training and is unequipped with the
means to train. Circumstances force it to win or to disappear. The Ital-
ian people has gloriously won. But the effort was too much for its
muscles, so now, panting, exhausted, almost unable to enjoy its great
victory, it curses us, its trainers, and opens its arms to those who counsel
it not to fight.

Between these partisans of quiet who want to keep our people down
and we who want to cure and raise it up again at any cost, a struggle
has broken out that disgracefully continues over the broken body of the
very wrestler himself.

The huge mess of difficulties, stumbling blocks, sufferings that every
war always leaves behind, the exasperation of all demobilized men
drowning in the immense bog of bureaucracy, the belated energetic

taxation of war profits, all this is crowned by the still-unsolved Adriatic question, the still-unsettled Brenner, etc., etc.

We were governed by an incurable neutralist, who did everything he could to diminish the moral force of our victory.

This government favored the Socialists who, waving the Communist banner of a people conquered like the Russians, took control in the elections of the tired and discontented but victorious Italians.

It is not a matter of a struggle between bourgeoisie and proletariat, but a struggle between those who, like us, have a right to make the Italian revolution and those who should submit to its conception and realization.

I know the Russian people. Six months before the universal conflagration I was invited by the Society for Great Lectures to give eight lectures in Moscow and Saint Petersburg on Futurism. The triumphant ideological repercussion of those lectures and my personal success as a Futurist orator in Russia have remained legendary. I bring this up so that the complete objective fairness of my judgment of the Russian Futurists will be plain. I am delighted to learn that the Russian Futurists are all Bolsheviks and that for a while Futurist art was the official Russian art. On May Day of last year the Russian cities were decorated with Futurist paintings.

Lenin's trains were decorated on the outside with colored dynamic forms very like those of Boccioni, Balla, and Russolo. This does honor to Lenin and cheers us like one of our own victories. All the Futurisms of the world are the children of Italian Futurism, created by us in Milan twelve years ago. All Futurist movements are nevertheless autonomous. Every people had, or still has, its passéism to overthrow. We are not Bolsheviks because we have our own revolution to make. . . .

We want to free Italy from the Papacy, the Monarchy, the Senate, marriage, Parliament. We want a technical government without Parliament, vivified by a council or exciter [*eccitatorio*] of very young men. We want to abolish standing armies, courts, police, and prisons, so that our race of gifted men may be able to develop the greatest number of free, strong, hard-working, innovating, swift men.

All that, in the great affectionate solidarity of our race on our peninsula within the firm circle of boundaries conquered and deserved by our great victory.

We are not only more revolutionary than you, Socialist officials, but we are beyond your revolution.

To your immense system of leveled and intercommunicating stomachs, to your tedious national refectory, we oppose our marvelous anarchic paradise of absolute freedom, art, talent, progress, heroism, fantasy, enthusiasm, gaiety, variety, novelty, speed, record-setting. . . .

Our optimism is great.

The Italian blood shed at Tripoli was better than that shed at Abba Garima. That shed on the Carso, better; that shed on the Piave and at Vittorio Veneto, better.

By means of the schools of physical courage that we propose, we want to increase this vigor of the Italian blood, predisposing it for every audacity and an ever-greater creative artistic capacity, to invent and enjoy spiritually.

One must cure all cowardices and all languors and develop the spiritual elegance of the race, so that the best thing to be found in a tumultuous crowd is the sum of its spiritual elegances: heroic, and generous.

One must increase human capacity to live the ideal life of lines, forms, colors, rhythms, sounds, and noises combined by genius.

If they could relieve the hunger of every stomach, there would always be those who can overcome their lust for refined, privileged dinners.

One must stimulate spiritual hunger and satiate it with a great, joyous, astonishing art.

Art is revolution, improvisation, impetus, enthusiasm, record-setting, elasticity, elegance, generosity, superabundance of goodness, drowning in the Absolute, struggle against every hindrance, an aerial dance on the burning summits of passion, destruction of ruins in the face of holy speed, enclosures to open, hunger and thirst for the sky . . . joyous airplanes gluttonous for infinity. . . .

There are shadowy, flaccid human masses, blind and without light or hope or willpower.

We will tow them after us.

There are souls who struggle without generosity to win a pedestal, a halo, or a position.

These base souls we will convert to a higher spiritual elegance.

Everyone must be given the will to think, create, waken, renovate, and to destroy in themselves the will to submit, conserve, copy.

When the last religions are in their death throes, Art should be the

ideal nutriment that will console and reanimate the most restless races, unsatisfied and deluded by the successive collapse of so many unsatisfying ideal banquets.

Only the inebriating alcohol of Art can finally take the place of and eliminate the tiresome, vulgar, and sanguinary alcohol of the proletariat's Sunday taverns.

Thus, in my tragicomedy *Re Baldoria* [*King Riot*], the artistic innovative dynamism of the Poet-Idiot ridiculed by the mob fuses with the insurrectional dynamism of the libertarian Famone [Big Hunger], to propose to humanity the only solution of the universal problem: Art and the artists to power.

Yes! Power to the artists! The vast proletariat of gifted men will govern.

The most sacrificed, the worthiest of the proletariats. Everyone is tired and disillusioned. The artist does not give in. Soon his genius will explode immense roses of exhilarating artistic power over Italy and the world, purifying and pacifying them.

The proletariat of gifted men in power will create the theater free to all and the great Futurist Aero-Theater. Music will reign over the world. Every town and city square will have its great instrumental and vocal orchestra. So there will be, everywhere, fountains of harmony streaming day and night from musical genius and blooming in the sky, to color, gentle, reinvigorate, and refresh the dark, hard, banal, convulsive rhythm of daily life. Instead of nocturnal work, we will have nocturnal art. Squads of musicians will alternate, to centuple the splendor of the days and the suavity of the nights.

The proletariat of gifted men will alone be able to undertake the wise, gradual, worldwide sale of our artistic patrimony, according to a law conceived by us nine years ago. This small spiritual seed will implant admiration for us in the crudest people of the world.

Sold to the world, our museums will become a dynamic overseas advertisement for the Italian genius.

The proletariat of gifted men, in cooperation with the growth of mechanized industrialism, will arrive at that maximum of salary and that minimum of manual labor which, without lessening production, will be able to give every intelligent person the freedom to think, create, and enjoy the arts.

In every city will be built a Palace or House of Genius for Free Exhibitions of the Creative Intellect.

1. For a month a work of painting, sculpture, any plastic art, architectural drawing, machine designs, or inventor's plans will be shown.

2. A musical work, large or small, orchestral or pianistic or whatever, will be played.

3. Poems, prose works, scientific writings, of every kind, form, or length, will be read, expounded, declaimed.

4. No jury trial or entrance fee will be required for the reading or display of works of any kind or apparent value, no matter how superficially absurd, cretinous, insane, or immoral they seem to be.

The Futurist revolution that will bring the artists to power promises no earthly paradises. It will certainly be unable to suppress the human torment that is the ascensional power of the race. The artists, tireless airmen of this feverish travail, will succeed in reducing suffering.

They will solve the problem of well-being in the only way it can be solved: spiritually.

Art must be an alcohol, not a balm. Not an alcohol that gives forgetfulness, but an alcohol of exalting optimism to deify the young, to centuple maturity and refresh old age.

This intellectual art-alcohol must be extended to everyone. Thus will we multiply the artist-creators. We will have a race almost entirely composed of artists. In Italy we will have a million intuitive diviners, eager to solve the problem of collective human happiness. Such a formidable assault cannot help being victorious. We will solve the social problem artistically.

Meanwhile we suggest the expansion of our people's faculty of dreaming, to educate it in a completely practical direction.

The satisfaction of any need is a pleasure. Every pleasure has a limit.

Dreams begin at the limit of pleasures. We must control the dream and prevent it from becoming nostalgia for the infinite or hatred for the finite. The dream should envelop, bathe, perfect, and idealize pleasure.

Every brain should have its palette and its musical instrument for coloring and lyrically accompanying every small act of life, even the humblest.

The common life is too heavy, austere, monotonous, materialistic, badly ventilated, and, if not strangled, at least clogged up.

As we await the grandiose realization of our Futurist Aero-Theater,

we propose a vast program of daily free concerts in every quarter of the city, cinema theaters, reading rooms, absolutely free books and magazines. We will develop the spiritual life of the people and centuple its faculty of dreams.

Thanks to us, the time will come when life will no longer be a simple matter of bread and labor, nor a life of idleness either, but *a work of art*.

Every man will live his best possible novel. The most gifted spirits will live their best possible poem. There will be no contests of rapacity or prestige. Men will compete in lyric inspiration, originality, musical elegance, surprise, gaiety, spiritual elasticity.

We will have no earthly paradise, but the economic inferno will be lightened and pacified by innumerable festivals of Art.

Portrait of Mussolini

From Marinetti and Futurism, *1929*

With Mussolini I have lived tragic, certainly revealing days. I can limn his typical and exceptional figure.

Mussolini has an exuberant, overwhelming, swift temperament. He is no ideologue. Were he an ideologue he would be held back by ideas that are often slow, or by books that are always dead. Instead he is free, free as the wind.

He was a Socialist and internationalist, but only in theory. Revolutionary yes, but pacifist never. He necessarily had to end up obeying his own kind of patriotism, which I call physiological.

Physiological patriotism, because physically he is built *all'italiana,* designed by inspired and brutal hands, forged, carved to the model of the mighty rocks of our peninsula.

Square crushing jaws. Scornful jutting lips that spit with defiance and swagger on everything slow, pedantic, and finicking. Massive rocklike head, but the ultradynamic eyes dart with the speed of automobiles racing on the Lombard plains. To right and left flashes the gleaming cornea of a wolf.

The round felt cap pulled down over the intense black of the eyes like the round black clouds that hover over the intense black of Apennine ravines. And when the cap is removed, the baldness of a Verlaine, a D'Annunzio, a Marinetti shines forth like an electric lamp.

His coat collar always turned up from an instinctive need to disguise the violent *romagnolo* words hatching their plots in his mouth.

His right hand in his coat pocket grasps his stick like a saber straight along the muscles of his arm.

Bent over his desk on large elbows, his arms as alert as levers, he threatens to leap across his papers at any pest or enemy. A swing of the agile torso from right to left and from left to right, to brush off trivial things. Rising to speak, he bends forward his masterful head, like a squared-off projectile, a package full of good gunpowder, the cubic will of the State.

But he lowers it in conclusion, ready to smash the question head on or, better, to gore it like a bull. Futurist eloquence, well masticated by teeth of steel, plastically sculpted by his intelligent hand that shaves off the useless clay of hostile opinions. From time to time, the great gesture-fist-image-conviction forcing a passage through a tangle of objections.

His will splits the crowd like a swift antisubmarine boat, an exploding torpedo. Rash but sure, because his elastic good sense has accurately judged the distance. Without cruelty, because his vibrant fresh lyric childlike sensibility laughs. I remember how he smiled, like a happy infant, as he counted off twenty shots from his enormous revolver into the policemen's kiosk on the Via Paolo da Cannobio. I remember how lyrically he sought the beautiful patriotic roses amid the barbed wire and sportively caressed the Frisian horses that cluttered the little yard of the *Popolo d'Italia* when it was raided in 1919.

Lyric child armed with lightning intuition, Mussolini was speaking to foreign representatives and journalists, with no false cultural modesty, as follows: "We are a young people who want and ought to create and refuse to be a syndicate of hotel-keepers and museum guards. Our artistic past is admirable. But as for me, I couldn't have been inside a museum more than twice."

For which reason we Futurists, prophets and preparers of the great Italy of today, are happy to salute in the forty-year-old President of the Council of Ministers a marvelous Futurist temperament.

Marinetti at home with his father and elder brother Leone, in Alexandria, Egypt, about 1890

Marinetti at eighteen

Milan, about 1910: the square in front of La Scala, with the
monument to Leonardo da Vinci

Marinetti in the salon of the Via Senato Apartment, about 1900

Marinetti holding forth at the Grand Théâtre du Gymnase, Paris, about 1905

The Red House in Corso Venezia, Milan. Marinetti moved here from Via Senato in 1911: "I return to Milan where on the first floor of the Red House built but never enjoyed by Garibaldi I organize and upholster with carpets and curtains from Persia Japan China Cairo the visit of the famous beauty Mata Hari"

Marinetti Estate

Photographic Archive, Castello Sforzesco, Milan

Marinetti in 1909, the year of the
First Futurist Manifesto

Marinetti Estate

Umberto Boccioni: *A Futurist Soirée.* In the center, Marinetti. To his right,
the maestro Balilla Pratella, clutching two batons and conducting an en-
harmonic symphony, and Boccioni, stamping his feet; to Marinetti's left,
Carrà and Russolo

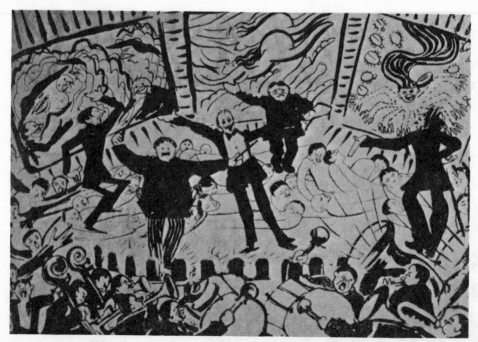

From Uno, due e . . . tre, *June 17, 1911*

The Futurist chiefs of staff, Paris, 1912. Left to right, Russolo, Carrà, Marinetti, Boccioni, Severini

The *Lacerba* period, 1913–1914. Left to right, Palazzeschi, Carrà, Papini, Boccioni, Marinetti

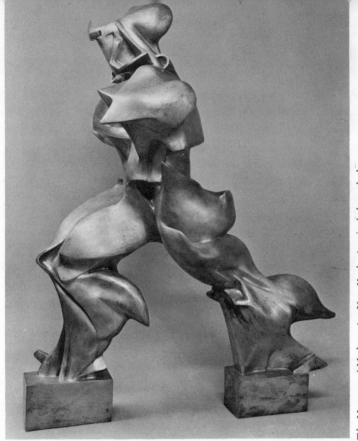

Above: Umberto Boccioni: *Unique Forms of Continuity in Space,* 1913

Right: Marinetti: *Self-Portrait*

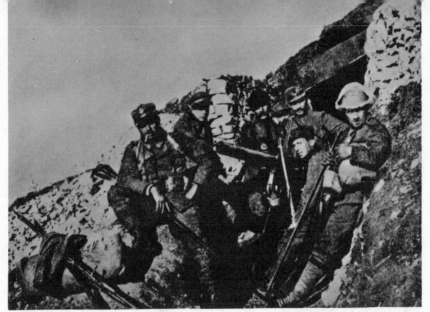

Mondadori Archive

Futurist volunteers at the front, October–November 1915. Left to right, Marinetti, Sant'Elia, an unknown companion, Russolo, Boccioni (*seated*), Sironi. Boccioni died as a result of a fall from a horse in drill on August 17, 1916. Sant'Elia was killed in combat on October 10, 1916. Marinetti and Russolo were wounded in 1917

Marinetti (*in uniform*) with the Russian Futurists Natalia Goncharova and Mikhail Larionov, and, at the right, Pablo Picasso; Rome, winter 1916–1917

Courtesy Leonard Hutton Galleries, New York

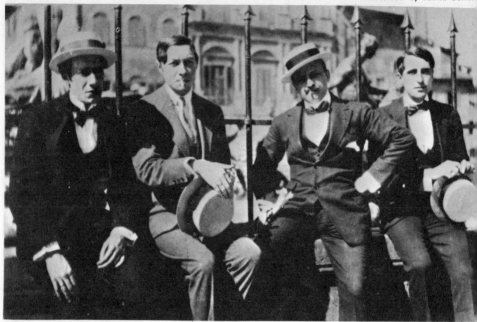

The Florentine, or "second," Futurist period, about 1920.
Left to right, Settimelli, Corra, Marinetti, Ginna

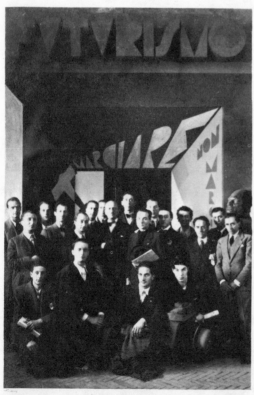

The Futurists in 1926: Marinetti is
in the center

Giacomo Balla: *Portrait of Bene-
detta*, 1923

ome, Marinetti Collection

Marinetti and Benedetta at home,
about 1925. On the walls, left, *Por-
trait of Marinetti,* by Fortunato De-
pero; right, *Portrait of Marinetti,*
painted by the Russian Futurist
Rouzhena Zatkova in 1917

Collection of Luce Marinetti Barbi

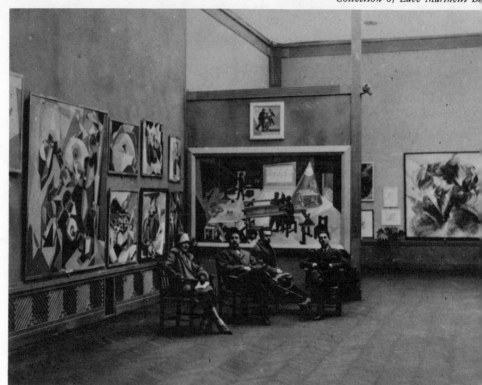

Above: Benedetta, Marinetti, Prampolini, and Tato, at a Futurist exhibition

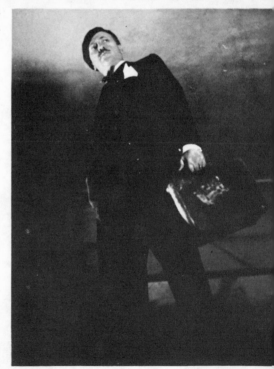

Right: Marinetti in 1933

Milano monocentrica
si presta ad una moltiplicata
espansione periferica di nuove
città giardino e con i milanesi
vagheggiano un vasto
quadrilatero di villaggi-fiori
di tre milioni di metri quadrati.
Così a tre chilometri dal
Piazzale Loreto e sulle tortuose
rive del Lambro si vivrà
solennemente a Crescenzago
Milano si rivitalizza anche
colla rinnovata Festa di
San Lucio
La Chiesa di San Bernardino
non lontana da Piazza Fon
tana che riunisce il sabato
agricoltori e contadini oltre
più di latte - latticini che
d'incenso
Il Rettore del Santuario di

From the draft of *Great Traditional and Futurist Milan*, 1943

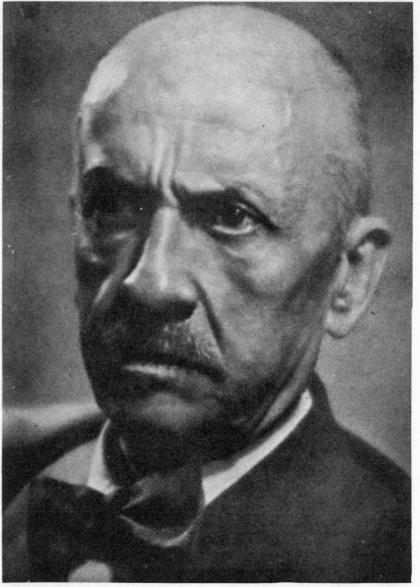

Marinetti in 1942

PART II

The Untamables
A Novel

Translated by Arthur A. Coppotelli

The Free-Word Style

How would one define *The Untamables?* Adventure novel? symbolic poem? science fiction? fable? philosophical-social vision? None of these categories fits. It's a free-word book. Nude crude synthesizing. Simultaneous polychromatic polyhumorous. Vast violent dynamic.

No doubt I had it in my free veins and my free muscles when, as a naked child, I would play with the naked Negro urchins on the burning dunes of Ramleh. A brown Bedouin tent surrounded by scrawny dogs, rags, carrion, garbage. The red silence in the faces of the Negroes crouched around an aromatic fire. Crackling. Spiral of blue smoke. Absolute silence. The air an anxious crystal. The silence whines. A flute. Dreaming perhaps of squeezing the freshness from the very pure green evening.

No doubt I had *The Untamables* in my blood during my last trip to Upper Egypt. But the idea for this free-word poem struck me when I was dozing one morning in September, a few days after I had finished *L'alcova di acciaio* [*The Steel Alcove*] at Antignano. Red banners fluttered over the factories in Livorno occupied by the workers. But they seemed gray against the scarlet white Negro laugh of the inspiring sea.

Words-in-freedom can claim very important works.

After my first words-in-freedom: *Battaglia Peso + Odore* [*Battle Weight + Smell*—August 11, 1912] and *Zang tumb tumb,* the Futurist Editions of the review *Poesia* distributed in Italy and throughout the world, *Piedigrotta* by Francesco Cangiullo, *Ponti sull 'Oceano* [*Bridges over the Ocean*] by Luciano Folgore, *L'Ellisse e la Spirale* [*The Ellipsis*

and the Spiral] by Paolo Buzzi, *Guerrapittura* [*War-painting*] by Carrà, *Rarefazioni e Parole in libertà* [*Rarefactions and Words at Liberty*] by Corrado Govoni, *Baionette* [*Bayonets*] by Auro d'Alba, *Archi Voltaici* [*Voltaic Couples*] by Volt, *Equatore Notturno* [*Nocturnal Equator*] by Francesco Mariani, *Firmamento* [*Firmament*] by Armando Mazza, and *Les Mots en liberté futuristes* [*Futurist Words-in-Freedom*] by Marinetti.

From other publishers and at exhibitions, there appeared free-word "tableaux" by Balla, Boccioni, Buzzi, Cangiullo, Caprile, Carli, Carrozza, Cerati, Primo Conti, De Nardis, Depero, Folicaldi, Forti, Ginna, Guglielmino, Guizzidoro, Illari, Jamar 14, Jannelli, Leskovic, Mainardi, Marchesi, Masnata, Morpurgo, Nannetti, Nicastro, Olita, Pasqualino, Presenzini Mattioli, Rognoni, Sandri Sandro, Settimelli, Simonetti, Ardengo Soffici, Soggetti, Soldi, and Steiner.

Free-wordism has conquered by influencing all literatures. Foreign avant-garde magazines are full of words-in-freedom.

Words-in-freedom orchestrate colors, noises, sounds; they mix the materials of language and dialect, arithmetic and geometric formulas, musical signs, old words, altered or recoined, the cries of animals, wild beasts, and motors.

Words-in-freedom split the history of thought and poetry neatly in two, from Homer to the last lyric outburst on earth.

Before us, men had always sung as Homer did, with narrative sequence and a logical catalog of events, images, and ideas. There is no substantial difference between Homer's poetry and Gabriele D'Annunzio's.

Our free-word tableaux, on the other hand, finally distinguish us from Homer since they no longer contain narrative sequence, but rather the simultaneous polyexpression of the world.

Words-in-freedom are a new way of seeing the universe, an essential estimate of the universe as the sum of forces in action that intersect at the threshold of consciousness of our creative *ego,* and are noted with all the expressive means at our disposal.

A difficult area of trial and uncertainty, a far cry from success and public approval. Heroic attempts of the spirit projecting itself beyond all its norms of logic and convenience.

From our words-in-freedom the new Italian style is born, a synthesizing, rapid, simultaneous, incisive style completely freed from the deco-

ration and solemn mantles of classical art, a style capable of wholly expressing our character as the ultrafast victors of Vittorio Veneto.

Destruction of the rhetorical period with its steps, festoons, and drapery. Short sentences without a verb. Punctuation used only to avoid ambiguity. Words isolated by two dots so that they can become ambience or atmosphere.

I offer to the public and to eventual critics several typical samples of this new Italian style. I'll begin with a passage from *Crepapelle* [*Bursting Out of One's Skin*], a volume of grotesque novellas by Luciano Folgore, who is the same admired, powerful, free-word poet who wrote *Ponti sull' Oceano* [*Bridges over the Ocean*]:

> A small terrace on the west side: an iron and slate footbridge to explore the bit of sea painted on the doormat on the balcony in front.
>
> We're on the last floor. A hundred twenty-nine steps. (The fat landlady weeps over them as she counts them every day; she eats my sunflower seeds while chitchatting with her bony neighbors drowning in the lettuce green of their house dresses.)
>
> I have a tarnished brass chain leading from my left foot to the short wood bar that's always swinging, and she makes me say yes like a raucous crow; I try my best to look sideways at the world.
>
> The world seen obliquely is quite another thing. Singular. Grotesque. Turned a bit on itself. In a difficult position. Always afraid of losing its balance.

I'll take a passage from Cangiullo's *Roma sotto la pioggia* [*Rome in the Rain*], published in 1916 in the *Piccolo Giornale d'Italia:*

> There's the station for the ones on leave: even the visor of its marquee is dripping. . . .
>
> A returning train howls on arrival like a black hyena that's devoured an enemy field.
>
> Outside in the square an automobile flies by, spraying.
>
> A rain desert.
>
> A desert of city squares sizzling with rain.
>
> The obelisk dedicated to the 500, the one in *Piazza del Popolo,* the column in *Piazza Colonna,* upright, impassive petrified guards in the rain coming down in elevators.
>
> And it's raining on the botanical heaps in *Villa Borghese* and on the cement nymphs of the Esedra Fountain, who have callouses only at water level. . . .
>
> Then

a *delivery girl* and a *military* driver
without umbrellas
one
behind
the other
along the wall
like 2 human dogs
Quarter to 11.

I'll take a section at random from Angelo Rognoni's novel *La Veste che faceva frou-frou* [*The Dress That Went Frou-frou*]:

We went into an alley. Black, rot, damp, damp, mold, stubs, leaning doors, windows askew, bars, dogs lying down, stink of wine, oil, sinister faces of thugs, unbuttoned pants, gnarled canes, dice, mafia, clinking of coins, rotten apples, smelly cabbage, snail slime, orangish lights from under doorways, from long hallways, from half-drawn shades, slums.

We went into a low house, a red room cluttered with lace curtains, naked flesh, mirrors, reflections, cheap perfume, cigarette smoke, rouge, powder.

I can easily demonstrate how the Futurist words-in-freedom have not only triumphed in world literature, but have also influenced journalism.

You can find stories and descriptive articles that have passages of speeded-up writing, synthesizing, essential and at times real words-in-freedom with the same quick flashes of thought, notation, simultaneity.

We quote at random from an article by Fraccaroli in *Corriere della Sera* entitled "Frontiers":

Alps, valleys, tunnels (close the windows, quick!), the Ticino River roaring, villages with their acute-angle-hooded houses, very little snow on the highest peaks, a cool wind, Swiss trainmen speaking in Lombard-Ticino to you, in German to the man next to you with his head shaved, in French to that lady at liberty.

The train speeds along.

. .

Here is the Lake of the Four Cantons. A white steamboat, the sunset unfolds violets over the lake, squirts red paint on the barren mountains, towns garlanded with flowers and inscriptions huddled on the shores, then at the farther end Lucerne, the crowd at flood level. The train full to the brim. Two hours later, Basel.

Balilla Pratella writes in the *Popolo d'Italia:* "Words-in-freedom have now won over, for their essentiality, our most important men and writers, among whom is Gabriele D'Annunzio. In his recent *Notturno,* he has ably made use of words-in-freedom in the first 130 pages; on page 124, for instance, he has achieved effects similar to the well-known "Flames flames flames . . ." from F. T. Marinetti's *Battaglia di Adrianopoli* [*Battle of Adrianople*].

Here is the passage that Pratella alludes to:

> Faces faces faces, all the passions of all the faces, race across my wounded eye, as numberless as warm grains of sand through clenched fingers. None of them stop. But I recognize them.

Giuseppe Lipparini writes in "Resto del Carlino":

> Do you remember Marinetti's campaign against syntax and for words-in-freedom? It was necessary to free oneself from every rule, free the word from the slavery in which the bonds of syntax were holding it, slay the sentence, decompose the proposition. One had to suppress every idea of subordination, had to express oneself only through coordinates. And these coordinates were to be reduced to their least terms, to the isolated word and the pure expression. The word, marvelous living creature, would thus recover its splendor and be free from the heavy veil of fog and tedium that was hiding its luminous face. . . .
>
> And all this was profitable because it bred a taste for a more various, agile prose style, one richer in surprises, more irregular, not in the bad French manner of earlier times but in accordance with an almost plastic concept of the collocation of words.

Now I open *Notturno,* Lipparini continues, and read pages like this:

> The city is full of phantasms.
> Men walk with no sound, wrapped in fog.
> The canals smoke.
> Some drunkard's song, a cry, a babble.
> Blue lights gleam in the smoky dusk.
> The cry of the spotter planes sounds raucous through the mist.

Or still more significant:

> The motor launch for Sant'Andrea throbs at the landing. I'm carrying luggage and a bag of messages.
> Rough lagoon.
> Water splashes.
> The Sicilian boatman with whom I'm chatting.

Or this:

> . . . Departure.
> The San Marco basin, blue.
> Sky everywhere.
> Stupor, despair.
> The motionless veil of tears.
> Silence.
> The throb of the engine.
> Here is the Park.
> We turn into the canal.

And I can quote other fragments from *Notturno* that are typically free-word:

> Bandaged head.
> Tight-closed mouth.
> The right eye injured, livid.
> Right jaw shattered, swelling begins.
> Olive-skinned features, an unusually serene expression.
> Upper lip sticks out, a bit swollen.
> Nostrils stuffed with cotton.
>
> The closeness of flowers and wax.
> The black pall, unchanged. The form of the body, unchanged.
> Two sailors, honor guards.
> From outside the noises of the day. Horns, bells, the city waking up, things inevitably beginning again.
>
> Blue water, the felicity of the golden air, flocks of seagulls laughing with their silly laugh.
> Darkness. Wandering shadows. Chatter. Smell of cooking, shadows of poverty.
> The grieving faces of Marys, faces strained from work and bad luck, pitiful faces.
> Emaciated children, all eyes, filthy, sad.
> The water in the sick river.
> The reddish house with the ten chimney pots.
> I turn. Go downstairs. War! War! Faces. Faces. All the passions on all the faces. Ashes. It's a March rainstorm. A northeast wind. Rain. I barely hear it pattering.

The great free-wordist Paolo Buzzi, after having quoted this passage, says: "To its credit, the book is full of these sections of words-in-

freedom. It's a truth that does not have to be shouted too loudly. All Italy is saying it, and—of course—the whole world where *our* Futurism, of us post- and pre-D'Annunzians, is what it is, and not just as of today, naturally."

At the opening of the great Casa d'Arte Bragaglia in Rome, I expressed my pleasure at all this with Folgore, Cangiullo, Carli, Settimelli, Pannaggi, and with the young Futurist painters Fornari, Paladini, Scirocco, Verderame, Tato, and Somenzi. The eloquent joy of our free-word spirits mixed with the exultant lighted ceilings and dynamic walls created by Balla, Depero, and Virgilio Macchi.

The great decorative art of Futurism has been realized. In Rome, yes, in Rome, which could no longer continue to be merely the fortress of past styles. Rome is becoming the always more powerful capital of the new Italy of Vittorio Veneto; it is becoming and will keep becoming the power plant of world Futurism.

<div align="right">F. T. Marinetti</div>

I

The Dune of Camels

"Vokur! Vokur! Wake up! I'm thirsty!" said Mazzapà, a herculean Negro dressed in white, sitting cross-legged on the burning sand. Intent on cleaning his rifle till the barrel and the bayonet shone with blinding brilliance.

On the crest of the dune not another living thing could be seen, so it seemed the Negro was talking to the desert.

A long, glaring silence.

"Vokur! Wake up! I'm thirsty!"

A form altered the silhouette of the dune: it was Vokur, who shuddered as he slept, lying there on his back with his eyes half-closed. His mouth gaping. Like a corpse. Next to him three other Negroes turned to stone by sleep and the murderous sun. They all looked foolish in their white cotton colonial uniforms. Their big, square, naked feet with their spread toes looked like muddy potatoes. They were hatless, their coal-black round heads covered by the frizz of their mica-blue hair. But their black, shiny faces were caged in by a strange muzzle, open-meshed like the ones on watchdogs. In the center of the muzzle, right over their doggy noses, an even stranger lock.

They looked like prison guards, but they were muzzled like wild beasts. That could have been disturbing in any other place, as any mystery can be disturbing, but on the Dune of Camels, here on the Island of the Untamables, there wasn't room for mystery.

Everything was dazzling under the merciless sunlight that would have reduced any European to madness. The race of the sun's burning

rays across the flame-congested sky forewarned of the tropical noon. The enraged sun glared like a sharp smooth sword held high by a celestial executioner. Below, the terrorized isle trembled, surrounded by its flames like the head of a condemned prisoner. Light. Silence. Destiny.

Perhaps it was an island off Africa. But I doubt it. It was more likely an island emerged from the lava sea within a volcano. The sky overhead, in fact, was the dome of an immense furnace. The air was scalding, heavy; slimy and dry at the same time. The sun felt like burning-hot scarlet sponges and sandpaper and iron brushes. The heat was piercing. It beat down on everything. Fierce. The white uniforms were blinding.

"Vokur! Wake up! I'm hungry and thirsty!" shouted Mazzapà. The yellow balls of his eyes shot cruel gleams.

His companion shook himself, then slowly began to get up as if he were bearing the whole burden of the heavy noon. A little way off, there was a well. Dry probably. Farther to the right, a pile of rocks. Vokur kneeled and with great effort lifted a sandy trapdoor. He took out two yellow bowls filled with a muddy liquid.

Vokur was short and stocky, fat, really, and flaccid in his large white uniform that billowed around his waist like a sail. An absurd sight he was, because the air was deadly still. When he got up, being very careful not to spill the contents of the bowls, the sweat was dripping from his steel muzzle.

He tried with all his might not to sink into the fine, gleaming sand that gave treacherously under his big square feet. He put the bowls down on the sand and crouched next to Mazzapà, who grunted, "Watch the water in the bowls. Count your breaths. At the eighth breath, the water will boil."

From the harsh tone of his voice, it was obvious he dominated his companion, who was dumb, lumpy, and closed-off in his primitive brutality. Mazzapà was the younger and the more agile of the two. His well-developed muscles would not go slack in the torpor of the sunlight. They poured sweat under his uniform, which stuck here and there to his body. Those muscles were always ready for action. His black eyes, shiny and malicious, struggled against the commanding violence of the Sun. The Sun wanted to hypnotize Mazzapà, but it couldn't. Mazzapà showed his scorn with his dazzling white smile. But suddenly his mouth tightened.

"In a while we'll have to feed those damned animals," he said, point-
ing with his fist to the right where the sand had piled up to form a
depression.

In the middle of this depression, there was a pit containing a myste-
rious tangle of rusty iron. A closer look revealed a slight movement.
That wasn't metal, or plants, but human beings the color of brick and
coagulated blood. The gleaming sand had sifted over sighing undula-
tions that seemed to be large, sleeping female bodies.

Here and there, shrubs stunned by the sun's heat. No shade. Beyond
the pit, still to the right, the incandescent heat waves veiled an immense
oasis that was reddish, almost bronze, a solid wall closing off the hori-
zon.

Sitting cross-legged on the sand, Vokur counted his breaths on his
fingers, inhaling and exhaling vigorously so as not to make a mistake,
and watching fixedly the two bowls that baked in the sun.

Ffoon, ffoon, ffoon, ffoon, ffoon, ffoon.

The liquid came to a boil, revealing gray beans. Each took up his
bowl and, throwing his head back, poured the contents into the sizzling
steel of the muzzle that enclosed his face.

"What a lousy job!" said Mazzapà. "Having to feed ourselves this
filthy broth when we're dying of the heat."

"You're the one who wanted it hot," growled Vokur. "I like it luke-
warm."

"If we didn't boil it, you idiot, we'd be poisoned by now. The water
under those rocks is rotten. Maybe it's the juice of a dead body. If only
our comrades would come with the buffaloes and sheep. Don't you hear
the noise of chains? The Untamables are getting restless because they're
hungry. Come on, Vokur, don't fall asleep again. Listen to me. When
we go to slaughter the buffaloes, remember to bring the bowls along.
While I shove the bayonet into their bellies, you be ready with the
bowls to catch the blood. That way we'll have something decent to
drink."

"No, Mazzapà, that's not for me. I can't do it. It's forbidden, you
know that. The Paper People are pitiless. They'd punish us by clamp-
ing the muzzle straps two holes tighter. I'd rather eat crap than spend
two nights with my muzzle on. The other night, the Great Chief of
Paper whistled in my ear, 'You'll be in dire trouble if you so much as
drink a single drop of buffalo blood, because all of it belongs to the

Untamables. You've got to drink boiled water if you want to sleep without your muzzle on in the Oasis.' "

"I don't give a damn about the Oasis! Day by day we're dying of hunger and thirst. What's the point of being allowed into the Oasis at night, if we can't remember anything the next day? We can't even tell what's in the Oasis. Even the Untamables don't know what they see at night. But they're smart. They were all rich, important men. They're always talking about their past, but they can't tell what happened last night. Old Negodrò told me this well used to be full of water. Negodrò had been to the Oasis many times. The Paper People protected him. He told me the well dried up all of a sudden. It was a horrible bird of prey that swooped down from the sky and stayed a whole day with his wings outspread over the well. He drank all the island's blood from that hole. One day I went down into it. But I was afraid, and I climbed back out. Negodrò told me it would take ten days to reach the bottom.

"I'd be willing to walk three hundred days if I could be sure of finding water at the bottom."

"That water's dead, Vokur!"

A long, glaring silence. Broken by a piercing cry. Mazzapà and Vokur turned toward their Negro companions. Woken up suddenly, they were blubbering incoherently. One of them stood up and was gesturing toward the Sun. Nobody understood what he meant. A dark rage bent his great bony back, decorated here and there by his dazzling uniform with slimy brown arabesques where the sweat made it stick.

He held his head back, so that his muzzle shone like a silver web under the onslaught of the sun.

He battered at the muzzle until his black nose bled. He kept trying to rip it off, crying, "It's biting into me! It's biting into me! A hyena is eating my face."

With his right hand, he grasped the lock of the muzzle and, pulling from the front, his biceps bulging, fell headlong to the sand. He lay there without moving.

Muttering to themselves, his companions lay down again. They fell asleep instantly, snoring like so many peaceful bugs.

II

The Battle of the Two Oases

A long, glaring silence. Mazzapà said, "Negodrò told me there was once a large oasis here called the Oasis of the Moon. Not so deep, but bigger than the one down there they call the Oasis of the Sun. The two oases lived next to each other separated by a deep wadi. The Moon reigned happily in its rich, thick, sweet-smelling oasis, full of blue lakes and silvery running streams.

"The Sun was devoured by jealousy and wanted to destroy it. He decided to fight it out at high noon, when he could send down his two thousand flaming solid-gold eagles.

"It was the hour when the Oasis of the Moon would lie languidly dozing to the tinkling of the camels carrying skins of blue water. Panic among the leaves. With a lacerating cry, the Oasis awoke under the assault. He immediately mobilized his perfumed greenery for defense. Like women who, without violence, softly fan their charms, their languor, their sweetness, their fragrance, their womb warmth. The two thousand eagles of the Sun hurled themselves in a mad assault. But they are forced to stop. What is standing in their way? Consternation. The first wave of eagles has already been defeated. Poisoned by cowardice and tenderness. Hesitant, played out, they tremble at the edge of the Oasis.

"Their wings, feathered with glowing coals, are listless, lulled by the gurgling of the melodious leaves. They fall headlong in a dizzying plunge. Others plummet like sacks of gold. Above, the more daring circle and spin like clock wheels gone mad. Most of the winged army

draws back while the whole Oasis of the Moon rings out in proud victory.

"A brief pause. Then the eagles return. This time with cunning. Pretending to be enraptured, they sing and sob of love. They fly around the silver tree trunks on the great blue lakes. The Oasis of the Moon revels vainly, with a long, honeyed gurgling of fountains. Its defenses, its languor and fatal perfumes, are helpless now. The eagles take advantage and plunge beak first onto the trunks. A frantic, shrill piercing of the bark. Their beaks, like acetylene torches, sear through the metal skins. Another palm thuds to the ground, split in two. Shrill screeching. More trees crash down, mortally wounded. Still others, decapitated, die standing. Shuddering. The shattered boughs fall upon the corpses of the trees like black-shrouded widows.

"Then the Sun unleashes its simooms of plumed sand onto the defeated Oasis to bury it completely under a splendid monotony of gold dust. Negodrò told me that on the crest of this very dune, the eagles of the Sun attacked the last caravan of camels that had been distributing waterskins during the battle. Of them all, there only remained those three carcasses of camels. . . . Look, Vokur, don't you see gold claws on the second carcass? Don't you see feathers of lava and a beak of fire?"

"I don't see a thing!"

"Maybe I'm out of my mind, but the island looks like an endless carcass of a camel caught in the claws of a huge eagle of fire. Those carcasses frighten me. It's as if our comrades were all dead. Who in the world ever led us to this damned place?"

"I don't know, Mazzapà."

"I feel we've been here for at least a hundred years. I never was a camel driver. I'm a soldier, that's what I am! But I think I could drive a caravan of camels. . . ."

"Mazzapà, I have an idea."

"It's probably stupid. You never understand anything."

"You're right. I'm not intelligent. But there's something that keeps buzzing under my hair, and I keep trying to think what it is. Mazzapà, we can't go on living on this godforsaken island."

"Well?"

"You know I can handle an ax, and I'm strong. The other night while I was looking at the trees in the Oasis down there, the idea struck me that we could cut one down, dig it out, float it and get out of here."

"You really don't catch on, do you? At night the trees in the Oasis soften up and crumple as if they were rotten. By day they're harder than these muzzles. How could you dig them out to make a boat?"

"You're right, Mazzapà, but I have another idea. Every so often, the Paper People come in their boats down to the landing . . . those boats with the creaky paper sails that are all wrinkled like old men and are covered with black marks. My plan isn't easy, but then it's not impossible either. We'll hide behind the rocks at the shore, and when the Paper People land, we'll climb aboard their boats and set sail."

"What a moron you are! Try it and find out. The boat will sink under your weight. Don't you know the Paper People are lighter than dry leaves, whereas you can't even walk across the sand without sinking in?"

Vokur fell silent, struck once again by the religious awe he felt at the intangible, airy lightness of the Paper People, the rulers of the island.

III

The Pit of the Untamables

Sitting cross-legged on the sand, the two Negroes shaded their eyes with their hands and looked at the island's azure edge, barely dividing the dazzling sea of sand dunes from the no less dazzling real sea.

Those two seas were competing in the intensity of their heat, multiplying a billion shimmering sea mirrors, silver, emerald, violet, by a billion frenetic gold X's. On that glaring expanse, black marks were suddenly scribbled.

"Here come our comrades with the buffaloes and sheep," said Mazzapà.

Very faintly, the bleating and lowing edged closer, suffocated under the sheer mass of the burning silence. To the right, shrieks and clattering of chains echoed in the pit of the Untamables.

These men-beasts, chained together, listened, sniffed, understood, already tasted their savory victims by snapping voraciously at the very sound of their bleating. The noise of the chains grew. One, two, three hoarse voices sawed through the silence. Anger surged up toward the sky's relentless furnace.

Suddenly Mazzapà stood up and shouted, "Stop your racket, you swine! You cadaver's pustules! Scrofulous dogs! Do you want a taste of my bayonet? By Allah, I swear, if the Paper People down there hear your noise, I'll stick you through the ass so many times with my bayonet, you'll be sieves!"

From the seething pit, there came back a biting, brutal answer:

"Whose bayonet? That toy you carry? It's just the right size for you, you disgusting, uneatable sparrow."

More insults came flying out of the pit. Sarcasm and mockery.

"That's right, a sparrow! A sparrow in a muzzle cage! You're disgusting and pitiful, all of you! Guards guarded under lock and key."

Mazzapà's athletic body swelled with anger. He called to Vokur.

"Come with me. Take your rifle. If I have to kill them all, I'll shut the Untamables up! If the Paper People hear this infernal hullabaloo they'll be sure to clamp the muzzles on us twice as tight!"

Mazzapà plunged ahead on the path that led to the pit. His rage drove him on. But the sand sucked him back. Behind him, Vokur growled, he too enraged by the sand and the Untamables.

The Untamables came into view, tall, red, their hair sticking straight up on their heads. About a hundred of them. All naked, but bristling with quills like porcupines. They were wearing iron collars like watchdogs, studded with spikes. Their calves, thighs, biceps, were encircled with bands of jagged teeth. Bands of every size. Heavy, thick ones around their broad hips and barrel chests. Around their foreheads, a special iron band, thicker, with long spiral teeth fastened to it. Several of the warriors had long gray or white beards. But they were nonetheless ferocious, because the rich poisons in their blood nourished their insatiable youth. Blond beards, tobacco-stained, even when they didn't smoke. Their mouths were red gashes lusting after revenge; their eyes bulged from their heads.

From a distance, all those naked bodies seemed reddish or tawny. But close to, they turned out to be multicolored. Several of them grayish, a little soft as if they had no bones. An old, gnarled man was as dark red as a skinned camel. Two thin youths, almost fleshless, showed their brown, worm-eaten muscles, their tendons like the dusty strings of an old piano. Oh God, for what music! Their skin was mottled brown and scaly like a fish's. Others were bile green, as if they had been squeezed from hate. Some, jaundiced and filthy, were arabesqued in the colors of decay.

A saffron colossus. A great sulfur paunch, like a gold ball in the sun. Their sweat poured off, faceted like precious jewels.

Their legbands, fillets, and collars, made of shiny steel, had pointed studs, festooned with shreds of bloody flesh. Human flesh that was passed from man to man in their continual squabbles. About twenty of these men-beasts had risen to their feet. Laboriously. Hauling up the

weight of the chains, welded to their wrists, holding the herd of them together. Crushed and whining, the weak writhed between the legs of the strong. They were almost all of them the color of coagulated blood, and their thighs, their buttocks, their arms, and their cheeks were covered with great running sores. They were fretting like carnivorous birds, there between the legs of the strong ones who kept them down.

"They're the ones who are making all the noise!" said Mazzapà. "That's enough! Enough! You cowardly runts! Stop shouting, you slimy snakes! If you keep it up, you won't get anything to eat, not a scrap."

A pathetic outcry was his answer. Then the strong Untamables piled on top of the weak ones on the ground and a loud fracas ensued.

The weight of the chains and studded collars gave the fight a grotesque rhythm as the slow movements of the Untamables counterpointed the furious darting of their eyes. Fists/pistons. Chests/bellows. Bodies/bottles grabbed around the neck by drunken hands.

"I've got you, dog!"

"Why are you opening your mouth?"

Down his throat goes the fist. But teeth clamp down and the fist gets pulled back, spongy and red with blood. Two giant human pliers interlock. Pulling out the invisible nail of the soul. They grab. Screams. "I have him! I have him tight!" A zigzag death rattle. A cube of terror on his chest. Faces of ancient yellow boredom, scratched by happy lights. The heavy tedium of a lip split by a laughing wound. The mercury of hate rises in the beaded thermometers of sweaty faces. They break against one another, those human thermometers, showering slivers of glass from their eyes. The mercury of hate pours down free, never to measure again.

But sometimes a greedy yen flashes from their eyes. Among the Untamables, there were some really cruel types, sly, vicious. They tasted things even before they could eat them. That belly, the one over there, has a wound that needs perfecting. A conscious wound that waits and begs, in a near delirium of joy . . . and the wound opens to the lust of three foreheads armed with spikes. A writhing tangle. The cumbersome, clanging chains, like the blue bells of a red-black hell of physical pain. Their collars rasp like files and padlocks, to sharpen, sharpen, to seal, seal tight men's souls. . . . If ever! . . .

"Enough! Stop it, you rats! Scrofulous dogs! Pustules of a dead man!"

Mazzapà was shouting his lungs out.

Grabbing his rifle by the butt, he waved it over his head, and clusters of white glints climbed the barrel, right up to the bayonet. Skewered on the very tip was the sun—that sun, which by dint of exacting cruelty can find no victim so worthy as its very self.

Mazzapà twirled his rifle over his head, holding it by the butt, so that his fist became the hub of a whirling scythe. Little by little the lethal wheel lowered on the fuzz of the Untamables' hair, eyes, mouths. ZZZZZZZTT! ZAP! The whirling bayonet mowed them down—a hunk of red flesh spurted out, with a bleeding eye attached. The battle went on in the rising clouds of sand that kneaded so well with that human dough of steel-flesh-blood. The sand began to bleat. Black on the horizon of the white sky appeared the buffaloes and sheep, among the flashing bayonets of the Negro soldiers. They slowly made their way down into the pit where Vokur awaited them with his ax raised.

At the head of the small herd, an enormous buffalo, black, laden with black magic, flushed by the dark streams of thousands of years. His neck, the color of a sooty wall, allowed his great bearded, pensive head to droop almost to the glowing sand. All at once he stopped. He sensed death. The Untamables stood mute. They watched. Two arm-lengths separated the buffalo's horns from Vokur's ax. It sparkled briefly and fell, splitting the black skull like a pomegranate. His head spewed out a long, long lowwwwing. The Untamables surged forward again. All those naked bodies strained against their chains, pawing the ground like horses. Their gaping mouths pumped out insults: "Get out of here, Vokur! That's no way to butcher animals! It's not your job, idiot! You've wasted the buffalo's brains, and they're so good to eat. Wretch! Shit-eater! Being able to squash lice doesn't mean you can slaughter buffaloes. Obviously this is no job for you. Leave it to us. Not everybody can master the art of killing. You spoil everything, Vokur. Look, there's the one who checks our chains every morning! Filthy damned Negroes! Just wait and see, now you're stronger than us and you keep us in chains . . . but in hell's name, at least give us our own chains. Separate us! Or you'd better be on your guard!"

Paying no attention, the Negro soldiers stripped naked and began to hack at the buffaloes and sheep with their knives and axes.

"Hey, we'd better keep quiet!" said one of the Untamables. "So we can watch these artists at work!"

The Untamables stopped jabbering and sat back on their heels or lay

down in a heap, poking each other playfully with their elbows as they watched Mazzapà direct the butchering. Beneath the flashing of the axes and the play of the Negroes' muscles, the backs of the buffaloes folded like black waves breaking into a froth of red horror. Terrifying moans. Slimy tangles of purple guts slipped out of their gaping bellies. Hunks of white fat. The Negroes' long black legs were like oversize brushes, mixing colors on that jelly palette, viscous with scarlets, violets, blues. Obscene. The skinned, naked carcasses spewed out their hairy sex. In a great jumble. Arms wielding axes became fantastic windmills struggling against a vermilion autumn forest.

The smell of blood made the Negroes drunk. They strode like barbarian kings over the spoils of battle. Maybe they were under the illusion of treading on writhing boas, or on the rigging of purple sailing ships, the sails gone slack after a rare conquest.

They piled slabs of meat on one side and the bleeding skins on the other. All of a sudden, Mazzapà raised a belly high over his head and showered himself in its blood, as he turned to face everybody.

"This piece is too big. It should be cut in four. Don't you know the Untamables can't use their hands?"

The sun was already roasting the meat. A sharp stench of burning sheepskins. A sickly sweet smell of rot, feces, and sweat. One of the Untamables, about forty, bald, with iron-gray eyes and a broad nose, sucked all that stench into his open mouth. He rattled his heavy chains with his muscular arms and cried out, "You're disgusting! Disgusting! O noble butchers! I can tell you because I'm the famous surgeon Mirmofim! You've spoiled some exceptional meat! What do you want, salami? Why are you hacking it to pieces any which way? You could have asked me for advice. Imbeciles! Ignoramuses! No, no! Don't cut up that belly! I want it whole! whole! I could do a better job of cutting it up with the studs on my headband! And you there, Mazzapà, what are you doing? Who's the idiot who put you in command? You're the dumbest of all the Negroes. But by God there'll come the day when *you* will be chained and we'll be giving the orders! In your place, we'd gobble up the Paper People! And those muzzles! Why, I, Mirmofim, have such teeth I could chew right through those muzzles!"

Mazzapà, who had been standing there watching the soldier-butchers, turned to the Untamable who was insulting him. He looked at him with a fierce frown. A cloud of black revenge blinded him and anger shook his colossal frame. He grabbed his rifle from the ground

and suddenly bayoneted Mirmofim in the side. The surgeon was ready for him, turning his right buttock to receive the thrust. Then with bitter irony that contained centuries of hate, he said, "I'm not young anymore, but I'm still quick, as you can see. You've struck me in an old wound that's scarred over. It's deep and lined with skin as hard as a knife sheath. It's a painless wound, a happy wound. I had it done to me on purpose, at the point I chose, between two muscles that had been useless for some time. You can shove not just one but three bayonets in it if you like. Go ahead, try again. I like it, I like taking your bayonet in my flesh, deep, deep, inside me!"

IV

Curguss the Priest

Mazzapà turned and gave a signal to the soldiers, who then began to fling meat to the Untamables. They made long arching throws, spreading a new furor of blood in that pit already full of furious bodies. The hunks of meat traced parabolas against the sky glowing red like a furnace. Strange wounded birds of prey. Most of the Untamables were on their feet and tugged convulsively at their chains trying to get in front of one another in order to spear the flying meat on the points of their headbands.

But there was a kind of comradeship among these men who were so used to fighting among themselves. When one of them succeeded in spearing a piece of meat on his headband or armband he'd immediately move over as close as he could to his friend. Gripping the meat between them with the barbs on their heads, the two friends/enemies would shred it into their open mouths. They'd drink up the red dribble, and the meat would disappear into their tough, crunching jaws.

Crunch, crunch, crunch, teeth grinding, teeth, teeth, shrill fast teeth, big red incisors, ugly yellow teeth ripping, ripping, grinding, hunger, hunger, bile, spittle, drunk and spat out, then drunk again.

Mirmofim, a sly, strong, and ingenious man, had succeeded in catching and devouring two pieces of meat. But when he couldn't find another tasty morsel, he began shouting, "Scoundrel! You cheated us today! The buffaloes were dried out from thirst, just like that well. The sheep were tough, dirty old shoeleather. But the day will come! The day will come! And then, finally, you'll be here and we'll be there!"

"Shut! up! Shut up!" screamed/spat at him the gray beard of another Untamable with a fat, oval, flushed, pimply, wrinkled face. "You're breaking my balls with all your surgery! You've eaten more than all of us, and you're still complaining, you sly dog! You even stole my second piece right off my headband! Thief! Well, you don't know who you're dealing with. I'm a powerful priest! And my life has been far more entertaining than yours!"

All the Untamables took sides.

"Yes, yes, Curguss is right!"

"No, Mirmofim is right! Mirmofim is smarter than anybody. He can really claim he's lived, conquered, seen, killed, tortured."

"But Curguss is more refined, more knowing."

"Hell no! Curguss is a goatskin full of shit!"

"Let's hear them both and then we'll put it to a vote. I'm betting on Mirmofim. Look at him! What guts! What muscles!"

"Quiet! Curguss is going to speak."

Puffing with rage, Curguss started to speak again. "I've had more damn fun than you could possibly imagine, making others suffer. I want all of you to judge! Listen! I am Curguss the priest, and the women of Belgrade know me. In my own way, I have pretty fancy tastes. My church was always full of women. A miraculous place that cured their ills. I remember a blonde, a beautiful girl, very pale. I hypnotized her and did whatever I wanted. For her own good, naturally. I have always despised lust. I prefer other pleasures. That little blonde was sick. But her mother was even sicker. Now I remember her name: Krumy. Krumy and her mother would come to the church every night when all the lights were out. I'd sit between them, and they'd hug me fearfully there on the pew. 'Give me a hatpin, Krumy,' I'd say. Krumy would hesitate, then she'd take a pin out of her hat, but she wouldn't give it to me. I'd have to take it away from her. Then, in the dark, I'd stick it in her mother's side. She'd moan. Krumy would huddle closer to me and say, 'What are you doing? What are you doing?' 'I'm treating your mother. Pray, pray, that she'll suffer more. So she can be forgiven.' 'No, no! My mother hasn't committed any sins!'

" 'Quiet, Krumy, don't utter blasphemy! Your mother is full of the ugly sins she committed when she was young. Your mother was a prostitute. She has to repent. Beg me to make her suffer!'

"All the while, I kept sticking the pin into her mother, who kept writhing from pain and fear, but didn't try to get away. Krumy would

get more and more excited until she almost went crazy. She'd keep stroking my face hysterically. Poor Krumy! She loved me so much. But I have always despised lust. I prefer other pleasures. Ah, what joy it was sticking that pin through her mother's rotten old body. . . . One night, after torturing her for an hour, I went into the sacristy and lit an oil lamp. Then I dropped it into a pile of sacred vestments. They caught fire. The church was closed tight. The two women began screaming in terror. I stayed calm, reached under the altar, and took out two buckets of water I had put there. I put out the small blaze. Krumy clung to me. . . . I have always despised lust. . . . I prefer other pleasures. . . . Now I'm forced to live in chains next to this pouting, ignorant scientist. What a beast! Do you want to analyze my shit?"

Mirmofim listened to him, grimacing, puffing out his chest, his head thrown back as a sign of disdain, despite the weight of the chains holding him down at the wrists. Curguss hissed his final insulting words, thrusting his big face and his dirty beard against the surgeon's. Without moving a muscle, Mirmofim waited, but his frown became more menacing. When he saw him come within range, he shot forward with surgical precision and ripped at the priest with his barbed headband.

Struck in the face, Curguss fell. A horrible tangle. Like an octopus whose beady tentacles have been crushed to a pulp. Rage spread. The chains make an epidemic of any small struggles among the Untamables. Two hundred raised arms bristling with pointed studs. Not one of them had eaten enough. Hunger and hate. Ripping each other apart. Cracking elbows amid the clawing of great red Angora cats. Their sandy breaths rose like cattails. Blood poured out all over. Vines with human grapes torn asunder by a hurricane. But there is no hurricane. The air is still. In the blinding glare of the sky, the sun's ax can no longer be seen, only the thousand gleaming, hacking axes that butcher meat for the Untamables.

Mazzapà kept running around the pit jabbing at them with his bayonet. The soldiers put their uniforms back on. The few already dressed moved about, but to avoid the blood showers, wouldn't go near the Untamables.

"Leave them alone! Leave them alone!" Vokur was shouting. "They'll kill each other off! Let the dirty bastards do each other in. So much the better."

"No, come on, help me. Gore them! Like me! Right in their open mouths! They'll settle down, you'll see, they'll settle down. I don't want

it to happen, Vokur. I don't want the Paper People to punish us. And they will, I'm sure of it. They won't unlock our muzzles tonight, just wait and see! Stick your bayonet in them, go ahead, do it!"

But Vokur's answer to his companion came at the top of his lungs: "Mazzapà, turn around, look! That bastard Falfar got out of his chains! He's escaping!"

The Untamables were having a good time.

"Great prison guards they are! Stupid Niggers, couldn't even keep watch over a turtle. You never noticed that Falfar hasn't eaten for eight days to lose weight. Yesterday he got down to two-thirds his normal weight. And this morning he slipped out of his chains."

On the blank, glaring white sand, a few yards from the top of the dune, a figure dragged itself along on its hands and knees. It looked like a huge yellowish lizard. It was Falfar the Untamable, trying desperately to achieve freedom.

"Don't kill him!" shouted Vokur.

"I'll only split his ass, just to stop him."

Mazzapà stood up and calmly took aim with his rifle. His white uniform was dazzling. His muzzle, drunk with white sparks, seemed to shoot out fat flames from the sweaty, shiny black of his cheeks. His ugly eyes shot out the red cruel spit of rifle fire.

PAMMM. PAMMM.

"You've had it, you bastard!" shouted Mazzapà, and he rushed over to Falfar's body with Vokur behind him.

Falfar lay face down, half sunk in the sand, from which his swollen, bloody ass stuck out like an enormous sponge soaked in red paint.

Absolutely still, except for a brief quiver that rhythmically sprayed the sand around them red.

Mazzapà and Vokur dragged him by the feet to the edge of the pit where the Untamables were waiting for them in great excitement.

"His pelvis is intact," declared Mirmofim. "The bullet sheared off his buttock like a razor. We ought to cut it to avoid infection. Let me worry about it. It's my job. I'll disinfect the wound with the hot sand."

Guessing that Mirmofim's words were only a dodge, and that Falfar's buttock would no doubt have ended up in the maws of the Untamables, Mazzapà speared the buttock on his bayonet and walked off, carrying human meat-on-a-spit that he had rescued from a cannibal feast.

V

Kurotoplac the Schoolteacher

The Untamables were in an uproar, laughing, bellowing, mimicking and ridiculing the Negro soldiers. The most insolent of them thrashed his skinny yellow body about like an eel; he had small gray eyes in a flat face that had red dots like a picture spelling book. His name was Kurotoplac.

"I like your bayonets. How ridiculous these Negroes are! They don't understand a thing about blood and torture. Mazzapà, you should know by now that we enjoy ourselves carrying on like this. To each his own, after all. When I was a schoolteacher in Odessa, during the time of the czar, I'd get a bang out of beating my pupils bloody to teach them respect for authority. And bare-assed, too. That's right, I'd whip them on their bare asses! Their asses were purple, like monkeys', like Kismikà's that I jab with my headband. He takes it, too, screaming and loving it, the bastard! I've throttled a few kids, too. I'd do things proper! If I agreed to educate their children, their parents had to sign over all their rights to me. 'If you do your homework well, you'll be able to see your mama in three days, and have a special treat besides.' Then I'd enjoy watching them go at it. All of them bent over their notebooks, writing their lessons so carefully. It was a contest. Every so often they'd look up with imploring eyes. The more loving among them would think about their mamas while they worked. I'd always give the prize to the good-looking ones! What joy in their faces as the time for their mothers' visit got closer!

"Then they'd tell their mothers all about the special treat awaiting

them while they opened the boxes of candy their mothers had bought. The moment the prizewinners came back from the reception hall, I'd grab them and throw them in a cell.

"A couple of hours later, I'd go see them. Then I'd throttle them, one after the other. I'd take three or four hours on each of them.

"Their dying looks still held the blissful memory of their candy. I'd bury them myself, in the school garden, between the lettuce and the cabbage. At night, I'd take my walk over them, reading Rousseau's *Émile*. They'd be breathing there, under my feet, those fresh mouths!

"On certain hot nights in August, I'd be surrounded by fireflies. How I would laugh. I'd kick their souls around. . . . Ah, those were the days! So civilized. And you, you dirty, uncouth Negroes, you want to be moralists, eh? We enjoy ourselves in our own way! Stick your bayonets in us, go ahead! We all have our wounds ready and willing to suck in the points of your bayonets, just as if they were sticks of sparkling cotton candy!"

VI

Mirmofim the Surgeon

In the meanwhile, Mirmofim was busy jamming his head barbs into Curguss's belly.

"Ufff!" He was panting. "What hard muscles! I've never come across such hard muscles in anybody's belly. You may not know it, but a rhinoceros would be jealous of your abdominal muscles! They're tougher than the ones that broke two saws on me at the Turin hospital ten years ago!—but that wasn't just an operation, that one, it was an orchestra of operations. Listen, this will make you laugh.

"During the great fire after the bloody offensive, my hospital was overflowing with wounded men who had to be operated on. I had five bright interns then. From dawn to noon, everything went normally. But while I was having lunch, they told me more wounded had been brought in. The corridors were full of stretchers. So I decided to divide the work.

" 'Boys,' I said to my interns, 'you're lucky! You'll have a chance to practice and serve science as well. But please, don't be too sensitive. You must be implacably cold. Science requires torture. I've come to understand all the secrets of life by listening to the screams of butchered flesh. Operate without mercy. Watch me and imitate me. You'll be able to test the human body's maximum capacity to tolerate physical pain.'

"I went into the operating room, followed by my five interns. The operating room seemed to be made of six sharp steel blades. Six patients were waiting for us on the operating tables. Like an orchestra before it begins playing, we tuned our instruments together. I assigned the parts:

one laparotomy, two amputations of right legs, one treatment of a
kneecap, and one amputation of a left arm. I raised my hand and gave
the signal and we all began together, orchestrally. Oh what a racket
that orchestra made! Without chloroform, or not enough. I invented
new kinds of heart failure right there on the spot! The bodies of the six
patients hopped about artistically and sang their lungs out. What har-
mony! But I could distinguish the voices of the emaciated wounded:
they were the woodwinds in our orchestra. The great big brawny
mountain trooper I was operating on made up the brass section, all by
himself! The two nervous ones had all the languor of violins and harps.
But suddenly I decide the orchestra no longer pleases me. Halfway
through I stop sawing my trooper's leg, pretend scientific rage, snatch
the instruments from my intern's hand on the right, and continue the
laparotomy he was performing. 'This is how you do it, not like that,
you fool!' Then I stop that operation midway, and grab the saw away
from my third intern. I cut off the wounded man's arm, and scare the
other two interns so much with my angry looks that they begin to saw
zigzag, like terrified violins. Finally, I remember my mountain trooper,
who, watching me take up the saw again, makes a heroic effort to sit
up, bellowing: 'You rotten bastard!'

"At that point, I pretend uncontrollable panic and sock him in the
nose. 'Don't you know I could let you die, you idiot?'

"My patient falls back flat on the table, and closes his eyes, exhausted.
I cut off his right leg, more than ever convinced it wasn't necessary. . . .
What madness! While I was sawing, a song came to mind. I think I
can still sing it from memory:

> Wide afloat
> is the boat
> of friends and relations
> salutations all around
> on the sea at night
> night bells sound.
>
> My mother gentle
> put her mantle
> over my sister
> kissed her when she coughed
> we feared the night

and its cold blight
would take her away.

"Mighty priest, do you like this song? If you do, I'll reward you by sticking you through the paunch again. Listen to the third verse:

Sister child
how mild the night
with melancholy
but our mother cried
as she espied Death
sitting in the boat
with the family. . . .

"The mountaineer was following the movement of my arm with his eyes bulging, as it worked the saw back and forth, and I felt that song laughing at me in my mind. I was almost whistling it. The trooper must have realized it, despite the fact he was a brute and insensitive . . . realized how I was enjoying myself when the saw would stick. He closed his eyes, horror-struck by what he saw, that satanic voluptuousness of mine:

Sister child
how mild the night
with melancholy . . ."

VII

The Paper Sailboats

The sun was setting, but the heat seemed to be increasing. Now and then the atmosphere pulsed as if stirred by a tired breeze that had come from afar.

The Negro soldiers were no longer paying attention to the Untamables and to their monotonous agitation, gradually subsiding. The Negroes standing around Mazzapà looked at one another, worrying about the gory stains that arabesqued their white uniforms.

"We did a good job to ourselves!" said Mazzapà. "There will be hell to pay if the Paper People see us in this condition. 'Your uniforms are white and must remain so!' they hissed at us last night. 'They must be so white that every pen imaginable will be tempted to write love poems on them.' What did they mean? I don't know, that's for sure. It doesn't matter, let's go!"

The Negroes set out after Mazzapà in the direction of the sea. The sand was cooler now, under their big, spread-toed feet. Their heads lowered, their torsos bobbing up and down, they were watching some big red ants like rubies in the sand, as they began to enliven the placid brilliance of the desert.

With its endless, shimmering lava, the sea embraced the scorched island. Even as it was setting, the sun poured down billions and billions of rays laden with molten gold. Rays like sizzling perpendicular tubes bounced blue-gold off the massive surface of the sea and then converged horizontally on the island.

The island was pierced perpendicularly by direct rays and horizontally by reflected rays.

On the shore, the black rocks danced the dance of mirrors. Maddening! On the gravel, liquid indigo, boiling. The Negro soldiers take off their blood-stained uniforms. They don't need to be soaked: just let them float a second in the water, and they can be taken out whiter than snow, burning hot.

The soldiers dressed again and continued on their happy way. But a rustling of dry leaves bothered them as they struggled to keep from sinking in the sand.

The Paper People were coming from their distant bronze Oasis. The rustling was heard again. Then stopped. Silence reigned. Mazzapà said, "Lucky the Untamables have quieted down. They're not shouting anymore. It stands to reason—with all that bayoneting. But they'll start in again anyway. Damn. I'd hate for the Paper People to punish us on account of those dogs. Let's go: just to make sure, let's give them a few more tastes of the bayonet. This muzzle is killing me. I can't stand it anymore. . . . Vokur . . . today's been a really bad day. Take the path to the left and go meet the Paper People. Hurry up! Try to hold them up for a while, make your report as long as possible. I'm going to the pit. Those animals could begin their racket all over again, you never know. Tell the Great Paper Chief that if they heard shouting, it wasn't our fault. We can't feed the Untamables with those meatless buffaloes. Why do the Paper People insist on sending us such skinny animals? They must have fatter ones on the Oasis game preserve. The Untamables need hearty food. Otherwise, one of these days they'll break out of their chains and eat us! They'll finish by eating each other."

Vokur ambled down the path. The rustling was getting louder. It spread, became more intense. The air seemed to be chopped up, ground to bits by that noise. As if great cracks were opening in the vault of the sky, with a loud ripping sound. Groveling, creeping, the noise expanded along the breeze that, still flaccid, seemed to test its strength against the thickness of the atmosphere.

When he and the soldiers got to the top of a dune overlooking the pit, Mazzapà stopped to take a look around. Down at the right, the Untamables lay heaped on one another, intermeshed like a grim mechanism, or a yellow hedgehog bristling with flesh, steel, and rusty iron.

The faint rustling was definitely growing louder, like dry leaves swirling in the wind. It was the typical sound of the Paper People. A

dune hid them from Mazzapà's sight. He squinted, spotted them. They were swaying back and forth very gently, moving across the sand in their robes shaped like yellow paper cones with writing on them. Each wore a circumflex cap, in reality an open black book turned upside down. They were within twenty paces of Mazzapà.

There are eleven of them, in single file, taciturn. They look out from gray, flat, eyeless faces, their mouths opened round like ciphers or O's of amazement.

They hissed, "Good! Bad! Wrong! Right! Duty and guilt! The Untamables are ruled by you who are ruled by us, because the Great No One does not rule or rules! You Negroes are imprisoned prison guards, worthy of our approving, inconclusive disdain. You will be punished or rewarded. And who knows, we may open your muzzles in a while?"

While they spoke, a light wind barely stirred the hems of their paper-cone robes that were written or printed on. The surrounding air was absolutely still. At the bottom of the pit, the Untamables had sunken in a heavy sleep. They snored and sizzled—*ssssss hrrrrrr sssssshhrrrrrr*—in the fat of their scars like fish piled in a too small frying pan. The sun was setting on the sinuous profile of the great bronze Oasis that seemed, under the brighter light, to grow fuzzy at the edges and to lose its mechanical stiffness.

On the other side of the island, against the arc of the sea's horizon, three small dark brown clouds were silhouetted. At first, round. Then they opened up like black petals. They were not clouds or black, those mysterious forms that the sun, still high in the sky, made seem black. Finally their actual form could be made out: tall masts with sails. The nearest grew clearer. Three sailing ships with lovely canary-yellow sails. Around them the sea was content. Or rather that inferno of molten gold gloried in them. A vibrant ecstasy of attentive gold faces. Swarming golden bees. An endless loom of frenetic gold. A hundred thousand nets loaded with crazed fish. A divining shower of diamonds. The three yellow sailing ships with their yellow sails cruised placidly with ceremonious dignity and low bows. Each of them had a terrifying whiteness about their keels. Then the tallest of the Paper People hissed, "Let us go to receive the commands of our King, Emperor, God, His Majesty the Contradictor."

They slipped away, one behind the other, those eleven Paper People, eleven yellow pointed cones, across the sand the setting sun had turned to saffron.

The sea multiplied its ever-changing marvels: zinc and silver plates with soft blue and flesh-tinted veining, maudlin glances, and turquoises in a swoon.

That inferno of molten gold grew ever gayer and livelier as it assaulted the skeptical, austere sailing ships. The ships seemed monstrous tropical flowers caught among buzzing liquid gold bees. The immense loom of the high seas trembled in the effort to weave sails even more beautiful than those of the splendid ships. In and around an uncertain light breeze flitted, with a thousand slithering, bright, metallic, tactile reflections, like silvered paper, smooth silk, ermine, and chinchilla. Now and then the very air itself stopped breathing, but the three ships would sail on under their own wind that filled the canvases taut, without stirring anything else. Now, all the parts of those remarkable ships could be made out. The keels were of brown leather. Not riveted, but sewn and fastened with studs of old gold. In some wondrous shipyard, perhaps one of the ports of the moon, skilled caulkers had sewn together the bindings of nine thousand ancient volumes, fashioning thus three solid but pliable keels, better than any ship keels imaginable, because they were made for the yielding flesh and capricious eyes of the sea.

The yellow sails, printed and written on, creaked loudly as they billowed out like starched skirts or books of empty philosophy.

The three ships hove to with a light pitching and rolling, their sails still inflated, perhaps with pride at what they were carrying. The eleven Paper People in a row on the shore stood silent and motionless. Bobbing gracefully, the three ships lined up with their bowsprits pointed to the shore. On each bowsprit could be seen a Paper Person identical to the ones waiting below. Each with his circumflex book/hat and his printed- and written-on conical yellow robe. All three opened their mouths in an amazed O. The first one sibilated, "ZERO."

Between the first and second ships, the sea gurgled for more.

The second Paper Person, on the second ship, sibilated through his amazed-O, "ZERO."

The sea between the second and third ship tapped out the word: "S-s-s-a-a-a-m-m-e."

The third Paper Person on the bowsprit of the third ship hissed, "ZERO."

All at once, the eleven Paper People on shore turned their backs to the ships and slipped away like conical vortices of sand, returning to the dune overlooking the pit of the Untamables.

VIII

Unlocking the Muzzles

The sun had set behind the Oasis lying across the horizon like an immense echoing rosy seashell.

The Untamables were all standing up, their heads thrown back, their eyes glaring defiance. The warm breeze lulled them with its soft morphine. They were already feeling its enchantment when the Paper Chief murmured, "Open the locks."

The Negro soldiers went down into the pit immediately and, without taking any precautions, began to release the Untamables from their chains.

The light was a voluptuous, iridescent cream. The air was plumed and pliant as if containing the softest springs. An airy touch, exciting, warm, reminiscent of velvet and wool crepe. Now and then, the sun's breath, with its grainy silks and warm sponges. The sand no longer sucked a man down. Numberless, the red, shiny ants turned the silky flesh of the sand into precious rubies. When the Untamables had all been released, Mirmofim, expanding his chest with a single breath, said in a jovial, paternal voice, "Ah, what a beautiful Sunday night with the family!"

A bright friendliness lit up the faces of the Untamables, while the Paper People, slipping hurriedly among the Negroes, their ivory arms flashing white from their conical robes, unlocked their muzzles.

They formed a single file, their muzzles clinking gently like happy pebbles in a spring stream. Ahead of them, the Untamables kicked their heels, joked, and gestured like so many schoolboys on holiday. On the

right and left, the Paper People acted as guides, like kind-hearted schoolmasters, and the rustling of the paper-cone robes accompanied the clinking of the muzzles and the steel-studded collars that no longer hurt but decorated their naked bodies like elegant charms.

And so that school of pacified Untamables made its way toward the Oasis of divine holidays, damp and dark.

The Untamables marched on for a few minutes, calm, unperturbed. The joy of being able to walk detached from one another made them forget the weight of the chains coiled on their backs, raucous knapsacks. They reveled in the fresh velvets of the night on their skin and strained their cheeks, still contracted in anger, to shape the first difficult smile.

But they contorted their faces clumsily and could not achieve the desired expression. Several amused themselves by improvising rather cruel practical jokes. Like schoolboys, they tripped each other or danced about to the clattering of the muzzles. But as soon as they felt the blue-green breath of the Oasis, they quieted down.

Their eyes were popping out as they admired the immense green wall of giant trees that majestically bore up its tide of foliage more than a hundred meters from the ground.

They were still quite a way from the trees when they found themselves already in their shadow, the fascinating and maternal shadow of the Oasis.

Mirmofim the surgeon, the always unexpected orchestral spirit among them, began to sing his favorite song:

> Wide afloat
> is the boat
> of friends and relations
> salutations all around
> on the sea at night
> night bells sound."

The other Untamables wanted to sing, too. They tried singing the tune in their harsh voices, broken by sobs, shrieks, gargles, and comic dissonances. The result was an atrocious cacophony.

"Keep quiet!" shouted Mirmofim. "Let me sing alone. You're all off key."

Mirmofim broke into the third stanza, completely infatuated with the triumphant pride of a singer.

"Sister child
how mild the night
with melancholy . . ."

"What melancholy? Don't be such a bore, you senile goat!" burst out
Curguss the priest, who was puffing under the weight of his pack of
chains. "We need fun! fun!"

"But I feel like being sad! sad!"

"And I feel like being happy!"

"And I sad!"

"I happy!"

"Sad, sad!"

"This is not the time or the place for sadness!"

"And this is not the time or place for happiness. So there!"

Mirmofim knocked the priest to the ground with a powerful back-
hand slap. Fight. Fierce tangle of bodies. Untangle. A tighter tangle.
Mingling of bodies, flesh, and sand. Thrashing around. A crush of rage.
In the swirling dust the Negro soldiers howled like jackals. Kicking
and punching to separate them. The others kept asking what was hap-
pening. No one understood.

Vokur distributed kicks in every direction, bloodying himself on the
barbed armbands and legbands of the Untamables.

"The Paper People are gone!" shouted Mazzapà. "They've deserted
us. We don't know the way. How are we going to get into the Oasis
without them? It's your fault! It's your fault, you damned Untam-
ables!"

A vague terror overcame the column of men already prey to bestial
rage. Their outcries ceased. They all stood without moving, gripped by
the tragic anxiety that floated out from the dark and menacing Oasis.

The pale sky had become livid, and below, at five hundred paces
from the trunks of the gigantic trees, there could be heard the sinister
creaking of numberless locks, perhaps like the ones that fastened their
chains. The Negroes remembered their muzzles. They were all trem-
bling. But the surgeon had a sudden inspiration.

"Let's go on! No more fighting!" he said to the priest.

He put out his hand to help him up. The priest was muttering.
Anger sputtered in his throat. But he got up, and they all set off again.
As if by magic, the sky immediately disclosed again its rosy whites, its
sign of pacification.

IX

The Oasis

The Untamables penetrated the indulgent shade of the Oasis. They could barely see, but were encouraged. Vokur, who had gone to the head of the column as guide, called to Mazzapà, "Look! This must be the right path!"

In fact the path grew clearer and clearer, as if paved with phosphorescences.

"You can see the tracks of the great snails."

"What are you talking about? There aren't any snails in the Oasis. You're the snail-brain here!" answered Mazzapà. "Those are the luminous tracks of the Paper People . . . just wait and see!"

From the green shade beyond, where the vaguely silvery path wound

z z

its way, there came a noise/sound like the rustling of the Paper People's

z z

robes, but less distinct. A bubbling, gurgling sound, as if from a fresh spring in love. The path went along an outgrowth of cactus and agave, prickly athletic warriors defending the dense colonnade of palms and sycamore figs. A warm, human atmosphere with the feel of suede and horsehair.

The vegetation grew thicker and its forms fused madly in the nightmare crucible of darkness.

Gigantic and bewildering, the cactus and agave dominated everything. Towering, they seemed to reign, resting as if after battle. But

underneath, the battle of the vegetal forms had already begun again with renewed violence.

Monstrous cactus and agave, like elephants and rhinoceroses in shreds, ripped apart by an attack of crocodiles, interlaced with the huge shears of their gaping mouths.

Witchcraft of light! They were not crocodiles but maybe the real, monumental shears of fabulous gardeners intent on putting order among that indomitable flora. Nonsense! Who would ever offend the venerable divinity of primeval disorder even thinking about the miserable human art of gardening?

The cactus and the agave were in reality the cut-off hands of giants bound in rusty chains. Bizarre games of cricket and lawn tennis broke out merrily with a great flashing of bats and rackets. Fast legs raced back and forth, firing fruits/balls into the air. But nobody was running. Everything was stone still. Spikes or spires? Very tall, metallic. Shadowy sieves of bronze dripping with the foam from prisoners' faces. At the right, monsters escaping. At the left, other crocodiles were half-buried in the mud. And in reality it was a hundred duels between the cactus and the agave, camouflaged.

With the sleek, proud charge of sharks, the agave attacked the cactus, right to their hearts, rank on rank, to the heart.

Above, without a sign, arose the stormy applause of a balcony of hideous hands. Higher up, erect, virgin-ravishers, the great phalluses of the agave were swelling with the bold lust of the stars.

The gnarled cactus, meanwhile, had reformed their ranks and were laughing with thousands of Negro laughs, poking fun at the agave that menaced them from all sides. These green fencers were showing off the suppleness of their muscles, arching out their metal necks and rubber torsos, but they dared not hurl themselves on the cactus, perhaps because they were so elegant they were leery of those lurid Negro forms.

Below, the thick, dark smells flowed into a single wide black river, in which the Negro cactus were massacring the sinister crocodile spawn of the agave with their oars. The more daring stood waist-deep in the water, killing the sinuous green jeweled octopus with their emerald daggers.

Above them, the crest of the Oasis was sagging like a bed under the weight of an invisible immense nude woman. There wafted about the perfume/memory of a night of love that had lasted a hundred years. As

they marched, the Untamables and the Negro soldiers kept their heads back to enjoy, with their eyes, their cheeks, their mouths, the fresh, aerial sea of overhanging leaves.

Baaaack and fooorth, uuuup and dowwwn, the leaves were trying to perfect the grace of their undulating rhythm with an untrammeled softness. The path turned toward the fleshy tenderness of the jasmine and acacia, and suddenly three large trunks heaved open. As at times the cottages of the forest open their warm hearts to the traveler wandering in the storm.

In each trunk, a Paper Person appeared, but lighted from within and quite different from the ones they had already seen.

Their written- and printed-on paper-cone robes seemed to be of translucent glass over their red, motionless bodies pointed wrong, like upside-down flames. Stunned, the Untamables came to a halt, half admiring, half afraid. But perhaps by some magic of those flame/bodies a constantly insinuating, compelling music came from their translucent robes, urging the Untamables on. And so the column advanced.

More Paper People sprang out around them from the other trees, and as these marvelous flitting lanterns multiplied, the Negro soldiers and the Untamables entered the Oasis, now sure they were being led toward a paradise of fantasies.

The surgeon and the priest were in front. They no longer were the least bit afraid. They wanted to see. They were the wisest. One day they would be able to tell all about it. But others wanted the honor of exploring and of being the first, the first to see.

"I'm a schoolteacher," said Kurotoplac, elbowing his way forward. "I know music. I can explain to you the harmony of the forest better than anyone. I'll walk ahead of everybody because the shuffling of your feet is distracting me."

"Oh, now we're really well off!" the surgeon muttered sarcastically. "Just a while ago you were as out of tune as a broken teakettle, and you've worn your eyes out reading too many books. You can't hear or see anything. With you as guide, we'd lose our way again."

"Quiet, for God's sake!" said the priest. "Let's not begin quarreling again. Haven't you all noticed that the minute we raise our voices to argue, the music of the leaves dies down, and what's worse, look! The lighted Paper People extinguish themselves and disappear. Let's walk silently and in line, without dragging our feet. I know what the dark's

about. I feel my soul welling up in prayer. It's like being in church!"

"Damn your church!" yelled the surgeon. "You'd give us the same line in hell!"

The path grew dark again, the music died down, and in the stillness could be heard only the rattling of the chains and muzzles, because all of them, the Untamables and the soldiers, were quaking.

A long silence of dark terror. A flapping of wings. A thud. A timid confession of humble, stuttering light against the confessional grating of the leaves. Then a white perforation and the flitting flames reappeared and the rising music once again wove its rhythms, now springing up cold like fountains, now sliding down in the long cadenzas of leaves that dream of flying.

The olive trees, the fig trees, the banana trees, lazily fashioned beds and hammocks out of the shade. Now they are already changing shape. Fleeting breezes from a female body are hollowing them out. Now they're becoming blue naves losing themselves obliquely in the depths of the Oasis.

The path became less irregular. It wound its way, always more silvery, like the luminous vein of a great heart bubbling with white light at the center of the Oasis.

With a melodious tinkling, a brightly lighted Paper Person, bigger than the others, appeared from a thicket at the right. He stopped for a moment on the path a few paces from the column of men. Then he began running around them. The upside-down red flame of his body was already being fanned by a steady wind, while his transparent conical robe whirled dizzily in the opposite direction.

Despite his speed, the characters printed and written on his robe could be made out. The Untamables, who had stopped to stare at him, were commenting in amazement.

As the Paper Person spun around the column, the priest said, "I've got good eyesight. I'll read him. Watch out!"

The great Paper Person spun by, a red flash in the dark.

"I've read him," said the priest. "On his robe is written: 'God is waiting for you on the lakeshore. In the lake ends all drought.' "

"We don't believe you," exclaimed the surgeon. "That's a priest's trick for the gullible. Besides, I'm thirsty too. Let's go!"

The great Paper Person ran ahead, and the Untamables followed, penetrating further into the Oasis. All their arguing stopped. Each was trying with all his might to change the expression on his face, still

deeply lined by all the old vengeful grimaces. Each praised his compan-
ion, extolling his virtues, his generosity, his goodness. They joked awk-
wardly, still testing the impossible tenderness they found in their voices
and their gestures. Their voices and gestures had been the foul, diseased,
runny spittle of ancient bile.

From the right came the faint tinkling of a distant caravan. It grew
louder. Then died down.

Suddenly loud again. Becoming a pinpoint in the dark, dimly. A
tremulous gold arabesque, dancing, dancing among the tree trunks.

Enchanted, the Untamables stopped, and the shining, twisting, coil-
ing arabesque unraveled to give birth to hundreds and hundreds of gold
spirals hung with bells. Living gold spirals that sing dreamily in the
fabled shadows.

X

The Green Harps

The silvery path now wound among endless tangles of liana wrapped around the trees. Strange white glints dripped down the listless vines. The music began again, but it was so oppressive in its suavity and tenderness that the surgeon turned abruptly to the priest and muttered, "Do you believe in the infinite indulgence of God?"

The priest did not answer, absorbed as he was in looking around where the marvels were multiplying. The endlessly tangled liana was becoming more and more capricious. No longer looking like liana but more like the slack strings of huge harps. Infinite strings overwhelmed by the sheer sweet excess of sound. Sound made up of a thousand sounds that clamor in the brain and blow it up.

The strange white glints on the liana seemed drops of pure sap, dripping down the vines in time to the music of the Oasis.

"That's not sap, those white things!" said Mazzapà. "They're white birds!"

Long white birds with very shiny thick plumage were flying around at a man's height, deliberately bumping into or brushing against the liana, drawing from the vines a broad polyphony, all crystal and bells, broken up into cooing chords and willful, tremulous notes cascading to infinity. Deceived, perhaps, one of the birds began flying close over the heads of the Untamables. It may have wanted, in its musical inebriation, to draw out a new sound from the sharp points on their headbands.

The bird's artistic delirium amused the men. They all laughed, com-

peting to offer their barbed heads to the strumming plumes of that winged musician.

"What strange claws, they're coral! Look! Its beak is carved out of turquoise," observed the teacher.

The bird swooped back, flying lower. Inspired. It brushed the stings of those nasty headbands that had become beneficent under that liquid/aerial strumming, rebaptized in a river of goodness.

The musical birds multiplied. They came in such white swift flocks that they seemed the rays of a hurtling moon. But there was no moon. There was, however, the longing, the hope, the memory, the yearning for a new moon invented by poets.

The daring arcades of the Oasis thrilled to the birds' white fluttering flight and the music, as if something superhuman were about to appear.

"Stop and admire all this!" shouted Mazzapà. "Here are the small blue teats. I recognize them. There were many in the Oasis of the Moon."

They all crouched around Mazzapà, who was kneeling in the grass pointing to a strange little animal that resembled a cut turquoise, breast-shaped, with six coral feet.

Wonder and uneasiness enthralled the Untamables: it was Thirst, that ancient thirst for knowledge that had burrowed in their bellies and in their lungs for so long. But transformed, purified into something spiritual. They felt it would not be long before they could drink their fill to eternity. A coolness—misty, tingling—descended from the trees. Droplets of honey and perfumed oils wafted about.

With uncontained joy, the Untamables exposed their wounds to the balms and unguents that impregnated the air—Illusion! Illusion! They are not balms or unguents! It's the merciful music that penetrates the flesh and anoints it with pity. Balmy lights that ease the torture of those sores.

In their mouths, on their tongues, on their foreheads and all their wounds, the Untamables were deliciously dying of thirst, thirst, thirst, thirst, thirst.

It seemed the thirst that had been caressed and cajoled from the waves of music. It became the thirst for a vaster, throbbing, consoling harmony. It was the great Thirst for icy spirituality and cool goodness. It sang, it cried, it spread, rising, rising, on the great liana strummed by the birds, sobbing, sobbing desperately, toward heaven, that Thirst, a Thirst stronger than any Thirst. And the lake appeared.

XI

The Lake

Motionless and dazzling, with a velvet brilliance between white and azure and ingenuous smiles like children swimming in the silvery water. No one was swimming in the still water, but its surface rippled now and then with fleeting apparitions. Dim profiles of evanescent women, curves of delicate nude bodies, misted hair, beringed fingers. . . .

There was not a thing in the water, not a thing. But all dreams bubbled softly there among velvets, crystal, and melodious jewels.

The lake was still, without a sound. But its blessed effulgence emanated power, nourishing with its bounty of light the immense growths of liana and gigantic palms, just as the heart supplies blood to the body's forest, whose trunk is bones and arteries, and whose leaves are trembling flesh.

The lake was not less than fifteen miles wide; it was as intimate and personal as a bath. Living, it breathed dreamy, infinite metamorphoses. It would have shrunk to a puddle under a child's feet. If it wanted, it could have waved aside the walls of resounding liana that closed it in, and washed over the entire Oasis, submerging it as greater pleasure submerges pleasure already enjoyed.

The shores of the lake were deserted, but their curving line had a painful, despicable harshness about it; and then, too, the felt solitude of prehistoric caves and at the same time the living mark of the artistic genius present there. Primordial yet recent shores, distant and near, dreamed and lived. They obeyed yet escaped the creative will of who-

ever would gaze at them. The air was an uncertain caress of silk, velvet, peach down, and bird feathers.

The lake seemed submerged moonlight painted by a diver/artist. Moonlight drained down from the heart of a wild poet. It had the fascination of great works of art. This fascination, projected against the vault of the night sky, had released and made away with the constellations, so that the stars, freed of their bonds to one another, flew about like red ribbons, blue diamonds, gold insects, fire ivy, scintillating clasps of joy, vermilion mouths, burning coals, bouquets of emeralds, ruby doves at absolute liberty.

The stars in freedom hurtled and fell over the lake lying in dissolved, oily moonlight.

Mirmofim, the first to arrive at the shore, was the first to observe the miracle.

"They've even freed the stars from their chains. No more constellations like files of prisoners. The stars are free! We've arrived finally at the Lake of Liberty."

Eleven Paper People sprang into view on the other side of the lake, whirling lighted cones rustling silkily.

The tallest spoke: "This is not the Lake of Liberty. You've reached the Lake of Poetry and Feeling. Drink up, bathe, and create, if you can, with the cool of these waves, the high serene music of Goodness."

While he was talking, other lighted Paper People appeared. By the hundreds. They came teeming out of the depths of the Oasis to the shore.

Mirmofim counted them. There were three hundred. But he tired of counting them because by then the other side of the lake was thick with Paper People, each one splendid in the pointed cone of his colored robe.

They seemed to be a tribe of thinking lamps wound up and flocking around the lake in search of a spectacle, lighting half of it with the brilliance of their own living glow. The other half lay in the unrippled silver of the moon.

The great Paper Person raised his voice: "Untamables! Don't be afraid of evil spells. Enter these beneficent waters and compose a soft music of affections. I know all about the poisons of war's cruelty that course in your veins. I know all about the damned bone deafness in your heads. But here you'll find the art of vibrations and woven sound. If you're uninspired, look through our robes and you'll find the right notes immediately. We'll judge. When you've reached the great human

rhythm, we'll lead you to the stupendous City of Spiritual Freedom!"

Irresponsible Vokur immediately dived into the water, crudely breaking the surface with the mass of his Negro body. They all began making fun of him. But the other soldiers were already following his example, stripping off their uniforms as fast as they could, while the Untamables decided to wait.

XII

The Last Dissonance

Mazzapà stood naked, his coal-black strapping body pouring blue-white reflections, and gesticulated wildly to Mirmofim to go in for a swim. Finally he seized his arm and dragged him into the water, which divided to receive them with a bleating chord.

Pushed and shoved, the others went in, too, joking and arguing with the splendor of that liquid light.

"It's too beautiful for me, this water is. . . . You're too affectionate, beautiful water! Beautiful water! Lady, marchioness, princess, queen, goddess of the waters! What beautiful jewels! And how many of them! Who stole them for you? You're a woman! Woman! Woman! Yet I know there aren't any women on this island. But you are woman! I embrace you. Will you let me? Let me embrace you!"

Everyone was enjoying the water as it spawned its fresh, fleeting fleshliness and its thousand offers/refusals of breasts bellies arms mouths.

"I'm going to dive into your heart, O Lake," shouted Curguss. "The lake is a fount of holy water. Look! I'm diving, I'm diving, and I bet I can stay underwater for twenty minutes, longer than a hippopotamus!"

Everybody clapped. A jury was named on the spot. Curguss dived in and stayed under. Childish wonder in all those faces that watched the surface of the water. Curguss was staying under! The ones who could not see joked, laughed, pushed each other around. The jury wavered. They ended by falling on Curguss when he emerged snorting like a hippopotamus.

By this time all the Untamables were in the water and were reveling in its healing freshness on their wounds. They were happy that thus with all those wounds they had more mouths to drink in more of that soothing water.

Mirmofim the surgeon took Curguss the priest by the hand, Curguss, the teacher Kurotoplac; Mazzapà and Vokur joined them, and the five of them began dancing in a circle in the water that held them by the waist. The points of their bands clinked together with a humble, desolate sound. Now everybody wanted to dance, just as they were dancing. The jeweled torpor of the water held their legs back. They had to content themselves with a slow march step.

"I can't stand this!" said Vokur. "It feels as if I'm still sinking into the sand around the damned pit. Come on, let's go around faster!"

Underfoot, the water with a thousand distracted fingers strummed sobs sighs whispers murmurs and gurgled songs invitations sucking down kisses licking and licking tears trinkets confetti rosaries cascades pearls and tail-waggings, castanets crystals and faint laughter.

"How maddening!" said Mazzapà. "If we only had a banjo or a darabukka!"

He left the circle and got out of the water. Standing on the shore, he called to Vokur and the other Negroes. They unwillingly abandoned the delights of the lake and gathered around their leader, who was shaking the chains piled among the trees.

"The Negroes are really good dogs," said Mirmofim, laughing. "Very ignorant certainly, but I hate them less than I did, almost not at all. They're not at fault. They're our condemned guards, and we're not very tame. To me they even seem too indulgent. . . . Vokur! Vokur! Come form a circle with us Untamables and we'll all sing together."

"Impossible!" said Kurotoplac. "Since we don't have any instruments and we don't know any songs."

"I can sing you one," said Mirmofim. "You know it, but you don't like it."

Everybody shouted, "Oh no, we do like it! It's beautiful! Let's try a chorus together!"

The great circle was formed. More than a hundred Untamables took each other by the hand, welding a new human chain, so different from the sad chains that were now reduced to playing the barbaric, monotonous accompaniment to the naïve music they were dreaming of.

The Negroes were goading themselves into a fury on the shore. The

Untamables rattled their armbands, headbands, legbands in time to the
march among the lunar lagoons shining on the lake. In the middle of
them, Mirmofim the surgeon directed the orchestra and sang.

> "Wide afloat
> is the boat
> of friends and relations
> salutations all around
> on the sea at night
> night bells sound."

But he stopped.

"No, no, not like that! A march step smacks of war and prison and
ferocity and chains. Don't you feel the contrast? The song is gentle, sad.
Stop your clatter, Mazzapà! Let's try the last verse, the one you don't
know. I'll sing it to you and you accompany me by buzzing like insects:

zzzzzzzzzz zzzzzzzzzz

Do you get it? All together! Ready now, I'm singing:

> Sweet is death
> when night winds blow
> into the trembling sail
> a white shroud
> on the dying white sea.

Their dance began again, with a drag step to their own *zzzzzzz*, to
the *ggtt, ggtt, glg, glg, chf, chf, clok, clak, plee, plee* from the water, the
clinking of their headbands, while from the shore the Negroes banged
out *zan, aza, aza, zan* with their chains and muzzles.

"That's enough!" shouted Mirmofim. "We're really unworthy of the
Paper People's friendship. We're making one hell of a racket without
achieving the least musical effect. It would be better not to do anything.
At least then we could enjoy the melodious music of the white birds
and the liana harps and the leaf guitars and the song of the liberated
stars. Keep quiet, by God! Keep quiet and listen!"

XIII

The Green Orchestra

They fell silent, and the forest immediately intoned a majestic chorus. Way up, the stars began singing, and there rose with their song, from one end of the Oasis, the sinuous, fickle arpeggios of the great harps of liana. Then the chorus ebbed, became languid, almost as if it were gently springing up and down on the tide of treetops. But then the branches came to life among the leaves, like frenetic bows of violins, drawn feverishly across the strings, pressing all the voluptuousness out of the night air.

How tender this last note. It awakens all the leaves of the big baobabs. They all play, countless leaves, piercing clarinets and winged flutes, while the trunks, like organ pipes, offer themselves to the high winds that race down them to come out the roots through round holes, with long, lowing, underwater notes, full of torment, menace, rapture, fortune.

Mirmofim said, "Listen to me! How marvelous this is! We must swim. Let's all swim, and while we're swimming, let's try to follow the beat of this supernatural music."

The Untamables began swimming, and as they swam to the strokes of that airy music, their gestures became more graceful; they were training themselves to gentleness. So that in their jagged, angular souls they were beginning to dream for the first time of a fraternal embrace.

The nightingales appeared on the scene, flying among the high foliage and over the lake in musical droves. With their trills, trills, trills, they started a competition. Brashly forcing all the musicians of the

Oasis to raise their voices in song, the nightingales completed the chorale, raising it to a more intense musical light:

tio tio tio tix tio tio tio tio tio tio tio tio
tio tio tio tio tio tio tix
 quitío quitío quitío quitío quitío tooooo
 tinoo tirradin
 ci

"They're the impassioned gallants of Light!" said Mirmofim.

"Gallants, gallants, gallants!" sang the Untamables as loud as they
tio tio
could, imitating the nightingales, who played gallants to their serenade.
tio tio
They trilled as the Untamables laugh cry sigh implore kiss, swooped
tio tio tio tio tio tio tio tio tio tio tio tio tio tio tio tio tio tio tio tio
down to a hail of crystal notes, as if they were trying to reach the depths
of human elation and grief.

Dialogue, repartee, and duels in sound. A defeated nightingale acknowledges he's lost with long, sobbing passages. But suddenly a conspiracy of notes bursts out in the irritated shade. Laughter cascades down. Chords tumble. Pause. In the familiar silence, another nightingale peeps out and sings to test the loyalty of distant echoes. He sings:

Squaaa pipi qui Squaa llia tidi qui

sings, sings, sings, sings, then drops into a hole. A mad merry-go-round of voices. . . . Cautiously silence comes back to the surface. A long suspense infused with magic. And it was the nightingales that imposed it, directing the chorale.

Now a single nightingale. His beak open, he hopped up, up, up

contio contio contio contio contio contio

a fountain of notes/tears/stars/kisses that splashed back showering the second nightingale with preciosity.

zozozozozozozo
zirradin tio tio
tio tio tio

The stream of melody that flowed from the first and the blood sound from the second aroused the jealousy of the other nightingales. All of them. Try and try again. To sing better. But they all preferred to im-

provise and the one hundred, two hundred, three hundred nightingales cast wide nets of trills to enclose the foliage of the trees in their immense musical rapture. Each net had thousands and thousands of hooks from which hung bait of silver notes.

And so the nightingales fished for flowers of light in the sea of leaves and in their nets pouring with harmony they brought in enraptured hearts. . . . Remembering . . . like seashells.

XIV

The School of Goodness

In the meanwhile, the Untamables were swimming in the lake, enthralled by the music of Goodness. Mirmofim suddenly stopped. He felt around for the bottom with his feet, and turning toward Kurotoplac and Curguss, who were swimming behind him, he said, "Let's rest for a while. This swim is healthy. I don't feel my heart weighing me down so much. It's as if I didn't have elbows or fingernails anymore. A tenderness is welling up in me that wants to keep rising, rising. Look me in the eyes, Kurotoplac. Don't they seem different to you? Yours are as soft as a baby's. All those children you killed are smiling at you, forgiving you, in those eyes. I think I've finally learned how to smile. Look at Curguss! He's not the nasty old priest he was! What a jovial, good-natured smile on him now. Curguss, what do you think of my smile? You smile, too. Let's all smile together. Let's see if you can really embrace!"

"I don't know how to," said Curguss humbly. "You teach me."

The Negro Mazzapà interrupted. "It's been two hundred years since my race practiced the art of embracing a friend. But tonight even the hardest things seem natural. How unlucky you are, all of you, because your damned bands with those sharp points stop you from embracing one another."

"We're cursed!" cried Mirmofim. "We'll never be able to hold anyone in our arms. Wounding each other, we learned to live together. We're condemned to expressing our affection by stabbing one another. But somehow, I feel today we can embrace."

"What will you do about those barbs?" asked Curguss.

"We'll try . . . very slowly. . . . Come here, Mazzapà. Listen to the musical love the nightingales and the liana harps are spreading about. Let's embrace, Mazzapà. Let's all embrace. With you, Mazzapà, and with you, Curguss, and even you, Kurotoplac."

The Untamables embraced, amazed that they were no longer hurting each other because the points of their headbands, legbands, and bracelets bent under the pressure of tenderness, like the tentacles of an octopus in the August-warm sea.

"Mazzapà," said Mirmofim, "call Vokur and the other Negroes so that I may kiss them on the cheeks as a sign of brotherly love."

As the Negroes ran over, trying to crook their arms into an embrace, the grand chorale of the forest pressed all the pedals of its ephemeral harmony. The nightingales strained their throaty song, trilling and imploring for love. The height of each outcry was reached, and the air felt as if some higher heaven had been thrown open, longing for all this tenderness, way up, toward the essence of absolute Goodness.

tio tio tio tio tio
tio tio tio tio tio tio
tio tio tio tio tio
tio tio tio

At that moment Mirmofim was throwing his arms around each of his Negro guards. After the last kiss on the second cheek of the last Negro, he said, "I finally feel good!"

The immense chorale immediately stopped. The numberless musicians of the forest, stunned, subdued, conquered by the supreme won-
tio tio tix
der. Three minutes of silence. Then, alone and recognizable, the voice of the head Paper Person was heard: "I praise you all, Untamables, and you, Negro guards, because you've discovered the great rhythm. You are all worthy of entering the City. Come, follow us, all of you!"

There was a great sparkling flurry on the lake. The Untamables came out first, pouring with light. Happy and docile as schoolchildren, they trooped into line and headed down the path.

The path was shining even more brightly than before, and one could see it curving around the lakeshore and then entering the thickets at the opposite point from which they had come. Habitually slow, the Negroes gathered the chains, and with their muzzles clattering over their

shoulders, fell in behind the Untamables. They felt the strength to go on walking for a long time, but they also realized, without being particularly concerned about it, that their bodies had in some way essentially changed.

XV

Lighting Up

"Strange!" noted Vokur to Mazzapà. "I have the feeling that my legs are full of wind, and my head is floating up, up. . . ."

"Naturally," answered Mazzapà. "Your head's a balloon anyway. But you're right. I've never felt so light either. My legs are as limp as rags. Something just crossed my mind, a memory, a flash, a light in the dark. Who knows what it means? We Negroes are poor folk, and we can never tell why something is or isn't. . . . Tell me, Vokur, what are the muzzles for?"

"I don't know. They're supposed to make a noise, like cowbells or buffalo bells, to let people know we're coming. If there's anybody waiting for us down there, they're certain to hear us, especially now that the birds have stopped singing. But I don't miss their singing. I feel like silence and the dark. What beautiful darkness and how good the damp feels on my skin! I feel like the king of this Oasis!"

The Untamables walked on in silence, but the few words they exchanged now and then revealed their contentment.

Overhead and all around them, thick shadows. But before them the path wound always more luminescent. Mirmofim was enjoying himself skipping among the silvery reflections and the long, dark shadows. Every so often he'd kick a stone that skittered away and was swallowed up by the darkness like a golden ball.

He was walking at the head of the column and often took Curguss by the hand because the priest couldn't see.

"Mirmofim," said Curguss, stopping suddenly, "I feel as if my head

were detached from my body and here in my chest I feel as if I were on fire. Look."

Everybody gathered around the priest.

"This is a miracle!" said Mirmofim, brushing his nose against his friend's chest. "Of course I see it, and I'm not mistaken. There's a flame under your translucent skin. Two, in fact. They look like two live coals, and I don't see your face anymore. Hell! It's turned to coal. You haven't changed race by chance, have you? Just to show sympathy for our Negro guards?"

Everyone was amazed and took a look for himself. Curguss explained, "It was just a few minutes ago, by the lake, when the nightingales began singing. I felt as if the music were burning my face. And it really was. Then I couldn't see anymore. Now I can see with my heart."

Everyone was listening to Curguss in astonishment, but not in fear. They were all standing quietly in the dark, rocking gently on their feet as if they no longer felt them touching the ground. Calm and sure, like hanged men glad to be strung up by the neck without feeling any pain, and with their souls at peace.

Lazy eellike reflections and shadows began slithering up their limp legs once again.

"I foresaw it!" said Mirmofim. "I'm being changed into a lamp, too. Look! Look!"

He raised his naked arms over his companions who came rushing to him. They had become as luminescent as two mercury-vapor tubes. At almost the same instant, Kurotoplac's round head lighted up with a white, studious, scientific, laboratorylike light. Then, despite the feathery feeling in their legs, the Untamables picked up their pace. They had enough light of their own now; the path could even be turned off. But it wasn't. Instead, its brightness increased maddeningly, giving them joy and power.

While the shadows thickened on either side of them, where the trunks closed ranks in their stony struggle, ahead mysterious points of light kept exploding, fiery balls, whirling aureoles of gold, sharp duels between reflections. They all sensed that the path had to lead to a great estuary of light, doubtlessly enclosing a vast sea of splendors.

XVI
The City

The Untamables marched on happily, cavorting like so many children, while the Negroes, who were a little hesitant, wavered like enormous lumps of coal between fear and hope. The Untamables kept embracing affectionately, like watchdogs happy on the leash.

Suddenly, a great polished light/sound that looked like an ivory tube high in the foliage blared out, its light forming a huge O of amazement in the dark silence.

The dazzling path climbed higher, but no one felt tired because they knew they would soon learn to see.

Thus it was that from the thousand-year-old shadows of the Oasis, the city appeared, lying open like a huge golden book. They all came to a halt and stood silently, overwhelmed by tenderness, as if they were looking upon the mother for whom for so many years they had searched and had finally found.

The city seemed to be arranged along neat, uncluttered heights that lent to its varied silhouette, twinkling with lights, the continuous, sure rhythm of a voyage at sea.

The Untamables wanted to pause here to prepare themselves for awesome sensations.

"Let's stop," said Curguss. "We mustn't miss this sight. It demands all our attention and appreciation. We probably do not have sufficiently trained senses to take in all these new forms. I can see with my new eyes—my heart—but not well, even though it's straining with all its might."

"I can't see well, either," said Mirmofim, "with these lighted arms of mine. Ah, if only their power to see were equal to their ability to perform operations! I feel, though, that I have nearsighted arms, tragically nearsighted arms! I should have my whole body lighted up to live in that beautiful city of light."

He had raised his right arm as far as he could in order to look around, like a submarine raising its periscope in a dark sea. At that point, Kizmicà, a grim murderer with a head like a starving wolf's, began to shake as if in convulsions.

No one had ever paid attention to him and to his inexplicable muteness. It was said that he had gone around the world murdering and robbing the rich, the poor, and other thieves. What could be wrong with him? His mouth hung open, but not out of fierceness or hunger. Maybe he was just yawning. He had fallen asleep while walking. But suddenly he gurgled like a drainpipe.

"How strange! My legs are lighting up!"

Everybody congratulated him on his feet, which cast beams like two flashlights.

"A vagabond like you could never have hoped for better. Let's not lose time!" said Mirmofim. "We can go on now. Our friend Kizmicà will make out the writing on the path with his feet."

They had noticed, in fact, that as the path widened, its light was broken up by phosphorescent writing. Farther on, tombs appeared along the road. But what they thought were tombs soon revealed what they really were. Large, open books, as tall as a man and lighted from within, but with a gentle light that was almost human.

There were more. Then the first incandescent houses appeared. Surprising, fluid, constructed of unknown materials. No one among the Untamables could really tell what they were made of. They came into a wide, very irregular street, with houses that were lighted differently, in varying shapes and proportions.

These fluid houses were constructed of a powerful vapor that flowed incessantly upward, shaping the walls, changing the forms, the volumes, the protuberances, the architectonic whole, so that it became a cube, then a sphere, an egg, a pyramid, an upside-down cone. The buildings didn't have windows, but movable holes, wounds, mouths, eyes, funnels, that opened and closed according to the whim and will of the inhabitants.

But no matter how the outlines changed, over all those houses of

gleaming vapor there floated a balanced point, platform, terrace, or spire that dominated on high . . . pensively. The strangeness of those buildings so overcame the Untamables that they did not observe the crowd in the street. The crowd was bizarre, too, distinctly out of a fantasy.

Teeming Paper People, lighted like the ones they had already seen. There were also men who seemed almost normal, with whom the Untamables felt a distant kinship. Although brighter than they were, these men still had not achieved the brightness of lamps.

The Paper People busily directed traffic, preventing the faster among them from going into the narrow side streets, as if there were danger there. From the depths of those streets, in fact, rose clouds of foul, acrid smoke.

Mirmofim, who had hidden in one, was forced to back out coughing.

"I know what that stuff is," he told the curious Untamables. "At the end, down there, there are huge ovens and incredible crucibles where they apparently destroy all the Paper People's old things: heaps of burned conical robes and shredded circumflex hats."

But a strange rumble drew the attention of the Untamables.

The street descended between the vaporous buildings, growing narrower as it went, like a funnel. No one was particularly aware of any danger, since they were all taken up with their new surroundings, and so they arrived happily at the wafting arch of a tunnel that burrowed under steel/smoke/dream girders. From the depths of the tunnel they could hear echoes of that always odder rumbling that forewarned of vast caverns. The Untamables advanced, but it was as if they were swallowed by the tunnel rather than entering it, sucked in by the voracious abyss.

Then, a burgeoning population of chimneys with flowing hair. Five Niagaras of fire. Staged naval battles. Daring, soaring gangways high over the warships that are sinking in seas of mist. Outstretched fists of cranes, fending off the assaults of rabid flames. Up high, the merry wheeling to and fro of tightrope dollies out of a circus. Reflections of rouge on the round throats of rivers. Blowholes, the broken pimples of volcanos. Blasts from furnaces. Sledgehammers pounding. Sparklers. Ray needles injecting fire into the dusky flesh of sick shadows. Air vents, panting like athletic trainers. Iron cages enclosing monkeylike fires with red-violet asses. Voluptuous masses of molten metal. Showering on walls of relentless convents. Rebellious populations of rope.

Dripping, swirling, running, pirouetting, up and down. Vertically. Horizontally. Like a pendulum. Alternately like a mountain, a mouse, a turtle, a feather.

Above, untouchable, the Paper People shone, the saints of this hell.

"Strange," said Mirmofim, who was walking in front, "what we're breathing seems like smoke, but isn't. We can breathe in as much as we want. I don't think it bothers our lungs. Go ahead and take deep breaths. It seems like immense human respiration: rich, endearing, healthy."

The air was gray. The atmosphere darkened. They couldn't see any-more; they had to stop. But tongues of light flashed out, and Mirmofim once again led the column forward, into the sloping, narrow tunnel.

He walked holding up his two lighted arms, happy with a scientific happiness, his heart gripped by the foreboding of an inevitable truth.

"Ah, I never thought I'd be a lighted candle guiding the faithful!"

XVII

The Light and Paper Workers

They were marching on in faith, like pilgrims in the catacombs, sure of
an imminent apparition.

"The halos of the Saints!" shouted Curguss, who had cupped his
hands over his flaming heart, casting a beam of golden light straight
ahead like a miner's lamp.

"Those aren't saints' halos you're seeing," said Mirmofim. "They're
Buddha's solid gold bellies. Maybe we're in an Indian temple."

The air cleared, penetrated here and there by pale, distant suns.

Ten. Twenty. Thirty. But as the Untamables were counting them,
those strange suns multiplied by the hundreds and grew brighter at the
same time. Finally they could be made out. Whirling, shining hubs of
immense perpendicular wheels.

That wheel on the right must be at least a hundred yards in dia-
meter!

Over the fantastic upright wheels, the vault soared lyrically to form
an impassioned arch whose heights were lost in the darkness.

Advancing farther into that atmosphere crisscrossed by lights and
smoke, the Untamables saw that the wheels meshed into each other at
great speed.

Around each wheel busily whirred a complicated mechanism of
smaller wheels, the height of a man, with what appeared to be black
rags flapping at the spokes.

The Untamables stopped, astonished at the sight. Those rags they
r r

saw seemed to be panting. They were living beings! Limp, as if bone-
r r
less, seemingly dragged around and around by the wheels, but in real-
r r
ity, it was they who were turning the wheels. From time to time, one of
the flaccid, contorted beings slowed down his jerking movements. They
could hear him panting and groaning from fatigue, while the wheels
around him, still in gear, also slowed. And the giant major wheel re-
vealed, as it too lost speed, its edge of bright silver teeth. A hissing sud-
denly cut through the hot air.

"No slowing down! To work! Faster! Faster! Whoever stops will be
punished! Work or death! Speed or death!"

Shouts, moans, groans erupted among the workers. Endless numbers
of workers. All of them bent over their wheels. The Untamables were
impressed by the precise figures flashing across a giant electronic board:

At work rotating: 10,000 right hands, 10,000 right feet
10,000 grinding mouths.

Meanwhile, amid the hubbub, some words could be made out.

"O.K., O.K., work faster. We accept it, but we're tired of turning the
same wheel all the time!"

"I want to change jobs. Today I'll build a motor, tomorrow a tractor,
and the day after I want to make a rifle!"

"I'm tired of running a machine somebody else invented. I want to
invent and build a whole new machine."

"I want to invent things, too! We all want our own personal work.
Everybody has to create and build whatever he wants. His own fancy!
Down with monotony!"

"Hurrah for imagination!"

"If I could only use my left arm! I've been working for ten days with
just my right arm. My left arm's going to be paralyzed!"

"Down with daily work!"

"Down with right-handed slavery!"

"Hurrah for the freedom of the body!"

The Untamables were shaken as they made their way amid all these
outcries from the workers, under those great upright wheels that clat-
tered round and round faster and faster. It was an inferno.

They ran into a long column of black, stooped men who emerged
three by three from the smoky depths of the cavern, swinging their

right arms in cadence. Their left arms hung slack and withered at their sides, and they lurched to the right as they marched because their paralyzed left legs couldn't support them.

By the time the Untamables had left the last stragglers from the column behind, the atmosphere had changed. No longer was the air rent by moaning and heavy panting, now it was foul from the white acrid smoke that rose in clouds from huge boiling caldrons.

"I know what this is!" cried out Kurotoplac. "We're in a paper mill!"

Under the high domes shaped like endless chimneys the smoke of hundreds of caldrons rose lugubriously. Each caldron was as wide as a city square and circled by the gleaming tracks of the many trains that whistled, smoked, and chugged below in the cavernous space that was like a giant railroad station. At the right, over the first caldron, the steel railing of the Observation Gallery glinted through the brimming smoke. A Paper Person appeared in his conical book/hat. Deadly white, a spectral chalky white, the Paper Person dryly hissed, "All clear second train loaded with silk, velvet, purple dye, and ostrich plumes!"

In that smoky subterranean immensity, red signals rebounded like the flushed, apoplectic faces of drunken, gluttonous demons.

A locomotive with a long silk swath of white smoke trailing behind it rumbled and squealed, and the train, like an overloaded dromedary, lurched forward with its fabrics, skins, furs, and plumes, slowly circling the entire caldron with its bobbing cars.

The first car tips, spilling its gaudy load. The second disgorges a landslide of ermine. The third car aerates the material piled in the caldron with a shower of plumed fans, topping the whole with a flight of ostriches in a burning forest.

Like enchanted children, the Untamables ran toward the second caldron, it, too, vast as a city square.

At the steel railing of the Observation Gallery, the great Head of Paper-making appeared amid the billowing smoke. He also was a Paper Person, but whiter than the other. He was as blinding as a block of crystal struck by a hundred suns. He hissed, "Send the fourth train on its round, loaded with all the Autumns, all the clouds of sunsets and dawns!"

The lights blinked their red eyes simultaneously, full of joy.

The first freight car dumped a hundred red vintages and whole lengths of autumnal vines crushed by thousands of grape-gatherers' feet pumping as fast as racers in the most frenetic bicycle race.

The second car broke up into red tears, cutting its veins and bleeding like an immense heart stuffed with all the hearts of grieving Madonnas and mothers widowed altogether of husband-son flesh and guts.

The fifth car inundated the caldron and all the caves around it near and far with a profusion of rose, carmine, ruby, decayed, light, heavy, ecstatic, prophetic, drunken, inebriating, gilded, mad, and melancholy clouds.

They swirled everywhere, dyeing everything, billowing into every corner, frenzied clouds whose sole intent was to conquer all black nights.

The great Head of Paper-making hissed again, "Call the fog train!"

Soapily slipping without a sound on the gleaming tracks, the fog train came like a long, long mother-of-pearl gray ribbon and emptied its wafting cars, permeating everything in gray.

No one could see.

"Hell, where are you?" shouted Mirmofim. "All the Untamables here! This is London fog. Reminds me of the time I was left groping with my instruments the day the fog in London poured into the hospital and hid the incision I had just made. I was hallucinating—I was a surgeon and I was lightning, magically suspended over the English Channel. It looked like a foggy incision miles long, just like this caldron."

Meanwhile there could be heard a vast rustling and wailing, which recalled the noise of the Oasis, even more so the sound of people rioting.

The Untamables hurried along, anxious to question somebody about all this, but all the human beings had disappeared, and they met only the Paper People who flitted away in their translucent paper-cone robes.

"As much as everything in this city might seem new to us," said Mirmofim, "I have the feeling that what's going on here is not usual for this city."

"Of course," said Curguss, "I have the same feeling . . . something unusual is happening. The Paper People we're running into are too worried. In any case, it's strange they're ignoring us!"

"I don't agree with you," said Mazzapà. "They disdain us because we're poor, and here they're all lords, princes, and kings!"

XVIII

The Riot

But Mirmofim was right, and the Untamables realized it when they came into a large square closed in on three sides by tall, fluid buildings that glowed brighter as more and more Paper People and half-lighted men thronged there. They weren't shouting or even talking, but hissing like thousands of winter winds at thousands of different cracks.

All at once, the crowd fell silent and the half-lighted men raised their heads. On the soaring, oscillating facade of one of the buildings appeared a huge megaphone that seemed to be made of transparent metal.

Within, a gigantic tongue of fire throbbed. The Untamables understood: a head Paper Person was lying flat on the roof in order to use his body to speak as an eloquent flame/tongue.

"Paper People!" he began. "You who have already reached the state of enlightened grace, and you, half-lit Men, who will certainly achieve the state of enlightenment, I plead with you to support the cause of the oppressed River People! I am not a River Person, but I love the River People and I defend their sacrosanct right to flow freely and to mingle with the Lake of Poetry!"

The crowd wove together thousands of angry hisses.

"This hissing," explained Kurotoplac, "is really applause. Apparently the Paper Person who's speaking is a revolutionary. Let's hear what he has to say."

"The River People"—from the roof of the building the Paper Person began speaking again with his tongue of horizontal flames—"the River People are no longer the scattered, rejected, irresponsible people they

once were. They've united to form a single river, and as such they don't want to be contained between stone walls anymore and have to labor so hard to turn the giant wheels of our generators. They want their river to flow freely through the Oasis and mix with the waters of the great Lake of Poetry, to find the peace they have longed for for so many years. But the privileged Paper People who rule us are opposed to their freedom. They're abusing their power! It's not just! The former government understood the times and conceded a great deal to the River People, that's why a bed leading from the city was dug to divert the course of the river toward the Lake of Poetry. A few yards from here rises the waterproof Cardboard Dam that is frustrating the hopes they've had for thousands of years to flow outward.

"The Cardboard Dam is blocking the arteries of the world! Put aside your fear! Get ready! The hour is coming when you will have to launch an attack on the Cardboard Dam!"

Sudden shouting and screaming.

"Rain! Rain! Rain!"

Not that it was really raining. Just a few drops. The fear of rain haunted the city. Then five Paper People were extinguished. Others flickered. A looming Paper Person made his way through the crowd that had become a series of shifting lights and shadows. Eleven Paper People followed him, but they were less imposing and not so brightly lit. Marching in step, they formed an orderly circle around the great Paper Person. Then each made a half right turn and bent over the paper-cone robe of his neighbor, ready to take dictation with their elongated blue hands made even longer by blue brushes.

The rain poured down, extinguishing the city. The crowd had dispersed. Only the Untamables had remained to watch the strange ritual. The great Paper Person, like a diamond in a diamond setting, said: "Rain of Time and Tedium, you will not defeat the city! My song is enough to put you to flight. I challenge you! I challenge you! I challenge you! You pour down water/boredom and I will hurl light up to heaven! You send down darkness, rot, and terror, and I'll send up joy, blue-white joy!"

How long did the struggle of those living diamonds of tenacious light rage against the murky offensive of destructive Rain?

The Untamables looked on fascinated as the eleven Paper People decorated each other's conical robes with blue writing at the dictation of the great Paper Person, who was getting bluer and more dazzling.

"The reign of Light is at hand! Light will triumph! With speed, in speed, and from speed Light will burst out. Speedlight! Speedlight! The whole world hopes for Light. We are real Light! Diamond! Diamond! I am Diamond the Poet!"

Light shot down from the heavens. A hundred thousand thousand Paper People turned on together. That living column of light moved forward. Caught up by the current, the Untamables followed. A voice cried out, "To the River!"

On the roofs of the vapor buildings, which were lighting up again, other Paper People appeared. They were lying flat, their body/tongues lighted in their sounding-horn robes. Motionless as if they were about to speak. They were all of different sizes. Some were small children. Others were adults. Some were very old.

The flowing crowd came to a halt. The road must have been blocked. The Untamables peered to find out what was happening. Around each building, they saw the same monumental books lying on the ground, at least two or three, which had amazed them when they first entered the city. A few steps from Mirmofim, one of them suddenly snapped open with a rustling of colored pages. The liveliest of the pages ripped off in a single twirl and formed a cone, pasted itself shut and stood point upward. Suddenly a light budded inside and, as it unfolded, became redder and fiercer.

Thus was born a Paper Person. A written thought magically transformed into action/life. Mirmofim, who participated more and more in the mysteries of the city, called to the other Untamables.

"Look there!" he cried. "Look at the gray vapor the Paper Person's flaming body is giving off and compare it to the walls of the buildings. I'm convinced the Paper People build their own houses out of the vapor/light their bodies emanate. These big books lying here are the cradles, the beds, and the graves of the Paper People."

XIX

Cradles, Beds, and Graves

While he was talking to the Untamables, another book opened suddenly right at their feet, giving them a terrible fright. There was only one page left, and the jagged ends where the other pages had torn themselves off and become living, moving things.

The page flapped.

"Kizmicà, go closer, go ahead, read it with those lighted feet of yours!"

Kizmicà, who like the rest of the Untamables obeyed the surgeon blindly, stepped forward to read.

"I've traveled all around the world and I know every language. Putting them all together, I should be able to make out this one language I don't know."

Then pointing his feet at the page, he began reading.

"At the top of the page, which must have been the last one in the book, I can make out: 'The Social Contract by Jean Jacques Rousseau' . . . and in the center of the page, 'End.' "

The Untamables could not contain their scientific curiosity. They had to find out what those marvelous books lying about really were. Kizmicà was first, ready to illuminate the flapping pages with his light/feet. As he deciphered the words, he discussed their meaning with Mirmofim. That is how they decided that the books in the worst condition, the ones with practically no pages left, had the most powerful spiritual significance. The others, still closed and new-looking, were obviously sterile or embittered, in any case incapable at the moment of

changing their pages into living Paper People. One of the most worn books fell open to reveal a splendid shiny blue page, on which Kizmicà could make out the single word: MAZZINI.

Meanwhile, the crowd of Paper People and half-lighted men were still struggling to break through the roadblock and reach the embankment of the river, which could be heard gurgling and lapping.

No one in the crowd paid any attention to the Untamables, who were poking around among the books lying in the streets like so many bookworms feasting in a very exotic library. There were the great books by Spinoza, Pascal, Machiavelli, Vico, Nietzsche, Kant, Marx. Gawking like provincials, the Untamables stopped before the largest and most brightly lit of the books. It was turning continuously, and its pages, as if caught in a comic frenzy, competed in twirling themselves into cones.

The Paper Person who was thus formed darted away with incredible speed and immediately went up the steps of the incandescent buildings to the upper terraces, from which point he could look down imperiously. In just a few seconds, that potent book gave birth to twenty-two Paper People. They weren't ordinary Paper People. The cone of their robes had the dazzling brilliance of a cut diamond—For a second they stood there, as Paper People usually did, then, turning upside down, they presented their round bottom orifices to the stars. Thus transformed into projectors, they printed blinding, diamond words-in-freedom on the sky.

Their piercing shafts of light searched the night sky, erasing the ancient constellations and giving birth to new stars. They kept writing, writing, with mad lights/letters, frightening thoughts, mysteriously beautiful thoughts.

XX

Toward Futurism

Straining their eyes to the sky, Mirmofim and his companions were trying to read that celestial writing. They were driven by unbearable curiosity. They thought of all possible readings of the message.

Suddenly an idea struck them. Mazzapà explained.

"That's right . . . one on top the other . . . we'll climb there. . . . At the bottom a good solid base. The twenty strongest, with their arms folded. Then eighteen on top of them. And on the eighteen, sixteen more, and so on till we reach the peak."

The Untamables mounted their Tower of Babel. Everybody pitched in, sure of success. They were very anxious to read what was written in the sky. Up, up, always higher. Being the brawniest, the colossal Negroes who had to support the great tower at its base didn't complain at all. Below, Mazzapà, bearing most of the weight on his giant caryatid shoulders, roared out, "Send Mirmofim the surgeon to the top of our tower/pyramid. He's the most daring and canny of us all."

Mirmofim, last, clambered up. At the summit of that swaying but balanced human tower, his chest swelled with pride at being as high up as the tallest of incandescent vapor palaces.

The shafts of light projected into the sky by the upside-down Paper People had multiplied, crisscrossing each other. The sky had become a tangled forest of spotlights inscribing acetylene words. To the right and left other searchlights, like immense plows and hoes, were breaking up the endless black plains of the sky.

Mirmofim raised his lighted arms and peered as far as he could. But

he couldn't make anything out. He felt dense and imperceptive. Disheartened, he let himself down, grabbing on carelessly here and there to the outjutting bodies. The tower took itself apart with sobs of bitter disappointment and defeat. But Kizmicà led all the Untamables back to the large book that kept on giving birth to diamond Paper People.

They all hunched over to stare at the bright flashing pages like provincials on the deck of a transatlantic liner peering through the glowing portholes at the hot fury of the engines.

In fact, that great book was not only a gaping, inexhaustible womb, but also a tireless engine of the voyaging city of Thought.

Kizmicà had been standing upright for five minutes, his head bowed, watching his lighted legs that cast rosy reflections on the flapping pages as they gave birth. They twirled away so fast, however, that no one could read them.

"I read one! I read one!" he shouted. "These words:

THE FUTURIST MANIFESTOS
MARINETTI

Mirmofim started suddenly, struck by inspiration.

"Friends! Friends! Listen to me closely! That crowd of Paper People and half-lighted men that's rioting needs a leader! They're all crying out for one, but they can't find him. They want to be able to recognize him on the spot. He has to be already tried out, like a well-cooked piece of meat. What imbeciles! The great book of Futurism teaches us to make up everything, even God! We've got to make up a leader for the crowd. And that leader is me! Come on, let's go!"

They all rushed after Mirmofim, who punctured a hole in that crowd and injected them with Untamables. The people made way, awed by this unknown opaque force that could rend them, so luminous and translucent, apart. The immense crowd of living lamps were soon dominated by that hurtling mass of black coal. Perhaps because they had become used to their own steady light, those lamps had forgotten their strength. Perhaps those blind coals, precisely because they were blind, had absolute creative insight.

XXI

The River People

The crowd followed Mirmofim and the Untamables, who were so used to not sparing their bodies that they blithely crashed into the condensed vapor and cardboard barriers. The Untamables did not have the fine fragility of the Paper People. They bloodied themselves in making the breach. Wasn't getting bloody their natural way of living, loving, and thinking?

The lamp revolutionaries and their half-lighted allies followed close on the heels of the opaque Untamables. But it was the Untamables who always led. Forward! Wreck everything! God, what jabs! Who dared counsel caution? Slow down? Hell no! The road is open! Instinctively, dashing head first right to the end. Madly opening, going, running, running . . . here's the embankment down to the river!

Thundering and fast the river flowed, its roaring made up of millions of roars put together. That formidable current contained curses solidified in the form of knotted ropes, tears in the form of women, sobs in the form of tubercular babies, vendettas in the form of elephant teeth, hatred in the form of steel saws, long threat/whips, damnation/daggers, kiss/bites, throttling embraces, bilious smiles, the dribble of winter dawns, the jaundice of anarchical sunsets, revolutionary taverns on the move, a hundred thousand red bottles talking and gesticulating, a billion backs of servants bent full round to form ferocious wheels, all the bloody, horrible catastrophes of the poor turned into shirtless living beings with red belly buttons, the seal of death by taxes.

That river blended all of life under the kinky coiffure of unsatisfied

desires that had their fulfillment in heaven. At a higher level, on the other bank, the tall, incandescent vapor buildings had statuary along their façades and galleries that were really the Great Paper Governors.

Above them, the sky was a tangled forest of bright swaths that were being projected from below on the arching vault of the night.

And as if it could feel the pressure of the Paper revolutionaries and the Untamables crowding at the embankment, the great River swirled faster, its surface crinkling with yelling mouths, clapping hands and bristling hair to acclaim its liberators.

<p align="center">o-eh o-eh o-eh o-eh o-eh</p>

<p align="center">aaaaaaaaaaaaa uuuuuuuuuuuu</p>

<p align="center">rrrrrrrrrrrr vvvvvvvvvvvvv</p>

<p align="center">iiiiiiiiiiiiiii</p>

The storm of applause lasted an hour. Then Mirmofim, who moved with great dignity, puffing out his chest and keeping his head back, spoke as if he were their recognized leader: "I greet you, great River People. I have led this crowd of Paper revolutionaries and half-lighted men to you to meet you, to admire you, and to help you in the final battle. I come from the great Lake of Poetry!"

A wild cry of joy leaped from the river, and the billions of river mouths went into a frenzy over the man from the lake. All of them shouted together: "To the lake! To the lake! To the lake!"

Mirmofim, his arms crossed before him, went on, "You're right in shouting out like this. You have certainly sensed the divine sweetness the Lake of Poetry contains. The great Paper People who want to imprison you in the city have ceased to govern. You have toiled too long under their wretched rule, running the generators, bent over them without ever being able to raise your eyes to celebrate the spirit of the sky. Now those dogs despise you because you don't know how to look at anything except the ground and your feet. I'll teach you to flex your necks and to take a good look at heaven!"

A long, long, long bared, writhing hiss—a saw or a strangled throat—interrupted Mirmofim.

The hissing came from the tall incandescent vapor buildings on the other side of the river. On the highest level appeared two sparkling Paper People. A name ran from mouth to mouth among the rioting crowd gathered at the embankment.

"Nonnot, Nonnot, Nonnot . . ."

It was Nonnot hissing, Nonnot, one of the absolute rulers.

In the total silence that fell over the crowd, he spoke: "Noooo! Noooo! Noooo! The River People will continue to obey. . . . They are brute force, the quantity. Only we can rule, we the quality!"

"That's untrue!" shouted Mirmofim. "Everything that used to be is wrong, because it used to be. Everything that has not been is right, because it has not been! It will be! Quality was! Now we'll get rid of it! Quantity has never ruled! It shall rule! We want it!"

This sibylline speech upset the Paper revolutionaries and some of the half-lighted men at the riverbank. Even the River People didn't understand. Confusion, uneasiness . . .

Wavering . . . yes . . . no. Why? Is it me or him, the imbecile? Murmuring of a skeptical sea. A rain of doubt on men's souls.

Mazzapà, holding Mirmofim up in his powerful arms so that he could persuade the crowd, grumbled, "Talk more clearly. I didn't understand a word you said. Explain better. If you don't, the crowd will turn against you."

The indecision of the crowd played into the hands of the Paper Governors. From the other bank, the second Paper Person allowed his honeyed, perfidious voice to drip down.

"I am Yessiir, who governed your city for so many years. You probably all know me, including you River People. I never said *No* to your demands for freedom. I was always your friend, and when you asked to flow unhindered to the Lake of Poetry, I answered *Yes*. Now, in the name of the new government, I still say *Yes!* So rest assured, you will go to the Lake of Poetry. Your bed has already been excavated. And don't forget that good bed was dug at my orders!"

A storm of joyous hissing acclaimed his generous speech. Everybody —the Paper revolutionaries, the half-lighted men, and the River People together—thought the ancient issue of a free course to the Lake of Poetry had been magically resolved, thanks to the paternal goodwill of the Governors.

A solemn, heavy silence. Yessiir went on: "Yes, you shall go to the Lake of Poetry. Indeed. But not everyone, however! Some of you will have to continue the great work that is so necessary to the city!"

Mirmofim realized Yessiir's mistake in a flash and shouted, "Liar! Imposter! Shyster! Your speech is just a cover for a swindle! River People, don't listen to Yessiir! The time to revolt is here! Paper revolutionaries and you, my brother Untamables, follow me! Let's smash

down the great dam of cardboard and condensed vapor that blocks the river from flowing through the forest to the Lake of Poetry. That dam won't hold for long! It's old and rotten! It won't hold! Come on!"

"No! No! Wait!" cried out a Paper revolutionary behind Mirmofim. He was very popular and respected for his honesty and wisdom. His name was But. Everyone quieted down to listen to But.

"Wait!" he began. "This is a very serious moment. Before deciding anything, we must study the condition of the dam and also if the new free course, which we all justly demand, might not, as I fear, over- whelm us, indispensable Lamps, and with us the enlightening spirit that must guide the river to the Lake of Poetry. Let us try to find a way of reconciling its right to flow freely with the continuity of the enlight- ening Spirit. For your sakes, for ours, for everyone's, I want the River People to achieve finally their goal of flowing to the Lake of Poetry, at the same time supplying light to the city. I am not a conservative, as you all know. I am an old revolutionary, and it pains me to say to you: Wait! Because my suffering along with yours has no more patience. But revolutionary wisdom and the experimental nature of violence urge me to pronounce these dreaded words: Wait! Reflect! We'll decide to- morrow!"

"No! No! No!" cried Mirmofim. "The great tomorrow is now, here in your hands! Death to the city! Death to the enlightening Spirit! Down with Yessiir! Down with Nonnot! Down with But! Let's de- stroy the dam. To the lake! To the lake! To the lake!"

Spreading out with a great shout, the crowd rushed after Mirmofim, who was held high on Mazzapà's shoulders as if he were on a moun- tain, waving his phosphorescent arms around, like a fisherman who had just gutted rotting whales.

XXII

The Cardboard Dam

Within the embankments, the River People rebelled, abruptly changing course and heading straight for the Cardboard Dam. When the Untamables reached the gates with the two hundred locks, Mirmofim and Mazzapà climbed up on the bars and began to hack at the retaining wall of reinforced cardboard with their axes. The Paper revolutionaries and the half-lighted men on one side, and the River People on the other, incited the wreckers with wild cries: "Rip it down! Rip it down! Open it up! Smash it, smash it!"

Mirmofim labored at that tough surgical operation with his two lighted arms, finally content at being able to open a belly worthy of him. The enraged River People hurled themselves against the dam, and with their teeth and bristling hair grated and ground at the tough wall, while the dam swelled like a belly under the surgical hand of Mirmofim.

Kurotoplac, hanging on to another gate while he drilled the bars, shouted, "Watch out! The center is giving! This gate's opening! Watch out! Here she goes!"

He clambered down and reached the embankment just in time.

PARAPAM PAM PAM TRAAAAK

sssssssssssssssss

rrrrrrrrr zzzzzz sssssssss rrrrrrrrrr

u u

The gate spewed out like a madman's thoughts.

Through the opening, thirty thousand River People splashed, in waves, in froth, in tidal assaults, across the city.

toom toom tooroozeeee
FROOON BOOOAAMMM FROOON BOOAAMM

The second gate buckled, as Mirmofim yelled out from the embankment: "Forward! Forward everybody! Follow me! Up the hill on the right! Let's get to the high points of the city! It won't take long before the low parts are flooded! Quick! Out of here!"

A thundering crash, shrill rending. Roars of wounded beasts. Bombardment of echoes. Smacking of water-filled bodies. The dam had shot all over the place, spewing the River People down onto the city, flooding the squares and streets . . .

ggg
ggg

From up above, a cascade of River People gushes down, surging and frothing in the spillway. It's full. Brims over. The water pours around two old incandescent vapor buildings that tremble in the wake of that possessed, swirling tide, totter and fall as if they really could be destroyed.

The whole city appeared to be flooded by the blue River People whose swift current insinuated itself everywhere, becoming a deeper blue-green, like inlets where underwater plants grow thick. But the newer incandescent vapor buildings floated gracefully, solemnly, without falling over. Several of them that had been sheared at the base by the immense knife edges of the blue current floated majestically free. On high, the Paper Futurists, unmoved by what was going on, intensified their activity as immortal lights and reigned over those wafting, luminous constructions.

Almost indifferent to the great blue revolution of the River People,
ggg
they continued to beam up at the sky from the cones of their robes
ggg
those long chalk/light fingers of theirs, writing imperious words-in-freedom.

Meanwhile, Mirmofim was rushing to the higher parts of the city along with the Untamables to escape the roaring River People, who were carrying everything away in their destructive fury. His body

seemed to have lost all human weight. Around him, along with him, things were hurtling, rolling, slipping. His mouth gaped with the mad flight of his heart running ahead of him.

"The path! The path! Where's the path? Quick! We must find the path again before the River People reach us!"

"There it is! There it is!" shouted Kizmicà with his lighted feet.

Mirmofim headed toward the Oasis waving his lighted arms. The Untamables ran behind him, terrorized, colliding with tree trunks and knocked rolling to the ground. The vaguely phosphorescent path guided them. But Kizmicà's feet were slowly dimming. They couldn't see the path anymore. The Untamables stopped. They had to catch their breath. Curguss said, "We mustn't stop! If we do, we're lost! The River People will be roaring right behind us any second."

Their hearts beat loudly in the silence of the forest, like thudding, funereal, rhythmic boiling. They fell to the ground panting and sat there, forcing themselves to admire the regal bearing of the colonnades of camerus, the stingy reserve of the carobs, the fencing arrogance of the agave, and the barbaric goliardery of the cactus.

The darkness was thick. But chipping away. A slight clear streak, then two bluish streaks, and the tragic moaning reechoed. Slowly, the depths of the Oasis were filled with a peaceful azure light.

"Let's get out of here!" cried Mirmofim.

They plunged into the darkness, sniffing their way like dogs trying to recover the scent. They couldn't find it. The path was lost forever. And now they had to flee as best they could before the bellowing blue assault at their heels.

On all sides and above, the gentle fanning of the foliage, still dreamy ggg from its nocturnal delights, was suddenly stiffening and hissing as ggg the leaves turned to metal, as in some giant crucible. The overhanging foliage under which they were running had turned to a ceiling of bronze. They could feel the ground trembling as the blue assault advanced; before them, in the distance, they could see the first red thrusts of the sun. On all sides, the trunks creaked as they grew hard, vibrating like copper sheets in the wind.

But it was all so terrifying, as the greenery of the Oasis became solid and metallic, twisting and writhing as the transformation quickened.

"Bend down! Run bent down!" Kurotoplac kept shouting.

The branches that had sagged from their night languor suddenly straightened and formed a resonating metal roof over them. The angry grass jabbed at the legs of the Untamables as they ran. The harps of liana tautened like metal strings, as if someone had tightened invisible pegs in heaven.

Before them, the solar furnace yawned open at the edge of the Oasis. The Untamables directed their mad course toward it. Twice Mirmofim barely avoided the angry thrust of a stiff branch, but the third branch struck him full on, and he collapsed to the ground.

He got up bleeding. Other Untamables were rolling on the ground, lashed by the bronze rods of the Oasis that growled as they struck.

"Out of here! Let's get out of here!" screamed Curguss. "Damned Oasis!"

The Oasis hated them and doubtless intended whipping them to death. The Untamables realized the decisive moment had come. The foliage overhead whirled and snapped, as if caught in a tornado. Now threatening, now pretending to be distracted, the rods suddenly lashed down on the backs of the Untamables.

Dodging like monkeys, when necessary slithering like electric eels, the Untamables finally escaped that flagellation. They fell on the burning sand, exhausted. Raising their heads, they looked at the sun, poised high and menacing like an ax. They all smiled at it, just as a child smiles at his mother's kind, comforting mouth.

XXIII

The Death of Mazzapà

Mirmofim was the first to revive. His eyes were bulging with rage and sheer nastiness. Upon seeing his fellow Untamables and the big bodies of the Negroes lying scattered over the sand, he growled, "At least we could have left our filthy Negro guards back there!"

Without moving, Mazzapà, who was lying on his side, said, "Don't start again, you damned doctor!"

Without answering, Mirmofim threw himself on Mazzapà's neck and began choking, choking him with all the strength in his surgeon's hands.

The Negro was very strong, but tired now and at a disadvantage. He tried to break free by heaving himself up from the waist. But the surgeon, with sudden malicious nervous strength, was grinding his knees into Mazzapà's stomach. His hands knotted around his throat. Steel bands. Around them, the tired expressions of the Untamables and the soldiers, who all turned to look but didn't put much stock in the fight. They were laughing. No one got up to look, they were too exhausted to be much interested.

The bronze wall of the Oasis seemed to have passed its power invisibly into the surgeon's hands. Mazzapà's mouth gaped open and his tongue popped out red, like a wounded lizard, and immediately disappeared, while his yellowish white eyes, fierce yet gentle, rolled in death. The surgeon stood up and, shrugging his shoulders, announced, "Well, that much at least! I can still perform an operation."

They all realized now what had happened and rushed toward Maz-

zapà's still body. Vokur raised long piercing cries toward his companions. Revenge poured strength into their bones and muscles and they soon had the upper hand over the Untamables, who were still shaky on their feet, stunned by that unexpected death. The Negroes chained the Untamables. Bayoneting and cursing them, they got them into line under the Sun, which had reconquered noon and reestablished its dominion of molten lead.

Chained at the wrists, Mirmofim walked at the head of the column, and spat intermittently at Vokur, who kept sticking him through the buttocks with his bayonet.

"Tomorrow," Mirmofim kept saying, "you lousy Negroes will be in chains instead of us. I'm glad I killed Mazzapà. And tomorrow I'll disembowel you, Vokur!"

When they had gone past the Dune of Camels, the Untamables were not surprised to see the Paper People standing there in their conical yellow robes, with the writing and printing across them, and on their heads the circumflex book/caps. The Untamables went down into the pit dragging their feet, while the Negroes headed toward the Paper People.

Like docile watchdogs, the Negroes offered their round, tired heads to the Paper People, who methodically and unhurriedly clamped new muzzles on them. The locks could be heard rasping shut over their muzzled noses.

The Untamables were lying in a jumble in the middle of the pit.

When the Paper People left, slipping across the dunes toward the distant reddish bronze Oasis, Vokur sank to the sand, tired and muzzled. Then remembering his companion Mazzapà, and his usual shout under the noon sun, he cried out in the same harsh, crude voice, "I'm thirsty, Mazzapà!"

No one answered.

He stretched out and fell asleep, his mouth hanging open under the sparkling steel muzzle.

The sun on high paternally sent him down molten lead to drink.

XXIV

Art

But the Untamables weren't sleeping. They were seething. Mirmofim jumped up and shouted, "I can see it now, here inside me, everything that happened last night in the Oasis and at the shores of the lake!"

They all stood up, yelling.

"What do you see? Tell us! Tell us!"

"Ah, my brain is waking up finally!"

Vokur had woken up. He thought the Untamables were rebelling and reached for his rifle. He found two, his and Mazzapà's. Taking up one in each hand, he went down into the pit.

The Untamables were crouched attentively around Mirmofim, who was telling his story with his head bowed.

"We are going into the dark Oasis by a phosphorescent path that twists and turns among the tall trees. . . ."

Reassured, Vokur sat on his heels in the sand at the edge of the pit. He held the two rifles by their bayonets crossed in front of him. Since his hands were trembling, the bayonets clinked together.

"A soft, sweet air patters down from the leaves . . . the path grows brighter. . . ."

The clinking of the bayonets kept time with Mirmofim's voice and grinding teeth.

Thus, stronger than the crude dissonance of Sun and Blood, it was finally the superhuman, cool Distraction of Art that caused the metamorphosis of the Untamables.

The End

A Note on The Untamables

The reader may welcome the clarification of *The Untamables* that Marinetti provided in an open letter of 1922 to a critic, Silvio Benco. This allegorical novel, published two years after his resignation from the original Fascist coalition, the Fasci di Combattimento, is a stylistic compromise between the radical free-wordism of *Zang Tumb Tumb* (1914), which was primarily a performance libretto with expensive typographical frills, and the normal florid art-prose of the prewar years. Its verbal lushness obviously reflects late Nietzsche of *Thus Spake Zarathustra*. The opening pages are reminiscent of Victor Hugo and the chapter "The City" strongly suggests H. G. Wells. It is a very syncretic work.

Marinetti also considered it his most subtle and complex philosophical statement of a position that in 1922 had returned full circle to the pessimism of his first play *Roi Bombance* (*Re Baldoria*). But in *The Untamables* his earlier "tragic" pessimism is modified by a cyclical theory of history not unlike Oswald Spengler's and a final testimonial to the redemptive, mollifying, distracting power of art. The destructive enthusiasm of classic Futurism has been transposed from the mind to the passions; the idea of Goodness (*Bontà*) plays a role that would have astonished the Marinetti of 1909. Marinetti wrote to Benco:

> Above the untamed ferocity of the Untamables is the less crude ferocity of the black Jailers, a guided, useful ferocity. Both are instinctive, primordial, cruel, unconscious forces.

Above them are the Paper People, symbols of ideas and hence of the Book that confines but does not master the instincts. The latter are submerged only in the calm, even light of the Lake of Goodness that cancels diversity, destroys harshnesses, illuminates wounds, dignifies the torment of sin. In the Lake of Goodness the ferocious humans become happy and luminous, but they cannot remain there. The human truth is not stasis even if happy, nor unconsciousness even if divine.

The Untamables emerge from Feeling to enter the kingdom of ideas, the life of the spirit, the life of abstract constructions. On the other hand the luminous, dynamic abstractions rise over reality, and it is the uniform, opaque, and sad mass of the workers that holds them high. The workers work, and because of the same general dynamism of the Forces they submit to work, still yearning for the ideal product of their atrocious labor. Their poor wish is already thoughtful and projects them into the great marvelous Lake of Poetry. A lake that is creation become reality.

They rebel at the rhythm imposed by the brain that demands their submissive work, and they want to reach the eternal, pure rhythm of constructed feeling. The overmastered instincts of the Untamables are freed and serve the Untamed River People. The Forces transpose themselves in this way and transmit themselves without limitation because neat divisions are absurd.

Only the ferocity, the cruelty, the destruction mastered yesterday but today conscious and willful can be a guide to the future. But the forces mastered for an instant break loose anew, anarchic, individualistic, ferocious. Again they become unconscious, brutal, and criminal and must be chained up. And everything starts again. But in Humanity there is the continuity of consciousness.

The book thus fosters the synthesis of the individual man in his striving for the emotive fullness that overflows into the cerebral life, which in turn sometimes becomes tyrannical and exhausts the material forces that it has attempted to master.

And the synthesis of the individual and society arises from a striving for progress. A striving toward a brotherhood almost achieved, illuminated by ideas, but arrested by the heat of the same ideas that newly inflame the dense and opaque elements.

And the synthesis of Humanity comes into being.

Humanity grieving in the agonizing mystery, none of its thirsts ever satisfied, its fevers always exacerbated. Humanity thirsty for a truth to embrace, flood, and caress it. The only truth, the only force: Goodness. Absolute goodness with no qualms or qualifications. Goodness of soul

that finds equal response in another soul, is content with that response and wants no possession. But goodness is not enough for human vitality. Humanity is dynamic, constructive. It believes in construction, wills the creation that is its future.

R.W.F.

PART III

Futurist Memoirs

Selections from
Great Traditional and Futurist Milan
and
An Italian Sensibility Born in Egypt

Translated by Arthur A. Coppotelli

Selections from
Great Traditional and Futurist Milan

An Italian Egypt in Lombardy

The great traditional and Futurist Milan, whose mechanized feelings, ideas, and thinking machines I am about to aeropoetically praise, is forever the central power plant of the energies and optimism of Italy

And she is also my blood kin because I'm an aeropoet born in Alexandria of a Milanese mother daughter of a professor of literature who lived in Via Monforte and of a father from Voghera a lawyer originally from Pontecurone where families of viniculturists bear the honored name of Marinetti as do the buses in Bahia Blanca in memory of the spectacular triumphs of Futurism and its nonlethal encounters with the mildew of reactionary crowds

My memory thus lubricated with olive and castor oil I take pleasure in evoking significant exciting waystops in the progress of my mind

Most seductive were reunions around a table at Savini's headed as the gleaming blue-green whitecaps of the Mediterranean by a true Italian Venus Lina Cavalieri the most beautiful twenty-year-old woman in the world once a paper-folder for the Roman daily *La Tribuna* a lower-class girl with a sculptured body and a quick elemental mind guaranteed to make for erotic-sentimental-artistic triumphs and fame abroad

She was favored by a financial breeze in her role as tall slim white regatta sail Prince Sciarra at the tiller taking turns with Florio heading her toward Paris with a layover in Milan an adolescent city moved by her

Old Milanese assert that this city of ours was already throbbing in

1851 when Emilio De Marchi described it as having "its streets narrow-
ing toward the center of town like a spider web" bastions lorded over
by chestnut trees walls assaulted by plump gardens fed by sparkling
water poplars willows sparrows dreamers of sumptuous urban life rich
cooking and lazy canals

Canals are slow in stimulating civic well-being but they collaborate
with the frothy blooming zeal of many flour mills carved from oak and
studded with copper like Roman galleys ready to powder themselves
with joy when the dawn pours illusory gold over the squares where
forgotten figures in marble beg for glory

Yellow fat sluggish twilights among mulberries smells tastes of
stables smoke with ambition and a starry syllogizer can't discourage
them

The hope of the suburbs toddles ahead smug and secure with the
short quick steps of an altar boy trusting the expert pince-nez of his
grandmother and the mewing of the veterinarians who rest their chins
and the future of Milan on their prodding canes

Suckling babies and children scribble fertility

Everything is motorized by the slow shrill sirens of the factories that
lure students toward an aesthetic of the machine multiplied by gasoline

The Milan sky is often rheumatic in painful worrisome winter but
mannequins in the perfume-shop windows offer a coy Parisian smile
while the Fair moves from the walls of Porta Genova to the walls of
Porta Venezia singing shouting snoring chugging like a big basket hat
spilling over with optimism

Provincialism shrills its bleating kid voice because the streetcar work-
ers and gas men are switching from horses to engines holding the bridle
of the Strike that prophet of revolutions

Thus immaculately free of timidity or indifference Emilio De
Marchi's mother earned the title of Star of Brianza during the Five
Days and like my faithful maid Angiolina would lean over the balcony
of the Busca House on Corso Venezia to shower the troops of General
Radetsky with pots of boiling oil

Milan loves to revive herself from her industrious inventive nights in
a daily potent fertile embrace that sprays forth abundance

Like her writers she has a conservative revolutionary character that
strains to reconcile a harsh progressivism with feelings for a higher
charitable justice

Even under the threat of a hard winter autumnal Milan fascinates with wooded parks in homemade purple and streets fit for lovers' strolls the soul of the lindens making them almost faint away on benches devoted to burning hands and thighs

Accustomed to touching and groping the bench is annoyed at the sight of a fair-skinned twenty-year-old blonde doing daring turns and arabesques on her bicycle an inspired scarf of hums and piano trills

Green eyes under a flow of gold and sensual lips

Proud of her clear Lombard speech

Batiste blouse with puff sleeves gathered at the elbows with a black bow

White silk tie

Man's straw boater with black velvet ribbon and catch-me-if-you-can bows

"Come tomorrow and we'll go sailing together in blue-striped white flannels and red belt but don't fail to come tonight because for you for you I'm going to play Vivaldi Chopin Debussy pump the pedal and on the bicycle seat in the gleaming embrace of the handlebars"

The scarf on the bicycle musically vanishes into the park

She's a girl from Milan who seduces my eyes and ears

Lina Cavalieri on the other hand is a winner of beauty contests against the famous Oterò Fagette Liane de Pougy Cléo de Mérode and reigns Mediterranean over the oysters lobsters mythic décolletages of a dinner at Savini's that sails with a sailor's tale told during night watch over the high seas

Once upon a time there was a bright and shining angel tired after having fought the unsheathed swords of defeated devils and who wanted to rest on Earth accommodating his marvelous twenty-year-old body all feathers and curls in some house or other or to be exact in a divan or easy chair that could sigh and stroke him in the right way

In short he desires a mortal woman for a really affectionate siesta for each and every pore

The waiter interrupts

"You asked I believe for a *saltimbocca?*"

Oh "meatball" tasty word that sits well on the tongue you're so inspiring I dream of you often and you're also the restaurant of bohemian Milanese artists in Via Pontaccio

Excellent risottos saffroned with the imagination of painters used to attacking the pedantry of critics and supporting an ideal disorder of the

imagination victorious over the True the Anatomical the Finicking
 Shrill laughter of Emilio Praga Cletto Arrighi Carlo Dossi Carlo
Porta Emilio De Marchi Ferravilla Arrigo Boito

Happy-go-lucky bohemianism of dialect verses mocking ironic licen-
tious that toss away all reserve in the hope of getting this onward
marching city out of its shackles and defeating the prissy abstemious
bound-up past opening art and life to wind-swept horizons

According to the sailor's tale steaming off the plates at Savini's the
archangel sees what he wants in the shapely body of Lina Cavalieri a
face like a large pearl happy to contain two blue jewel eyes of mystic
and philosophical seas

And her buttocks and thighs are like the sparkling soft fabulous fish
drawn in by the nets of the stars

In short this ideal divan or ideal chair with perfumed breath made
the archangel so happy as almost to forget heaven and here he is glad to
join us at dinner

You can see and you can't see but you can feel in the air his august
authoritative almost holy gentleness

Refreshing as they were Savini's feasts were often churned to a
froth by the most surprising political demonstrations

Amid the rural and genteel graces of old Milan life its shaded half-
tones conspiring with flowers and dreams suddenly the crude clashing
poetry of the Great Steel Industry

Flood of exciting salaries

Whirling roar of lathes and wheels

Tribes and tribes of sublime redskin smokestacks suddenly capture
more than half the once-familiar horizon

Endless belching scarlet of conceited furnaces

Their clamor of real money derides the groaning church bells that
rock with medieval tears

Tumultuous fanning out of long slippery rails infiltrating the Con-
crete

The death throes of the Unexplored

Solemn unwinding of coal into the sky and night morning evening
the slow outpouring and reabsorbing of streams of workers

Milanese echoes are no longer alabaster seashells the ears of children
with their sweet little hands on grandfather's whiskers but walls of
eyeless houses a hundred meters high and smoked over with Destiny

Insolent insolent poetry of the hard Breda Foundries tractors railroad cars ploughs machine guns torpedoes airplanes merchant ships rails rails

She smiles without running away Rosa the ideal little country girl and her fingers dripping with raspberries fit purple fingernails into typewriters for the mirror-bright Banks the new Enchanted Palaces

In front of Savini's a demonstration of 2000 students from Trieste led by me swapping punches with the carabineers demanding a free Italy outside the Hapsburg Empire

In the mad fray I get my slim neat figure in morning coat starched collar all wrinkled black tie soaked in sweat and then while drinking a cappuccino I note beautiful bejeweled hands of women in furs and pearls applauding me from inside the café for my unusual patriotic outburst

I skip over this period in my life in Milan with a longer leap back to that distant evening in May 40 years ago when my father Enrico Marinetti a famous Italian lawyer from Alexandria Egypt inaugurated our summer family life in Milan by showing his two children the now famous mouse-train that lighted the gas jets high up in the vault of the Victor Emanuel Gallery a pleasing example of the commanding aesthetic of the machine that gently started the nerves tingling in my fingertips already excited by the perfume of the lindens

My adolescent feet habituated to the yielding sands of Africa try out on Milan's marble pavements Life as conquest Science as proof of a theory Fantasy as sentimental erotic aggressive literature

While Determinism seems an African horizon to me blowing a few torrid blasts Positivism barely interests me it's so weak and I gird myself with Poetry that untiring heroic exploratory elevation

Theaters of Ideas Art Voices
Sublimated Loves

The priests of Milan are books of the symbolist poets who suddenly precipitate out a woman a censer Reginella of the Mislaid Anchor

Edward Sansot-Orland introduces me

"Lovely Creole Poetess I present you the poet Marinetti"

I answer at once

"Eyes like irises amid the wheat and thoughts peppered by a red carnation in the ivory of a hand"

I correct this phrase to myself since in fact not flowers but gems spice those pure attractive hands and the gay spring frock that sheathes in loving destiny a body too lithe to be athletic but trained for a witty daily dance

Stupendous amphora neck

Magnetic the perfection of her belly

While sitting at my editor's desk wrapped in romanticism leafing through French poems I murmur

"A poem isn't worth publishing if it's not the equal of the beautiful body of the most beautiful woman in the world"

Profound delicacy of her white paper skin soft to the touch and supple and smooth with a down so fine so fine one can scarcely believe it

Oh that I could drink from her with my lips feverish with this divine morsel

Delicious the moment has come

And without effort I carry away this vibrant and tender volume to the beautiful milieu of my alcove

There is enough here to ruin a man

I read the long poem to her again till I am out of breath

Then I extinguish the light and suddenly it's Night who enfolds both of us in her great book with its luxurious blue paper whereon are embossed the dead stars of nothingness

Her little sweetly stockinged feet try to make me forget the already famous hands of Reginella they want to attract my attention to the mysterious shudder of her knees under her skirt and to shout that up there up there are the gates of paradise

"Marinetti I prefer that you hail my verses and not my eyes that look to you like irises amid the wheat"

"Signorina now your eyes are banners in port when the ship weighs anchor without taking in the gangplank"

Suddenly the oily sadness of slag stirred by a propeller that can't bear to start the least wake of danger curiosity waste discovery

Impelled by all the forces of sensuality toward the beautiful creature who fills the editor's office with her fluid femininity I recognize that only Poetry with a capital *P* must yoke our souls and quickly with Egyptian skill

Eyes like irises they seem

Rather they are radiant ultramarine eyes between eyelashes of floating vines

May the night tar the horizon and the Sirens of the East foul the rudder and propeller with sweets

The sailboat churns and rechurns its liquid destinations while this female passenger takes pleasure in painting the miniscule softness of the almost suffocating office with nostalgic space

A few minutes' silence

Mutual respect stills the lips

But deluxe editions of poets jabber slyly

Slickness of splendid glossy paper

Typefaces have fun boasting special essences of rare ideas

I lure my interlocutrix out of her coy good graciouses into telling me if she loves yes or no the daring of free verse and the liberated new images so far from the classics

Poking their heads from board and leather bindings these enlighteners fugitives from a madhouse competing with the still-closed books laying siege to the walls and the couch defended by a Persian carpet

Even at this distance my glowing mouth wants to attack without offending her and I launch torrents of praise like roses praise for her supposed genius as a poetess

From shyness and guile I put my own verses aside in order to declaim Mallarmé's *Fenêtres* portentous in its pomp trying to put the setting sun into the shade

Setting sun washing Milan with pink blood gold and her terraces I scan as extensions of Reginella's half-closed lashes half-open blinds of Seville emerald amaranth

Growing success childishly accentuated by her reveling little feet and by the avant-garde books breathing torrid lyricism

I recite a fragment of *Hérodias* that enables me to pump out with proper nuances a hasty declaration of love by the flexible movement of lungs and throat

On the other hand you can't restrain the pulsing imperious flattering verse of *Hérodiade au clair regard de diamant*

I would have liked I hope I still would like and who wouldn't still like and it was a duty wanting to follow it or rather following it or holding back or even possessing that living poetry that seared my twenty-seven years but I remained instead hesitant ardent

The mysterious engagement of our thoughts and our nerves admiring each other without further discussion

I am so taken by that unexpected feminine beauty that I'm afraid I'll put it to flight with my excessive enthusiasm

I sit down again at the editor's desk now reddening modestly under the setting sun and like the sun bent over probing around coolwarm fleshy folds of the deluxe paper in the most resplendent edition of Mallarmé

Impelling duty to lower the blinds on crude desire

Moved to tears I smile while quivering and it seems to me I keep on greeting that perfumed hand on the stair landing

Roger Lebrun and Orland electrify verses books pens paper and streetlamps with the renewed charm of colleagues who are not envious

"She is really a marvelous girl and I can see you're in love with her already God how hot Italians are but I don't want to show you the French poetry she gave me for the review if you'll send me your latest I'll publish it in the next issue alongside Reginella's so that both your verses can kiss in public like two provincial newlyweds"

Love or its facsimile stopper my stomach like the restaurants abol-

ished by my imagination I run like a poetic spirit to Teatro Garibaldi
where Filippo Turati Lazzari Arturo Labriola and Walter Mocchi are
the scheduled speakers on the popular evening bill against czarism and
Siberian prisons

Overflowing with a lusty argumentative subversive proletariat that old
barn whose filthy sagging balconies creak sinisterly under the pounding
of feet like the sloshing of gallons of water in a tank hardly suitable to
holding those thousands of men and women workers who flaunt their
revolutionary uniforms that night come what may

But the weight of the monstrous stupidity under discussion increases
and in fact Filippo Turati a wild-eyed bearded revolutionary under
thick black brows climbs on stage and begins naming off the Russian
rebels imprisoned and suffering from cold and torture

An ardent observer of the mob's behavior I enjoy my vantage point in
an upper balcony despite the elbowings the only thing I have to do is
get rid of a fifteen-year-old who's blocking my view hanging from a
column and kicking at my armrail when suddenly during a pause in
the speaker's diatribe a question erupts from the boy in the form of a
mocking criticism of incompetence and ignorance

"What about Bakishev? Why're you leaving out Bakishev?"

All at once the gates of catastrophe are opened and a storm of insults
curses fists slaps at the untimely remark of said fifteen-year-old and his
innocence judged even as delinquency

Police carabineers and detectives burst in

"Stop hold up everybody stop the theater is collapsing"

The brawling mob rolling down the broken stairs knocks me over to
the cry of

"The theater is on fire *sauve qui peut* it's made of wood"

With the river of people coursing down I am shoved as far as the
orchestra and out into the street where police whistles are blowing to
break up the mob and anarchists spill out head over heels until from
the melee of flying fists there bounces like a rubber ball a broken um-
brella or an old siren shredded by sharks the implacable wave crest of
the Milan riots the skinny Russian Maria Rigyer

This dynamic courageous instigator of anarchy in Milan takes de-
light in these now traditional brawls man to man with the fattest and
heaviest carabineers and famished or lewd she loves to sink her teeth
into their three-cornered hats their cartridge pouches their holsters

Funniest spectacle in Via Garibaldi whose balconies faced the street

revealing oil lamps on tables fringed with curiosity while below rumors spread through cafés butcher shops stationery stores newsstands the hawkers crying out *Popolo d'Italia* and *Il Secolo* with the names of Bakishev Godunov Baliev Koriov Gahinsky Bilowsky Rotuzov Chirchikev Parwosky Zamakon

All of them illustrious even if forgettable thanks to the efforts of Socialist editors who would like to replace the current foreignophilia with the names of Labriola Lazzari Rigyer and with these thoughts I follow slammed about by the dense crowd my anarchist friend and café genius Serafini a stupendous detailed explicator of all social problems with the habit of cramming his trunks in the attic with millions of newspaper articles he is saving for a philosophical work to be written in eternity

The moon befurs the violent demonstration in damp white and delights in rocking the blocks of houses in its gondola

Now it slices its marzipan and mother-of-pearl nougat very fine and distributes them to the poor

The moonlight has its own special Milanese habit of mirthfully making and unmaking and trigonometries thicken in the great established businesses and industries blanched by "accounts payable" and dilated with "accounts receivable" melt with a warm desire to stroke the unyielding Infinite to tame and regulate even him

Enrico Marinetti

I see you again and hear your voice O my beloved father Enrico
Marinetti in your great role as lawyer thinker widower capable of try-
ing marriage again

Your brain was the legal steelyard of the Egyptian ports and now
evaluates delays discusses and defeated welcomes the Divine.

O my father I admire you now as then O you who were the sublime
reef of my childhood

Your two powerful frontal lobes loom over life and attempt to spot-
light it

So many years in business surround you in the form of Persian rugs
Japanese carvings Turkish lamps

Dining room and thoughtful reading to discern between true and
false healthy and harmful

The scything cyclone called History of Religion twists high above

Your humble female reader with a face of abstract nunnish goodness
transmits its oceanic boom

I also see at your round table multicolored by a Bukhara rug a short
Sardinian secretary who is attempting to organize your widowhood by
exploring the mercenary ladies of the city and the extent to which they
are capable of being faithful

"This Rosina is famous and beautiful but there are serious doubts
about her financial honesty and we must find out in court whatever
truth there may be in that accusation or that conviction for robbery"

As for the carnal rest of it we need proof proof and pass the buck between male and female

The History of Religion speaks like the poets of Lechery that sharpens a mysticism of its own: "In the satiated beast an angel awakens"

There are common Principles of Evil and Good Flesh to be punished sacrifices to be offered to God

Drawing its sail of respectable and elegantly advertised spirituality toward the open sea *The Life of Jesus* by Renan billows out and the female reader reads aloud about the wasteland of souls and then a short story by Maupassant that recharges the atmosphere with sin and ambition

My father's high forehead transforms its two powerful lobes into rigorous opposing judges

"The more Renan describes the splendor of Christ's divinity the more difficult it becomes to deny his divinity since a sublime exception can mean the Divine and it did cost him his life"

On the round table polychromed by the Bukhara rug and the electric hearts of the mosque lamps a pulsing of books or billowing waves or unexplored shores

The Lives of the Apostles The History of Israel Dante *The Prayer on the Acropolis* Pascal's *Pensées* Guido di Petrucelli della Gattina's *Memoirs*

Delirious debate till the lamp-lit evening

The reader pauses to allow the ringing of the bell that waits for invokes the appearance of the first star inscribed on the gilded case of day

Strauss's *Life of Jesus* shouts a storm of objections

A festival of miracles weighed and reweighed in the laboratory

"If there are so many of them it's certain that Jesus fractured the order of the natural world"

The austere profiles of the Himalayas of Mahabharata and Brahmaputra flood the room with the Indian origins of European Civilization anesthetizing Buddhist ecstasy

"I've frequently asked myself whether it's better to lead men or possess women and now I think there's something else besides and that for example is what my son the poet proposes I mean Poetry"

"Certainly Father you are the sturdy pedestal of the rarest poem and I admire your solid Lombard knowledge of waterways and streets and fertile fields"

The extremely studious atmosphere is pregnant with the vital importance of famous names repeated right to the incarnation of their syllables

The tears you masked after Mother's death

Amalia pure flower of melancholy your brow O my father Enrico seems so dry

But now appears the second tear on that intelligent face that always tries to be cold and controlled

He cries while applause rains down for my brilliant recitation of Victor Hugo in the auditorium of the Beccaria Academy in Milan

A storm of insults like moralizing stones cast by the ascetic Jochanaan in *Salomé* by another Strauss without Viennese waltzes causes an upheaval in the meditative dining room

A tidal wave of sensuality wells up in my father's throat drowning the female reader among the Persian carpets and *A Thousand and One Nights* translated by Mardrus

Poetry and the Arts are efficacious prayers

"O my Father why aren't you still the spiritual master here?"

I feel like a helpless child

The apartment in Via Senato 2 is a hotbed of ideas and the Futurist Luigi Russolo comes in bristling with projects seeming like a clothes hanger for clouds of pink silk

The Canal of the Past Mirrors Manzoni's *I Promessi Sposi*

I receive from Karl Boes editor of the review *La Plume* the volume of my epic poem *La Conquête des Étoiles*

Twitching intoxication of fingertips leafing through my first published work printed on heavy paper that emits the good slightly acid smell of the best sandwich spread and the very spiritual Parisian asphalt

The board binding has its seaport-green depths when you're on deck with a lively company of stars and the addresses of dear friends

After having nervously looked for mistakes in the three thousand lines that roil up two oceanic armies that leap over one another to bite into the edges of the Milky Way I'm sated with joy to the point of drowsiness and go to bed clutching the newborn book

Waking the next day not even the pleasure of a letter from Marta the maid of the so-desired and evasive Violetta Mandorli can tear me from my book

Her mother an authoritarian shrewd businesswoman owner of the biggest flour mill in Milan tries graciously to keep me away for fear I will seduce her daughter Violetta a very attractive twenty-five-year-old widow already engaged to a rich industrialist but distracted by my poems

Outside Porta Venezia the carmine and lapis lazuli porcelain sunset glorifies the walking stick I hold under my left arm and the green volume of my inseparable epic poem that loving fingers grasp in my right

A dance step in my heart

The wheel of the Mandorli Mill looms huge and purple and its steel arms having refreshed themselves in the canal like a meadow pond sprinkle the spring clouds with lime and chew the first stars

The shimmering in my nerves of all those conquered treasures in my right hand now more than ever literary and stylish

I hide dark and furtive in the golden green haystacks ten meters from Villa Mandorli a square farmhouse dressed and perfumed in wisteria and don't let me drop my poem and walking stick so that I can creep right up to the edge of the mill

Excited exhausted

Drowsing sleeping for an hour or two before our rendezvous through a window cautiously ajar

The hours pour with the rich stream of the falling constellations that limn in hard colors shiny rolls of fluid velocity and my dream rounded into a ball and rolling headlong into an abyss of lyricism seared by sensuality

A shadow odorous with female flesh shakes me and I stealthily reach the window that slowly lifts a shuttered eye on a leafy and blue ground floor

Making up my mind amid wisteria whispering like little butterflies

I drop my cane on the grass and with my right hand clutching my poem I pull myself up and somersault gracefully inside to make no noise in the hard soft bouncy stuffed couch chair tablecloth that sheds white gleams as it slips off watering me down with a tumbling clinking glass that I catch on the fly until we come to a stop on the rug

"Dear dear my dear I was waiting for you last night why didn't you come?"

A metal embroidery extinguishes its cold gold in the caress of silk that becomes a nude magnolia shoulder and her mouth adrift finds the peeled banana of a long long long kiss breaks away and begs

"Dearest dearest you mustn't come anymore because my mother is terrible and you know I mustn't I don't want to burden your life your art you're already so glorious"

"Violetta my Violetta you're cruel if you don't believe in my immense love"

"I know you love me but I will never be your bride and I was sure of it just now while reading in the paper what you shouted from the airplane to the Gallery and my fiancé was there too and he heard you"

"Violetta I cried out we must love love by accelerating our feelings without driving the breath out of them no we must intensify them or rather make them precious as I am doing now on your perfect mouth which belongs to me and will never escape me"

"Is that book in your hand for me?"

"This is my first literary work and it's the acceleration of a thousand thousand oceanic visions in search of the Absolute and total Plenitude"

The rush of calories struggling to enter all at once into one single sensation of bliss tears the fragile breast of Violetta a warm moaning springtime

I embrace her passionately and compose like a mad inspired sculptor a tactile plastic complex of evaporating happiness tears inebriating carnations caresses of watered silk and elbows and soft hair sprayed by the sweat of pleasure and it's the sea of her Liguria seeking right down to the roots of the holm oaks and the olive trees quibbling with the roses the delirious joy of cool ardor and always always under my flesh quivers the epic volume

The next day I enjoy this night again among electrified mosque lamps and shining Persian and Arabic trays listening to painters novelists poets architects who collaborate on my review *Poesia*

Milan World Powerhouse of Futurist Poetry

Legendary it was and still is the Congress of the Panettoni (egg bread) in Paris

The Futurist aviator Fedele Azari comes in for a beautiful landing and declares

"I extended my research up there into the dynamicizing power of central Milan which points north and Boccioni who was up there with me can confirm it"

"Form does not exist and I as a Futurist painter intuit its plastic dynamism and the force lines of its simultaneous compenetration of time-space dream-desire concrete-abstract near-far"

I interrupt as poet

"Rome is a star with foreign points

"Italy is a jetty thrown up often by the sea and Genoa a seashell orchestrating speed and calculations of coal and Milan is the puffing engine of the peninsula-train"

"While flying this morning I could feel underneath me Pascal's definition of the infinite 'a sphere whose center is nowhere and whose circumference everywhere' that's the rhythm of Milan

"And that despite every statistical calculation"

The Futurist cook Garavelli speaks up

"I want to make a gigantic panettone the symbol of Milan but I have my doubts about the strength of the yeast and for good measure eggs and flour eggs and flour eggs and flour for an illusory golden color and

then a sublime soupçon of calories by the billion to achieve that crunchy crust that's so like coal"

"We need the expansive power of Poetry to make it rise and for this we'll take that good dough up in the cabin of our plane and all the better if as we fly over Como the sky will bless it with some of its rainwater the mistress of flavorful bread"

Flying with the pompous panettone in a Caproni to aerate it before we cook it

Sweetening added by the Sky

The flavors of the air grow insipid

All around tongues hang out green

Blocks and blocks of houses turn upside down from hunger like immense sharks

Argument between two clouds with white chef's caps

But the guide plane signals our need to return to the alluring ovens

They are numerous and purplish pink

Adulating enticing flattering the calories

Allegorical smell of a warm paradise

The palate descends from the zenith right into the teeth of the working-class districts

All that appetite harquebuses space with the lapping of medieval dogs

A spinning dive

The brush-wing's point dips into the very heart of the flier

Joviality of the Lombard sky spraying pink liquid on this gastronomic infancy

Unquestionably all the flour mills will whiten the first flying domino capes of velvet night

The windows invent orange deserts tricking roosters into overdoing their crests and their crowing to apotheosis

Racing through Corso Monforte Piazza San Babila Via Arcivescovado Piazza Fontana Verziere Largo Augusto Via della Passione Garavelli ex-Garibaldi partisan and Futurist cook of student souls rouses the Faculties of Law Surgery Veterinary Medicine

"Milanese students Futurism is presenting you with a new symbol for your Goliard caps the Gigantic Panettone we're cooking will save the city"

"But the city isn't in danger now"

"Who knows who knows who knows"

Garavelli raps out his message with the students' clip clap clip of tongues

6 meters in diameter and 2 meters high

It will have a hundred younger-brother panettoni which the International Review *Poesia* will ship in sleepers of free verse cut up onto gilt onionskin paper

In our fabulous oven rise the grandiose outlines of a chain of comestible mountains

Garavelli's gestures become tragic

"Help help we need stronger yeast help help"

"Get the sick in the hospitals to come give us a hand with their indomitable will to get well"

Garavelli surrounds the round loaf with desperate cries

"No no it's not enough not enough"

They call in all the girl pupils and here they come kids and their panting teachers

"Get ready to have more fun than you've ever had be happy and even a little crazy and all your pranks will be forgiven"

The crowd of pink children charge bearing triumphantly on their heads a mechanization of horses wheels drums crews ships locomotives antennas etc. such a festive jocundity of tiny clapping hands

From the hospital wards roar a thousand motorized beds each with its own outboard headpiece of improvised health

Delirious with terror Garavelli oversees the rosy steaming oven drunk with sparks

"We need calories quick quick"

The enraged African sky weighing down the Giant Panettone writhes like a demented lizard

Poetry comes rushing in carrying the crunchy brown crust in its arms

"A bit more childish joy and it will be cooked to perfection at last"

"Let the sick men's muscles revive revive"

"O Poetry cook cook our beloved panettone with your leaping torrid lyricism"

The tasty offshoots of the Gigantic Panettone cooked to perfection arrive in Paris

Henry de Régnier Gallic poet with drooping mustaches says

"This Milanese loaf made by fauns is admirable"

Paul Adam the author of *Trust* pronounces

"Panettone is the cake of big business"

Verhaeren writes

"Thanking you for the cake of the workers"

The poetess of Noailles concludes

"Panettone is the literary cake par excellence"

All of this thrills the theater box filled with Lombard beauties Zizi
Visconti di Modrone Erba nobility and medicine a perfume factory à la
Pelléas Mélisande in sweet-smelling phials

Reginella d'Ancora Smarrita

In the reception hall of the Beccaria Academy I am magnetized by
the joy of running into Reginella of the Mislaid Anchor holding a copy
of the long thin Italo-French review put out by my friends Sansot-
Orland Roger Lebrun containing things to be fingered things kissing
each other inside his sentimental poems and my free-verse poem *Les
Vieux Marins* dedicated to the creator of French free verse

Reginella introduces me to her father an Argentine banker and busi-
nessman whose fat hearty face and honest cobalt-blue eyes barely con-
ceal a financial ambition exceeding all limits

I spend a whole night inspired by my *Roi Bombance* the tragicomic
synthesis of all the experiences and observations of my headlong dive
into Communist Socialist turbulence

After returning later from Paris where all the literary world had
crowned me the most original poet and winner of the annual prize
given in the theater where they hold Sarah Bernhardt's *"Samedis Popu-
laires"* and intoxicated with the laurels the celebrated artist had placed
on my head after she had recited my poetry and proclaimed my genius I
offer a swift Marinettian dinner to Reginella and her father who de-
cides to give me a lesson in commerce and industry amid the Persian
carpets and the mosque lamps with their electric hearts

But the covert insistence of my foot seeking Reginella's being careful
at the same time of her stockings and the insistence of the myopic
glances she shot through the window, cursing the summer mugginess

and turning the bridge over the Naviglio Canal to the washerwomen's island to search out Elvira's bedroom

I'm determined to poeticize even the seething sociology that bubbles beneath the pronouncement of a general strike

I go out with Reginella and her father and we decide that according to the political formulas of the day Giolitti is corrupting the leaders of the Socialists to preserve the Monarchy the troops ordered to their barracks to avoid encounters with the mob which breaking the streetlights and keeping tight ranks is marching platonically through the city threatening revolution

Here they form a black barrier across the half-darkened Corso Venezia I head toward them in my dinner jacket and straw boater at a determined pace and back and to the side of me rapid steps silk jewels winks and smiles Reginella and her father between the entrance to the Seminary and Palazzo Casati

Suddenly situation gets worse because from my experience with street demonstrations I intuit more than hear what they're saying in the front ranks of the strikers when they mistake me for a well-known thin pale young police official cane and boater like mine

"There he is there he is that dog of a police lieutenant get him"

I dash into the middle of the street right up to the first line of workers standing there with their arms crossed

"I'm not the lieutenant I'm the poet Marinetti and I live near here in Via Senato 2"

Then in a thundering voice

"Do you understand me I'm not the lieutenant Now let me and my girl and her father pass"

We are let through in one piece and I cavalierly apologize

"Forgive me Reginella for having called you my girl it was an unthinkable falsehood"

She answers by digging ten fingers into my right hand

A few minutes later probably by telling a lie she leaves her father outside the telephone booth and after I had voraciously kissed her on the mouth I reach under her heavy mass of hair and give her tender magnolialike neck a bite that draws blood making her cry out with delight and barbaric rage

"Yes yes bite me like that it wasn't a banal kiss and it makes me want to neigh like a horse of the Pampas"

"Inspired by a horsy poetics . . ."

While breaking away from Reginella that evening I'm full of grati-
tude for her father's absorption in financial calculation and I say into
my pillow that I like my devoted editorial secretary Lisa Spada very
much and Elvira Selvatico from Chioggia is preferable to her but Regi-
nella throbs in my veins sublime and is maybe synonymous with Poetry

Two nights later all of us poet friends reinforced by students group
leaders of the university strikes mount a demonstration in grand style in
defense of the Spanish anarchist Ferrer who was imprisoned and
charged with immorality by the Barcelona clergy and who it is believed
will be executed at any moment

Our fever rises to such a pitch that I recognize only later a young
man in a tight black velvet suit with a black sombrero but deep languid
eyes mouth hardly masculine

It turns out to be Reginella disguised as a Spanish painter and with
her help I direct to the front of the Visconti di Modrone Palace a band
carrying long poles to be used as a kind of upright trench against the
cavalry troop about to charge

Gleaming unsheathed sabers while hundreds and hundreds of shoul-
ders carry enormous beams in unison to build a new Nineveh or Baby-
lon

Repeated trumpet blasts sound their warning and we keep passing
cobblestones torn from the street from hand to hand and heaving them
but the pounding of horses' hoofs slipping and sliding on the pavement
brings ever closer the fatal possibility of falling and being crushed

I quickly grab Reginella and we dive under the beams because by
lying flat under the thick beams nothing can happen to us when the
charging horses leap over

We're the first to get out of the mess and pursue the anarchists who
want to get revenge against the police by devastating the Church of San
Barnaba

While I'm grappling with one of the more rabid anarchists both of us
Reginella and me are suddenly struck across the back by a herculean
metal worker with two blows from his fantastic crowbar which
dreamed of pulling nails from the still more fantastic beams that had
just saved us

Stepped on and crushed underfoot again and again pouring sweat
and blood running down my face I find myself on a stretcher then in an
ambulance and have the pleasure of hearing the driver say

"This student in the demonstration for Ferrer the one the Spaniards

want to shoot he's the least young of them broke his head and he'll be dead before he gets to the hospital"

In the ward however there's Reginella happily hiding under the sheets even her nose with its postage-stamp bandage over a trivial injury

The doctor on duty shrewdly leaves us alone and it becomes a feast of the Imagination that handles and rehandles and kisses the perfect beauty of a poem I tactilely insinuate

"I'm so happy because nobody could call these kisses or these caresses banal"

"In fact unheard of"

"I want to publish them"

A voluptuous operating room with crazy windows and tables chromed with melancholy and feminine coyness before the male of the species

"I like secret caresses"

"No no let them be kisses Italian-style expert and burning with poetry"

"I accept despite your damned willful Futurism"

We burst out laughing looking each other straight into the soul

Futurism

I appear on the stage in a tuxedo pale thin and eyes resolutely circling the theater making out enemies friends beauties among these Elvira Selvatico and Reginella of the Mislaid Anchor fascinating and quick and a little too restless in her box that looks like a huge mechanized jewel

At my right Armando Mazza with bulging muscles and strapping lungs gargles for the next thundering out of the manifesto and smiles gently rosily at the slim decked-out Palazzeschi and the other speaker poets Giuseppe Carrieri Sodini and Michelangelo Zimolo

A brief opening presentation of Futurist proposals for an artistic literary revolution in Italy and the world out of patriotic pride and in homage to the surprising and inexhaustible creative energy and aesthetic of the machine and speed

The public seems spellbound by my boldness and then at the first hisses and boos the students in the balcony hurl down an overwhelming storm of applause enthusiastic approval of the manifesto thundered forth by Armando Mazza

I solemnly announce Paolo Buzzi's ode in defense of General Di Bernezzo against the threats of the Monarchy and Michelangelo Zimolo begins reciting it in a stentorian voice

I take a seat with my back to the curtains to enjoy it all but a hand begins tugging at my jacket from behind it's the police commissioner of Milan muttering

"Don't let Zimolo go on I repeat I demand you stop him"

"I can't interrupt this admirable poem"

"I repeat my warning that the law allows me to arrest him if he goes on reciting"

Michelangelo Zimolo projects the free verse right up to the top balcony with great flare condemning the antipatriotism of the Monarchy and its cowardice and I say ironically to the commissioner

"Let him finish reciting this great poem and then tell me who you're going to arrest Marinetti Zimolo or the seething poetic verve that's capturing the whole audience"

"I'll have you all arrested"

"And I commissioner have a way of having you arrested before you can arrest me"

Dashing to the footlights with Zimolo Armando Mazza I shout about fifty times without stopping

"Dowwwwnnnn with Austria"

Deafening uproar masses of police carabineers and detectives and a boxer to arrest the athlete Mazza

Marinetti and Michelangelo Zimolo also arrested while in the private boxes of Donna Vittoria Cima and other noble ladies Baragiola Crespi Scotti is renewed the frantic amazement of their soirees and the balls they had enjoyed in the company of the poet Marinetti always adroit and ready to lead a quadrille or organize an all-night party always holding up for display his bright luxurious international review with its revolutionary title and contents *Poesia*

But tonight Marinetti is very different in the rowdy shirt-sleeve brawl

I see Reginella in her seat beautiful pale and disapproving but nonetheless directing the student demonstration that stretches into the nearby streets and squares protesting against the Socialists despite the fact that Mussolini and Corridoni are among them who used to be admirers of Futurist frays

I sense that the Argentine poetess's snobbery makes her criticize Sodini because he's too baritone Giuseppe Carrieri for his thick Calabrian accent Armando Mazza because he's stocky and barrel-chested Palazzeschi because he's too effeminate a mamma's boy

Undoubtedly disciples cooperative or useful as the case might be in a world revolution of thought might have been less inadequate but then it would have been necessary to risk a longer period of training destined to fail for other reasons

"I'm telling you Reginella that your sensibility is triangular with

three bisectors and three axes from the center of each vital side and so you are continuing to split our ideals with economics"

These disagreements don't make the complex and delightful flavors Reginella's father offers us in their suite at the Hotel Milano at all foolish

A *risotto alla milanese* and a perfect Florentine beefsteak arrive products of culinary skill each one boasting its own Italianate flavor and the various ladies present compare it to the now legendary Futurist evening at the Lyric

Gilded atmosphere of pearls smiling white teeth attractive ivory shoulders and truffles

"How is Signora Cima born?"

"She's born"

"How is Signora Baragiola born?"

"She's born"

"How is Signora Scotti born?"

Annoyed to death by the sequence

"We need a compass micrometric-waisted dancer"

These elite ladies are the result of a poetic plane lying over a prosaic one

They were born unfortunate because to be born beautiful you have to have the Future as your father and Poetry as your mother

Enormous banker's Havana in his mouth and the play of jeweled fingers producing those automatic brushstrokes of Giacomo Balla

Out of all that bric-a-brac darts the triangular mouth with its pointed red beard of Luigi Russolo who notes while inserting the blade of the knife between his lips

"Signorina Reginella you're using your compass wrong and you're missing angles and degrees"

Russolo lets food pile up in his plate barbarically apostrophizing the stupidity of superficial people without paying attention to the ladies present who are deeply offended

The sparkling crystal and fleshy porcelain under the tricky light mock the badly ironed collars and wrinkled jackets of Futurists and fear the bone-breaking virility of their gestures

Like a brisk and stimulating breeze on shipboard in the pineapple-scented bay of Bahia Blanca Reginella that caressable bubbly girl comes into my room at the Hotel Milano at two in the morning

I pretend I'm sleeping relishing like a lonely blade of grass those

catlike steps I snore and quickly dodge one of her little attempts to bite my nose

"Do you like this Japanese pearl that I want to give to the pretty little anarchist who showed such spirit during your lecture"

"It's worth a thousand liras and she'll be radiant about it

I approve drowsily and Reginella disappears

A noisy group of demonstrating students applauds and calls out for a speech at the balcony of Via Senato 2

"Students of Milan Futurism wants to deprovincialize Milan free her from her past from bureaucratic nonsense and from foreignophilia"

I receive this brief note from Signor Dell'Acqua

Illustrious sir Poet Marinetti it is my duty to inform you that because of urgent improvements I am obliged to raise your rent by 20 percent

I accept and the increase in the weight of my library becomes steadily more apparent and I hasten to lessen it by distributing books from the top to the always more numerous Futurists in the streets

At our favorite theater the Lyric we fill two rows of boxes to demonstrate our harassing techniques how easy it was for the public to fight Futurism right from the start so while Francesco Pastonchi sermonically reads my friend Butti's *The Castle of Dreams* twenty of us begin calling out from the stage "Enough enough" thereby provoking a storm of protest

To the ladies and gentlemen in the orchestra shouting back at our two rows in the balcony egged on by a doctor who declares "I am ready to sign the certificate of Marinetti's insanity" Armando Mazza hurls back this thundering reply

"Come on up here you reactionaries I'll fix your cult of the past"

The cult remained intact because the tonnage of the threatening fist was so tremendous

More than forty policemen and carabineers invade the theater and form a sort of mule train on my left arm while I hang on to the red-velvet-covered rail with my right and I won't let go absolutely unuprootable I laugh at them sarcastically indicating my friend Armando Mazza whom none of the brave brutes dares approach

But out in the street arguments with newspapermen and literary critics and among them Carrugati whom I punch resulting in a general row face-slapping clubbing in Piazza del Duomo at Caffè Campari and among the glasses and steaming plates at Biffi's and Savani's.

Milan is anxious to get on with the elections very few Milanese in

favor of but many against Futurism and their ambitious candidates put a lot of money into vote-getting but a Futurist manifesto appears in more than a thousand places throughout the city asking the voters to elect "the pure patriots not the ones who skate along with the old and with the priests" stirring boundless anger at me

I go to my room at the Hotel Milano to try to rest

Reginella has shed her languid aristocratic Spanish sinuosity and more elegant than ever the agile knowing Milanese falls asleep in my arms liquefied by the first bells

This is the passéist bell of Sant'Ambrogio with swooning notes never changing prone to make mistakes during the Sunday crush an ancient bell

It wants to drip the cold tasty minestrone of dawn into a cup covered by a dish to fend off flies and the cat

She misses Mass by a minute and so the bigoted grocer woman cold-shoulders the profitable corner store annoyed because her son-in-law neglects the tradition of honest generosity with his customers in his haste to make money

At the American Bar a center for financiers and elegant courters of expensive courtesans the old Milanese tell my landlord Dell'Acqua

"How do you manage to keep that Marinetti as your tenant he's the very genius of folly"

Exasperation has turned everything around and now when I go to Paolo Buzzi's room lawyer and secretary of the provincial delegation at Palazzo Monforte the ushers turn their backs on me and the mustache of my dear friend original poet and conscientious functionary bristles with doubt and compunction

As in one of his free-word poems we silently listen with our Eustachian tubes wide open to the *s*'s of rustling silk as through the monastic portal swish and almost whistle the opulent skirts of the prefectess courted by homing pigeons just composing their chorus of *vooroom vooroom vooroom troc vooroom troc*

Disdaining the offer of a clerk's job the Futurist poet Enrico Cavacchioli takes his chances isn't satisfied with just creating and publishing a volume of free verse *Le ranocchie turchine* [*The Blue Frogs*] but also introduces me to the head of the wild artistic bunch Umberto Boccioni

He strikes me at once as being a most attractive genius and generator of novelty

They have already formed into a group of painters sculptors with

Bonzagni Carrà and Luigi Russolo musician chemist etcher and mechanic inventor of philosophic systems motors artificial leathers musical instruments and the first noise machines

In his garret he amazes me with boiling pasta to replace rubber in tires

Piatti and Carlo Erba are having a discussion with him Erba from the family that started the pharmaceutical firm

Carlo Erba a chemist who is becoming a Futurist painter

While explaining his theories Russolo accompanies me to the Hotel Milano where I sink into a creative sleep made up of leather speed insults

Reginella's voice puts the color back into my nerves

"I'll give you kisses and kisses on condition that you forgive me my sins of snobbery foreignophilia actually I'm really Italian"

In magical shadows her tasty fingers unwrap candies

Pop this Sicily of yours into your mouth the gardens of Bagheria ices with pistachio lime and flowers from Genoa

Like an Indian forest Reginella leafs through rearranges wets her billowing skirt of gold brocade purple and watered silk in the torrent of the divan's stream and the rug is sprinkled with it

"I've ordered special pepper-scented carnations smell smell how the sweetness wakes beneath the pepper that stings your nostrils

Like a den the room reeks of cats

"This outfit that looks like jaguar skin was designed by me I'm Italian you know and don't insult me ever again"

"Brava I proclaim you Milanese"

Reginella jumps up happily and runs off

"Wait for me I'm coming right back with a woman from Milan you don't know"

I get up from bed but fall back stupefied as I watch a metallic figure with eyes like black agates flashes of lightning enter the door

Reginella tugs her forward holding her up by the paw like a panther tailed by an idol

With Boccioni at Previati's we watch the merry-go-round horse-drawn electric streetcars clanging their way slick automobiles evening already night the bustling of blue almost lunar cottonwool linen handkerchiefs bleating lights to be caught on canvas

Previati disapproves of the muddling critics who know nothing of the problems of painting

A long discussion about the luminosity of objects and the powdery iridescent aura that adds eloquence to the expert manipulator of lights

Obeying a mystical urge Previati loves to introduce evanescent angels and diaphanous virgins into the atmosphere thus achieving the typical religiosity that refines and idealizes for example the majestic coach of the regal Sun

"We must accustom material to expressing ideas"

Umberto Boccioni argues with me and Luigi Russolo inventor of theories and new formulas and prefers my company but perhaps in a spirit of emulation loves to talk to me about his amorous adventures and is very worried about his first elegant clothes to replace his usual black suit buttoned up to the neck matching the points of black fire in his eyes and the lean sharp face of a rebellious and ambitious Italian in search of glory

When he leaves I can always find him again at the Caffè Cova where he satisfies his yen for the life of ease among rich fashionably dressed men and women

A kind of austerity of erotic pleasure and rich pastry mark this café on the corner opposite La Scala a corner that has known very few riots thanks to omnipresent ghosts of the Don Giovannis of thirty-five years ago who took great care of the pleats in their trousers and their high collars starched in London

The monocles that served to scan expensive prostitutes would even attract certain motorized adventuresses to the mere fantasy of a life that after all cost them nothing and with my own eyes I relished one of them most original a self-proclaimed adept of love intent on arousing tempered caresses and embraces for just so long and no longer and to hell with continuity

Boccioni craved this continuity and would lament his unhappy adolescent loves and the poverty of his family and so was intent on a powerful plasticity an aggressive Don Juanism and luxury among luxuries

He suffered from his tiny room in a little bare apartment beyond Porta Genova shared with mother and sister forced to earn their living by making shirts while he went vainly from shop to shop trying to sell his etchings and returned to a lonely dialogue with his cup of coffee he'd air his genius at the window also thirsty as it drank in the whole patchwork quarter of lopsided terraces old roofs and clothes on the line dynamized by the wind

His brush lived the metamorphosis from horse-drawn to electric

streetcars and the immense buildings that the city's reinvigorated finances multiplied for the sole purpose of making money by appealing to the social ambitions of the buyers

Careening into a ditch with my 100-horse motorcar I teach about machines and speed Boccioni who was eighteen when he educated himself between Paris and the rivers of Siberia on the backs of work horses dedicates himself to studying the possibilities of monstrously heavy wagons of stone steel beams cement stretching his nerves like reins and straps around his muscles pulling them up to the stars

Like flames the great ardent red-maned horse of Boccioni's *Città che sale* [*The City Rises*] rears up becoming his sibling Milan or rather fused right into his Calabrian-Romagnan veins

Giovanni Papini has linked himself with Futurism and pays a visit to Boccioni's new workshop which opens onto the Bastions through large glass windows that reveal his white malleable structures

"You're beginning the life of a great gentleman"

I correct Papini

"Boccioni you're becoming a workhorse in a hectic hasty city and you're trying down deep to capture the uncapturable at any price the ecstatic crisscross of lines of an unfinished block of houses rising slowly with the leaping lines of a racehorse or better yet with the movement of a loaded car with people getting in and out back and forth far and near reflections"

We argue about it with Carrà who reluctantly leaves his corner of the meeting rooms where he plays counterbass and English horn muttering extreme leftist opinions about "the need to commit the artistic crime" or "employees only"

Our Futurist argument picks up speed from the witty Luigi Russolo and I go with him to Via Dante to the shop of the Divisionist painters where Morbelli and Trubezkoy and other followers of Segantini rave about the theories and achievements of the already famous painter of the Engadine who is always up there at 2 or 3000 meters rightfully enjoying the light that has vibrations iridescences shimmerings a flow a mysterious suggestiveness that the valleys smother dim or confound

Futurism was resounding everywhere in Italy and abroad and after many exhibitions and tumultuous rowdy evenings in Turin Genoa Naples Rome I present along with Luigi Russolo three new noise ma-

chines at Modena that whistle back at the catcalling audience and also a new explanatory book *L'arte dei rumori* [*The Art of Noises*]

Milan has always been the city of music par excellence and so it is she who must decide at the Teatro Dal Verme if this bizarre orchestra made up of many-colored boxes whose handles and levers can refine down to quarter tones the hardly praiseworthy sounds of running water rainfall wind leaves insects and cars an orchestra worthy and capable of enriching the usual type of orchestra and of constituting a new way of organizing spiritually and imagistically our sound-wave patterns

While the angry but imperturbable Luigi Russolo is directing precise and painstaking I go down through a side door and hurl myself against the first row

We slap them around cramming our fists down their jeering throats and left and right Futurists and carabineers fists flying body against body egged on by Lydia Borelli's white clapping hands in her private box until the mad crush sends us hurtling through a trapdoor on stage down to the lowest cellar and the newspaper *Il Secolo* noted that although the Futurists were booed they didn't get the worst of the fracas since the eleven people who were injured and brought to the hospital were all passéists

Then followed a lawsuit brought by Luigi Russolo against the deputy Cameroni who had accused the Futurists in his proclerical paper of having exercised a scandalous deceit to stir up the hostility of the audience for the sake of publicity but luckily and with more than Ciceronian wit the judge Carlo Portiano praised me Russolo and the Futurists as well as the countless fisticuffs we dealt out the signs of which were still written all over us

The editor of *Verde Azzurro* gave an example by slapping a famous lawyer who wanted to have his paper seized and also rightly offered to take on any of the moralists who were denigrating his novel *Quelle signore* [*Those Ladies*]

You have to fight certain contagious moralizings with Futuristic means and such was the hundred-place dinner that Count di Rudinì offered to some elegant ladies of pleasure in the downstairs salon of the Fiaschetteria Toscana

To mock the hypocrites Count Rudinì presided over this tableful of garrulous saucy young females Boccioni is there too seething with wit the dynamic lady-killing genius all evening in that enormous liberated nest or den or tribe or harvest of the sexes happy not at all intimidated

Squares and Streetcorners of Productivity
Interventionism Blows Pistolshots
Political Artistic Simultaneities
Escapes into the Absolute

After having struggled to compel all the forces of bodies in motion into synthetic forms with oil paints Plasticine or metal Umberto Boccioni sets up a show at the corner of Cova's including his own slim nervous figure the perfect pleat in his trousers his biting sweet smile that seduces all the women and makes several rich passéists buy his paintings even if they're not very convinced about Futurist art

Our nights are spent defining and verbalizing the first three manifestos in preparation for the shows in Paris London Brussels Berlin and our discussions are strung together by the keening wild-eyed looks of Luigi Russolo like some weather-beaten magician in love with the great electric signs on the facades of the Piazza del Duomo

The dynamism of racing cars and our will to pierce the Milanese darkness with the electric signs that advertise food or cars excites us much more than poetry-reading contests between Leigheb and Calabresi Zacconi De Sanctis Fumagalli and Duse Reiter Mariani

We pit industrialists against passéists with a newspaper campaign in behalf of the aesthetic of electric signs that we will never betray

The new railroad station in Milan that will erase the old one blacked out by the sheer energy of Carrà's brushstrokes is forgiven its ugliness because its proportions have been judged too big for Milan and therefore justify it and maybe will even make it beautiful

Each original thought springs up on one of the seven inventive balconies of my apartment overflowing with artistic literary creativity

In summer these balconies seem like drunks run over by double-

decker trams on the Monza line thundering down their tracks on the sloping Corso Venezia and if the cobbles are slick with rain they really look as if they're falling headlong into a bottomless abyss trailed by the globes of the streetlights like so many fast underwater divers

Our excitement is so great we write it into the technical manifesto on painting and I music it with an oratorical translation into French

Not because Paris is a fetish but in order to spread our revolutionary Italian ideas throughout the world

The debate and the exact wording are listened to casually by my secretary Decio Cinti a bright literary intelligence but so enervated by his pessimism an enthusiast without ambition that he's called the "Half Mourner" or "Marinetti's Wet Blanket" or the "Gray Eminence of Futurism" perhaps because he doesn't know whether to go to his own funeral thin dressed in black pale his nose holding up a pair of glasses he's always cleaning with his handkerchief sharp and caustic

The noisy enthusiasm with which we Futurists oppose prejudice and cliché and uphold imagination in all its whimsy would appear to make him seem out of place and ridiculous if it weren't for his sly humor he's the one who defined Luigi Russolo as a "Sheep driven crazy by the butts of genius"

Boccioni who worships friendship prefers Russolo to Carrà

The painful problems of poetry and the plastic arts so urgently in need of renewal hail down in the train from Brussels Berlin Vienna Milan to the point where I can't stand it any longer and begin screaming right in the middle of the octagon in the middle of the Galleria

"Boccioni do you or don't you know if there's anything outside of painting"

But the beautiful Milanese Sunday with its variegated pastry of clouds and cream puffs and flaky cheese buns demands we leave off theorizing in order to enjoy art-life

Boccioni taciturn in his black austere painter's jacket buttoned right to his chin studies the workers with their jackets thrown over their shoulders and sweating dauntless waiters dashing about with trays of precariously balanced ice-cream cups in this premature summer heat

We run into Reginella

"Marinetti surely you like my Botticellian dress?"

Her beautiful mouth echoes the ocean like a seashell

The transparency of the air makes the distant mountains seem closer and Via Dante becomes the world

"Friends I have never felt the poetry of the Great Milan as much as today"

Building on hillsides like an amphitheater or following the rising curves of the land constitutes a tradition

Building monocentrically on a plain forces virginity into being Futurist

I feel that Milan is Italian and universal and we try to describe each of the Milanese we meet

Hermit face

Face out of the fourteenth century

Lawyer's face

Grassy face

Face like a winding mountain path

Medieval face

Orthodox face

Clairvoyant face

Clerk's face

Monkish face

Prophetic face

Aureole face

Inventor's face

Face like a bell tower with its eyes closed

Face like a thorny rose garden

Shipwrecked face

Face like a truck garden

Face like a dusty road

Fake antique face

Overcast face

Cadaver's face

Carburetor face

Reginella is amused by faces reminiscent of cars

"You can find all the types in the world right in Milan and if you study their voices it would be even more surprising"

A voice like a plucked harp

"Those two have voices like bell clappers"

The woman with them is a mandolin

You could put them all into Reginella's hundred-horsepower car

An hour of fast driving puts the shine back in her splendid eyes the

color of irises like her Spanish grandmother's that used to steal Madri-
lenian hearts

"Marinetti why does your secretary resent the attention you pay me?"

"I can readily explain"

Drawing a perpendicular to my creative radius you'll obtain the tan-
gent that is my secretary

But don't bisect my arc of feelings with your snobbery

We understand one another Reginella and don't despise our synthe-
sizing nights together with eggs butter coffee milk that look askance at
the nights Modigliani and Romani [?] the painters spent with rum and
cognac

Reginella picks up speed through the thickening fog rising from the
twilit fields and plays roulette with the sun that bets one last gold
coin

A screeching stop just before a disastrous head-on crash with a truck

Everyone to work with Reginella who's a whiz at motors

Stretch the drive chain over the rear wheel shaft and have the truck
back up and wind the front half of the chain making sure that the teeth
are centered

The poetry of the machine burns in us while the truck stops and the
front half of the chain is in position to be put back on its shaft as happy
as we are with the rhythm of things

Suspense

Screw screw in retaining bolt

Wrench to tighten down the nut as far as possible and Reginella
gloats about it to her friend a working girl who declares her the soul of
Milan

I decide on a violent street demonstration during the Battle of the
Marne and Boccioni agrees

Castellani the nationalist is absent and so is Corridoni who is dealing
with the gas workers

In the box at the Teatro Dal Verme Armando Mazza next to me his
strong round face and affectionate paunch with muscular crowd-clear-
ing arms

Tonight his girth doubled by several turns of a tricolored banner
stuck in his threatening pants makes me think of the meshing of teeth
with the toothed connecting rods then freeing the tool to stretch the
drive chain over its shaft

In the box in front of us Boccioni with the Futurist painter Garbari
and other Futurists and in another box the prefect Panizzardi who later
leaves scandalized and gets a lecture the next day from the Austrian
consul at home

La Fanciulla del West offers the Milanese audience its own Giacomo
Puccini with whom I first began to taste the pleasures of flying at the
Milan airport in the planes made by Bielovucic Bregi Chavez

Counting the minutes still to go I recall what the director of the
Diaghilev Ballet Company said

"We must do something new for Paris every year and we can't be less
modern than Marinetti Futurism Cubism there's the last word"

This affirmation of Futurism's absolute primacy was read to me from
the book on *Nijinsky* page 365 by Reginella who spoke to me also about
her project for a dance of wounded bridges and rivers

The first balcony turns into a white bank applauding Diaghilev his
big thoughtful head his flesh the color of magnolias under ebony hair

A Mohammedan smell propagates Far Eastern sloth

Insinuating opium

His delicate small talk as expert impresario is a suffering web of or-
chestrated wedding and funeral

This luxurious Russian flaunts a very special Paris to be set in Futur-
ist modern and worn in the buttonhole

The wardrobe mistresses incarnate and envelvet perfume of the flow-
ering hay of the steppe and honey of the golden straw roofs of Russian
isbas

Diaghilev showers plummeting precisions on the Italian grand piano
but its laughing melodramatic Neapolitan keyboard spills this sultan of
the muzhiks onto the divan's Crimean beach

Sly clinking pearls of applause Reginella swaying palm tree and test
of sexual normality

Noiseharmony masked as a multihorned Bull trumpeting and roaring
comes out on the first balcony and his bellowing lungs are pierced by
the punch-flame goatee of Luigi Russolo

Chomping a Tuscan cigar his triangular face cursing yellowgreen
with a genius's bile Russolo brings to the rail of the third balcony an
intonarumori for the surflike whisperings of a sinner at her confessions

"Marinetti I'm happy to announce that the Futurist noisemakers will

be presented to Paris by me personally if Russolo will sell them talk to him and set the price"

"The sole condition for the sale of the noisemakers which the French will call *Bruiteurs Russolo de Mouvement Futuriste Italien* is that they will only be used to reproduce the sounds we approve"

"I hope they won't be love duets because the Ballets Russes hates them"

The supernatural power of words spoken aloud

In fact the words *love duets* unleash a storm from the passéist and pseudomodern critics against a Futurism accused of returning to sentimentalism

Marinetti decides

"We are changing the aesthetic order of the Night and we beg the Moon to give up her function as "the venomous nurse of lunatics" to become the most knowing spectator of Futurist spectacles

Reginella declares herself a string instrument with Herons and Parrots perched to pluck her firm tingling flesh

In my bed at Corso Venezia 61 new editorial offices of *Poesia* and Futurism I turn and toss with my phlebitis that once again is slowing me down and when with the bells of San Carlo's the Milanese twilight sounds its warning reminding us of Radetsky and the Five Days in '48 torchbearing demonstrators can be heard below coming from a rally against Giolitti for being a neutralist and calling upon Salandra to make up his mind the crowd swells below beneath my balcony of lions' manes running tar reddening in the sunset shouting

"Viva Marinetti the first interventionist come out come out on your balcony Marinetti"

The art critic Bugelli running sweat and fired by their enthusiasm yes Bugelli the cold skeptical pessimist comes into my bedroom with Decio Cinti and the maid Nina and they carry me out on the balcony where straining my lungs to the full I three times shout *"Viva l'Italia!"*

Unforgettable sight the wheelchair from which Umberto Boccioni's semiparalyzed mother with her beautiful face of an honest country-woman of Romagna follows her eyes full of love her brilliant lively son in his soldier's uniform with the blanket that looks like a boa skin around his neck and his rifle that's too long and can't be handled like a paintbrush

Conquering my acute phlebitis I take out my bicycle its tires fully

inflated and lead it forth as my future companion in what is sure to turn out to be a shooting match and I take stock of the weight of the flowers heaped on the handlebars and the weight of the weapons and the weight of the balconies and the terraces way up there loaded with beautiful beautiful beautiful Milanese girls with cascades of flower petals smiles cries of joy *viva*

An enthusiast with a mustache like a falling rose arbor certainly an ex-booer of mine grabs me by the head and plants a big disgusting kiss on my nose

I wipe it off after wheeling through sparkling clouds of dust up to the guardhouse of Fort Peschiera nicknamed the Mosque because of the garlands of excrement streaking the walls left by the old artillerymen and the swarms of flies when Russolo with his wispy red beard quivering threatens to bayonet Antonio Santaria in one of their nervous crises brought on by the bicycle race

They are reconciled by their Milanese good humor which we take with us to Redecol along the path turned to mud half a meter deep chocolate-colored amid the falling ill-humored Austrian shells

Hectic improvising of an ultra-Futurist Milan out of the Alpine landscape Antonio Sant'Elia builds bridges out of the arching mountains to span the mechanized valleys the elevator towers are the rising fog from the lakes graduated connecting byways for sadly waiting out the enemy

Umberto Boccioni checks his theories about plastic dynamism interpenetration of planes simultaneity of radiuses shadows echoes orchestral masses of projectiles

Carlo Erba all wrapped up in his chemistry of limestone and the wheel develops his passionate imitation of Michelangelo the sculptor of mountains

With his megaphonic voice Luigi Russolo prolongs in the valleys and glaciers the thundering canyons of sound he created during Futurist evenings at the Teatro Dal Verme

I'm always making my noisy words-in-freedom more smellable more touchable and I send them in a letter to Cangiullo the master of shining tears and to the Parisian Futurist Apollinaire asking them not to lose these ever rarer pearls called originality family purity friendship good humor elegance total feeling for Italy now that these concepts are threatened increasingly by the forces called Money Envy Subjugation International Business Standards

Sironi sick with gingivitis and memories of Rome shares his tent

with Boccioni and Marinetti in sleeping bags against the fifteen-degree cold guarded by the field mice who imitate the march step of the Kaiserjäger

Milan lends her inventive gay ardent tone even to that unforgettable night in the middle of the campaign at Vertoibizza where a companion had painstakingly constructed a Duomo out of black mud in the trench eight meters high but enemy fire knocked it over

Under cover of a torrential rainfall the Austrians invade my trench which we defend with bayonets and Thévenot bombs but two guns are captured

Then my herculean first sergeant Minone from the Porta Genova district wading waist-high in water counterattacks yelling "Charge 'em we're from Milan and our honor's at stake we're from Milan *viva* Milan grab the top of the Duomo and whack them on the ass with it!"

The two beautiful trench guns are recaptured

On the Piave among the artillerymen now deployed as infantry the Milanese distinguish themselves for the underground passages they dig in the heavy muddy escarpments and soaked to the skin after a five-hour inspection by a second lieutenant I dive into my warm sleeping bag and sleep so soundly I don't even hear the bombardment from the irritated Austrian batteries that level all of Nervesa

The next day at officers' mess I argued with my fellow officers who were convinced I'd heard the murderous cannon fire the night before and accused me of playing the hero because I'm a Milanese "big shot"

I've always felt I was Italian right down to my nerve ends like the extreme ends of this peninsula of ours but pride in Milan is a legitimate aspiration of every Italian who wherever he may be especially at the front can consider the city an example of power dynamism creativity and unflagging energy

We Futurists feel the city as alternately sympathetic hostile and enthusiastic but from the bottom of this freezing courageous hole I criticize her for providing artificial economic success to the fake avantgarde artists who traffic in modernity and only seeming originality

An example is that half-Spanish half-Lombard half-Parisian Gonzalves whose soft cloying ebony eyes would irritate me at Reginella's table also because he was protected by the economic positivism of her father

Everybody thinks I'm in love with Reginella but in fact it's only a physical passion made more acute by jealousy that has nothing to do

with the higher purer feeling of Love even though it does have the power to accelerate the train wheels bringing me to Milan on leave

Directly from the station under the lights veiled in blue that provoke groups of soldiers and ladies of the night into muffled hilarity I click along in my artilleryman's spurs to get a good meal at the house of one of the most intelligent elite patriotic Italian women Delia the mother of Massimo an ideal student and editor of *Fiamma Verde* the spokesman for the Italian student movement in favor of the war

While bringing myself to public attention I think out several possibilities for tricolor propaganda that I can put into action during my leave

A tortured shrill cry

Silence

Growing cosmic anxiety

My ears drink in this tragic dawn at the telephone

"Marinetti Marinetti get up I'm Azari get up and get over here right away just think last night they massacred all of poor Boccioni's plastic structures I beg you come right over so we can save them"

Absurdly entrusted to an envious passéist narrow-minded sculptor they were ripped apart by the workmen anxious to clear out a profitable part of the building and all is ended

The funereal courtyard is full of the moaning slaughter of the sublime plaster sculptures hacked into livid pieces that make me sob just to look at while Azari openly weeping picks up the pieces of a bottle and some force-lines and we leave with the pitiful white remains to paste them together and put them up again

Vibrant and whole once again they triumph in Boccionian vermilion

The Green Quickening Edges of Milan

With a letter from Reginella of somewhat dubious warmth burning a hole in my inside pocket I make a decision and act on it the very next day as an expert in street fighting I look over the corner of the Sforza Castle I once used to defend myself with a pistol against the neutralists' counterattack and without meaning to I dramatize the place with my affairs of the heart or should I say skin

Just as I foresaw here's the slender figure of Reginella a hundred meters away under the linden trees which announce her with their perfume but she's not alone at her side is the obsequious Gonzalves

In my conscience I debate the moral elegance of a soldier wasting his time attacking a love rival but just to clear myself ahead of time I back up against the medieval wall of the castle and those sharp angular stones lose all their roughness in response to my sentimentalism tempered with hate

Aiming right for Gonzalves about thirty meters away I hurl myself wordlessly at him and give him such a swift punch in the nose that he falls down and I'm on top of him slapping him silly with my right hand while my left tightens around his throat

Freeing himself with a great effort he stalks off bruised and humiliated

Wild-eyed tears screams frenzied flapping of arms purse gold cigarette case and ripped stockings Reginella chases after him but not to stop him her mouth streaming with yips and yells of a horsewoman on the Pampas amid the flying manes of wild horses

"Stupid stupid weak sissy I never loved him you you are the only one I love and I went for you and I still go for you I thought you were a tiger when you were on top of him"

As I calmly straighten out my jacket and leggings I explain

"Good day Reginella I have a fifteen-day leave but you're wrong in saying I'm a tiger I'm exactly what I was before muscular and dynamic"

Poetry the color of the sky and the future who disinterestedly punches and squashes insatiable and muddy Prose

In the course of the afternoon meeting we lose about 30 percent of the attendance because of our aggressive attitude and they go without signing and among them some of the most courageous patriots such as De Capitani D'Arzago

Among the most unusual and unexpected gatherings of soldiers wounded veterans republicans Futurists independents anarchoids all anxious to defend the great victory and the glorious Italian army and at the same time to develop both responsible and irresponsible personal ambitions as neoorators and neopoliticians

As an exuberant and excessive Futurist I set a Day of Simultaneity for Milan

At five in the morning Reginella carries out my program in the *Gazzetta del Popolo* for new feats of daring at the wheel of her 100-horsepower car driving with her left hand so bejeweled as to catch and fire back the first rays of the sun and shooting with her right at the pigeons with a carbine

In a flash she whips out pencil and paper from her pocket to note down

"My speed skewers the cooing sunrise"

I reach across and embrace Reginella who whispers in my ear

"Dearest are you happy with your simultaneous happening I'll tell you confidentially that I lost only eight seconds between poetry and the third pigeon but you'll admire me I'll be so cute in the sack race plus poetry-reading contest"

The printer specializing in free-word publications Cavanna is waiting for us at the door of Cavanna Printers a few meters from Ospedale Maggiore where the portaits of the Milanese Benefactors painted by Induno demand at least one victim of our dangerous Simultaneity Day so they'll be in the right in passéist terms

Along with Reginella I read the sensations in lead type sublimated by images mixing into the ink of the fine presses such odors that linger on the pages of a book whether it's opened in the bookstore or in one's study

The printer's shop is all athrob with words-in-freedom already printed and their hard harsh and soft colors splash and spread out beyond the windows of the ground floor onto the ox-blood wall of the old building formerly dedicated to the human body

A powerful rumbling in the air draws Reginella into the street to applaud Azari doing as he says "what a mad hornet does over Milanese houses" with his light touring plane

We precede him to the Electricity Lab of the Polytechnic in Piazza Cavour where the philosopher Arnò is dressing in jerky movements each one combined with a physical exercise feet calves knees thighs belly chest arms hands

Pants neatly pulled on while his hands massage his sides energetically and his lungs suck in push out air

As a Futurist Arnò begins again vowing to mix into his simultaneity a reading of Dante's *"Conobbi il tremolar della marina"* insisting on proving that *tremolar* also contains a green layer of leaves on the sea

In Piazza Cavour Reginella Arnò and I enjoy Azari's touring plane doing a dance of the seven veils up there at 500 meters and Azari jotting down notes between maneuvering the levers and shouting through his megaphone descriptions of the theatrical variety of the roles his fusilage can play

Paunchy Banker then jealous Lover then faded Whore whom the afternoon heat strips shamelessly to the shouting of the crowd

"There's her naked thigh there's the plane's naked thigh and it looks like flesh and the plane really looks like a naked dancer"

All the eighteen-year-old editors of *Fiamma Verde* lean over the balcony showing off their tapestried Depero vests blood-kin to our polychrome vests which they slyly douse with grotesque bellicose jovial oranges cobalt blues emerald greens

Even in the alleys and the public park people are excited which restrains the solemn sagaciousness of Cavour's statue

From a bunch of workers a girl emerges I recognize as the anarchist worker friend of Reginella Mario Carli and Cerati

Point-blank we suggest demand that the word *fatherland* be included in their next manifesto

The pretty plump dialectical anarchist girl refuses in the name of her love for the Eskimos

Hopping mad Azari shouts

"Just as my name is Fedele Azari the Futurist I want to start immediately the first and most important Society for the Protection of Machines"

"You're right Azari and I Marinetti am going to be your first member because our machines made of nerves muscles flesh are exposed to superhuman strain and need regular rest"

In the Laboratory of the Polytechnic we organize the Society for the Protection of Machines recognized as autonomous mineral-vegetable-animal-quasi-human beings and therefore worthy of being cared for protected sheltered questioned

Gabriele D'Annunzio flies in from Gardone and I receive him with so many descriptions of our daring that he is carried away and when he gets back into the plane he has with him a packet of Futurist poems by the younger poets clutching them in his refined hand like good-luck violets

The corner by Cova's is guarded day and night by our partisans after one of the performances of synthetic theater suffered a surprise incursion by our rivals between two lines of the synthesis *Il corpo che sale* [*The Rising Body*] and a second attempt led by the writer Mariani between two movements of my theatrical synthesis of inanimate objects called *Vengono* [*They Are Coming*]

Thus a string or a chain or even a corridor of punches links the great exhibition of Futurist painting overflowing spiritual hypotheses to the Piazza del Duomo a tremendous plastic dynamicism of clubbings and pistol firing

In the editorial offices of *Popolo d'Italia* on the evening of April 14 we can foresee everything that's going to happen the next day and despite the fact there are so few of us we feel the necessity to face whatever danger and possibly even a very hard victory preparing for it by buying pistols in the arms stores in Via Garibaldi and by telephoning the Polytechnic where Chiesa guarantees us a goodly number of students that have already been tried out in the battles of the Carso and the Piave

Casually just to get the show going the two corners of Caffè Campari that face each other become the catalyzers and the knots of us demonstrators coming together add up to about a hundred not many more

around two in the afternoon and it takes a great deal of fake optimism at the two famous corners if they don't laugh at us reflected in the shiny marble café fronts how pathetically few of us there are while our lookouts telephone that a hundred thousand demonstrators are flooding the Arena with anarchists and young Socialists itching to attack the center of Milan but trying not to drag along the timid and the speech faucets

We exchange a few words we're three hundred by now and we break through the first rank of carabineers and on to Via di Monte Napoleone Corso Vittorio Emanuele where we pick up another hundred fist men and gun shooters

On the way back through the Galleria they applaud us from the corners of the central octagon where there used to be expensive shops catering to the tenor trade but now the citizens applauding from those architectural tympanums have patriotic spirits but weak flesh

At each of the lions in the corners of the monument speakers try to disgorge their speeches but the daring Maraviglia who's been reconnoitering for us explains

"A hundred thousand from the Arena thirty thousand with the young Socialists leading and the anarchists come on let's go bring your rifles and revolvers"

The air is already throbbing with their chanting and we rush over to where the mounted police are blocking off Piazza del Duomo at Via dei Mercanti

Hurtling their two-pronged lances a stone and a club or two on us and suddenly just as in the movies rearing horses flying manes and flashing swords part and we have a clear opening

We fire our pistols from a standing position and the rifles answer from the other side but we're not pigeons or sitting ducks and a hundred rushes with weighted clubs break up the mounted police formation slipping and sliding on the cobblestones the sidewalks heaped here and there with bodies trying to lie low to avoid being shot or clubbed

The corner of Via Mercanti is warrior proud and its gray stones shine like the metal plates of a battleship the streets echoing like a dockyard where rivets are being pounded

The chase soon overtakes the group of red-shirted anarchist women carrying Lenin's picture and we're right on their heels with somersaults and playful punches down in the cellars and the doorways of Via Dante each street corner a hellhole of gunfire

From the now blazing offices of the Socialist newspaper we are toss-
ing desks tables chairs seats out the window and watch as they arch
down into the still green water of the Canal

We tear off the sign on the balcony and carry it in triumph display-
ing their fake future to the authentic past of dust and noble privilege
which the ancient oaks of Palazzo Visconti Modrone with their green
and heavy heraldry lend to the lazy Naviglio Canal and its sly ironic
reflections

The metal sirens on the small bridge with their Neapolitan philoso-
phy are laughing and one of the more daring of us tries to pull them
down to use as weapons but we're moving too fast proudly crossing
Milan in the dusk of electric shop signs indifferent to politics to cele-
brate our *Popolo d'Italia* chortling over the death of the Socialist paper
Avanti!

Via Paolo da Cannobio becomes a bivouac and in the courtyard of
the saber-rattling paper the chevaux-de-frise renew the fantastic forms
of petrified boars those nights at the front on sleeping bodies wrapped
in their cloaks watching nonetheless among rifles and bayonets

The counterattack never comes and I am called by General Caviglia
along with Ferruccio Vecchi to the Hotel Continental where we are
complimented on our decisive and militarily successful action with se-
lect phrases Ligurian solidity by the hero of Vittorio Veneto

The riots in Milan increase as the conflict of political ambitions and
economic interests haggle over ideals and old hates and try to suffocate
pugnacious heroic patriotism pure and simple

The Milanese not taken up by the legitimate desire to return to
homes and jobs turn to the democratic republican neo-Socialist hope
offered by the *Corriere della Sera* and *Il Secolo* which pay little atten-
tion to the Great Victory and instead seek to reconcile everything in a
mediocre antiwar compromising parliamentarianism led by Bissolati
and they are preparing the way for his being named President of the
Council of Ministers

He is speaking tonight at La Scala and it ought to be a triumph for
him they hope and we arm ourselves with pistols bullets and orchestra
seat tickets not one of which we got by trickery with furious elbowing
and bold decorated officers we make our way into the theater occupying
the famous box on the left a few meters from the stage

Instead of the Dragon being fought by Siegfried Bissolati appears

lacking all Italian spirit and already incapable of acting like Borgatti with his weak tenor voice and naturally he's given support by Innocenzo Cappa a brilliant speaker blowing his stubborn pacifism around the pacific vaulting and he in turn is defended by General Grammantieri all wrapped up in his rhetorical greatcoat

The general tries several times to make himself heard to establish himself as principal speaker against the storm of hisses and whistles I've organized throughout the packed audience he keeps trying to praise the kindness of the Slavs of Dalmatia Slovenia and Croatia and to urge us to embrace them all

Grammantieri's oratory is like a bass drum but by now the orchestra is directed by a sergeant among our partisans who ritually answers the general and his stars from Toscanini's podium by pumping his right arm up and down in the revolutionary salute

Our box is the center of all the hate-inspired stiff-armed salutes but I calm them down for the moment

The audience's rapt attention is broken by the screaming of the Italian Dalmatian women in the second balcony near the box where Mussolini is listening mute and undaunted

"Better study geography better study geography Signor Bissolati"

Bissolati stops speaking takes a breath and then weakly starts his litany again

"The good Slavs all heart amenable friends of the Italians"

Angry and sensing the opening for some strategic wit I raise my voice

"Aaaaammmen Aaaammmen"

The lacerating sob of caged animals chewing the bars to escape sounds among the audience who react with a storm of blows slaps clubbings dumping everybody on stage into the orchestra Bissolati speechless and unsteady on his feet among his disconsolate supporters all being beaten and kicked out of the theater

The theater is certainly happy about all this after centuries of delicate materials and good manners and beautiful jeweled hands on the sighing red velvet of the seats since now the rude revolutionary cyclone is finally out the door

But Leonardo da Vinci admires the cyclone whirling in concentric circles around his genius for simultaneity

The piazza is in fact a synopsis a great free-word table of madmen

We're for our adored Italy that needs to be renewed with pistols at the ready holding up our friend whose leg was bayoneted on the Carso because the pushing makes him lose his balance while his ideas make our hair stand on end and those ideas are born again in my bald dome now the target of a flying club

While the club flies by we congratulate ourselves for silencing the now defeated Bissolati the heroism of an anarchist being led away handcuffed stands out synoptically

"Long live anarchy long live anarchy long live anarchy"

Leonardo da Vinci whose study lamp is the only streetlight still not smashed synoptically enjoys the corner where the Banca Commerciale stands

This same corner no matter how marbled sea green mountain blue paper white is in reality the Beggar's Corner with his invisible but noticeable hand stretched out under the nose of the tall distracted bank with its tellers' windows made of star gold

The Corner of the Casa Rossa draws spirited young men their every gesture determined and manly who climb the stairs to Marinetti's to join the Futurist movement a tide of volunteers telepathically tuned into the young men organized by "Futurist Rome" after I had spoken eloquently along with Ferruccio Vecchi from the railing of the press box in Parliament against Nitti and had been congratulated by Gabriele D'Annunzio in a very original letter that unfortunately I was relieved of at machine-gun point by the Milan police

That corner is always subtly perfumed by the linden and mimosa trees of the nearby park but now is pockmarked by pistol shots and forced to be a violent corner a place to be handcuffed and led away on account of its bloody color and without stopping Ferruccio Vecchi and I salute it after the storm of clubbings insults punches between our men and the Socialists after the election defeat of *Popolo d'Italia* nine thousand votes for Mussolini seven thousand for Marinetti and the imprisonment of the two along with fifteen supporters under the dead leaves of a funereal autumn without hope

Selections from
An Italian Sensibility Born in Egypt

An Italian Sensibility Born in Egypt

In the tropical garden of the French Jesuits when I was twelve my poetic impetuous character was regularly torn between the red cassocks and white surplices of the Pentecost procession and fights among the schoolboys organized and abetted by the St. Francis Xavier School of Alexandria Egypt

The poetry of my first bicycle shiny spinning spokes chasing after the plumed carriages of beautiful women and proud Arabian horses

The poetry of pedaling my bike furiously to its destruction amid sandals wheels under the iron gates of the Antoniadis Park where imprisoned roses chatter madly

Black poetry of mud-caked buffaloes emerging from the Mahmudieh Canal through narrow streets of villages paved with sunbaked excrement squawking hens bristle-haired dogs and long ribboned tails that the dusk studs with stars

The poetry of Catholic church bells along the walks outside the old abandoned forts where pimps thieves whores ragpickers fight among themselves

The poetry of running from village to village as far as the Ramleh bathhouses built on iron stilts for the delight of mussels so flavorful they must be offered to the first greedy star

The reserved sorrowful poetry of my mother prolonged every evening along the shore where the slaughterhouse mixes its purples and carcasses with the tasty crabs I chase from rock to rock

Then I get tired under the indulgent eyes of the one who gave me these muscles bursting with mischief and ambition

Poetry of imaginary naval battles fought by the clouds at sunset to amuse me as my brother surveys the dark-green sea while fishing under a floating chapel for Protestant sailors

The poetry of my tin armor and commander's shield under the fire of hard leather balls

Often after we had wound in our knowing arabesquing processions under showers of rose petals and the sinuous melodic swaying of gilded censers toward the sweet face of the Madonna in her clouds of paradise I would lead 300 armed and shielded classmates to the systematic bloodying of the faces of 300 other schoolboys enemies of our shield and cuirass

During study hours the classrooms seethed with hostile nationalities tossing insults at one another no respect among them and naturally Italy was defended criticized argued over hated loved so that later in the schoolyard we had a fight that summed up the struggle among nations and at the same time was a great poem to be lived and fought for

That is how I proved my passion for my country so far yet so near in my mother my father and my brother and I came to covet Life as conquest Science as proof of theories and Imagination as the literature I must write while Positivism and Determinism bored me I'd already taken to Poetry as a way of exploring the world a marine navigating intrepid aerial poetry

I feel the beauty of an elastic passage from necessary brutal violence to delicate responses of the soul

The poetry of 300 censers carried by boys in red and white lace and garlands of roses to honor the altar of the Madonna set in the thick side of a baobab tree a few meters from where we stand in formation dressed as crusaders in tin armor ready for pitched battle with hardened bolls of cotton from the Nile

The erotic insolent poetry of a pretty maid from Trieste Matilde always busy perspiring rosily from store to store then coming up to offer me russet maps of Karamendin and sweet apricot paste

Washed combed and defleaed by me Rask the black poodle barks at her heels in his red bow and everything and everyone tempts me with thighs breasts tongue and wagging tail on my little wood balcony a shady shelter for birds from the palm grove

Loaded with Latin Greek math books my little hanging study even

welcomes the limp branches of the nearby date tree that dissolves into the muggy air the willful voluptuous loving of the turtle doves anxious to become noisemaker words-in-freedom

The poetry of the desert and its burning sands breathing on me with a gift of pink-nosed white mice who sit on their hind legs and nibble at macaroni they hold in their black-nailed forepaws

Escaping while my father carries on during dinner about money being spent in this house I used to build a castle of eight dictionaries around those gluttonous mice and they'd try to escape to my father's Bedouin clients at Khartoum

Gustave Kahn creator of French free verse used to say he never was as enthusiastic about passionate writing as he was about mine

It's possible to find its source in my youthful boat rides with the Jesuit Fathers red- or brown-bearded cassocks and glasses affectionate dark moralizing that offends the foaming breaking waves of the African sea

The smell of pitch pistachio frying oil coal sweat and wool baking under the noon sun

The sun showers its rays that divide and hold two port cities shimmering flat plates a vast steelyard of heavy gold

Rowboats are nuisances at Port Said which holds the weight of warehouses docks exports imports bilateral agreements an emporium of means for the fastest transportation Suez Canal marine-miles-traveled annual-traffic fast-delivery perishable-goods voyages around Europe beer German colors passengers logic rationality dock-area wharfs low-operating-costs protection subsidies banks stock market

Swaying with deceptive weightlessness the second dish of the scale proud to call itself the Old Port suddenly crashes down with a hundred thousand tons of historical memories conciliations naval battles forcing it to hang suspended over the abyss while my mother's tears pour forth sparks her eyes the measurers of blinding flashes Christian halo

The Jesuit Fathers fish silently with hook and bait in their threadbare purplish bluish black cassocks getting wet in the green sea while my brother invites the Sun to refresh his luxurious burns and lures it with his mandolin trembling warm musical skin of Egypt whining high-pitched fluting of nose his head in the hot lime of the sky

I explain to my classmates that the seaport probably resembles our distant homeland and the shore drive of the Old Port is a dry dock of nostalgia.

Grinning white teeth of Negro sailors at the prow

The air is a searing steel brush

Once they raise the lively snapping sail the Negroes castanet with their woody hands the voluptuous twisting of their hips and muscular bellies

Waves of sinuous Levantine schoolgirls

I improvise the images of my poem *La vita delle vele* [*The Life of Sails*] that I elaborate on later in August while traveling in Europe in touch with the sugared air of the carob trees rust iron filings fish soup electric carbon fluid of acetylene torches on the Giano Dock in Genoa

From the pathos of the boat trip my seaport sensibility literally jumps to a mad fistfight over a ball fought over with scratches and bites by a shipboard companion a Greek and a rival in poetry

Bleeding we are patched up at the infirmary

My mother a flower of tenderness and [. . .] shining literary poetic spirit is very indulgent about my violent character and forgives my bruised knees cuts on my nose and makes a sack for the hard leather balls we use during our crusades

Perhaps she intuits the spirit of my violence and sensing my hypersensitivity and multiple talents she fires my imagination by reading parts of the *Divine Comedy* to me regularly also because my education at the St. Francis Xavier School is predominantly French

Of the Parisian writers I prefer Zola whose novels excite me also because I learn his family was originally from Venice and he was denounced for being immoral which compels me at times to defend his genius in class with my fists

A serious scandal and a threat of expulsion from the Fathers against whom I had already rebelled but this time because I refused to read an account of Pius IX in refectory that was loaded with hate for Italy

My determined patriotism could not tolerate having to read for instance that "Garibaldi is a highway robber" and so I fling the hated book into the soup to everyone's great horror

My mother is fussing over a smoky oil lamp and sadly accepts my expulsion from school along with my white mice while my father disapproves of the headstrong rebel in me so foreign to his practical notions as a lawyer which I must listen to drowsily in the afternoons amid growing eroticism and huge flies in the room next to his office

I seem to him an irredeemable savage his commercial legal mentality is capable of going on for hours about a clause in the law analyzed and

squeezed dry phrase for phrase for the whole 3 kilometers of his after-noon constitutional along the canal

Although I adore my father I hate legal problems and legal prohibi-tions and so one day in the oppressive heat I feel the urge to insult the law by releasing an arching stream of an especially insulting fluid through the railing of my wooden balcony down on the noisy Arab market and on their goods cooking in the sun they all explode into curses against that pisser of a son of "Couns'ler Marinetti"

My mother smiles at me but frequently holding back the tears for my brother Leone sick with rheumatic fever a handsome young man pas-sionate bold chased after by women but always forced back to bed in agonizing pain

My sensuality spurred on by the Antoniadis Park and the sugar-cane fields allies with the wild desert dogs and the buffalo cows a melting together of shadows and milk in the smelly villages with their cattle chickens brightly feathered roosters I find in them the inspiration for my very first literary work *L'Aurore sur le Canal Mahmudieh* [*Dawn over the Mahmudieh Canal*]

The Jesuit who teaches humanities at the St. Francis Xavier School is flushed with enthusiasm as he proclaims in schoolboy fashion

"You have a genius among you Thomas Marinetti and I'm going to read his *Aurore* to you because its descriptions surpass anything Cha-teaubriand wrote"

In summarizing all those sensations in my poem *Le Baiser Amer* [*The Bitter Kiss*] I bury the poetic sensibility awakened in me by Egypt and the works of Rousseau Leopardi D'Annunzio and Baude-laire and I set off on another path with tumultuous free verse and words-in-freedom accelerated by the decisive new aesthetic of the Ma-chine that I already sensed

Matilde's fascination seems in fact mechanized from the jolly efficient maid she was now she has decided to make my brother Leone fall in love and to take me away from my studies with warm tempting offers

Racing by she brushes against my desk

"Look here feel my calves go ahead feel them and at the Ramleh baths you'll see what a Venus I am a lot prettier than the singer they dress as Cleopatra during the Carnival parade"

Then dashing downstairs followed by the joyful terrier Rask who

races over to sniff at and embroider with sunny golden drops the feet of
the paunchy habitués of the Tussurn Pashah Club

Futurist simultaneity dominated by an urgent sense of being Italian
that drives me from one station to the other at Ramleh pausing only to
hear the acclaim of my Arab Turk Greek French Syrian Dutch Rus-
sian schoolmates whom I always challenged for the supremacy of
muscles and images

When we straggled as far as Aboukir I didn't take much interest in
the oyster beds but a great deal of interest in the displacement of Napo-
leon's ships

Which permitted me several years later in Paris to pass a hard exam
in history and geography at the Sorbonne

My mother is reading D'Annunzio's *Giovanni Episcopo* to me in
Hérelle's French translation the *Memorie di Giuda* [*Memories of
Judas*] and the *Re dei Re* [*The King of Kings*] by Petrucelli della
Gattina thoroughly enjoying them and being excited by them I ran
from my house to the Zizinia Theater and took a seat in the balcony
and frantically applauded the lusty very southern Italian opera by Mas-
cagni *Cavalleria Rusticana*

The Sorbonne Robinson's Isle Plump Renée Her Lover Joli and the Literary Policemen of Paris

The Latin Quarter is really not the right place for classical studies what with the nights out and the noise trying to prepare for the written final in philosophy at the Sorbonne

The hotel resounds like a flopping fat pork sausage what with the slapping kissing fistfighting rolling around and cursing

"Oh come on now la la you young Italian poet leave your Latin and your math because my good French flesh is waiting for you don't be a fool look at me I'm beautiful"

I stick to my desk with my books in front of me quaking at the rowdy love play in the hall

At the door of the examination room a Cuban student asks me

"Dante's great but Petrarch's greater and he wasn't Italian either but a Frenchman by choice"

"You're wrong Barblek and I'll prove it to you by just being here and standing up for Petrarch's Italianness"

"That's not logical and has nothing to do with Logic"

"A new absolutely Italian Logic just as that island of Cuba where you're from isn't cubic but flat"

A muggy July night in Paris in the hall it feels like Sudan

My Egyptian classmates Robert Rollo and Isaac Aghion take out short skirts made of clinking seashells that make us drunk with memories of our dancing native country

We squeak with a special madness before we hit the cognac and rum

the girls bring in armed with bottles and human bones forcing us into
their game

"Put away your damned Latin"

"My name's Rose the Mad and those fools at the Sorbonne insist I'm
a crane but that's not true just touch me here and you'll feel that I'm
really the Goddess of the Latin Quarter"

An Argentine student declares

"She's my girl but I confess she drives me nuts she doesn't know how
to drink and I don't want her to come with me to Buenos Aires"

"You Italian or Egyptian I like you and you're a chic guy in other
words I sense a great poet in you and I'll tell you in your ear that I'm
horrified by the Argentinian and I want to shout from all the rooftops
that he's a brute"

Rose the Mad begins to undress to try on the funny shell skirt

But the delicious perfume of that beautiful girl turned into a primi-
tive native by the animal night and the firecrackers the crowd is setting
off on the street below gets to my brain and I shout at her

"No Rose please button your bodice and keep those beautiful things
for the man you really love really Rose I'm in love with you and I'm
jealous jealous"

Rose puts her blouse back on and modestly tries to hide behind a
bearded student who's holding a skull in front of him and shouting the
praises of surgery but every once in a while he flees behind a screen to
vomit after all his drinking

The Removal of Émile Zola's Ashes to the Pantheon

My rowdy and triumphant months at the Sorbonne had won me many friends among the students from every country who jammed the picturesque but flea-infested hotels in the Latin Quarter so when I got my degree from the University of Genoa I went back drawn by the literary life in Paris and the political ferment

On the way from the Gare de Lyon my cab was almost overturned by a march of anti-Dreyfus students chanting against Zola

I go visit my friend and famous writer Jules Bois

"Good morning get me an invitation for the Zola ceremony tomorrow"

"You don't really mean it did you just come from the moon imagine coming to Paris to be bored like that it will be too dull for words"

"There might always be a kick in it"

"Yes maybe a very hard one"

The next day Jules Bois and I are admitted to the Pantheon with our special invitations standing a meter away from the President of the Republic and from the famous and internationally discussed Jewish army officer who had been condemned as a spy and retried

Dreyfus

Hot and crowded

"See for yourself it's going to be a tedious ceremony"

My answer was drowned out by the report of a pistol shot whistling by me and wounding Dreyfus in the shoulder

General hullabaloo orders being shouted women fainting everybody

struggling elbowing pushing the Garde Républicaine and dominating the whole scene the black top hat of the prefect of police Lépine whose loud voice booms out

"Close all the exits have the mounted police circle the Pantheon six times playing the *Retraite aux flambeaux* on their horns"

Dashing through the cordon of mounted police with my friend I manage to escape and meet some students I know and we all end up at the Restaurant D'Arcourt for some quick refreshments but then another run-in with the police and the windows go bowrang vraam

The crowd is forced back by the police and the cavalry overturns tables and students alike in the free-for-all that spreads to the upper floor of the restaurant with arguments about the dirty bastard and shouts of To the Pantheon To the Pantheon

Without meaning to I find myself in the limelight

"The Italian poet is the one who has to speak yes no yes no we need his originality because he doesn't give a damn about the world it's bad enough he speaks Italian Down with Lépine Down with Lépine"

In the mad melee of waiters and crazed prostitutes I am forced to shout

"You're forgetting and this is serious you're forgetting that Zola is a great writer he's originally Venetian in fact"

Loud laughs and crashing of broken dishes and the shrill voice of a student friend

"That's the opinion of an absolutely mad young Italian poet"

Zola Obsessed Me

I loved and often read Jean Jacques Rousseau's *Social Contract* I liked *Émile* more and I would finish by reading Zola's *Germinal* when I didn't abandon myself to the dreamy smoky walks inspired by the railroad novel *La Bête Humaine*

Locomotives and trains had become my stylistic blood relatives leading my imagination toward social problems and to the mystical beyond that scientific positivism was trying to dispel

With my first Parisian publishers Sansot and Roger Lebrun I was traveling to the Atlantic coast at the end of September when a small railroad station suddenly filled with Breton pilgrims on their way to Lourdes

The youngest of them a beautiful slim girl dressed in black but resplendent with big violet eyes daringly strung a scapular medal and crosses across my chest

I fall in love on the spot drop my two friends and head toward the town of miracles becoming a very important pilgrim and a member of the Breton family she is taking care of a very sick young wealthy relative who lies pale and dying on a stretcher

In studying the literary origins of Futurism Acquaviva must take into account these exceptionally warm days doubly enveloped by the flaring of the sun and divinity

In the immense area in front of the shrine twenty thousand pilgrims stand in long ranks and more than a thousand stretchers uplifted arms

in waves imploring the mercy of the Virgin up there white and blue in the cathedral built of special burning snow

Obviously devils too mingle among the crowd in search of trouble and you can feel their horns shining among the red sweating jowls of certain fat prelates who have led the faithful here their voices not very mystical indeed very red-blooded

"Holy Mother pray for us Holy Mother pray for us Holy Mother pray for us"

"If it be your will cure us"

But the clouds like billowing robes of archangels swell among the piercing burning brassy rays of the sun and the swooping of sparrows flashing and sure around the cypresses and pines baking and dripping rosin like candles

Next to me the heavy breathing of the pale and dying rich cousin on her stretcher under an oppressive cushion of hot air

I give her some water to drink with my right hand while with my left I almost mash the beautiful fingers of my beautiful pilgrim

> Yvette aux yeux de violette
> si tu me donnes ta bouche
> en disant "bois" et ne sois pas farouche
> que veux-tu que je mette
> dans la fièvre de mes lèvres
> sinon un peu de miel d'or
> ravi à ton âme vermeille
> ou mieux encore aux abeilles
> du mont Hymette en feu
> Ma belle Yvette et sans effort
> donne-moi à boire ton corps
> béni du bon Dieu

I had a book on science in my pocket that had informed me a little earlier that the belts around the planet Venus contain 99 parts water and that a single part not liquid holds the whole thing together

I had also read in it that bacteria capable of resisting pressure freezing temperatures intense heat cannot stand the presence of gold or silver and die

That September afternoon perhaps out of sympathy for the name of Lourdes lay heavy in the air lopsided calvaries of endless heavy molten brass crosses such was the weight of the sun's rays shaped like crucifixes

beating down on our fragile hands or digging into the shoulders of us poor souls

Some breaths of air random but certainly malicious slunk around the priests in black and white panting under the sun's cutting rays with their tide of prayers trying to lift the always heavier and dangerous blanket of heat

The pale tender flesh trying so desperately to cover her slight bones was now very hot the very sick girl white against the white of the stretcher next to me

But her two immense green eyes opened as the sea does after surging against the rocks and perhaps it was a sign of life or of God's will

Because certainly the Divine reigned there pressing on the vast flat space where faces sins devilishness darted back and forth like sparks cast off by a roaring fire

The merciless glare sharpened into a single voice followed by two others less harsh

I was trembling all over

In my throat I could feel a sweet painful sob intoxicating me with the expectation of the impossible

"A miracle"

"Yes yes a miracle"

"Yes look he's getting up he can walk"

I try to talk to the girl next to me on her stretcher but my lips quiver to see her struggle up moving raising a hand pushing her blankets aside she's very white but alive with the muscular throb of life

A voice not my slight pilgrim friend's but the powerful voice of a man I couldn't see thundered and is still thundering

"Behold a fourth miracle"

Everybody on his feet crying shaking overwhelmed gathering around that white shadow that now can walk while in my visionary eyes the falling and leaning crosses and the calvaries of dazzling metal multiply amid the spreading mystical furor

We enter into the crowd and the excitement outcries arguments and they take us into a medical station where the delicate girl is made comfortable

A careful examination shows that all her running sores are healing and looking less gruesome I say to the doctor

"You are probably aware of theories to explain this phenomenon some think it's the heat and the crush of the mob and others all the

excitement that fires the faithful and creates empathetic waves but I think they are real miracles an upsetting of the natural order and we'll witness another authentic miracle when you dip the healing girl into the slimy turgid water of Saint Bernadette's pool and apropos of this we can quote Zola the writer who as you know was of Italian origins or rather Venetian 'The miracle is if a human body escapes infection in that water crawling with murderous bacteria' "

An hour later in our small pension I was reading aloud with a certain vehemence the epic Futurist finale of *La Bête Humaine* when a maritally betrayed machinist and an adulterous fireman came to blows with the engine going at full speed and fall off so that the locomotive realizing it was finally free of all control raced madly ahead hauling carloads of soldiers through the terrorized stations like a cyclone thus becoming the lugubrious symbol of France of 1870

The great creator of French *vers libre* Gustave Kahn my patron and teacher in Paris was delighted to hear me read aloud incomparably according to him that most important short poem on the North Sea sailors' bar and I can still see him splitting with laughter when to his wife's and daughter's consternation I got carried away while declaiming and sent our picnic basket flying as I made an unfortunate sweeping gesture with the hand I was holding it in my suddenly overinspired right one

My imagination hungered for new literary forms and was nourished by Paul Adam's friendship and I went to visit him in his villa with pleasure one hot August afternoon

In the darkened rooms I stumble among the cushions and finally sink into the couch whose deep velvets evoke Baudelaire

I think I'm alone so softly does my renowned host enter agile but short with a blond beard on his optimistic Latin face a fierce yet gentle glance he begins speaking about his book *Trust* and of another probably more Futurist

A sudden movement behind me reveals an exotic sleeping animal but it is the poetess Anne de Noailles who is just waking from her usual siesta as the sick sleeping beauty

Paul Adam decrees

"She's the most beautiful sparrow in France"

Her large heavy-lidded dark eyes with their long lashes and the fringe of hair over her forehead and her lovely slim body freeing itself from

the chilly materials of her wrap recall rather the strange nest of some very tropical bird

The poetess is delighted by my lyrical outbursts published in my international review *Poesia* with a portrait drawn by Enrico Sacchetti and she sighingly sighs like a feline and I follow her and Paul Adam into the hot garden in search of shade

Sweat beads on the forehead of the sickly poetess as she offers meal in her hand to the fat pigeons and murmurs

"These are twelve pigeons in Piazza San Marco in Venice you are to recite to them your words-in-freedom against museums and old cities looking them straight in the eye because I want to know what they think of them and they'll tell me on my shoulder and I'll turn their message into alexandrine verse which will move along almost as quickly as your words-in-freedom to be added on to my *Coeur Innombrable*

Reciting Poetry While Marching and London Ladies

The 1912 winter season in London was at the disposal of Italian Futurism and my sculpture made out of stray materials such as frames brushes handkerchiefs tin cans entitled *Running Man* hanging from the center of the Doré Gallery provokes arguments among the newspaper critics racking their brains to show how unconvincing my marching poetry recitations are they compare them to sermons being spewed from different pulpits in the same church

I refute them with a single loud recitation *Passeggiare e poetare nel tornare al fronte di guerra* [*Strolling and Poetizing While Returning to the Battlefront*]

I recite this Futurist lyric at a brisk pace while racing from one room to the other where refreshment stands have been set up with couches and shady-leaved plants and blackboards on which to write typical words-in-freedom

While I flute sentimental delicacies and boom out cannon fire I get further into my poetry and using precise gestures drum it home to the English audience

This seems all rather strange and moving to the many curious ladies among whom the very elegant millionairesses draped with awesome ropes of pearls Lady Cunard and Lady Cornwallis West who get caught up in my rhythms and shocking images and begin clapping encouraged by the gracious young secretary of the Gallery and by the clients who forget they came to buy antiques and are intoxicated with Futurist works

A late supper follows at two in the morning at the Three Crabs Club where aristocratic or mercantile beauties exhaust their artistic sense with too much succulent food and heady costly wines I break away and secrete myself with a coy energetic young lady in a remote room

"You're very beautiful you must have a magnificent body will you forget the art nouveau on the seventh floor and concentrate on an amorous interlude that's real right here on the ground floor"

"Without even hesitating at such a proposition that's so Futuristic I'll answer yes because the past is no and the future is yes"

Our amorous interlude was spiced with the romantic fantasy of danger and adventure and peppered with her Hungarian and Argentine blood but she closed it with this rather foreseeable and prosaic proposal

"London is out there with her chilly dawn and in here our love has fired up our tummies like a locomotive we'll need some cold meats for them my dear Futurist Marinetti"

"I'm burning hot and for that I'll need some of the special cold meat of your Rosary of Santa Fe

Poetesses Actresses and Poets in Marseilles

The summer sends all literary artistic and theatrical Paris to Marseilles

Gustave Kahn the creator of *vers libre* considers me his best pupil and invites me to lecture and read my poetry in the large theater put at his disposal by the city of Marseilles for a series of encounters and performances in honor of poetry

There gathered Émile Bernard with the poets of Mistral who celebrate the bullfights in Provence Boldini with several of the famous subjects of his portraits and the renowned poet of the sailors' underworld and the princely refinements of Montecarlo Beaulieu Nice Cap Martin San Remo Bordighera looking very artificial with his makeup and rouge a gardenia in his lapel and a sour stomach bearing the name of the undoubted genius Jean Lorrain

Gustave Kahn the director of this affair stubby somewhat paunchy with a powerful skull squared by all the possibilities of imagination and cunning while his wife a little countryish pompous and springlike with jet black eyes was admired as the beautiful Arlésienne but husband and wife were out of keeping with the grand to-do of feathers silks and seminudity that along with the theater and opera companies from Paris filled the Marseilles bathing establishment we all gathered in with bizarre and very showy oddities

At the moment Jules Casagrande dominates his round pink face soft and sickly-looking his fat hands loaded down with rings he's much sought after because he's the most important jeweler in town and at fifty he's been saddened by the death of his only son at Tonkin and

consoles himself with liquor always having a drunken grin on his face

He immediately shows a sort of paternal affection for me but he covets you can see it in his sensual glances one of the beautiful girls who is going to compete against me in poetry reading and various recitations the very beautiful Algerian Alice Princess d'Ali

This twenty-year-old poetess her looks softened by the full languor of her enormous licorice pupils is followed by an ambiguous tubercular brother everyone considers an Adonis but so dissipated-looking and muscleless that his big love-sick black eyes do not win over that overwhelming blond beauty with the nice breasts everybody says is a virgin "but in her own droll way" Georgette Hartmann of the Comédie Française

The moon insists on putting us all into the same boat and fills the billowing sail with her milky whiteness as the team of naval cadets casts off and keeps hoping the wind will in some bizarre way freeze some icebergs for us just to escape the mugginess that is making us all pant after the heavy meal

Anxious to establish my Italianness I begin reciting aloud several verses of my French translation of Leopardi

The fire whistle on the dock interrupts me and suddenly before our eyes the Casino goes up in flames the entire port becomes an endless coral forest

The Algerian poetess's brother lying next to me murmurs

"The Casino is burning in keeping with its noble habit of burning its chips"

The jeweler says

"The usual malicious insinuations"

The Algerian poetess waving her handkerchief like a censer in an Indian temple in a low voice

"When we get back come to my room and recite your poetry to me but stop looking at Georgette she's a vulgar beauty not worthy of you"

The muggy air is oppressive and the sails are slack like benign discouraged nudes so that we are forced to get to our feet rather shakily in the rocking boat near the flaming Casino but we manage to get tangled with one another and plop plop plop all fall into the water

The firemen are called away from their hoses and ladders to rescue us laughing mightily at our plight

An hour later the now famous Alice Princess d'Ali receives me in her room that looks like the back of a Turkish rug and jewelry bazaar

"My dear poet you must swear to me you don't like Georgette you'll find out tomorrow that she doesn't know how to recite alexandrines perhaps she can read free verse but I don't know anything about free verse and besides she's a hypocrite I vow to you she's not been a virgin for some time leave her to Casagrande especially since the dog is very jealous and is a stockholder in the Casino which was heavily insured and he had it set on fire by some of his henchmen in the firemen's corps which he also owns"

"So he's a millionaire"

"Yes and he's madly in love with me but I tell him to go to hell quite regularly he's so disgusting"

"He'll revenge himself for that"

"He's going to have me booed tomorrow night in front of all Marseilles"

"But someday my brother David will gun him down in the dark side street by his villa and even you will have to be careful my brother is terrible"

"I'd rather have your alexandrine verses drawn out voluptuously by your kisses than your brother any day"

"You'd better go now I don't want David to find us here but just don't be impressed by Georgette Hartmann's poetry and her buzzing nasal way of reciting it"

I don't know how it all ended that night but one thing is certain Gustave Kahn found me still in bed at eleven the next morning in a very glum mood

"You know Marinetti that David boy is stirring up a small scandal because he says his sister came here to visit you"

"You're wrong because the only woman I received in my room is called Indigestion followed by Miss Folly but I'm getting lost in this free verse that Tristan Klingsor the poet tries to accent to the last syllable maybe to imprison his lines forever

I leave mine free along with yours about the North Sea bars that I hope will be applauded tonight"

In that Marseilles with its bustling traffic of transatlantic liners coal Chinese and Indians and piles of cocoa sacks it's strange to find such an interest in poetry

The scorching hot tables out in front of the Café de la Canebière must be amazed to hear arguments raging over free verse and new

Italian poetry and to watch all those stands and seats go up for a show without music and dancing girls

The orchestra seats are overflowing with businessmen naval officers sugared dandies who sport their summer Parisian manners at the beach big pearl stickpins straw boaters and display their girl friends with knowing glances all decked out in feathers flowers and big southern eyes under massive Provençal hairdos.

On stage the Algerian poetess squeezes my little finger and warns me

"If you want to be successful don't recite Baudelaire because he's the moon of the Latin Quarter just think of our Algerian sun or the sun that's in the hearts of the whole audience the sun of Mistral"

Even Madame Kahn has some advice for me

"Please do your best with my husband's poetry I'll be listening from the boxes but remember the beautiful Arlésienne will never give in to the whims of a Milanese sultan like you but you might also remember I love your birthday *panettone*"

After Georgette Hartmann of the Comédie Française received a whole minute's applause for her recitation of a Provençal sonnet by Émile Bernard two boxes jammed with young toughs started exchanging insults and visiting cards for duels

I'm just about to go on stage when the Algerian poetess warns me

"Please while you're talking and reciting face the box on the right where you see my mother and don't turn to the boxes on the left because they're full of gambling house owners and panderers and you'll even see our impresario and jeweler among them Casagrande"

The atmosphere was charged with colors material and spiritual very violent and yet very friendly ready to erupt but the applause in the theater for this young Italian poet declaiming French poetry turned out to be a storm of enthusiasm *à la Marseillaise* that is without subtleties or irony maybe because all those men and women felt that I was more southern than they were

In my talk I explicitly condemned the way the Comédie Française taught the art of reciting poetry and I praised *vers libre* and its creator with such a burst of sudden inspiration that when I went backstage Georgette Hartmann slipped a bunch of violets into my pocket along with a note to be opened later

But I opened it right away and am surprised to see the Algerian poetess burst into tears just before she's to go on stage to recite

"No no I don't want to recite alexandrine verse anymore I'm for *vers libre* too and Marinetti is right and I'll write it too but now what shall I do with my eyes all red and weeping"

Drying them with sinuous grace her hands tinkling with rings and bracelets her handkerchief fluttering back and forth like a censer Alice Princess d'Ali the Algerian poetess was the roaring success everyone expected her to be and a servant with a sly air came to offer her a crown of laurel set afire with an enormous emerald

I was stunned but Gustave Kahn as the director of poetry managed despite his short stature to be elegant while crowning the poetess and reading among the laurel leaves

"Jules Casagrande following Marinetti's advice invites the Algerian poetess to write free verse about her Mediterranean Sea"

Like a blue flash among the veils and flounces of the ladies in the upper balcony a sailor began hitting his companion who was calling out for the Algerian poetess to keep reciting

Everybody's madly in love with her and the sun-drenched freedom of poetry but everybody's equally upset because you can't touch eat drink poetry and when I leave with Gustave Kahn between the two poetesses there spills out with us from all sides the tumultuous crackling of fresh applause with all kinds of tight knots of masculine desire still left unsatisfied in the wake of the herd of poetesses actresses and poets as far as the restaurant where the night breeze from the immense port brings to perfection the tasty banquet of an endless bouillabaisse

I too ate out of all proportion but no matter how the fish spurred on by the hot pepper and the wine tried to drown out the winners the free verse the real triumph and the real obsession were and still are right there in front of me the gems that that night Casagrande who now had become once again the bigwig displayed appraised weighed slipped around one waist and then another citing fabulous sums and ended by presenting them to Alice Princess d'Ali and after three minutes' pause while we all held our breath also to Georgette Hartmann of the Comédie Française

Since beneath where we are banqueting the carriage horses supplied to us for our after-dinner ride were pawing the ground and I was asked to recite "for good digestion" I illogically amuse myself by presenting over the mullets and eels my free verse in honor of racing cars

At the first booming out of my powerful voice they immediately demand that I recite standing on the table and so I push aside the still-hot

platters full of bright oily fish scales and tails right into their liquor-glazed faces

Thin and elegant in my smoking jacket my shirt wringing wet and my collar twisted into its own anarchical freedom I begin thundering out and send motors roaring up up right past the Milky Way like a racecourse

Gustave Kahn is gloating and declares he's a bit taken by all the wine

"Your free verse has won the hearts of the ladies fish and jewels of the richest jeweler in the world we all have to go breathe some air on the docks"

The carriage horses don't know if they're Arabian or dromedary or steam horsepower or car engines and while the women crowding in scream like drowning hens David who is still the sly brother of the acclaimed poetess wants to take the coachman's place and snatches the reins from him and turns to Casagrande who is sitting in front of me with his right hand in the Algerian poetess's and his left in Georgette's

"My dear Casagrande you played a nasty trick on me this evening and I'm not going to forgive you for it because you're the one who filled the moon's mouth with that damned brandy I can't keep down you're no friend I can tell you"

He was driving so badly that the horses sent the carriage crashing against a streetlamp making us bang our heads and unwittingly whipping two policemen

A few meters from the splashing surf an argument burst out and spread to the whole party about the free verse of the horses who are also forced to drink in the water while waiting for us drinkers outside the all-night cafés and at night they have the right to knock policemen around for whom a little gift slipped into their pockets can become a bottle of champagne at five in the morning when their rounds are over and they couldn't care less about thieves and murderers and fights among the whores

An hour later at the hotel the silence was broken by a pistol shot

Everybody runs out in his pajamas or bare-chested and several beautiful actresses faint in the arms of the bellboys

"David has killed Casagrande"

"He's not dead maybe he's been badly wounded"

"Why ever did he do it?"

"David's crazy"

"He's jealous of his sister Alice"

"No no he's in love with Georgette"

"Georgette doesn't have anything to do with this"

"It's that Algerian woman's fault"

"No no the fault's that Franco-Italian poet's that Marinetti"

Alice Princess d'Ali appears slithery and suspicious half-naked in her dressing gown

"I'll stand up for my brother David he's a great poet but nobody gives him the recognition he deserves and that discourages him but the fact is tonight he shot Casagrande because he was drunk with the poems of that Italian Marinetti Marinetti where's Marinetti

Briskly stepping up I conclude

"I'm not at all surprised I've already had the experience of sousing people to the point of crime with powerful doses of free verse" and with a loud laugh between us we went to the jeweler's bedroom where he lay on the bed bleeding and saying

"The surgeon removed the bullet from my shoulder and says I'm not in danger and since I'm good-hearted I've decided to give David this pearl that's worth at least thirty thousand francs"

My Poem *I Vecchi Marinai* [*The Old Sailors*] Wins a Prize at the Sarah Bernhardt Theater

A young Milanese bank clerk Emilio Gavirati charming intelligent and so enthusiastic over Ardigò's positivism that he studied English to translate his works and who was killed by a stray bullet fired accidentally by someone distributing political fliers in Via Verdi says to me one day

"Dear Italo-French poet I advise you to go to Via Garibaldi 83 there you'll find two French men of letters who know you already they're publishing an Italo-French review here's the first issue they'll be glad to have you work with them"

I became a friend of the *Anthologie-Revue* and my *Les Vieux Marins* was published in it a free verse poem that was then submitted to the great poetry contest known as the *"Samedis Populaires"* of Sarah Bernhardt and the theater managers Catulle Mendès and Gustave Kahn gave it the prize

The three hundred liras I begged from my father who wanted me to become a lawyer and was little disposed toward my poetic fancies were enough to provide me a triumphant month in Paris

Gustave Kahn was on the jury because he was the creator of French *vers libre* awarded first prize to my poem and became my affectionate patron and so I appeared on the stage of the packed theater next to him as he was greeted as the literary maestro of the French avant-garde of the time

No matter how official and solemn the ceremonial presentation by Gustave Kahn and the reading by that great actress who made my free

verse sound a little monotonous with her usual way of reciting alexan-
drines arguments kept breaking out pro and con with violent applause
from the balconies jammed with students on the verge of open battle
which was in the headlines the next day even though the papers all
agreed I'm a poet of genius

That same night in a restaurant with Sarah Bernhardt eating big red
shrimp we talked for a long time about the unexpected tempestuous
Italian quality I brought to French meter and about the southern lav-
ishness of my imagery all of it very powerful without the subtleties and
half-ironic delicacy of the Parisians

The triumphs that followed for me were unforgettable among the
editors of *La Plume Mercure de France Revue Blanche*

La Plume launched my first book two months later *La Conquista
delle Stelle* [*The Conquest of the Stars*] followed shortly after by my
second book *Destruction* published by Vanier Paul Verlaine's famous
publisher

The controversy about free verse went on and the conservative critics
took advantage of my poem *La Conquista delle Stelle* to criticize Gus-
tave Kahn for using his talent to corrupt the harmoniousness of French
poetry to the point of bringing in a foreigner himself a tradition-breaker

Among the arguments and bitter letters exchanged I had the pleasure
of meeting an unquestionable literary genius of the underworld Alfred
Jarry in the editorial offices of the *Revue Blanche* which was mainly
political-social in content and run by the Nathanson Brothers

Thirty and thin with an emaciated face strings instead of buttons
holding his baggy jacket together certainly not his own that made his
large flapping pants swing back and forth and this was a gratuitous
way of life in a very prosperous Paris a flagrant banner of voluntary
poverty

Tender affectionate grateful for very little he followed me everywhere
and I would insist on introducing him the most threadbare genius in
the world into the most elegant salons despite what horrified people
were saying

I could get away with it because Parisian salons then had a certain
passion for ingenious creators and bright minds

I can see myself now with Alfred Jarry in the ornate salon of Mme
Périer where from three to eleven at night thirty or forty men and
women spouting poetry would parade through all ages appearances bel-
lies breasts long hair beards celebrities

Even the unknown and even old women intent on ruining Victor Hugo's or Musset's poetry

I toss off my ode on the speed of cars and Jarry his metamorphosis of a bus into an elephant

The passion for literature was so keen in those days that while they were devouring their hors-d'oeuvres and cups of chocolate the ladies would stand open-mouthed before the milk or alcohol of poetry and drink in my raging Futurism and the originality of my friend's caricatures with a constant smacking of lips and spewing out of praise

"Very good very good better all the time but I do prefer these two poets the Italian is a real natural force a formidable element a storm these Italians all are great poets musicians and great lovers"

Numberless successful love affairs always under the guise of concentric circles around the splash caused by my free verse

The Parisian night would give me a peculiar mastery of the underworld the picturesque tragicomic depths of tears laughs mockery fascinated me

The prince of poets Paul Fort was declared the king of it all the gentle ardent author of ballads that lent grace in the French manner to the freshest images of the Swiss and Italian Alps

In fact his authentic and persistent Gallicism mixed in with a certain medievalism an ancient chivalry recalled Villon and he loved talking for hours about Petrarch's way of loving in verse

With clusters of curls falling over the nose of the prince of poets and upturned mustachios looking like gray suet of Jean Moréas the other famous king of the underworld and the Parisianized Greek Papadiamantopoulos I entered the very bizarre tavern on the Bièvre a canal lined with tanneries and made grim by the tottering shacks small workshops mountains of garbage muddy heaps of leaves on which the moon was having fun at times spreading marvelous cloaks of silver lapis lazuli pearls

The notorious moon friend to thieves and murderers but at that time when money was not yet king the guts of the capital could still laugh and a poetic genius taking in deep easy breaths could proofread the galleys of his translation of Pascoli into French between good sausage a glass of beer ex-cons and a prostitute with a black eye who smiled deliciously

From the Café Bulgaria in Sofia to the Courage of the Italians in the Balkans and the Military Spirit of Désarrois

Words-in-freedom were born on two battlefields Tripoli and Adrianople

Coming away from the maddening mixture of smells and perfumes of the Souk I wrote in my mind words-in-freedom telling of the murderous weight the colonial infantry carried under the burning sun that made even heavier their rifles knapsacks blankets ammunition machine guns cannons mules and the sand in their boots unfit for desert dunes I am explaining all this to the pale Slav Bulgarian poets in Sofia's great café bristling with political controversy and filled with spirals of smoke from their cigarettes and pipes and ambitions

Since the Bulgarian General Staff thought fit to requisition my horse I have to take the train to Stara Zagora where my landlady a rough but handsome peasant woman very sympathetic toward Italians robs my time with her attentions and succulent food day and night but I put an end to it by deciding to depart immediately for the front on a buffalo-drawn cart I've bought and will drive myself with the help of a Viennese correspondent who is more of an ox-driver than a journalist

To start on this trip I have to shoot at a pack of wild dogs and then slowly make my way to the village of Mustapha Pasha to the tinkling of cart bells

A night in a shack with Corrado Zoi and Bevione gagging on the stench of cabbage and fish seeping through the floor boards from the corpse of a murdered old Turk and we're off again on a meal of chocolate bars through the Bulgarian batteries pounding Adrianople

The long worms we swallowed from the necks of the bottles filled

with water from puddles and the awful thirst and the bridges the Bulgarians threw across the Maritza all become part of my famous words-in-freedom expressing the swirling poetic and geometric mechanics of a bombardment

I finished that short synthesizing noise-making poem while witnessing the machine-gunning of three thousand horses ordered by the Turkish general who was the governor before the fortress fell

The poem also contains the shrieking of the train bearing the wounded when it became tired of the tracks and went mad in the Balkans

Perhaps because the erotic essences from the roses and the great retort-shaped boilers stuffed with petals or perhaps because the wounded suffer too much as they are knocked about on their stretchers their bandages loosened their wounds stinking without the gentle hands of their mothers but the fact of the matter is the cars hurtling down against each other snap their brakes and whole train overloaded with flesh wood metal screams picks up speed down the mountain between steep rock cliffs

Beside the wounded who are practically heaped inside the train there's me and five journalists a Frenchman a German a Russian an Englishman an American

They're white with terror because the thundering of the wheels foretells a disaster

Suddenly overcoming the more or less chilling physical circumstances I decide to set an example of Italian fortitude and I stand up to explain that what we need is a poem completely free of both classical and free meter but made up of words-in-freedom to express that tragic and strange breakneck and breakwheel plunge I start declaiming with all the ingenious possibilities of my lungs my free verse in honor of racing cars

The white faces of the wounded spotted with red and the livid faces of my friends the foreign correspondents follow enrapt the sheer vehemence of my Futurist poem with the amazement they themselves later raved about because they didn't believe it was possible to win out so elegantly over fear with an outburst of poetry

Having been invited along with several of the major literary figures of the world to speak in French at the Salons of the Louvre I ask Désarrois the avant-garde art critic if he would advise me to describe the experience I've just recounted

His answer

"I can boast that I was a brave French soldier dear Marinetti go ahead and inject some bellicosity into this salon full of beautiful women and fine materials and even of the most delicious Parisian ironies which unfortunately hide weaknesses that ought to be punctured"

With a burst of nonstop and extremely graceful eloquence I improvise a speech that provokes enthusiastic laughter blissful gurglings and knowing applause

They are charmingly persuaded that with the same courage of an Italian which reaches its poetic apex in the midst of danger the innovating typically Futurist genius of Leonardo da Vinci Umberto Boccioni Antonio Sant'Elia Marinetti can put together a marvelous poem capable of summarizing simultaneously the whole universe

Everybody says out loud that I am one of the elemental forces of nature to be approved of always especially since I'm armed with noble and very sophisticated weapons that are strictly feminine and French

Vehemence and virility with a touch of worldly refinement that is seductive and enchanting

Praises pour forth in front of my friends Casella and Buccafusca in a half-lighted rough astrological gothic all-night restaurant that's trying in vain to discourage the rather grand and dynamic literary ladies who have invited me to supper and declare it's "just heavenly" to be celebrating "those devilish Futurists"

Aggressive Noisiness and Russolo's Noise Machines

The 100-horsepower Isotta Fraschini with which I ventured 30 years ago into the shack-strewn mud flats of Romania and Macedonia broke down in Sofia forcing me to acclimatize in the Restaurant Café Hotel Bulgaria where hundreds of journalists politicians party leaders writers and bearded poets along with a flock of peasants with upturned cord shoes smoked themselves in the steam from their tea

I immediately sensed the probability of an early war

The next morning I followed a line of wagons loaded with cases marked Creusot and I mentioned it to our ambassador assuring him that the war between the Bulgarians Greeks and Montenegrins on one side against the Turks on the other was imminent

The ambassador a gentle refined cultured man says I'm imagining things and speaks to me about Theocritus and Sappho

The war does break out and I buy a horse for 200 liras but the Bulgarian General Staff cheats me out of it and I have to wade through the thick fudge of a rainy October with a Viennese journalist behind a buffalo-drawn cart carrying our suitcases and several bundles of canned and dried food which was very hard to get

On the hills overlooking the Maritza and Tungia rivers after having slept on some flea-ridden floor with my nose pressed against a trapdoor over a cellar rank with Turkish corpses every morning I would measure the amount of heroism contained in the cry *Petnanoie* with my aeropoetic words-in-freedom the cry the Bulgarians and Turks let out every hour to the *ta ta ta* of machine guns and the *zazu zazu zazu zazu*

of axes against the supports of the bridge that had to be destroyed in the struggle for the river crossing

Every afternoon on the same hills now become my desk I spell out with my pencil the harmonies and chords of the opening and closing rounds from the medium-caliber guns of the Serbs who are so envied by their Bulgarian officers even though they are allies to the point where I am witness to the spectacle of superior officers being slapped around in the battery

The Turkish cannons reply and each day as the Turks return to destroy the Bulgarian bridgeheads the siege of Adrianople is prolonged synthesizing in my nerves and my lungs until it finally becomes the now famous *Bombardamento di Adrianopoli* [*Battle of Adrianople*] which I read in more than 100 cities in Brazil Uruguay Argentina it was termed "South America's banner in sound"

From Sofia I rush off to London where Luigi Russolo had already arrived to direct his orchestra of noise machines at the Coliseum

Mistrust and hostile traditionalism lie in ambush

The impresario tries to break his contract

The orchestra players attempt to ridicule the noise machines pretending they've mistaken them for toilets

Luigi Russolo who is held up at rehearsal by an old lord making passes at a ballerina in the darkened orchestra streaks out like a red flash at the conductor and smashes him in the nose

In London where the English Futurist painters Nevinson Wyndham Lewis Wadsworth have distinguished themselves for their proposal to camouflage ships by using dynamic Futurist color patterns originated by that genius the Roman Futurist Giacomo Balla there took place before and after the concert other furious fistfights and encounters that didn't stop me at all but rather were inspiring as I dared explain even though I didn't know English and pronounced the few phrases I did know badly to the rich and well-educated London that mattered persuading them with gestures and intonations that they should respect Luigi Russolo's talent and his way of making those noise machines sing the spirals of sound entitled *Il risveglio d'una città* [*The Awakening of a City*] and *Si pranza sulla terrazza dell'albergo* [*Dinner on the Hotel Roof Garden*]

From London I go on to Tripoli where in the back of a shop in the Souk I can look over the skins of jackasses and sheep used to make

darabukkas but I am more attracted by the 200 to 300 phials of perfumes and erotic essences that a Turk shows me behind drapes and rugs between two cups of Turkish coffee which inspire touch and smell words-in-freedom in me

From Isadora Duncan to Giuntini's Musical Syntheticism

Isadora Duncan American dancer from San Francisco danced at the Théâtre des Champs Elysées in Paris describing a variety of movements to the melodies of Gluck with the indolent and light grace of schoolgirls tossing a ball to one another in the foaming sea

I am enthusiastic about her performance and am introduced by Lugné-Poë and she immediately gives me a special invitation

"I adore originality and original people so please won't you the creator of Futurism come to my house New Year's Eve and there'll be just the two of us I hope you won't be bored"

She had rented Rodin's old and spacious studio and draped it with long swaths of pearl gray lilac smoky violet velvet that deadened muffled held down sly and vaporous dreams

It was steaming hot in there worsened by an Indian supper of spices and fruits mixed with her forest chill and suspicious essences

After midnight a pianist in tails arrived looking like a mechanical ghost emaciated his eyes bulging out who played at her command and never said a word or looked at us once

More intoxicating than intoxicated on champagne cognac whiskey Isadora Duncan stripped her mysterious body almost completely with unexpected fascinating revelations that her dynamism made even more beautiful and dancelike just as a great speaker speaks or a knowing courtesan offers every part of her body or a beautiful flower blows in a spring breeze

She is not beautiful but her big intelligent eyes demand that her thighs her buttocks her left knee her right knee and her small breasts each part of her in other words be fascinating

She uses music as a veil to surprise and caress always stimulating the imagination of the onlooker and even gauging his degree of excitement

Intent spirituality and intense sensuality

A dance to the love duet from *Tristan und Isolde* and after that she feels like exercising her imagination so she improvises a folk dance to the song "Mariette ma petite Mariette"

To make fun of herself or to dampen my rising ardor which is about to explode she cools her ardor down with fresh showers of champagne

I'm assaulted by a thousand desires and by this time the multicolored and very diverting fury of forms and poetic colors beyond time and space kisses caresses the embrace and rekindling of our passion are not enough for either of us and more so since she loves to rationalize the frenzy of her torrential music

As a good Futurist poet I offer her a theme

"Dance my beautiful friend dance to these Futurist words 'Thus three hundred electric moons erased with their dazzling chalk beams the ancient green queen of loves' "

Tossing down another glass of champagne the nude Isadora as brilliant a white as acacia flowers moves among the pearl-gray draperies evoking the voluptuous lunar lassitude of the blissful sickly amorous green queen of loves

After a preliminary unfolding of steps sighs and moans the dancer is transmuted into a motor turning at full speed accelerating the maddening whirl of a hundred light bulbs vying with each other for supremacy

Isadora's arms flashing with rings and heavy oriental bracelets whip themselves into a frenzy exciting the night that sends its beams like lifelines down down into the storm of humming crackling tinkling phrases truly fallen from the moon

"Marinetti I'll dance in Russia and marry a Russian Futurist unless you marry me"

"Russian Communism is made up of a dash of French revolution much German militarism some Marxism some Carbonarism some Cartesianism"

We went to finish the night hoping for and tasting the dawn over the gardens at Versailles

Although I was madly in love I didn't accept her marriage proposal but spoke to her of the infinite spiritual and therefore musical freedom of the Gulf of Naples and also of the musical syntheticism of Aldo Giuntini

Suffragettes and Indian Docks

O my poetic words-in-freedom sing your touch smell noise of that so palpable city London

Fifty meters up in a dock crane I the aeropoet and Boccioni the aeropainter turning and turning two sun people imprisoned in the thick fog

Endless phantasmagorical three-hinged crane with its hungry jaws snapping away as if it wanted to take the roof off the squat dockside tavern but instead sinking its teeth into sacks and sacks and jacks and spewing them out on the wharfs and barges of the Thames

The eight o'clock tide incessantly repeats its ebb and flow slowly urging the bored ships out in the harbor toward shore

With the subtlety of Monet one by one the hollyhock-purple washes of distant trees banks slip through a three-meter wide opening through the rank stench of oil slicks coal herring pitch tar pages from *The Times* describing the march of the suffragettes armed with lead pellets breaking the vast display windows of the shops along the Strand

Several of us captain the tide of women along the street where the Ministries are located but the increasing flow and tumult of other legions coming in from the outlying districts compel the mounted police to give the signal for a charge all hell breaks loose as the horses come galloping down on them clubs flying screams pistol shots people knocked down and the crashing of more windows in the stores invaded by the madwomen

I and Boccioni are dragging a pretty suffragette along by the arms

when two huge horses with two immense policemen on them charge
down on our suffragettes and we all go tumbling head over heels into
the entrances and down the front stairs of the buildings

Three hours later in a big room of the large building the suffragettes
have taken over as a hotel I was explaining in French with endless
semaphoric Latin gesturing out of a miniature painting the aesthetic of
the machine plastic dynamism and idolatry of things modern the im-
portance of flying in literature and art to the more attentive of the 1000
women there all of them ugly except one just a meter away who was
betraying me by holding Boccioni's hand but promising me an early
revenge

The warehouses pretend they're gothic cathedrals with their walls of
reddish brick dunked in frozen smoke and rust sweating their lizard-
brown filth soaking the oily atmosphere with it and clinging to the
quibble of vague sparks that two sticky little sparrows weave on their
yellow jam of horse dung

Old dung besides because as far as horses are concerned the only ones
cooking are the horses in the Sicilian tavern-keeper's Ford and he's a
piece of plum pudding

With his muscular Negro arms veins and arteries branching out like
the ropes of a tug he sweeps the rugby field himself with great smelly
strokes and the players clear out in their pink blue yellow sweatshirts

Many suffragettes converted to Futurism more by our aggressive Ital-
ian physical attractiveness than by Futurism's ideas come to the station
with a hasty show of friendship to see us off

The Birth of Russian Futurism
Milan Paris Moscow Saint Petersburg

The art of noise was born in Milan with the publication of Luigi Russolo's book and the performance in Modena of the noise-machine orchestra which was laughed at and which consecrated my word *intonarumori*

"I have the impression of having introduced cows and bulls to their first locomotive"

Futurist architecture was born with Antonio Sant'Elia while in a Paris still echoing with the success of the first exhibit of Futurist painting I set up an exhibit of Boccioni's Futurist sculpture

As an innately plastic painter he is anxious to try sculpting and we go together to visit Archipenko's studio

Slavic starkness meaningful for the synthesizing energy it reveals does not entirely please Boccioni

As we go out into streets alive with flashing lights and traffic snarls I press down with all my poetic might on the accelerator of Boccioni's genius

This accelerator is called pride and it's so sensitive it responds immediately to my pressure

"Dear Boccioni there's no time to lose you're ready now for the great creative effort we're demanding of you you must be a success as a sculptor by creating a sculpture of movement and certainly you must be encouraged by the birth of Orphism shaped by what Lhote calls sensitive Cubism and influenced by us and our discussions

"Remember that Picasso created his *Port of Le Havre* because in real-

ity we're the ones who persuaded him to give up his cold engineering style and the anatomical dissections of objects and to come over to our fiery lyricism that embraces the universe including the modern electrified city we love"

We return to Milan and in Boccioni's studio sculptured muscular shapes of speed are taking form and especially his great polymaterial velocities the first sculptures of ambience light and shadow made solid

The ignition of Boccioni's genius having been switched on I return with him for the opening of the first show of Futurist sculpture at La Boétie the most famous gallery on the street of artists

An unforgettable afternoon for the almost divine fervor of our devotion before the miracles of art and this supreme new beauty

A strange creative originality burned in the air brushing against our nerve ends like razor strokes imparting fresh energy

At the door Guillaume Apollinaire a trifle egg-shaped fat almost oily high priest of novelty and eccentricity with a honeyed smile his big intelligent eyes half Polish half Roman whispers to me in Italian

"The aims of Futurism are bound to succeed and you're right all the way I'm joining your words-in-freedom movement and I'll announce it publicly and you can announce it to this gathering of important Parisians"

We greet Picasso Gleizes Lhote Delaunay and his wife Sonia Valmier the art dealer Rosenberg the art critic Fénéon the semi-Futurist philosopher Mercereau and the poet Salmon while Boccioni grips my hand and mutters

"You're forward enough you do the talking because I don't know any French and it's absurd you know really absurd for me to try to speak in French off the cuff"

"You're the one the public is interested in and as the most daring sculptor in the world you must do you understand must Futurism commands you improvise your ideas and explanations in French I'm sure you can do it"

Boccioni launches into the strangest most tortured wheezing cut-up patched-up explosive flowing gesticulating propped-up lecture imaginable and when I remember it he seems a prodigy of prodigies

Boccioni can't speak French but he has so many pretty prompters always providing the right word that he forces himself with come-on looks and gestures to explain plasticity affinities contrasts so that every-

one understands admires especially the beauties stretched out on red rugs under the bold musculature of the white plastic structures

Polymaterial environment with surprises Tastéven a small carefully dressed gentleman looking like an important official of some ministry comes over to greet me his blond goatee twitching and his little red Russian eyes sparkling

"As director of the lecturers' group in Moscow I have the honor of inviting you to give a series of lectures in the larger Russian cities lectures for which you will be paid whatever you ask with half your fee in advance and traveling expenses do come soon if possible because they're waiting for you anxiously in Saint Petersburg and Moscow"

I accept and run over to help out Boccioni tying together in one ad lib speech plastic dynamism and the simultaneous essential surprising quality of words-in-freedom and I announce that Guillaume Apollinaire has declared himself a free-word Futurist and I'm pleased to see among the plumed hats of famous beautiful poetesses Gustave Kahn and the Parisianized American *vers-libriste* Vielé-Griffin author of the *Cavalcata di Yeldis* both showing great empathy with me and Boccioni by approving of our undoubted victory over poetry and the human figure in order to poeticize the velocity of whole environments and freeze them forever

In London poets painters sculptors playwrights headed by [H. G.] Wells invite us to a banquet in honor of Marinetti and the Italian Futurists in the hall of the Poetry Society

While praising me in his toast Wells says in his chirping voice

"I am a bird but Mr Marinetti is a lion"

The comment hides a sly irony about the declared systematic violence of Futurism and I reply by reciting my free verse in honor of racing cars and *The Battle of Adrianople* and acclaimed by the whole group I conclude in French improvising extremely light words-in-freedom on the scratchy metallic noise made by the inhabitants of Mars

A pretty twenty-year-old poetess the niece of a lord gets so excited that flapping her rope of pearls that's probably worth a million she carries me off in her car amid snow and gusts of icy wind and newspaper boys standing barefoot in the frozen mud

The elegant automobile is lined with the truly exotic warmth its beautiful owner emanates as the Creole niece of a great English poet who was almost governor of Calcutta

"Let's stay here in the dark on my fur next to this good coke fire that's looking at us with all those savage red eyes and now repeat your poem about the Martians and I will call my uncle whose spirit comes to me every night I want him to appreciate you too"

Huddled on her fur we call upon the lord's ghost and since I believe in ghosts a chill goes up my spine at the loud bonging that suddenly silences us

"It's the clock chiming in the dining room"

Many times have I missed that strange exploding pendulum clock as I remembered the unforgettable hands that wound it

In Berlin before I took the train to Warsaw and Moscow at a concert with Walden pounding Wagnerianly on the grand piano the most beautiful German poetess who signed herself Princess of Thebes insisted on eloping with me and it's the third time I've had such an offer in this remarkable spasmodic verbalizing culture like Parisian literature in its gay exquisite quibbles among flowers butterflies perfumes but here in Berlin only talk about plants and roots

Acquaviva's book *The Essence of Futurism* accurately points to the sense of adventure and risk as a characteristic of Futurism that becomes the very rhythm of the white drifting snow and fatality of the sleeping car which takes me ever farther into the depths of a blue-white destiny

After a deep sleep I wake in the austere barren frozen Moscow railroad station feeling like a piece of lost luggage that's been found but there's no key and so it must await its owner while pretty customs inspectresses gather around solicitously ugly if they speak Russian but better if they speak French while their men pickled in alcohol curse the cameras and magnesium flares popping all over the place laughter and great bouquets of flowers while criticism and praise of Futurism multiply on all sides the Futurism safely back in Milan not the real me approaching the great cold frightening heart of Moscow

In the packed amphitheater lecture hall of the university I use a large portrait of the czar to explain the absurdity of *verismo* when all of a sudden a group of officers and soldiers with bayonets at the ready begins moving toward the speaker's stand but fortunately are stopped by my usual female admirers excitedly explaining over and over again in Russian that I didn't mean anything revolutionary or disrespectful but just an artistic explanation

Standing to receive their enthusiastic applause and the repeated com-

ment "Yes you are the great Futurist not these stupid sensation-mongering Russian Futurists"

I note the ugly incivility of the city and the rarity of taxicabs which forces you to use *isvoschi* a vehicle that favors a satisfying communion with beautiful Russian women but discourages our sudden love behind the ballooning back of a driver swollen with whips and reins and horses with the jogtrot rhythm of the steppes

My lectures provoke arguments between the group of Russian Futurist painters known as the "Ass's Tail" headed by Larionov and the group of Futurist writers called "Ferment" who decide to protest against the Italian poet by leaving Moscow

A third group crops up known as "Bouquets to Marinetti" headed by Tastéven but he turns out to be a peculiar supporter and impresario having written an article about me in the most solemn and deadly terms saying that "Futurist depravation is a force and therefore a glory to desire cripple the defeated and woe to the woman who feels pity for a man's tears she must kill him immediately unless she wants to debase herself below the basest whore"

In all the bookstores and smart shops there's a caricature of me in the window showing me half bombarded by rotten fruit and half colonized by feminine hearts

My raging success with women arouses the ire of the "Ass's Tail" group whose leader after he had denounced me as a traitor to Futurism in an article introduces me affectionately into the most important literary circle and eating drinking and talking in French with his Russian wife Goncharova I'm allowed to attend an important meeting

We stand in the back of the packed room and discover that a violent argument is raging on stage between university professors and poets about Futurism and me

Larionov shouts

"Dear Marinetti that clown on stage with the red cloak gold cheekbones and blue forehead is Mayakovsky an imbecile in red arguing with four idiots in black"

In the freezing air outside some typical Futurist lines flame out so brightly as almost to declaim themselves

> Bear in mind first of all: do not live for the present
> only the future is the tomorrow of poetry;
> Remember secondly: don't pity your fellowman;

Love yourself with infinite love;
Don't forget, thirdly: bow before art,
Only before art, without limit and without purpose

I receive a manifesto that reads

In 1912 a new movement was born that took the name of Acmeism
(from the Greek word *acmē,* summit) or Adamism (from the new
Adam who must give new names to things).

These poets acknowledge symbolism as "their worthy father" but
they reproach it for directing its greatest energies toward the realm of
the unknowable. This is what Goumiliov says about it: "The true role
of literature has been put in great danger by the mystic-symbolists. They
have transformed it into a series of formulas that are supposed to express
their own traffic with the unknown. . . . As Adamists we are some-
thing of wild animals and in no case will we ever exchange the animal
in us for neurasthenia. . . . For Acmeists a rose has become beautiful
again for its own sake, for its petals, its perfume, and its color, not for
its mysterious analogy with mystical love or anything else. Acmeists
want to lead poetry toward life, toward man, toward nature."

The most important of those university professors gave a grand ball
in my honor and while sitting on a couch in the salon I unwittingly
carried out a surprising simultaneous theatrical synthesis

Two beautiful ladies enter masked as voluptuous orientals like two
jaguars in their slow feline grace

One on my right one on my left a trilogy of seductive French small
talk and giggles while the husbands of each are sitting right in front

Two pasty anemic husbands a little limp who can only murmur in
Russian but seem to prefer taking down mysterious phrases in their
notebooks

My host endowed with a strong character almost Italian shows great
sympathy for me and begins playing the part of the stage manager
turning the lights off and on in time so that in the ensuing darkness I
can give a long kiss alternately to each of the ladies on either side

As an Italian I ordinarily would be worried about their husbands but
I'm soon convinced I have nothing to fear on their account when hav-
ing asked them for their observations they show me the madrigal son-
nets they had just written

In the freezing air of the streets the most typical Futurist lines spell
themselves out with their own intensity

"The watchword behind which the first formalists allied themselves"—
Eichenbaum was saying—"was the freeing of the poetic word from the
philosophical and religious bonds that had taken more and more posses-
sion of symbolism."

Mayakovsky added to this new state of things an innate feeling for
justice and a desire for publicity as strong as it was difficult to achieve

> In a second
> I will meet
> the master of the heavens—
> I will kill the sun!
>
> . . .
>
> To you
> who cry
> "I will destroy
> I will destroy!"
>
> . . .
>
> I—
> who have kept an intrepid soul
> send out my challenge!

After the lecture on the scandalous Futurists the dance begins and I
am strongly attracted by a very young dancer an apparently well-bred
girl but in the Russian way that is a charming manner of moving her
buttocks at a martial step when she walked that still makes my nerves
tingle
She even has a special way of smiling and saying
"The Futurist poet Mayakovsky plagiarized you today in the news-
paper because you had said 'a racing car is more beautiful than the
Victory of Samothrace' and he wrote 'the slipper of the prima ballerina
of the Opera is more beautiful than the *Venus de Milo*' and I'll add that
I'm sure he doesn't know a thing about Venus while I'm sure you
know a great deal
"We'll see each other tomorrow night at Mantashev's house"
Without the slightest exaggeration I declare that that masquerade
ball with its amazing costumes and fabulous prizes given in Moscow in
my honor constitutes my most successful aeropoem in words-in-
freedom
Three days and three nights of the most varied entertainment at the
house of the Armenian Russian millionaire who controls all the oil

interests and loves to tantalize the czar with lavish parties to which he
invites all the celebrities of the theater and arts from all over the world
paying them the highest fees

A Neapolitan mandolin player gives a low bow and some advice

"They're preparing a mad party for you but be careful of those last
few drinks"

Probably to fight off the thirty-degree-below-zero temperature the
newspaper *Gifle au Gout Public* ("A slap in the face of public taste")
writes

> We alone are the face of our time. . . . The past suffocates us. The
> Academy and Pushkin are more indecipherable than hieroglyphics. Let's
> throw Pushkin, Dostoevsky, Tolstoy, etc., off the Ship of Actuality.
>
> The man who can't forget his first love will not know his last. There-
> fore who would entrust his last love to the scented trash of a Balmont?
> Does he reflect the virile spirit of our time . . . ?

The bluish slate of a forty-degree-below-zero sky competes with these
lines by Mayakovsky:

> All around me
> they're laughing.
> The flags
> a thousand colors.
> They pass by.
> They take offense.
> Thousands of them.
> They cross
> Running.
> In each young man Marinetti's fire
> in each heart Hugo's wisdom.

The lines triumph over the ice-blue slate and other dissonant voices can
be heard

> Listen!
> Every man
> No matter how useless
> must live!
> No!

No poetry!
I would rather tie my tongue
than speak.
That
can't be said in verse.

In the waiting room a scandal-rousing Futurist hands me a declaration

Concerning sympathy and antipathy toward our illustrious guest Marinetti the Italian poet complete freedom of choice is accorded him among "bouquets of flowers" "rotten eggs" "drunken female hearts" and his choice does not interest us signed Burliuk Kamensky Mayakovsky Matiouchine Kruchenik Livshitz Nisen Valemir Khlebnikov the Russian Futurists

The women immediately demand my free verse poem in praise of racing cars to lighten the festivities they say but that provokes an argument between two art critics who've already been drinking and talk too loud which annoys the otherwise placid host his pale face set against an opulent Chinese robe overembroidered with dragons and real pearls for eyes

An argument between two expert art dealers about the price of pearls in Paris is interrupted by Mantashev whose face is always gently kind his black eyes dripping indulgence

"Dear poet Marinetti come with me into the salon of perfumes"

I am sinuously absorbed into a soft velvety wafting of remembered smells part flavor part idea part desire part lust

A light cloud of beautiful ladies evanescent in their feathers ribbons flowers tulle and intermittences of a precise desire

Sergei Diaghilev sits next to me thirty years old on the quiet side snub nose licorice eyes a heralded genius and instructs me in something I already know but that he thus recolors

"A great artist must possess the qualities of both sexes as did Leonardo Michelangelo Wagner etc. and be homosexual and heterosexual because the sexual act is bereft of beauty if it's merely fecundation a continuing of the species"

"Dear Diaghilev I adore Russian women"

"Dear Marinetti you'll be convinced that love between persons of the same sex creates beauty because of the resemblance of their two natures

"Thus an aesthetic joy in this double beauty lifts friendship up to

ecstasy and when the cord of emotion is stretched to breaking the human body becomes a musical instrument quivering and excited not broken but lowered to infinite bliss *à deux"*

In one corner about a hundred smoking censers were swung back and forth for a whiff then put back then taken up by others with servants all over dressed in green watered silk they claimed was asbestos and a well of perfumes commanded by a bearded man in white with the stylized gold cassock of a sublime perfumer

I agree to lie down on heaped violets surrounded by electric bulbs smothering mounds of overheated roses which begin to burn

On my back I recite my free verse poem to racing cars although I feel trapped in my rhythms by my position and forced to throw my images up to the ceiling where infinite spirals of smoke mix orange sapphire cobalt sky-blue smells chancing the stench but applauded dazed by my effort and the strong essences I relish the mouth of a woman who creeps up to me to give me advice and that mouth resembles the girl's with the unforgettable walk from the previous night

"Turn on the big fan so everyone can smell the perfume of acacia along the Mahmudieh Canal in Alexandria the native city of Marinetti the Italian Futurist poet"

This kind thought of Mantashev's encourages his very attractive woman friend a Parisianized Jew

"Keep the fan going as long as the Italian poet can smell the very special perfume of his famous fiancée and brilliant poetess Jane Catulle Mendès"

I leap to my feet so as not to be dissected further and follow Mantashev into the salon of gifts

A theatrical arrangement of objects each in its cradle or nest or shell of petals a jewel hundreds of them under the play of spotlights that dimmed any recollection of the shop windows in Rue de la Paix

Monstrous pink and white pearls with tropical waters swirling around them pearlfishers among slick sharks

Suddenly two gems so dazzling I have to rub my eyes and steady myself even though I haven't had anything to drink and it's her again the girl from last night and those lips a while ago and she too with a slight turn fleeing

They can see me from the other side of the room the low chatter and suppressed laughter of the women vie with the terrible heat I abandon

myself to the fronds of the potted palms and the large feather fans of the ladies

Without visible bodies we're in an artificial paradise under the sultry hazy air of the tuberoses

I pick my way among the writhing pale forms of beauties lying on the floor while along the walls doze tuxedos and tails like so many copper funeral jars with ivory stoppers one of them murmurs

"Prince Martin de Coloredo-Orlov killed himself this morning and his beautiful fiancée Sonia between them they owned all of the Ukraine each more beautiful than the other"

I answer

"These are current facts of a cosmic nature and interesting in any case they'll be a logical part of this poem of mine"

I don't know whether it was because I had finally reached that famous mouth that had so painfully eluded me or because of the sheer weight of all those odors I dozed or fell asleep amid the unraveling of pleasureful sensations from which emerges a junipered flavor of pastry and rose petal jam but the fact is I'm standing there contemplating the large diamond on my finger the gift of the preceding night

I must have eaten a great deal the whole night and like a vagabond who's fallen asleep under the bridges of the Seine I look up at the soaring arches of smoke rising from the censers converging toward the room with the fans

Dreaming kissing wandering in the shadows and among the flashing of jewels wandering here and there aimlessly guided and then lost by the always less real host whose face seems like concentrated moonlight

In the conservatory they call San Remo I spend the third night of this mad party and I'm still forcing myself to keep awake and away from alcohol while many Russian gentlemen and ladies are blissfully snoring I laugh at the sight of them among muscular stalks of various cactus plants trained like athletes by a little queen in violet a more or less Indian goddess with a violet or cobalt-blue if you like turban or even cocaine-silver.

I can hear the whole group of Futurists known as the "Ass's Tail" raging behind a huge glass screen framed in ebony and finally Larionov speaks up lying there gigantic declaring in Russian which my recaptured beauty with the sinuous lips and buttocks translates for me

"Marinetti will have to declaim his "Let's Murder the Moonshine""

right here in this artificial paradise so that with all of his cutie's kisses he'll really be a traitor to Futurism and we'll only be amused"

I get up and shout each word-in-freedom of my African poem *Battaglia Peso + Odore* [*Battle Weight + Smell*]

The atmospheric forces become strangely mechanized and march in ranks to the rough metallic cadence of colonial troops cactus fronds wads of cotton the breath and stink of soldiers meat roasting in the sun big breasts and squirrellike or better yet vulturelike scurrying bodies that stripped are as white as long hairy (. . .) chomping on the moon

My words-in-freedom excite even the dissident Futurists of the "Ass's Tail" who join my great polyphony of an army marching into the burning sands and the Tripoli-smelling Souk

But the popping of enemy bullets don't hurt at all because they're most probably the champagne corks flying

Toward dawn after the third night I'm a little worn out and would like to enjoy the Venetian Room

Never has a refined millionaire achieved such a decor complete with a miniature lagoon mirroring carved palaces with gondolas in perfect detail black and red pennants flying music coming from the prow the beautiful voice of a gondolier rowing through the perfumed smoke of a censer that suddenly disappears and simultaneously there springs out at the balcony of the Ca' d'Oro the powerful yet jaded face of Wagner with his hooked nose

And the chant swells to the trickling of water and blissful intimacy of foam ebbing away wanting to die trying to cry but laughing when it is reborn again and falls away into nothingness

Meanwhile Erminia under the shady plants seems to hover between life and death

Mantashev approaches with his face the color of a cold dawn his deep-set eyes the last vestiges of night

"Dear Futurist poet I'd like to thank you for your splendid recitations and say I admire Italy greatly

"You Italians are a great people and my brother in Africa admired the Italian troops you're courageous bright and patient but as drinkers . . . you simply don't make it as drinkers"

I burst out

"Have them bring me any kind of wine anything drinkable even your petroleum I accept the challenge"

The balcony that runs around the Venetian lagoon and its gondolas fills with ladies and drowsy drinkers or grumpy sleepy servants and Negro waiters

Next to me the Neapolitan mandolin player in a red jacket with an ironic smile

"Be careful you're a great Italian poet but these Russians want to polish you off their way"

I begin the contest by swilling down huge glasses of champagne each one with the toast

"Vive la Russie"

Mantashev's pale face turning slightly green because he's already had more to drink than me

"Vive l'Italie"

At my fifth glass I sigh

"To give me strength to go on I need emerald liquids in love with the woman who eludes me always yet is always here"

The beauty with lips now pouting graciously squeezes my fingers as they clutch the fifth brimming beaker that's beginning to mock me

The excited attention of the men and several women poising their pencils to take down bets is as agonizing as the vibrant reflections from the mirrorlike surface of the lagoon determined to become a maddened mosaic of eyeballs

But I'm still not drunk and containing my own lagoon I conclude in great style

"Sometimes the beauty of a work of art is complete and you can't be certain whether another brushstroke word or note will perfect or kill it in any case I'm going to dare to add something

"Vive la Russie"

At the tenth brimming glass I feel a sort of liquid madness surging through me but stopped in time by my iron will power but maybe I would have succumbed if I hadn't heard my rival say

"Vive l'Italie that can't drink like Russia"

I gurgle back

"You're fooling yourself I drink to your defeat vive la Russie"

"I am defeated vive l'Italie"

A whirlwind of voices knocks two tuxedos into the water followed by a lovely young thing and I am very happy about my victory but desperately trying to hold down a fountain of vomit jeweled fingers

clutching me on both sides trying to keep me on my feet dead or alive stoppered or unstoppered foreseeing the inundation but victorious nonetheless

I managed to keep up the façade and the beautiful Jewish girl Mantashev's mistress asks to drive me in her car to the Hotel Metropole and I bid everyone and everything good night

"Good night good morning rather I have so soundly defeated Mantashev that I hope I see you all tomorrow night in the first row at my lecture and I advise you first to get your bearings with a sextant or a plumb line"

The car ride became rather dangerous because of the car's hardheaded efforts to compete with the bumpy cobblestones in forcing me to spew out a new type of red army all over Moscow

Now that I'm in bed at the hotel the city can spin around all it wants even flip over twenty times and the whole grape harvest stain the Milky Way purple

Two expertly trained servants come in and empty me out like a trough but I'm bottomless and no matter how drained and pumped out I look positively awful in the mirror and stunned to receive more than ten visiting cards the next morning at eleven announcing beautiful ladies or audacious unmarried girls

Great God one after the other like glasses of champagne as the congratulations handshakes marriage proposals sly winks and suspiciously vague gestures get bolder and bolder

Just as before I have to demonstrate I can drink like an Italian and maybe I was still feeling the effects of the alcohol but at any rate considering those Russian women as so many bottles to down I even tried to reach bottom with several of them

I didn't bother with the usual interlude of grateful kisses but simply fell asleep in the Moscow manner as soon as I had downed a beautiful Russian who knows if I'll ever wake up again but this last one was so good I take a few more swigs and again fall asleep and that night I go out not intoxicated but drunk with all the victories and hear the newsboys shouting the Futurist Marinetti's triumph and how he can drink like a Russian and how he beat Mantashev at champagne

In the great lecture hall I speak about the Futurist theater of Bruno Corra Mario Dessy Remo Chiti Settimelli Mario Carli Pratella going into the problem of simultaneous action and logical surprise and I find I can verbalize my thoughts easily but at a somewhat supernatural level

losing touch with earth time space letting my imagination take wing but Mantashev's face was looking green making me think mine must be purple maybe but my heart golden with Italian pride

My personal successes follow one on the other and the more or less coy sweet plots to checkmate Futurism multiply

I leave for Saint Petersburg promising definitely to return to Moscow after receiving a telegram from Paris from the most famous and eloquent Russian jurist challenging me to a speaking contest

The crowd that fills my train compartment with flowers is divided into fans who are sure of my invincibility and the semi-ironic who are relishing a foretaste of my defeat given the so far unbeaten talents of the famous lawyer poet demonstrated everywhere like some new Parisian Muscovite Demosthenes

At Saint Petersburg the station is jammed picturesquely with the wildest most luxurious furs monumental white bearskin hats mustaches of iced Bernini proportions and all through this enthusiastic reception I keep thinking with every arctic blast about having my triumphs in some cave somewhere

A peculiar avantgarde this one different from the French and even from the avantgarde of Moscow bringing together shabby poets beautiful actresses loaded with pearls grand dukes Futurist painters dancers cartoonists industrialists engineers electrical technicians Siberian prisoners ship commanders from Odessa policemen university professors sculptors and Italian architects who swarm around me with too many ribbons and blasts of wind and I'm swallowed into a downstairs place called Sabacha which means wild dog

Luxurious enough but I still feel like a wild dog forced to bark for his supper no matter how tired and longing for sleep and Italian solitude

Beautiful in so many ways the Russian women there demand new proofs of Futurist energy and I'm compelled to take refuge in the arms of one of the prima ballerinas of the Opera who decides to outdo all the Moscow women I admire by whisking me off in her sleigh making sure we're followed to a small station café by her rival friends according to their nightly habit of meeting at the station at dawn in the hope of taking the last ideal train

Many letters inform me that this ballerina is doubly celebrated for her beauty and for her constantly affirmed purity otherwise known as frigidity which my Futurist poetic Italian genius tries in vain to warm up

I am told later that this mysterious beauty has announced she'll give an unusual gift in keeping with her wealth to anyone who succeeds in defrosting her

As a licensed defroster I evade the watchful eyes of my beautiful maids at the Sabacha every afternoon and go out to the ballerina's opulent and cozy villa outside Saint Petersburg by sleigh even though it's buried in snow she always manages to blend her burning kisses with endless diatribes about purity of soul and the horror of lust

I remember acting as nimbly as a Capri fisherman who watches the squid he wants under the blazing noon sun until the right moment when he spears it suddenly to avoid the powerful backlash of its judicious rational chilling chastity

I come to the conclusion that she is too educated to be intelligent but superbly beautiful in every point of her body the ballerina nicknamed flesh of pearls is worthy of indulgence and infinite love

The long-awaited gift is brought to me by the ballerina personally at the Sabacha it turns out to be a small phial containing a cream she mixed herself of ground pearls and several essences whose composition she keeps secret

A scandalous backwash of rumors and idle chatter while flesh of pearls dances for me alone nearby I spot a poet from the "Ass's Tail" with an emaciated effeminate face he whispers that love of women is out of fashion

They ask me to improvise some words-in-freedom on the theme "Her pearly thighs are the best cushion for the head of a poet but the firemen are on duty"

The downstairs of the Sabacha is made up of about seven rooms painted and draped with a variety of materials velvets and purple brocades and many portraits of me done by Kulbin and Larionov but memories of the now legendary drinking contest at Mantashev's party punctuates my inspiration with annoyance and with a moved and moving outpouring of sensual images I free-wordly condemn alcohol and moralist cold showers and seeing flesh of pearls lying on the carpet I lie next to her and lay my sleepy thoughtful head on that ideal thigh

Murmuring

"The phial of ground pearls erases the Queen of Sheba from legend and I feel like a young Solomon but not Jewish because I don't give a damn about how much the pearls cost all of them paid for by the soaring price of my images"

Flesh of pearls covers me with kisses while in a corner among the barmen and the pastry and caviar sellers the group of beautiful Russian women gather armed with their grudges and vendettas against her

Whispering with their smiles prattle sighs buzzing shrieks and tinkling of jewels amid flesh winks malicious grins and busy hands rushing me away so I won't hear what's going on it's supposed to be an eye-rolling surprise

I sense that something special finicking complicated and perfected is coming to the fore hidden in a fistful of gold

All of a sudden the boldest one a dark-haired Caucasian dressed in a green sweater that clings so she's almost naked declaring herself the sister of the girl from Moscow with the beautiful lips leads me aside with trembling hands and makes me read a slip of paper on which are written the words *Ya lubli vas*

Which means I love you very much followed by sixteen signatures written in blood extracted patiently from their arms with a gold stiletto

But the head of "Ass's Tail" bursts in to drive the blood-thirsty excited beauties away with Russian imprecations and offers me a gold nugget from the Caucasus a gift from the "Ass's Tail" group now half-converted to Italian Futurism on condition that Marinetti decides to get rid of the moonlight he prays to too much on his knees in the sleigh of those very vibrant Russian women

The night gives way to a heated argument with the usual availability of beautiful Russian women to explain my ideas in French curling on the floor or sitting on cushions like a wordy flowering hedge while a short distance away I am being besieged by an aggressive legion of tall bearded long-haired misogynist Futurist poets artists who because of the occasion or their nature are very suspicious and indignant about the too-cuddly female translators

Both the former and the latter are untiring and all along eating and drinking talking and answering pretending to give in just to take a breather

Even a little squeeze of the hand with a newly discovered beauty serves to distract me from the boiling caldron of theories pro and con and even the pleasure of being in the wrong among the maniacal and fantastic ways of reasoning

An exhausting new task awaits me in Moscow where all the papers are announcing the great contest between the Futurist poet Marinetti who defeated Mantashev at champagne drinking and the illustrious

lawyer Karashevsky on a subject to be drawn by lot a minute before

I succeed in visiting Shimkin's gallery alone he's the very well known art patron a director of the Trans-Siberian Railroad and in a kind of golden warm Mediterranean ecstasy I admire the great Algerian paintings of the greatest French painter Matisse

With a sunny brightness reminiscent of Mistral Matisse painted scenes of daily life in Algeria after having achieved a unique mastery of color by modeling the native men and women with just simple areas fifteen or twenty centimeters wide and high of chocolate and khaki tones

I am convinced that pre-Futurist French and world painting has achieved in him its greatest effort after which of necessity painting has to go into plastic dynamism into the violent movement of the aeropictorial and into the simultaneous action of time-space near-far remembered-present concrete-abstract

While I'm enjoying Matisse's genius and happily learn that the gallery will soon acquire Futurist works by Boccioni Severini Russolo Balla Carrà I hear the people around me repeating the name of the famous lawyer I'm about to contend with

The encounter will be lively and so is the leonine head of his wife when she dances

Conditions of the encounter first the speakers will improvise in French second each speech will last an hour third the debate will take place between four and five in the morning after a strenuous day outdoors and an abundant feast in the taverns of Pot and Pan streets

Karashevsky and I are there looking foolish in the steamy puffing of the horses taking us out for a long and snowy day in the country along with a crew of lovelies anxious to tire us out under the upholstered *kousher* of the *sani* a highly uncomfortable luxury sleigh

I'm already tired but still have to accumulate the required fatigue more or less sheer gastronomic volume at the Donon Restaurant on the Astrovar Islands in the inlet at Kronstadt

Even by playing hide-and-go-seek in a park with crystallized trees and pillars of ice or up and down on steep streets

Vodka served in teacups or blinis of caviar melted butter sour cream enclosed in scalding hot napkins and a contest among the eaters

"I've eaten fifty and my wife has eaten fifty-five"

I feel somewhat like an Eskimo being driven around by beautiful

furry but too gentle she-bears when their white jeweled hands are splashed by a fresh swirl of heady wines

The theater where the speaking contest is to be held gathers together in addition to all the business and industrial elite of Moscow the entire corps de ballet of the Petersburg Opera and playboy grand dukes and I go on stage gathering all my energies and my Futurist mastery in my chest and fingers with the memory of Jane Catulle Mendès's sparkling wit and the determination not to imitate either French or German or Russian speakers but to provide a complete example in perfect fluent French of the many-sided tentacular farsighted Italian genius kisses

The eating never stops and the true Russians come and go spouting talking

The lot falls to Karashevsky who will speak first on the subject "the labyrinth of female gratitude for an exotic male" to which is added another topic in case there is a second round "the immortality of the soul according to the pope of pipes on the Volga" referring to a folk character a traveling pipe seller with a big white beard a greatcoat embroidered in green and yellow and dirty fur cap

Amid general annoyance and to my great pleasure I see that Volnov Karashevsky is the usual French-style lawyer who rounds out his speech with melodious well-constructed phrases replete with literary historical quotations and at times dropping choice bits of international scandal

He delays praising the refinement of Moscow women and their charm which he prefers to that of Parisian women but seeing he's not making an impression on the fair sex he sallies forth with Cartesian philosophy and ends with an undesired eulogy of Saint-Simon's memoirs

He is loudly applauded without much conviction but seems to many to be unbeatable

I get over my physical exhaustion in my lust for battle with subtle double entendres slipping their way through this labyrinth of female gratitude trembling and delighted by the appearance of the ideal exotic male

I undress the better-looking ones with short quick remarks that promise later brutality and then launch into passionate lyrical praise of Russian women in detail

I excuse myself and ask their indulgence repeatedly for what I con-

sider the absolutely fatal obedience imposed by the perfect body of a woman

Thus having absolved the women of their sins and sinful pleasures their lovers logically being the lustful ones I suddenly pick up my pace firing off pyrotechnical images of the soul's immortality alternating between Futurist simultaneous action and the imagined folk language of the pope of pipes on the Volga

Their applause rewards this image and the baking-hot oven of sensuality toasts the bread of life to a turn for the devil's teeth but leaves the inner that is the immortal part all white which then offers itself to the good Lord's swallows "yet another image of the soul's immortality that can be compared I think to the starry sky over a tent in the desert where the simoom of lust pretends to dominate"

"Dear Larionov and you Futurists of the 'Ass's Tail'" you're mistaken when you try to reduce Futurism to the brutal destruction of academicism and sentiment by exalting only pointless cruelty

"We Futurists are not talking about machines that grind men down or teach cruelty we Italians are trying to point out instead the aesthetic of the machine as the new form of the universe's dynamicizing and immortal soul

"The feeling whose pulsations must be sensed and whose energies must be expressed demands at this moment for instance that I reject your applause if it is only motivated by the foreseeable attraction to novelty from other countries which will eventually destroy your own Futurists just to celebrate foreigners

"To the Russian soul I send a plea for the recovery of Russian Futurism"

Rosa Exter the Futurist who afterward became the original and daring set designer for Tatiana Pavlova says to me

"Where will we end the night?"

"Although dedicated to my own bed as is every Italian we'll end the night at the station to listen to the metallic advice of the railroad tracks but with our pockets filled with bottles of beer because beer cures hangovers"

Yuribilaev the art critic and the ballerina Catherina Ghelzer a delicious tall brunette are with us and we all agree to go pray in the Iverskaya Church of the Mother of God

After those nights in Russia I rest in the clear water of Portofino where Nordic fumes are dissipated and the cobalt blue of the Mediter-

ranean dices the truths of the world with cruel precision I hear Schnitz-
ler the novelist saying between drinks

"Dear D'Aroma I have to admit that my *Fräulein Elsa* came out of
Marinetti's Italian Futurist Movement"

Selective Index of Names